# ART AT AUCTION
1966-67

# ART AT AUCTION

The Year at Sotheby's & Parke-Bernet

## 1966-67

The Two Hundred and Twenty-third Season

American Heritage Publishing Co. Inc.  New York
Distributed by The Viking Press

American Heritage Publishing Co. Inc.
551 Fifth Avenue, New York 10017

© Sotheby & Co. 1967

First Edition

Published in the United States 1967

Edited by Philip Wilson assisted by Alison Brand
Jacket designed by James Broom-Lynne, photographed by Cecilia Gray

Printed in Great Britain by W. S. Cowell Ltd, Ipswich

# Contents

The written introductions to all the sections of Art at Auction are by Frank Davis unless otherwise stated.

# Old Master Paintings

When the death of Lady Craven, daughter of the New York financier Bradley Martin, brought many fine things to Sotheby's during the 1961–2 season, one of them was the Canaletto—*Santa Maria della Salute and the Grand Canal*—as limpid and as sun-drenched a painting as anyone could wish. I have a vivid recollection of the murmur of surprise and shuffling of feet when the hammer fell and a familiar quiet voice announced £40,000—the highest price ever paid for a Canaletto up to that time. This year we have had to readjust our thinking drastically, for in the last major Old Master sale of the summer, *A Regatta on the Grand Canal*, one of six views by Canaletto painted for the then Duke of Buccleuch about 1740, fetched £100,000 and a second, *The Campo Santa Margherita*, £60,000. This picture belonged to a series of twenty-one which were almost certainly painted for Consul Smith. Its neighbour, a view of the Grand Canal from the Rialto Bridge, from the same series, made £38,000. Although Canaletto attracted most attention, there were many other pictures which in any ordinary dispersal would have provided a mild sensation. One of them was a sump-tuous triptych, *An Adoration*, dated 1517, by the little known Jacob Cornelisz. van Oostsanen, with the customary donor and donatrix on the wings accompanied by their children, the coat of arms that of the Heereman family of Amsterdam, which made £37,000. A second was a dignified, tender *Madonna and Child with St. Bridget and the Archangel Michael*, formerly known as 'the Poggibonsi altarpiece', ascribed by Berenson to a follower of Domenico Veneziano, by others to Andrea del Castagno, and now to The Master of Pratovecchio, which was sold for £14,000.

It is difficult to realise that the production of tourist souvenirs was, after glass manufacture, a major Venetian industry and has done as much as anything to fan the embers of the Englishman's age-old love affair with the city; first Marieschi and Canaletto and their followers, and then Francesco Guardi adding to the tradition his personal sparkling sensitivity in dozens of little scenes, some of them no bigger than outsize postcards and in their time rated not much higher—and now three of them going for £8,000, £6,000 and £6,800. Later that morning, from 17th century Holland, a winter landscape by Aert van der Neer signed and dated 1644 was sold for £11,000 and a well-known Jan Steen which had been seen at the Royal Academy Dutch Pictures Exhibition in the winter of 1952, for £24,000. This was *The Village Wedding*; the bridegroom, hat in hand, welcoming the bride amid dogs, children, music and general jollification. In a wholly different category was a pastel, a revealing and vivid self-portrait by Maurice-Quentin de la Tour, apparently executed in 1754 when he was fifty, with complimentary verses on the back, a bibliographical note and a Latin epitaph by the learned Curé of St. Quentin who, with pardonable pride in his distinguished fellow-townsman, addresses him as 'Citoyen de la Somme, Apelle de la Seine' and speaks of his 'Bienfaisance, candeur, esprit, talent, droiture.' It was no surprise to see this attractive portrait sold for £20,000. This was a dispersal which reached a total of £594,990 for 122 paintings. A rather more modest one at the end

of 1966 which none the less accounted for £240,430 for 131 items, included a haunting portrait by Piazzetta of the painter Giulia Lama, known as Lisalba, who was his pupil and one of his chief assistants—a highly dramatic picture in which, in a brown dress with gold-braided collar, a palette in her left hand and brushes in her right, the sitter turns half right looking dreamily at the spectator. It made £17,500, and a Jacob van Ruisdael landscape with a dead silver birch in the foreground went for £9,500. In the spring, in a sale which reached a total of £334,150, one of the best pictures by Jan van Goyen to have appeared in the London auction rooms for many years—a winter landscape of 1625, that is, from early in the painter's career when he was twenty-nine—was sold for £15,000, a landscape by Jan Siberechts—*The Ford*— dated 1662, for £8,000, and a majestic *St. Catherine,* her pink cloak over a green dress, standing against a gold background, by Bernardo Daddi, for £22,000, while another Bernardo Daddi, a fragment from a Crucifixion, was bought for £9,000. £22,000 was also given for a circular panel by Jacopo del Sellaio, illustrating the story of Esther and King Ahasuerus; an interior of a picture gallery signed and dated 1612 by Jan Breughel the elder and Frans Francken II made £7,000; a pretty fantasy by J. B. Pater, a Chinese hunting scene of more than oriental splendour £7,000 and an elaborate Pannini of Pope Benedict visiting the Trevi fountain (as good an excuse as any for an architectural composition with figures) £10,000.

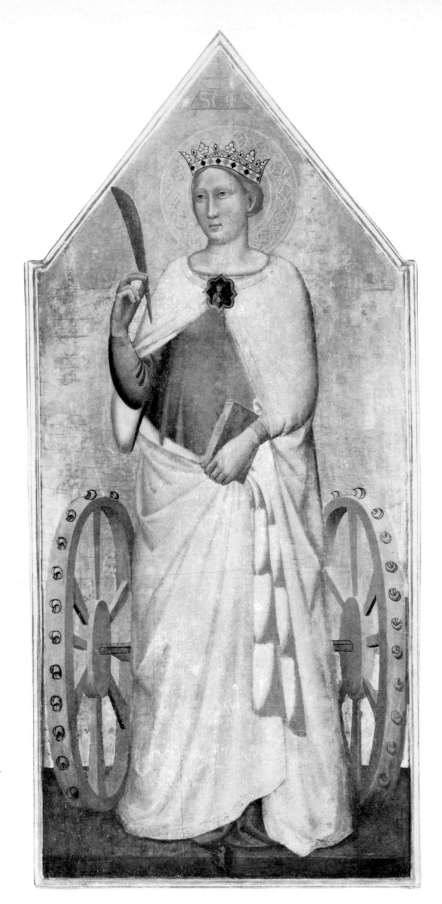

BERNARDO DADDI
*St. Catherine.*
On panel. 70½ in. by 32 in.
London £22,000 ($61,600)
19.IV.67.
From the collections of
Auguste Valbreque, Lord
Somers, Walter Burns, and
Major-General Sir George
Burns, K.C.V.O., C.B., D.S.O.,
O.B.E., M.C.

9

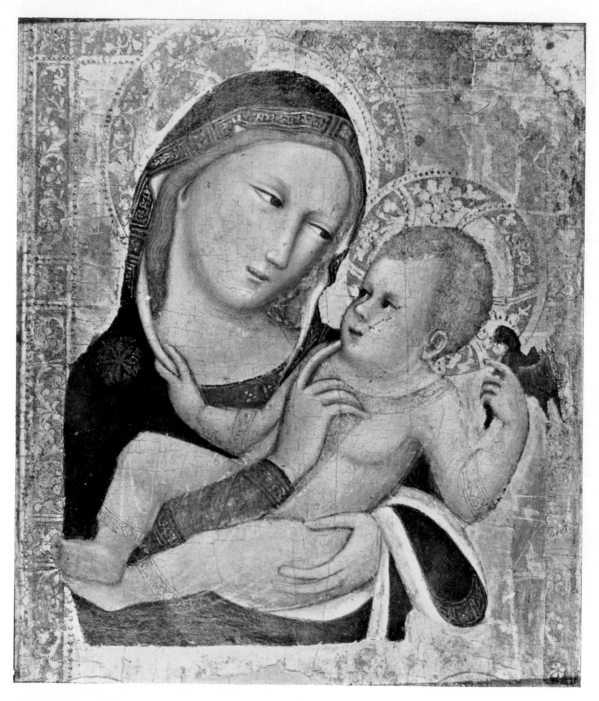

VITALE DI BOLOGNA
*The Madonna and child.*
Gold ground, on panel. 15½ in. by 13½ in.
London £4,300 ($12,240) 5.VII.67.

BERNARDO DADDI
*Figures from a Crucifixion.*
On panel. 13¼ in. by 6¾ in.
London £9,000 ($25,200)
19.IV.67.
From the collection of George
Farrow, Esq.

PSEUDO PIER FRANCESCO FIORENTINO
*The Madonna and Child.*
On panel. 31¾ in. by 19¾ in.
London £4,200 ($11,760) 30.XI.66.
From the collection of the Misses J. and O. Joseph.

THE MASTER OF 1518
*The Adoration of the Kings.*
Inscribed 1525/L; on panel. 43 in. by 28¾ in.
London £6,500 ($18,200) 5.VII.67.
From the collection of the late Fürstin Marie zu Wied,
Princess of the Netherlands.

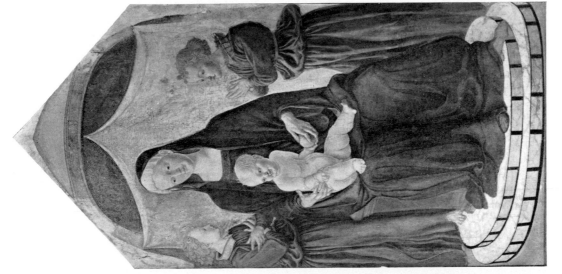

THE MASTER OF PRATOVECCHIO
*The Madonna and Child, St. Bridget and St. Michael.*
On panel; centre panel, 59¼ in. by 30 in.; side panels 54½ in. by 22¼ in.
London £14,000 ($39,200) 5.VII.67.
Formerly in the collections of Galli Dunn, Florence, Giorgio Sangiogi, Rome, and A. Sambon, Paris.

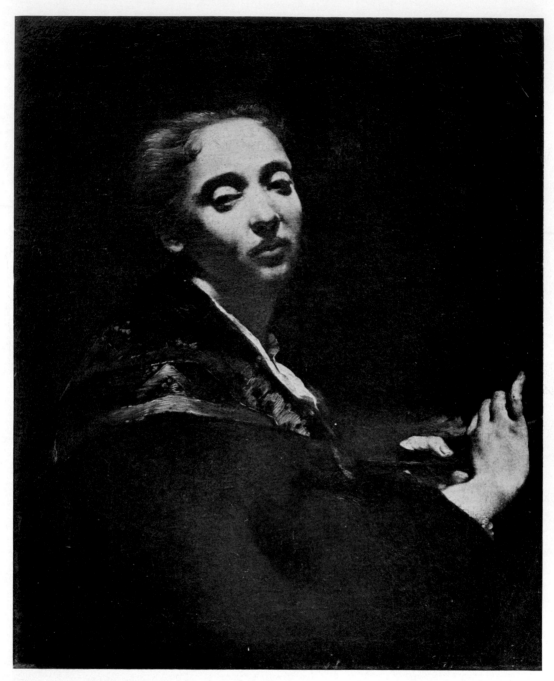

GIOVANNI BATTISTA PIAZZETTA
*Portrait of Giulia Lama.*
27 in. by 21¾ in.
London £17,500 ($49,000) 30.XI.66.
Formerly in the collections of Eugen Miller von Aichholz, Vienna,
Leo Planiscig, Florence, and Clive Pascall, Esq.

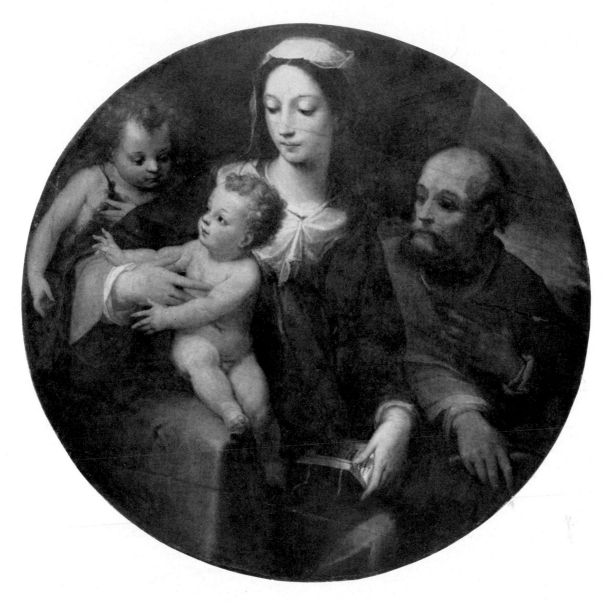

FRANCESCO SALVIATI
*The Madonna and Child.*
On panel. Diameter 43 in.
London £7,500 ($21,000) 19.IV.67.

BERNARDO STROZZI
*Madonna and Child with the Infant Saint John.*
52 in. by 41 in.
New York $13,500 (£4,821) 8.XII.66.
From the collection of Helen M. de Kay.

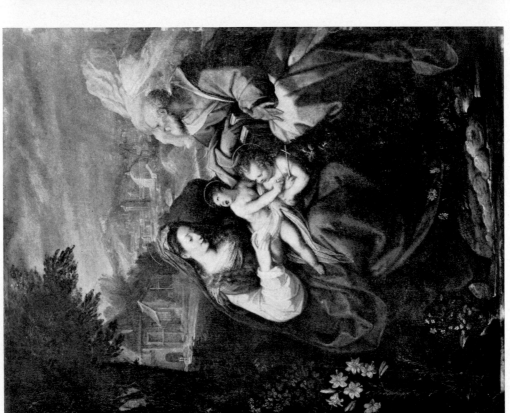

JACOPO ZUCCHI
*The Holy Family.*
On metal. 18¼ in. by 14¾ in.
London £4,000 ($11,200) 19.IV.67.

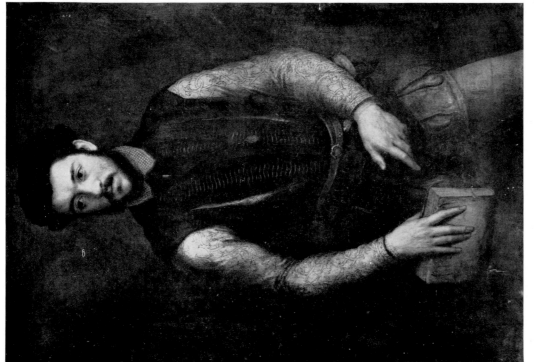

GIULIO CAMPI  *Portrait of a Young Man.*
48¼ in. by 35½ in.
The sitter is reputed to be the French poet, Clément Marot
(1495–1554).
London £3,000 ($8,400) 5.VII.67.
From the collections of King William II of the Netherlands,
1843 and the late Fürstin Marie zu Wied, Princess of the
Netherlands.

BARTOLOME ESTEBAN MURILLO  *The Madonna and Child.*
40 in. by 30 in.
London £7,500 ($21,000) 5.VII.67.
Formerly in the collections of C. A. de Calonne, Paris, 1795,
Bryan, London, 1798, and the Duke of Bedford, Woburn Abbey
(by 1821).

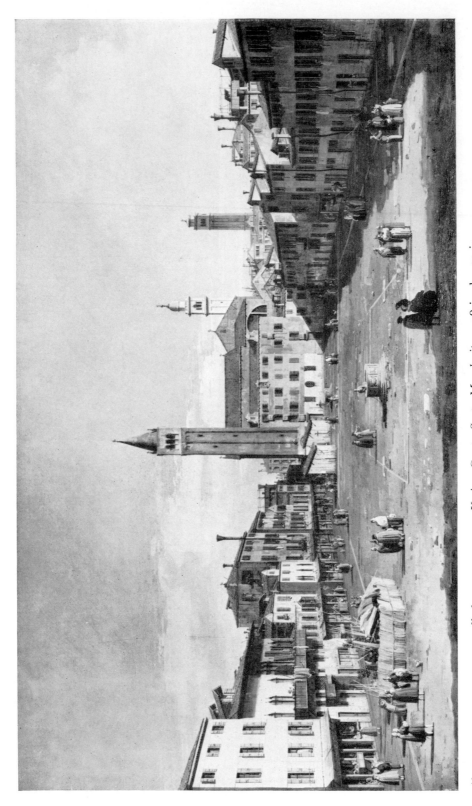

*Above* ANTONIO CANALE, called CANALETTO  *Venice: Campo Santa Margherita.*  18 in. by 30 in.
London £60,000 ($168,000) 5.VII.67.
Formerly in the collections of the Duke of Buckingham and Chandos, and Sir Robert Grenville
Harvey, Bt., Langley Park.

*Opposite page:*
ANTONIO CANALE, called CANALETTO  *A Regatta on the Grand Canal, Venice.* 45¾ in. by 58½ in.
London £100,000 ($280,000) 5.VII.67.
This picture is one of six views of Venice painted for the Duke of Buccleuch. The *macchina della
regatta* (part of which is shown on the left) is a temporary pavilion erected each year at the first
bend of the Grand Canal (the Volta di Canal) where the races end; the winners receive their
prizes there. In this picture it bears the arms of the Pisani family; Alvise Pisani was Doge of Venice
from 1735 to 1741.

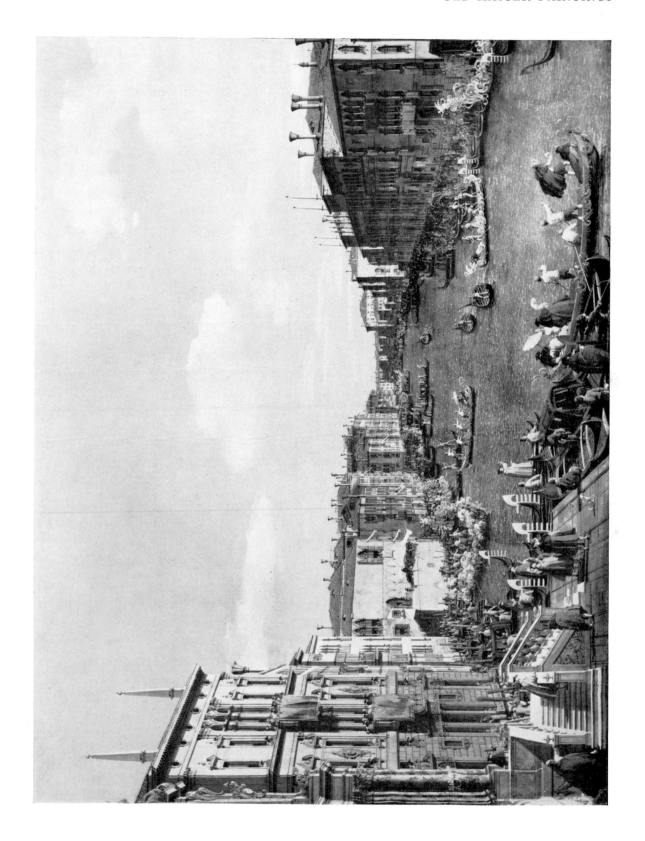

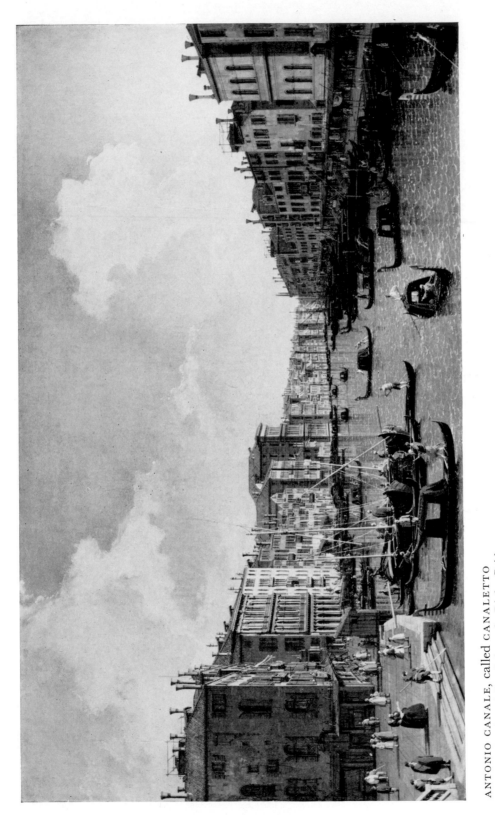

ANTONIO CANALE, called CANALETTO
*Venice: The Grand Canal from the Rialto Bridge.*
18 in. by 30 in.
London £38,000 ($106,400) 5.VII.67.
Formerly in the same collections as *Venice: Campo Santa Margherita* reproduced on page 18. Both paintings belong to a series of twenty-one views of Venice, which were almost certainly painted for Consul Smith. Nine of these were engraved by Visentini in 1742. They were bought in Venice by the last Duke of Buckingham and Chandos.

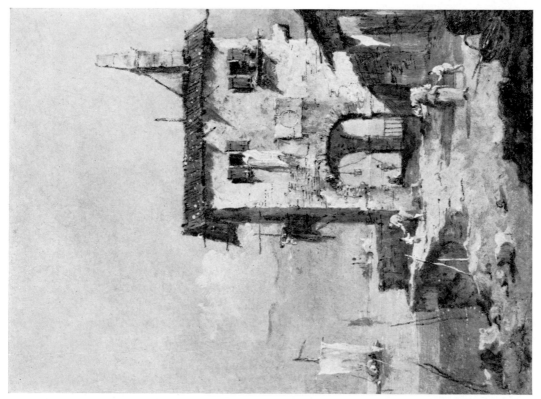

FRANCESCO GUARDI
*A View near Venice.*
Signed with initials; on panel. 8 in. by 6⅜ in.
London £8,000 ($22,400) 5.VII.67.

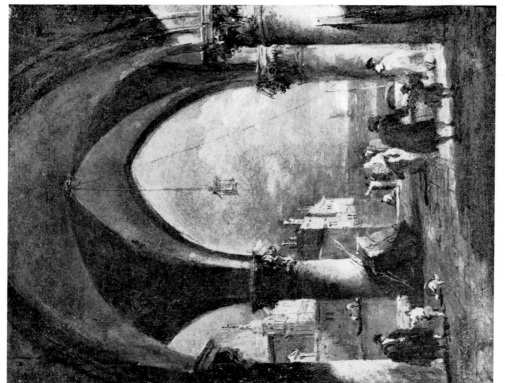

FRANCESCO GUARDI
*Venice: Figures under an Arcade.*
On panel. 8 in. by 6½ in.
London £6,000 ($16,800) 5.VII.67.

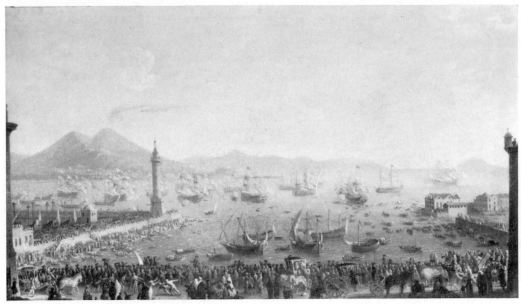

ANTONIO JOLI
*The Embarkation of Charles III at Naples, 1759.*
Inscribed: Imbarco di SMC da Napoli . . . Ottr 1759. 29 in. by 50 in.
Charles III of Spain (1716–88) was King of Naples and Sicily
from 1738 until he ascended the Spanish throne in 1759.
London £4,200 ($11,760) 30.XI.66.
From the collection of Sir Edgar Newton, Bt.

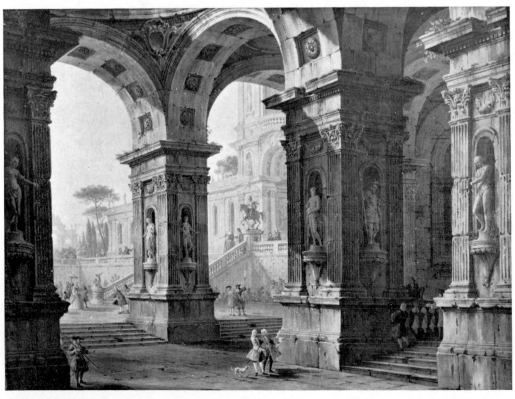

G. P. PANINI
*Figures outside a Palace.*
34¾ in. by 44¾ in.
London £5,400 ($15,120) 5.VII.67.
From the collection of Joan, Viscountess Ingleby.

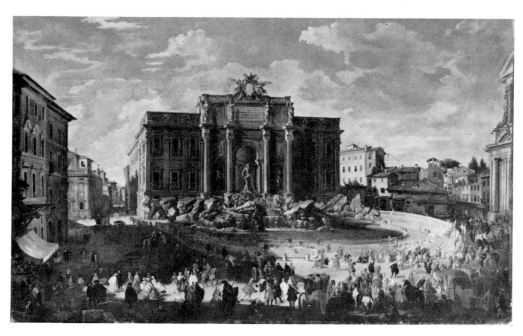

GIOVANNI PAOLO PANINI
*Pope Benedict Visiting the Trevi Fountain.*
$42\frac{3}{4}$ in. by $67\frac{3}{4}$ in.
London £10,000 ($28,000) 19.IV.67.

THOMAS PATCH
*A View of Florence.*
$34\frac{1}{2}$ in. by 47 in.
London £4,400 ($12,320) 5.VII.67.
From the collection of Mrs V. Brookes.

ISIDORO BIANCHI

*The Entry of The King of France into Aquila*

The King of France on horseback, followed by mounted
soldiers, receiving the submission of the city; the town in the background.
The King of France successfully besieged Aquila with the
help of Count Amedeo VI of Savoy (1334–1383).

*The Suppression of The Revolt of Lyons*

Count Amedeo, Louis le Hutin and Archbishop Pietro of
Savoy at the entrance to a tent surrounded by men-at-arms.
The revolt of Lyons against King Philip the Fair was
suppressed with the aid of Count Amedeo V of Savoy (1252–1323).

*The Battle of Mons-en-Puelle*

In the foreground, cavalry and infantry in a hand-to-hand
struggle, two opposing armies in the background near a castle on a hill.
King Philip the Fair, assisted by Prince Edoardo of Savoy
(1284–1329), defeated the Flemish at Mons-en-Puelle in 1304.

*Charles VIII of France Received in Turin by The Duchess of Savoy*

The King with his followers was received by the Duchess
of Savoy and her son, Duke Carlo Giovanni Amedeo, on the
5th September 1494 at the beginning of the King's expedition
into Italy. The Castello is seen in the background. Bianca,
Duchess of Savoy, was the widow of Carlo I (died 1490).

These oil sketches for four of a series of frescoes in the
Salone Centrale of the Castello del Valentino at Turin
constitute an interesting addition to our knowledge of
Italian painting in North-West Italy. The frescoes, all
representing scenes in the history of the House of Savoy,
are documented as the work of Isidoro Bianchi (active 1617–38)
and his two sons. The preparatory sketches are likely to be by the father.
The scene representing the meeting of Charles VIII and the
Duchess of Savoy is particularly interesting in that it shows the
Castello of Turin, later known as Palazzo Madama, with the
towers of the Roman gateway, the Porta Decumana, which were
covered by Juvarra's façade between 1718 and 1721.
The panels were commissioned by Madama Reale
Cristina of France, daughter of Henry IV, who married
Vittorio Amedeo I in March 1620.
Isidoro Bianchi's style of painting derives from that of one of
the most important artists working in the Turin neighbourhood, P. F. Morazzone.

The series of four, on panel, in grisaille. 17 in. by 12 in.
London £1,300 ($3,640) 19.IV.67.

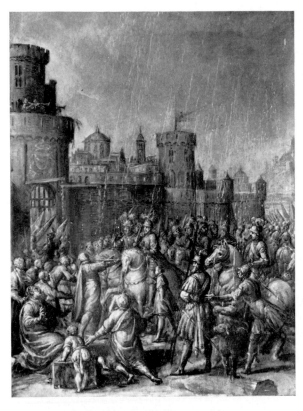

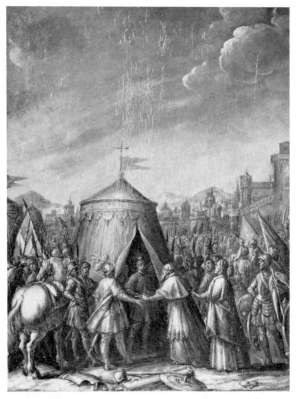

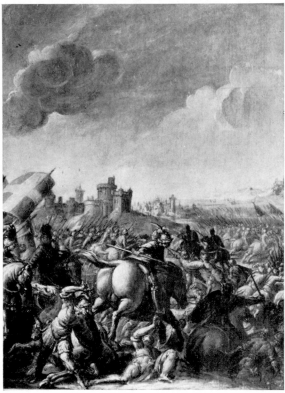

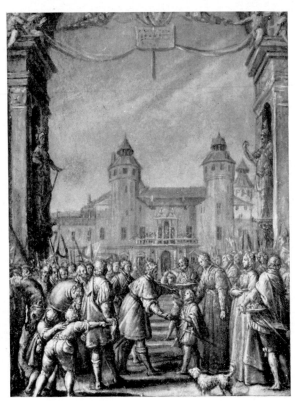

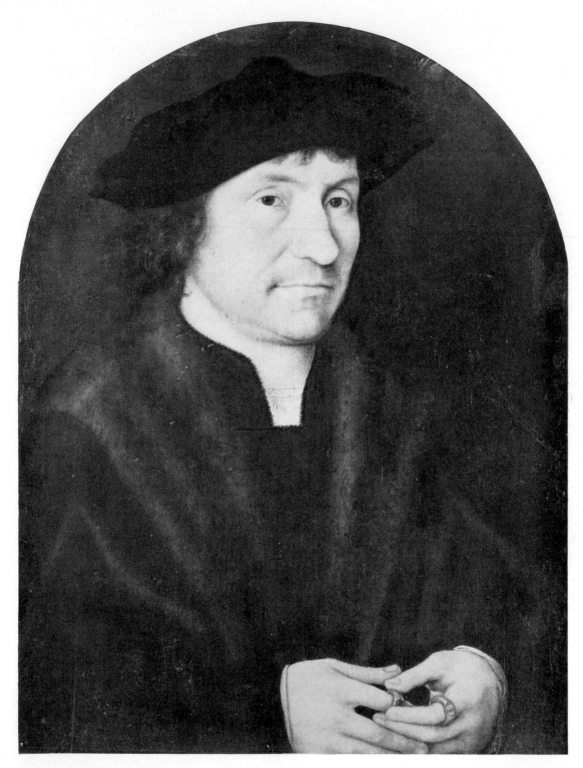

JOOS VAN CLEVE
*Portrait of a Man in a Furred Robe.*
On panel. $14\frac{1}{2}$ in. by $10\frac{3}{4}$ in.
London £7,200 ($20,160) 30.XI.66.
From the collection of Lt-Colonel Sir Michael Peto, Bt.

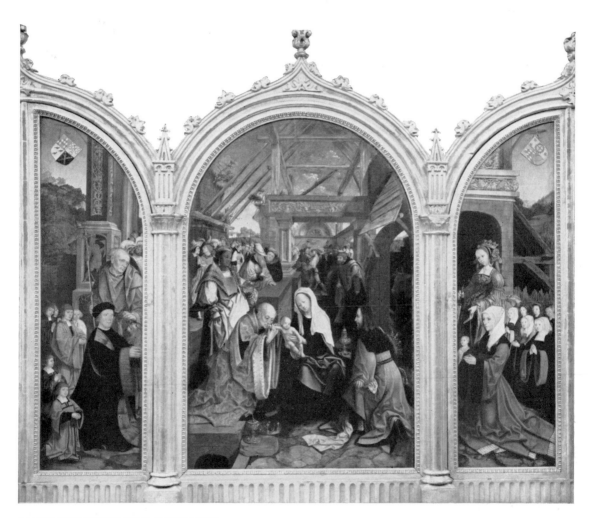

JACOB CORNELISZ VAN OOSTSANEN
*The Adoration of the Kings: A Triptych.*
Dated 1517; on panel.
Central panel, 33 in. by 21¾ in. Wings, 33 in. by 9½ in.
London £37,000 ($103,600) 5.VII.67.
From the collection of King Willem II of the Netherlands,
Prince Frederik of the Netherlands, and the late Fürstin Marie zu
Wied, Princess of the Netherlands.

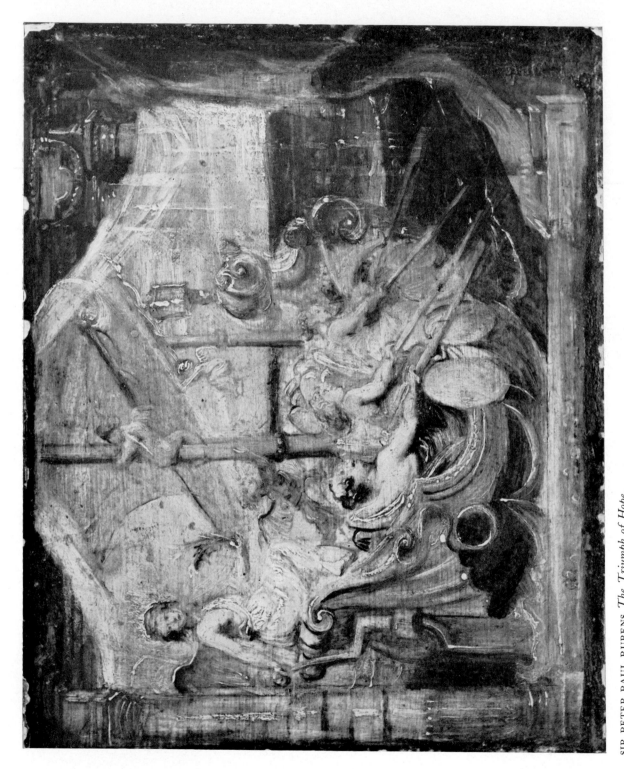

SIR PETER PAUL RUBENS *The Triumph of Hope.*
On panel. 6⅜ in. by 8 in. London £9,000 ($25,200) 19.IV.67. From the collections of Samuel Woodburn, the Rev. Thomas Kerrich, Albert Hartshorne, and Oliver E. P. Wyatt, Esq.

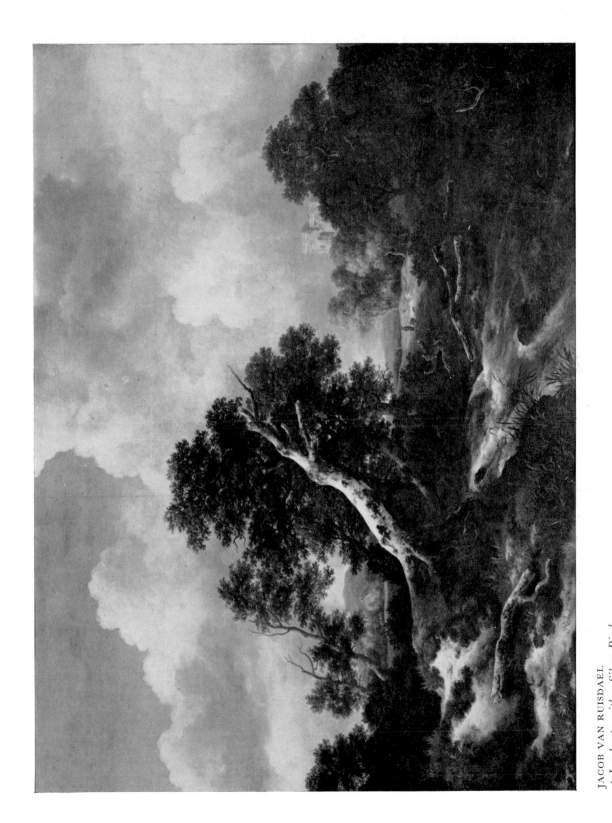

JACOB VAN RUISDAEL.
*A Landscape with a Silver Birch.*
Signed. 38½ in. by 51 in.
London £9,500 ($26,600) 30.XI.66.
From the collection of Mr J. J. van Leeuwen Boomkamp of Naarden, Holland.

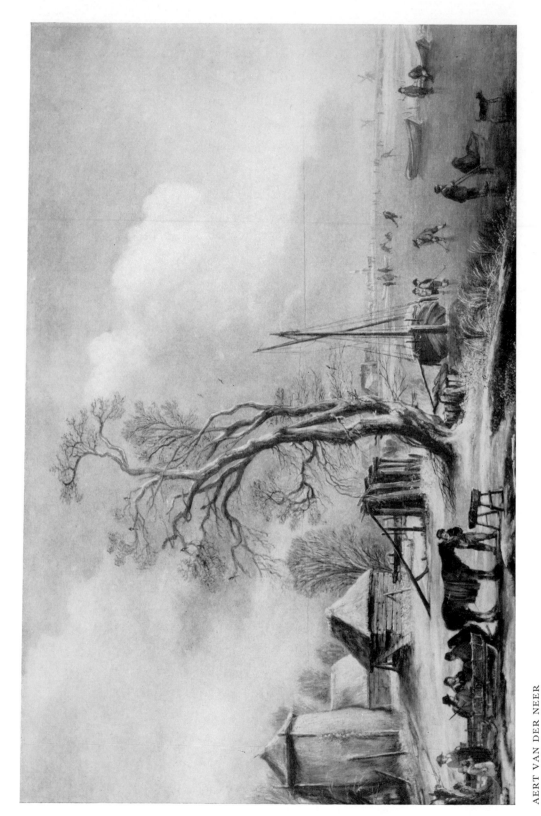

AERT VAN DER NEER
*A Winter Landscape.*
Signed in monogram and dated 1644; on panel. 21½ in. by 32½ in.
London £11,000 ($36,800) 5.VII.67.
From the collection of R. M. Robertson, Esq.

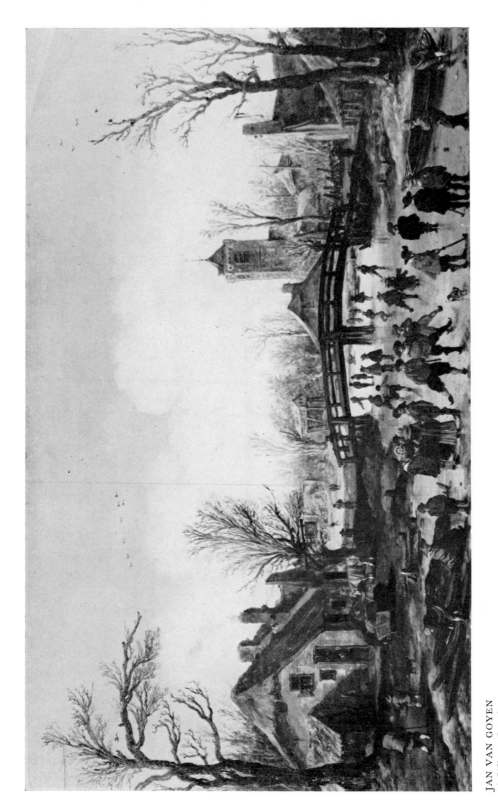

JAN VAN GOYEN
*A Winter Landscape.*
Signed and dated 1625; on panel. 15 in. by 25½ in.
London £15,000 ($42,000) 19.IV.67.
From the collection of the late Sir Alfred Bowyer-Smith, Bt.

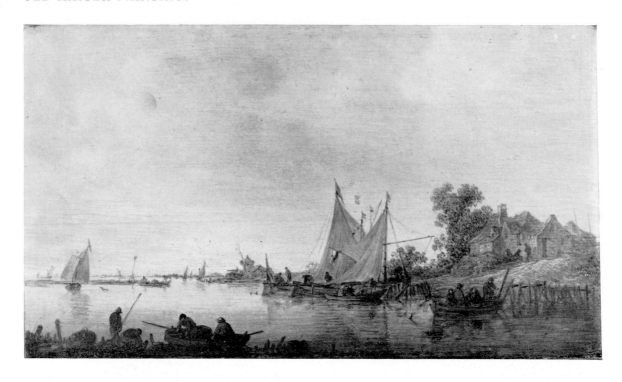

JAN STEEN
*A Village Wedding.*
Signed. 26½ in. by 33 in.
London £24,000 ($67,200) 5.VII.67.
From the collection of Jeremy Glyn, Esq.

*Opposite Page:*

*Above*   JAN VAN GOYEN
*Landscape with Boats on a River.*
Signed with initials: on panel. 7½ in. by 13⅛ in.
London £5,700 ($15,960) 30.XI.66.

*Below*   JAN SIBERECHTS
*The Ford.*
Signed and dated 1662. 51½ in. by 77¼ in.
London £8,000 ($22,400) 19.IV.67.
Formerly in the collections of N. von Bülow, Düsseldorf, and
Dr C. Berk, Neu-Hemmerich.

NICOLAES MAES
*Interior with a Dordrecht Family.*
$43\frac{1}{2}$ in. by $47\frac{1}{4}$ in.
London £5,000 ($14,000) 5.VII.67.
From the collection of Christopher Sandford, Esq.

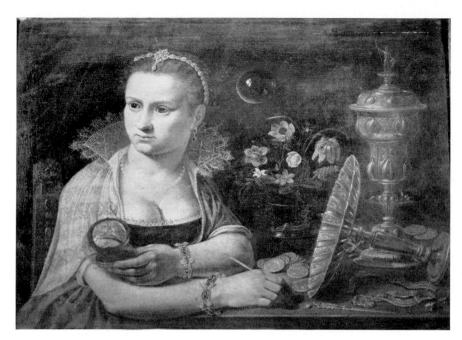

CLARA PEETERS
*A Young Woman seated at a Table
(self-portrait?)*
On panel. 14¾ in. by 19¾ in.
London £3,900 ($10,920)
30.XI.66.
Formerly in the collections of
John Skippe, Esq., Overbury,
Mrs Martin (sister of John
Skippe), Waldyve Martin, Esq.,
Evan Hamilton Martin, Esq.,
and J. Hanbury Martin, Esq.

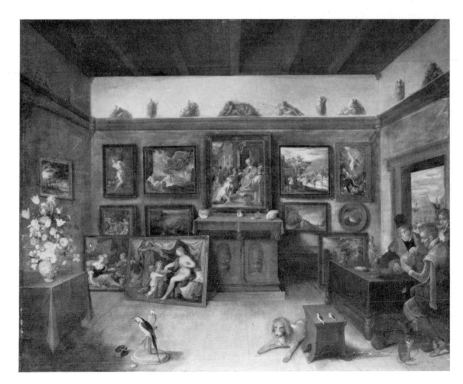

JAN BREUGHEL THE ELDER
AND FRANS FRANCKEN II
*The Interior of a Picture Gallery.*
Signed and dated 1612; on
panel. 35 in. by 43¼ in.
London £7,000 ($19,600)
19.IV.67.
From the collection of the late
Joseph Bliss.

35

JAN WIJNANTS
*A Hilly Landscape with a Falconer.*
On panel, signed and dated 1663. 15¼ in. by 18¾ in.
London £2,700 ($7,560) 22.II.67.

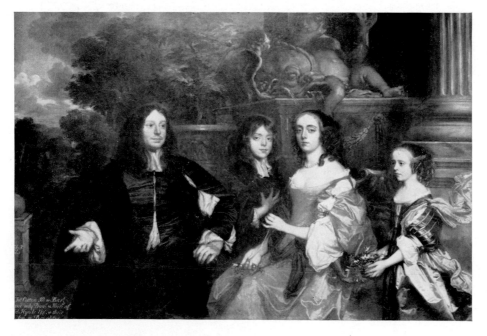

SIR PETER LELY *Sir John Cotton and his Family.*
Inscribed with the artist's name and the date, 1660, and the
sitters' names. 60¼ in. by 87 in. London £3,800 ($10,640) 30.XI.66.
From the collection of the Rev. J. S. Brewis.

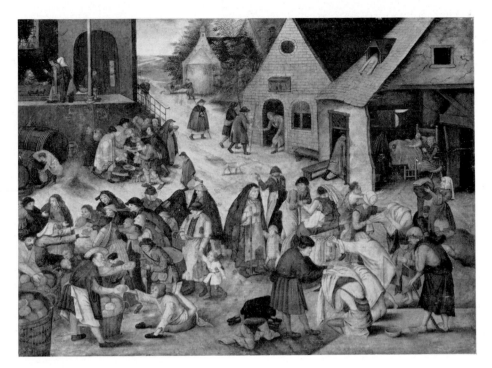

PIETER BRUEGHEL THE YOUNGER
*The Seven Works of Mercy.*
16½ in. by 23½ in.
New York $10,000 (£3,571) 26.IV.67.

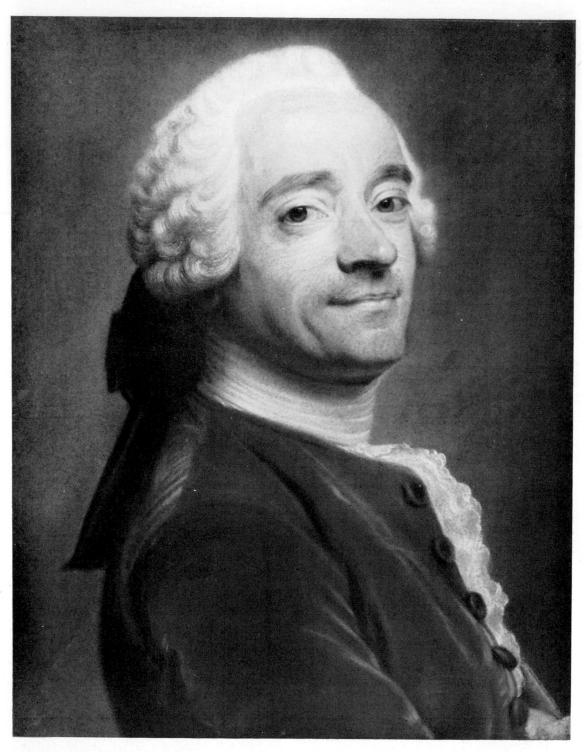

MAURICE-QUENTIN DE LA TOUR
*Self-Portrait.*
Pastel. $17\frac{1}{2}$ in. by $14\frac{1}{2}$ in.
London £20,000 ($56,000) 5.VII.67.
From the collection of His Excellency Señor A. Costa du Rels.

JEAN-BAPTISTE PATER
'*La Chasse Chinoise*'.
21¾ in. by 17¾ in.
London £11,000 ($30,800) 19.IV.67.
Formerly in the collections of C. Sedelmeyer, Paris,
and Jacques Péreire, Paris.

A Russian Icon of the Birth of the Mother of
God, Northern School, early 17th century.
12¼ in. by 10¾ in. London £300 ($840) 10.IV.67.

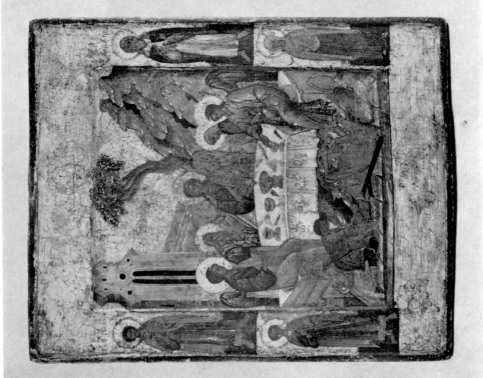

A Russian Icon of The Holy Trinity, Moscow. 17th Century.
12½ in. by 10½ in. London £1,000 ($2,800) 10.IV.67.

A Pair of Panels, one of the Mother of God, and the other of St. John. Moscow, 16th Century. 12¼ in. by 7½ in. London £800 ($2,240) 10.IV.67.

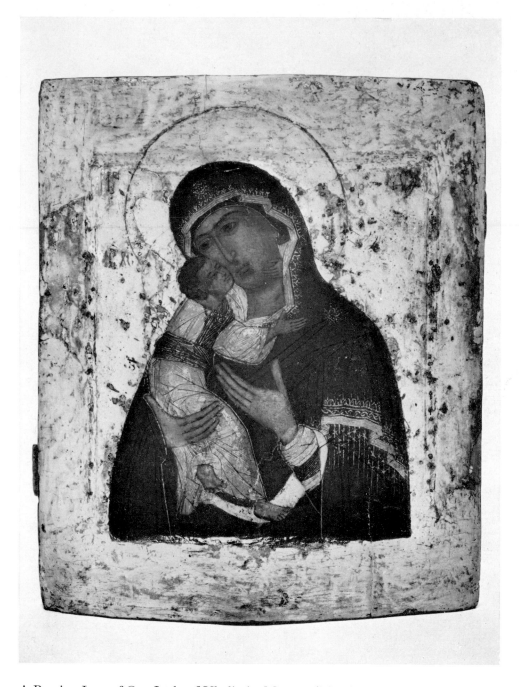

A Russian Icon of Our Lady of Vladimir, Moscow School,
early 16th century.
London £500 ($1,400) 24.VII.67.
From the collection of Ragnar Bergkvist, Esq.

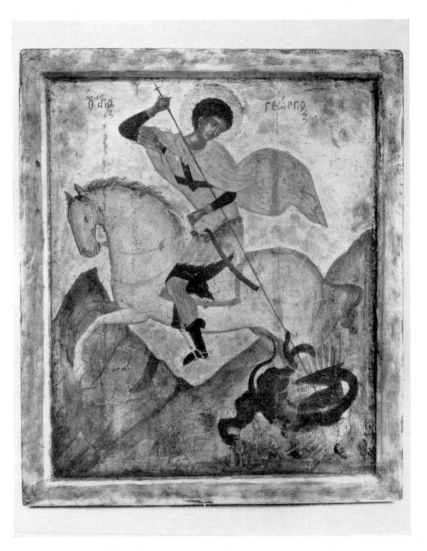

A Greek Icon of St. George slaying the dragon. *circa* 1600.
17 in. by 13½ in. London £650 ($1,820) 10.IV.67.

A Georgian Gold Repoussé Icon of St. George
and the Dragon. 12th–13th Century. 2¾ in. by 2½ in.
London £500 ($1,400) 10.IV.67.

# Impressionist Paintings and Works of Art

The first Impressionist and Modern sale of the season was on December 7, when a snow scene of 1875 by Camille Pissarro—*L'Hiver à Montfoucault*—made £37,000, Gauguin's luminous painting from his Pont-Aven period—*La Baignade au Moulin du Bois d'Amour*, £34,500, this last from the collection of Lord Sieff. This is the picture which the English painter A. S. Hartrick, who was staying at Pont-Aven in 1886, noticed when he described Gauguin returning to the Pension Gloanec 'carrying a canvas on which he had been painting some boys bathing on a weir, painted brilliantly with spots of pure colour in the usual impressionist manner.' Another Pissarro, *L'Hermitage, environs de Pontoise*, painted in 1877 (at the same date Cézanne painted the same view), went for £29,000, and a second Pointoise picture, this time in gouache, *The Potato Market*, for £12,300, while a golden Sisley of 1873—*Les Chasseurs (Lisière de la Forêt de Marly en Automne)* fetched £33,000.

A small sketch in thin oil, a brilliant study of man and horse executed by Degas between 1866 and 1872 was sold for £24,000 and a Matisse, *Filets à Etretat*, for £10,000 —a picture painted about 1920. The same painter's first attempt at sculpture, executed in 1899–1900, a free version of Barye's bronze, *Le Tigre*, entitled *Jaguar dévorant un Lièvre* fetched £2,200—one of an edition of ten. He worked on this sculpture fourteen hours a day for several months in the studio of the École de la Ville de Paris. He even went so far as to study the muscular structure of a dead cat. The sale began with some rare early drawings by Forain, one of which, a contemptuous satirical study of a stage door Johnny of 1875, was bought for £1,550, and another—*Au Café* —for £1,000, and these were followed by several drawings and paintings by the dashing Alfred de Dreux who, among French painters of horses during the latter part of the 19th century, knew equine anatomy better than most and would have had a much greater reputation had Degas and Toulouse Lautrec not been so greatly his superiors. As it is he is a splendid second Empire type somehow endowing all his animals with a romantic aura. A drawing by him, *Cavalier et Chien Enragé*, made £1,000 and an oil of *Nizan*, an Arab stallion in Napoleon III's stables, £4,000—a painting which evidently had a great success at the time for it was engraved and published in Paris, London and New York by the firm of Goupil—and indeed it can bear comparison easily enough with all but the finest horse portraits by Stubbs or James Ward. In fact, one could say that de Dreux has achieved the same reputation for horse paintings as Winterhalter for portraits. This sale realised just under half a million pounds for 121 paintings; more than twice as much was obtained in April for a mere 86, one of them the tender, compassionate *Maternité au bord de la Mer* which Picasso painted in Barcelona in 1902. It appears that originally it was given to a Dr Fontbona at that time in payment for medical services and is inscribed to him. It was now sold for £190,000 by far the highest sum yet given anywhere for a work by a living painter. The previous highest was the £80,000 paid for the *Death of Harlequin* by Picasso in the Somerset Maugham sale in 1962.

Had it not been for this formidable figure, the world would no doubt have heard more about the £90,000 given for Cézanne's *Sous-Bois*, painted *circa* 1895–1900 and the £145,000 for the other Cézanne sold that morning—a ravishing still-life water-colour of table utensils, and seven pears, probably one of Cézanne's six best water-colours. It was decidedly an opulent morning with only four works out of the 86 going for less than £1,000—a notable example of an exception to the general rule that, even in the biggest dispersal, a few crumbs usually fall from the table for the benefit of the hungry poor. Among other delights that morning Chagall's *La Maison Brule* of 1917 went to Switzerland at £30,000. *La Partie de Balle* by Bonnard painted in 1905 at *Le Clos*, his mother's home at le Grand Lemps, Isère—a marvellous evocation of comfortable French provincial life as are all Bonnard's pictures of his family—was sold for £26,000 for a private Australian collector. The Tate Gallery acquired one of Robert Delaunay's 'Window' experiments for £14,500—this was one of the series towards abstraction which he began in 1912 and was one of the rarest and most sought after of all cubist pictures. He explained—'La nature n'est plus un sujet de description, mais un prétexte, une evocation poêtique d'expression par des plans colorés qui s'ordonnent par les contrastes simultanés'. It had the additional interest of an inscription to 'cher Tairoff amicalement'—i.e. Alexandre Tairov, founder and director of the Moscow Chamber Theatre.

One astonishing price was £20,500 paid for a small Jongkind landscape painted in Normandy in 1865. £14,000 was given for a still life by Juan Gris, £13,500 for a little late Renoir, *Three Girls seated on the Grass*, and £31,000 for a landscape by Bonnard painted about 1913 in the South of France. A good deal more astonishing was the £18,500 cheerfully given for a Degas bronze, *The Rearing Horse*—a marvel of its kind but none the less one of an edition of twenty-two.

Sentiment, I am often told, has no part to play in business—but it makes life much more pleasant when it does happen to creep in, as it evidently did to some extent in the final Impressionist sale of the season at the end of June. Sir Chester Beatty sent over ten of his paintings from Dublin and these were sold during the first twenty minutes for £242,100. It was something of an occasion—just fifty years since Sir Chester Beatty had played an important part in encouraging the then senior Sotheby partner, Sir Montague Barlow, to move from the premises in Wellington Street, off the Strand to New Bond Street and expand the old established book business into the all-embracing enterprise it is today. Rarely has a trek Westwards shown more gratifying results. The remaining ninety-five works in the sale brought up the morning's total to £718,890. Of the Dublin pictures, *Courses de Taureaux*, executed by Picasso in Barcelona in the summer of 1900, a pastel, made £42,000; a delicate, limpid Monet, *La Plage à Sainte-Adresse*, painted in 1867 when his family was trying to made him break off his liaison with Camille, made £41,000. However, the Monet of all Monets, by general consent as fine an Impressionist picture as exists, came half an hour later in an anonymous property. This was *Hiver à Argenteuil*, painted in the winter of 1875–6—trees and grass flecked with snow—which was sold for the phenomenal sum of £116,000. Returning to the Sir Chester Beatty paintings, Sisley's *Pont de Moret*

of 1891 made £26,000, the same painter's *Hiver à Veneux-Nadon* of 1881 £37,000, *La Prairie de Moret* by Pissarro £19,000. This was painted in 1901—and *La Mare à Ennery*, twenty-seven years earlier, went for £32,000, while *La Ferme Normande aux Trois Commères*, painted by Corot *circa* 1872 and which M. Beugniet purchased direct from him for 2,000 francs was bought for £27,000. Among other properties, a late Bonnard, of 1936, *Voiliers sur la Mer*, a warm ecstatic vision of the Gulf of St. Tropez —made £30,000.

A good many observers before this dispersal, their eyes looking anxiously to the Near East, were of the opinion that we should witness at least some hesitation in the international market. The sale so briefly summarised above dispersed these fears effectively enough.

Some notable sales of modern paintings in New York have included a still life by Diego Rivera of $12,000, a brilliant—almost savage—flower piece by Maurice de Vlaminck $19,000 and *La Victoire* of 1939, with its cool, austere symbolism, by René Magritte, $8,000. A Jules Pascin, *Deux Jeunes Filles* went for $14,500 and a fascinating Chagall *Mariage Juif* ('Fiddler on the Roof'), gouache and pastel, for $31,000. This picture, painted about 1925, was well known from many exhibitions throughout the United States, and had been presented to the Museum of Modern Art, New York in 1934, by A. Conger Goodyear with the understanding that it might be sold—the proceeds to go to a fund in the donor's name for further purchases. This was in October 1966. Another and more extensive sale of modern works was held in April 1967, when another Chagall, an oil from the year 1910, *La Marchande de Pain*, one of his naïve, touching memories of his Russian youth, was sold for $70,000, Paul Delvaux' oddly haunting (and oddly titled) *Penelope* for $9,250, and the *Regatta* by Friesz for $23,000. *La Danseuse Espagnole* of 1910 by the nowadays more than fashionable Kees van Dongen reached the high price of $55,000—the rise of van Dongen during the past few years to Old Master status has been phenomenal—and an austere work by the sculptor Giacometti—painted *circa* 1950—*Nature morte aux Bouteilles* fetched $22,000. A major work by that pioneer of Cubism, Roger de la Fresnaye—*Les Baigneurs*—to be compared and not to its disadvantage with the more celebrated *Les Demoiselles d'Avignon* by Picasso—fetched $70,000, and the naïvely charming *Bote und Klippen* by Paul Klee $26,000. A Vlaminck landscape 1909, *A Village by a Stream* went for $32,500 and Rouault's sombre, deeply religious *Le Saint Suaire* for the same sum. Finally, there were, if not greater, more widely-known names—a Monet of *circa* 1873, *The Port of Amsterdam* $95,000, a Sisley of about the same year, *Le Givre* a fine winter landscape—$50,000, a flower piece by Renoir, signed and dated 1881 —$100,000, another Sisley—a summer landscape, *St. Mammes*, also signed and dated 1881—$65,000 and finally two landscapes by Camille Pissarro, both early, one 1863 and the other 1877, which went for $60,000 and $57,500 respectively.

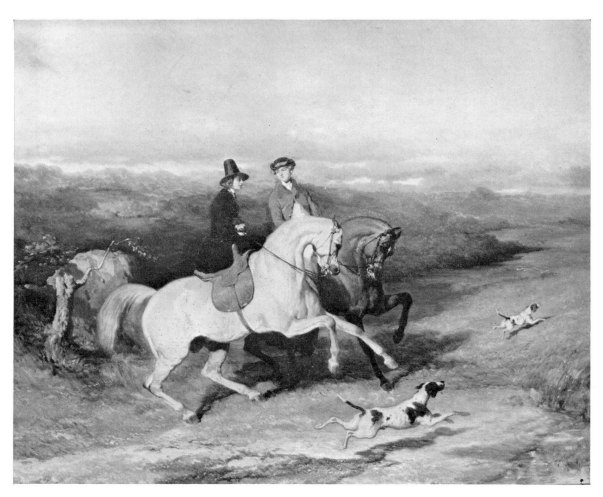

ALFRED DE DREUX
*Cavaliers dans la Campagne Anglaise.*
Signed. 23 in. by 28¼ in.
London £4,200 ($11,760) 26.IV.67.
This subject was engraved by Achille Giroux and Eugène Ciceri.

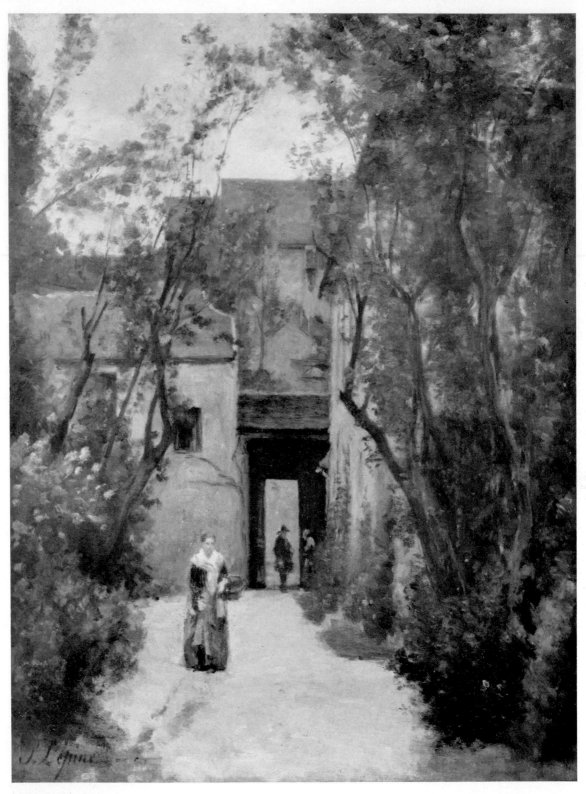

STANISLAS LÉPINE
*Personnages dans la Cour d'un Château.*
Signed. 17½ in. by 12½ in.
London £6,500 ($18,200) 28.VI.67.
From the collection of Sir Chester Beatty whose ten paintings were sold at Sotheby's in June 1967
for £242,100 ($677,880).

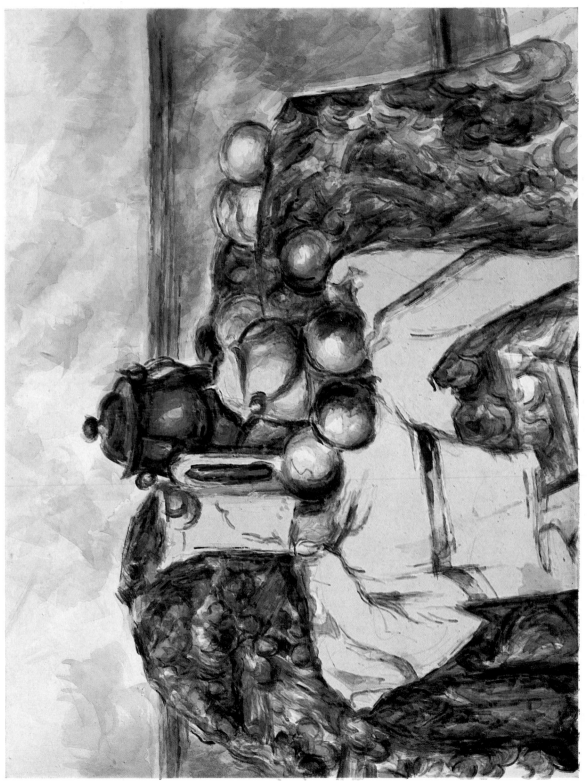

PAUL CÉZANNE
*Nature Morte: Bouilloire, Pot-au-lait, Sucrier et Sept Pommes.*
Watercolour, executed *circa* 1895–1900. 18¼ in. by 24¼ in.
London £145,000 ($406,000) 26.IV.67.
From the collection of Lord Sieff of Brimpton.

CAMILLE PISSARRO
*Coin de Village.*
Signed and dated 1863. 15¾ in. by 20½ in.
New York $60,000 (£21,428) 6.IV.67.

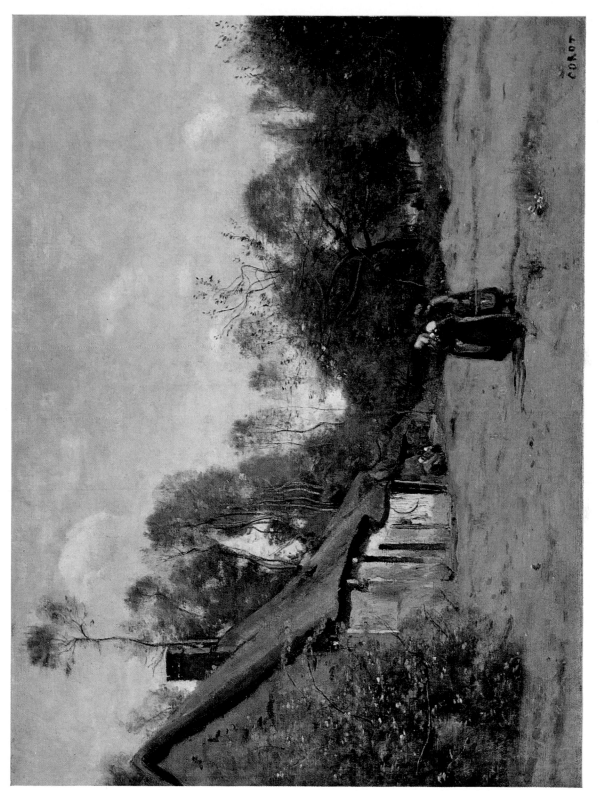

JEAN-BAPTISTE-CAMILLE COROT
*La Ferme Normande aux Trois Commères (Etretat ou Yport).*
Signed. Painted *circa* 1872. 18 in. by 24 in.
London £27,000 ($75,600) 28.VI.67.
From the collection of Sir Chester Beatty, Dublin.

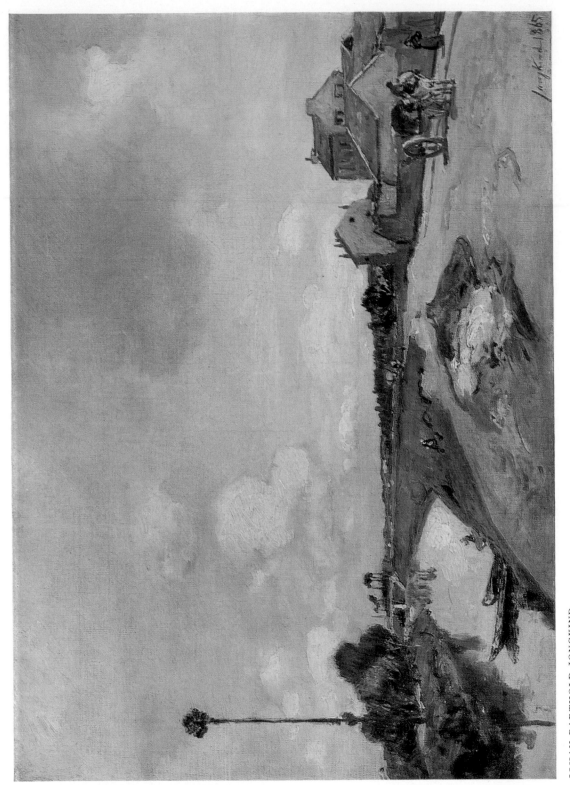

JOHAN BARTHOLD JONGKIND
*Paysage de Bas Meudon.*
Signed and dated 1865. 13 in. by 18½ in.
London £21,000 ($58,800) 26.IV.67.

EUGÈNE BOUDIN
*La Plage de Trouville.*
Signed and dated Trouville '89. 21½ in. by 35 in.
London £30,000 ($84,000) 26.IV.67.

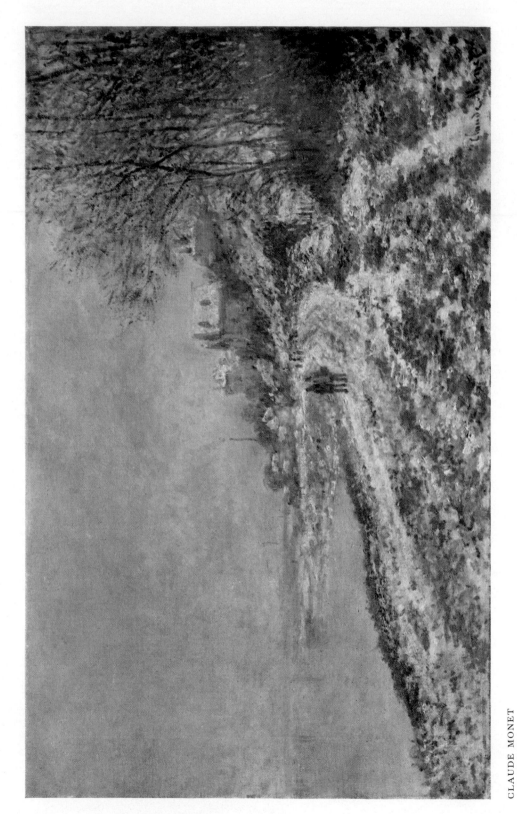

CLAUDE MONET
*Hiver à Argenteuil.*
Signed. Painted in the winter of 1875–6. 24¼ in. by 40 in.
Another painting of the same size, an *Effet de Neige* in the Albright
Art Gallery, Buffalo, shows the same place but viewed from the
opposite direction.
London £116,000 ($324,800) 28.VI.67.

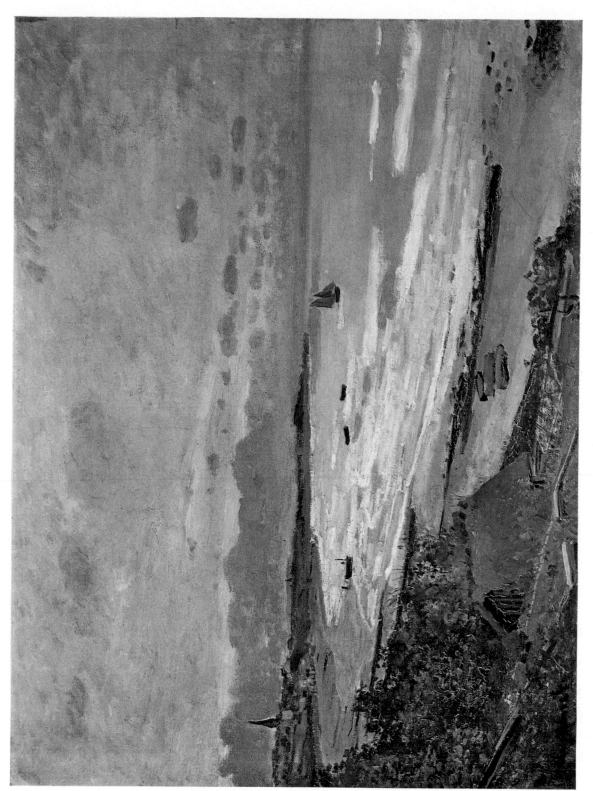

CLAUDE MONET
*La Plage à Sainte-Adresse*
Signed. Painted in 1867. 23¼ in. by 31½ in.
London £41,000 ($114,800) 28.VI.67.
From the collection of Sir Chester Beatty.

CAMILLE PISSARRO
*La Mare à Ennery.*
Signed and dated 1874. 21 in. by 25¼ in.
London £32,000 ($89,600) 28.VI.67.
From the collection of Sir Chester Beatty.

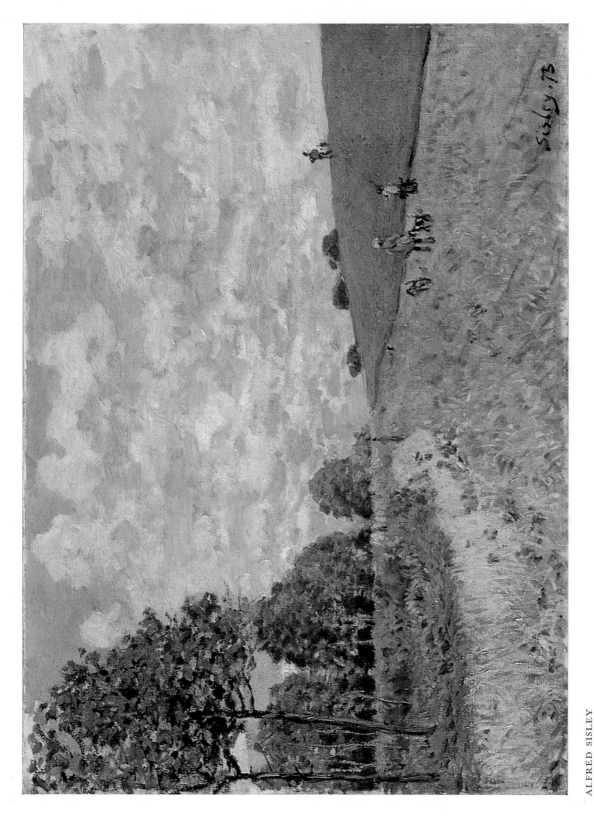

ALFRED SISLEY
*Les Chasseurs* (*Lisière de la Forêt de Marly en Automne*)
Signed and dated '73. 18 in. by 25½ in.
London £33,000 ($92,400) 7.XII.66.

CAMILLE PISSARRO
*L'Hiver à Montfoucault* (*Effet de Neige*).
Signed and dated 1875. 45 in. by 43¼ in.
London £37,000 ($103,600) 7.XII.66.
From the collection of Miss Martha Hyer, Hollywood.

CAMILLE PISSARRO
*L'Hermitage, Environs de Pontoise.*
Signed and dated '77. 26 in. by $21\frac{1}{4}$ in.
London £29,000 ($81,200) 7.XII.66.

ALFRED SISLEY
*Hiver à Veneux-Nadon.*
Signed and dated '81. 20¾ in. by 28 in.
London £37,000 ($103,600) 28.VI.67.
From the collection of Sir Chester Beatty.

PAUL GAUGUIN
*La Baignade au Moulin du Bois d'Amour, Pont-Aven.*
Signed and dated '86. 23½ in. by 28¾ in.
London £34,500 ($96,600) 7.XII.66.
From the collection of Lord Sieff of Brimpton.

PAUL CÉZANNE
*Sous Bois.*
Painted *circa* 1895–1900. 32 in. by 25½ in.
London £90,000 ($252,000) 26.IV.67.

PIERRE BONNARD
*Panier de Fruits au Soleil.*
Signed. Painted *circa* 1927. 23¾ in. by 17¼ in.
London £23,000 ($64,400) 26.IV.67.
From the collection of Mr Theodore H. Cummings, Beverly Hills.

63

PABLO PICASSO
*Courses de Taureaux.*
Pastel, signed. Executed in Barcelona in the summer of 1900.
13¾ in. by 15½ in.
London £42,000 ($117,600) 28.VI.67.
From the collection of Sir Chester Beatty.

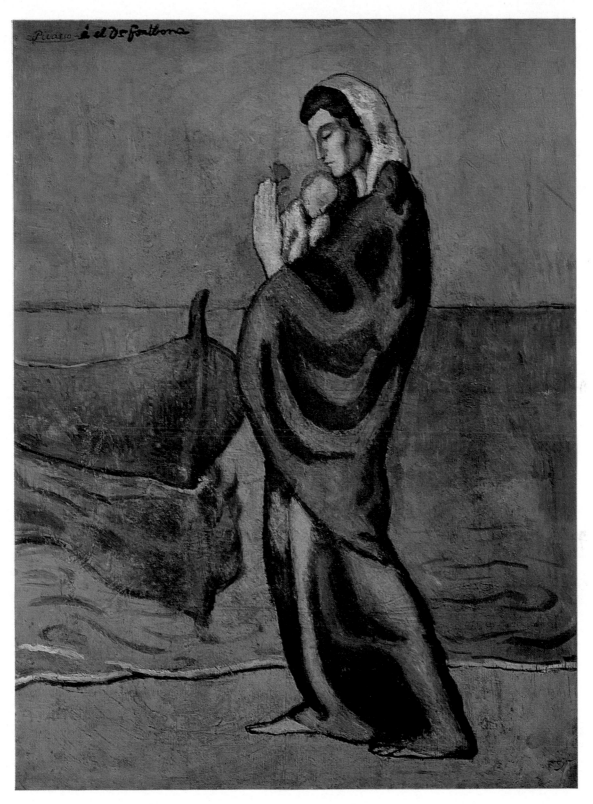

PABLO PICASSO
*Mère et Enfant de Profil* (*Maternité au bord de la Mer*)
Signed and inscribed 'a el Dr. Fontbona'.
Painted in Barcelona in 1902. 32¾ in. by 23½ in.
London £190,000 ($532,000) 26.IV.67.
The highest price at auction for the work of a living artist.

65

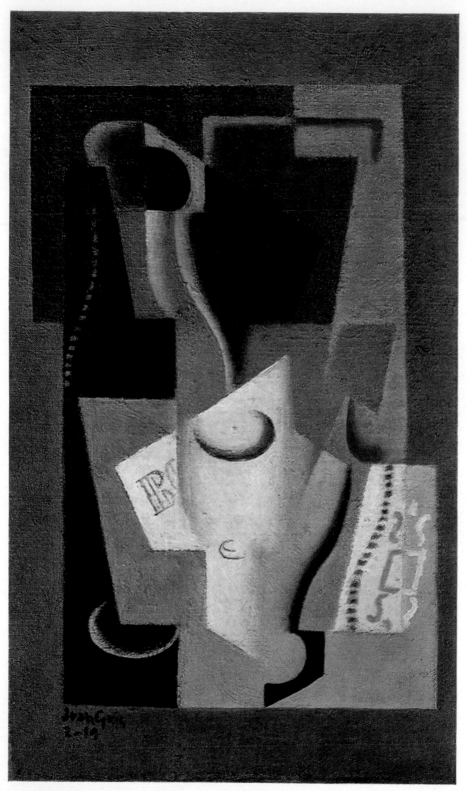

JUAN GRIS
*Nature Morte*
Signed and dated 2–19. Painted in 1919. 18 in. by 10½ in.
London £14,000 ($39,200) 26.IV.67.

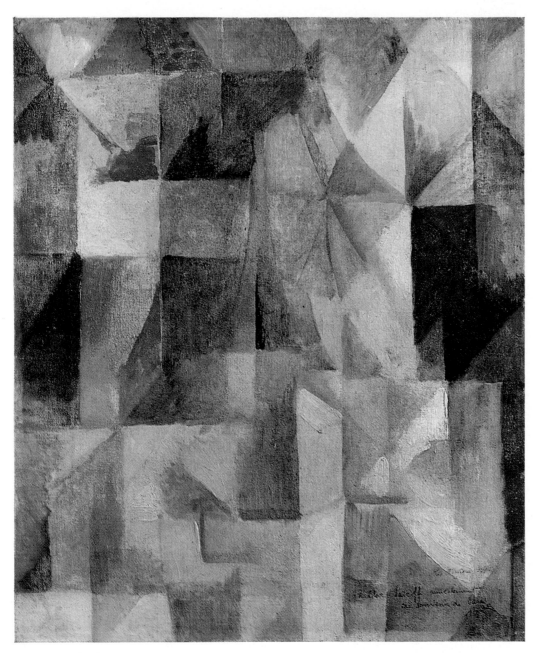

ROBERT DELAUNAY
*Fenêtres Ouvertes Simultanément*
(*1ère partie, 3ème motif*).
Signed and dated 1912. 18 in. by 14¾ in.
London £14,500 ($40,600) 26.IV.67.

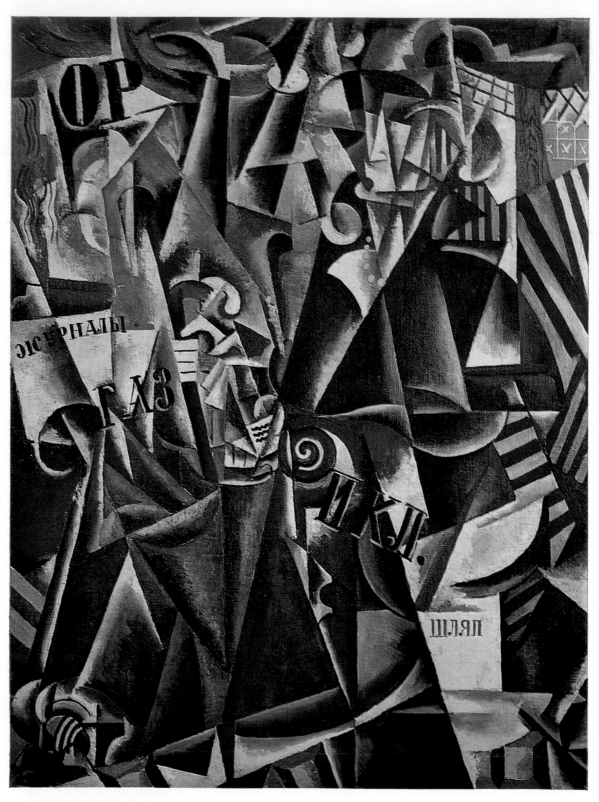

LIUBOV POPOVA
*The Traveller.*
Painted in 1915. 56 in. by 41½ in.
London £9,000 ($25,200) 26.IV.67.

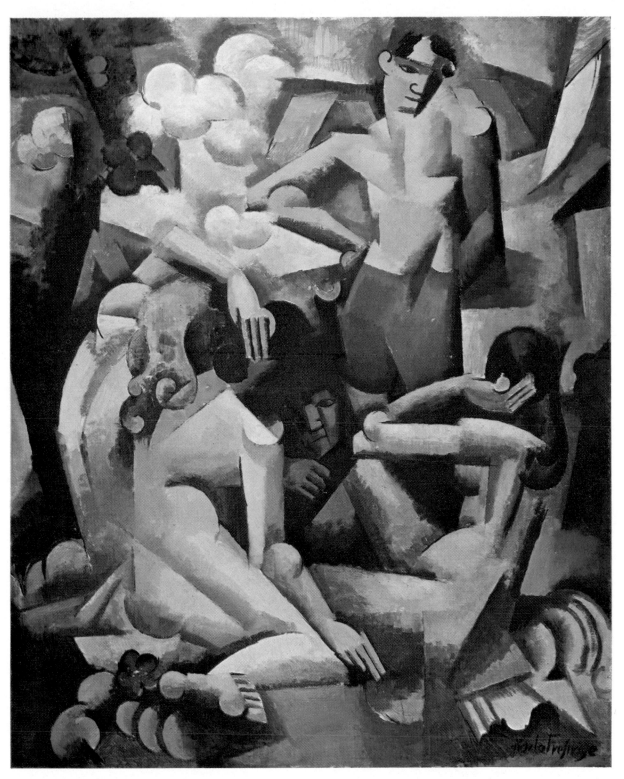

ROGER DE LA FRESNAYE
*Les Baigneurs.*
Signed. Painted in 1912. 63½ in. by 50½ in.
New York $70,000 (£25,000) 6.IV.67.
From the collection of Washington University
and the St Louis Symphony Society, St Louis, Mo.

69

GEORGES ROUAULT
*Le Saint Suaire.*
Signed. Oil on paper, mounted on canvas.
Painted *circa* 1925. 28¼ in. by 23½ in.
New York $32,500 (£11,607) 6.IV.67.
From the collection of the late Mary B. Higgins, New York.

DIEGO RIVERA
*Nature Morte*.
Signed and dated '15. $31\frac{1}{2}$ in. by $25\frac{1}{4}$ in.
New York $12,000 (£4,286) 20.X.66.

PAUL KLEE
*Bote und Klippen*.
Signed and dated 1927. Oil and mixed media on canvas.
$18\frac{1}{4}$ in. by $26\frac{1}{4}$ in.
New York $26,000 (£9,286) 6.IV.67.

71

MARC CHAGALL
*La Marchande de Pain.*
Signed and dated 1910. 25¾ in. by 29½ in.
New York $70,000 (£25,000) 6.IV.67.

MARC CHAGALL
*La Maison Brule.*
Signed. Painted *circa* 1917. 22½ in. by 24 in.
London £30,000 ($84,000) 26.IV.67.

MARC CHAGALL
*Mariage Juif* ('*Fiddler on the Roof*')
Signed. Gouache and pastel. Painted *circa* 1925–6.
21 in. by 25½ in.
New York $31,000 (£11,071) 20.X.66.
From the collection of the Museum of Modern Art, New York.

KEES VAN DONGEN
*La Danseuse Espagnole.*
Signed. Painted *circa* 1910. 39½ in. by 32½ in.
New York $55,000 (£19,643) 6.IV.67.

PIERRE BONNARD
*Voiliers sur la Mer* (*Golfe de St Tropez*).
Signed. Painted *circa* 1936. 20 in. by 31 in.
London £30,000 ($84,000) 28.VI.67.

PIERRE BONNARD
*La Partie de Balle.*
Signed. 21 in. by 29¾ in.
Painted in 1905 at 'Le Clos', The house of Bonnard's mother.
Le Grand Lemps, Isère.
London £26,000 ($72,800) 26.IV.67.

MAURICE DE VLAMINCK
*Village au Bord d'une Rivière.*
Signed. Painted *circa* 1909. 25¼ in. by 31½ in.
New York $32,500 (£11,607) 6.IV.67.
From the collection of the late Mary B. Higgins, New York.

MAURICE UTRILLO
*Maison rouge à Sannois.*
Signed. Painted *circa* 1912. 23 in. by 31¼ in.
London £13,500 ($37,800) 28.VI.67.

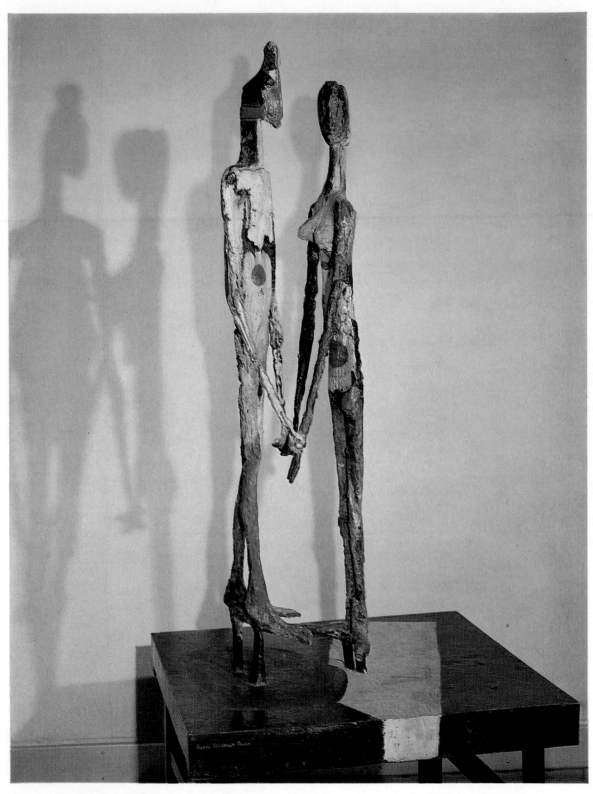

GERMAINE RICHIER
*Sablier au Soleil (Grand Couple)*
Bronze, signed, numbered 1/6. Executed 1954–9. Height 55 in.
Of the six bronzes cast of this model, this is the only one which
the sculptress painted in coloured enamels.
London £11,100 ($31,080) 7.XII.66.

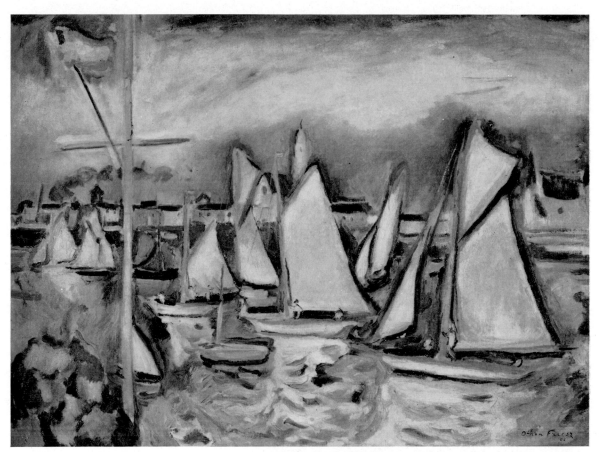

EMILE-OTHON FRIESZ
*La Régate.*
Signed and dated '06.
22¾ in. by 31¼ in.
New York $23,000 (£8,214) 6.IV.67.
From the collection of Isodore
Usiskin, Hewlitt Harbor, New York.

ALBERTO GIACOMETTI
*Nature Morte aux Bouteilles.*
Painted *circa* 1950. 18¾ in. by 17 in.
New York $22,000 (£7,857) 6.IV.67.
From the collection of the late Ethel
Steuer Epstein, New York.

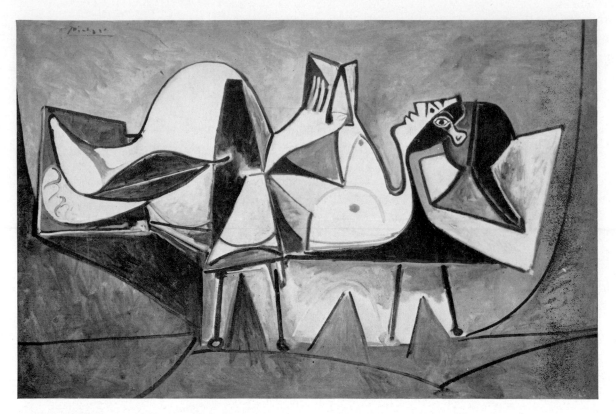

PABLO PICASSO
*Femme Couchée Lisant.*
Signed, dated 5.12.60 on reverse. 51 in. by 76¾ in.
This picture was given by Picasso to the town of Florence. It was
sold in order to raise funds for the rescue work following the
flood disaster of autumn 1966. The sale in New York was
televised and relayed in colour by satellite to bidders in Fort
Worth, Los Angeles, and London.

The picture was sold for $105,000 (£37,500) to the Fort Worth
Museum of Art.

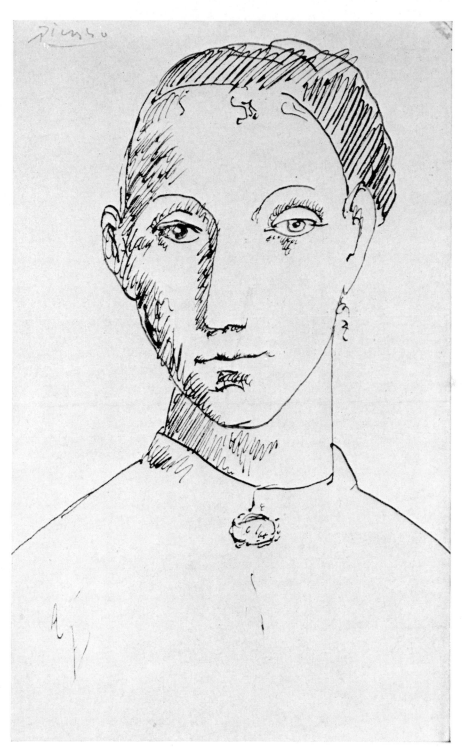

PABLO PICASSO
*Tête de Paysanne.*
Pen and Ink. Signed. 8¼ in. by 5¼ in.
Executed at Gosol, in the summer of 1906.
New York $6,000 (£2,143) 4.V.67.
From the collection of Adlai E. Stevenson III, Chicago.

DIEGO RIVERA
*Portrait of a Woman.*
Signed and dated '44. 48 in. by 60 in.
New York $12,500 (£4,464) 16.II.67.

JULES PASCIN
*Deux Jeunes Filles Assises.*
Signed. On board. 25½ in. by 21¼ in.
New York $14,500 (£5,178) 20.X.66.
From the collection of the late
John Barber, Philadelphia.

PAUL DELVAUX
*Penelope.*
Signed and dated 3–46. On masonite.
47½ in. by 69½ in.
New York $9,250 (£3,303) 6.IV.67.
From the collection of John Day
Stuchell, New York.

LOUIS VALTAT
*Femme au Collier.*
Signed. 31½ in. by 25¼ in.
New York $10,000 (£3,571) 6.IV.67.

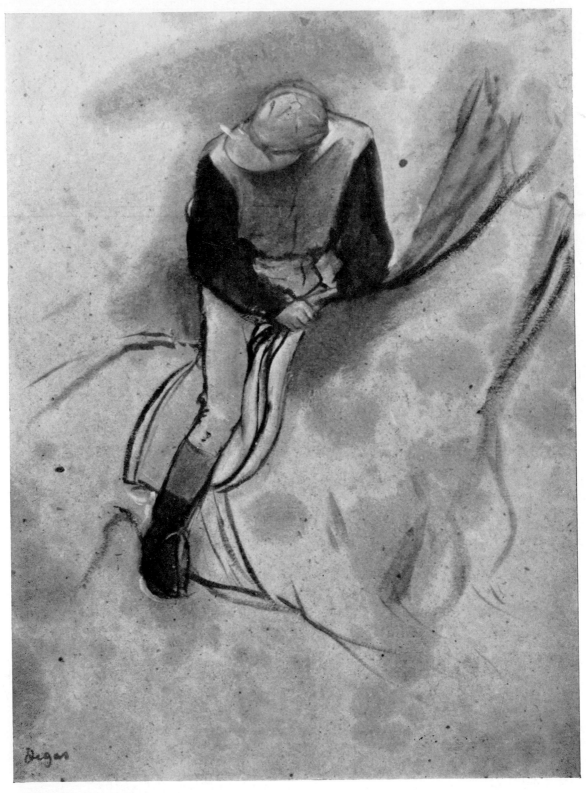

EDGAR DEGAS
*Jockey.*
Peinture a l'essence. Stamped with the mark of the Vente Degas.
Painted *circa* 1866–72. 12¾ in. by 9¼ in.
London £24,000 ($67,200) 7.XII.66.

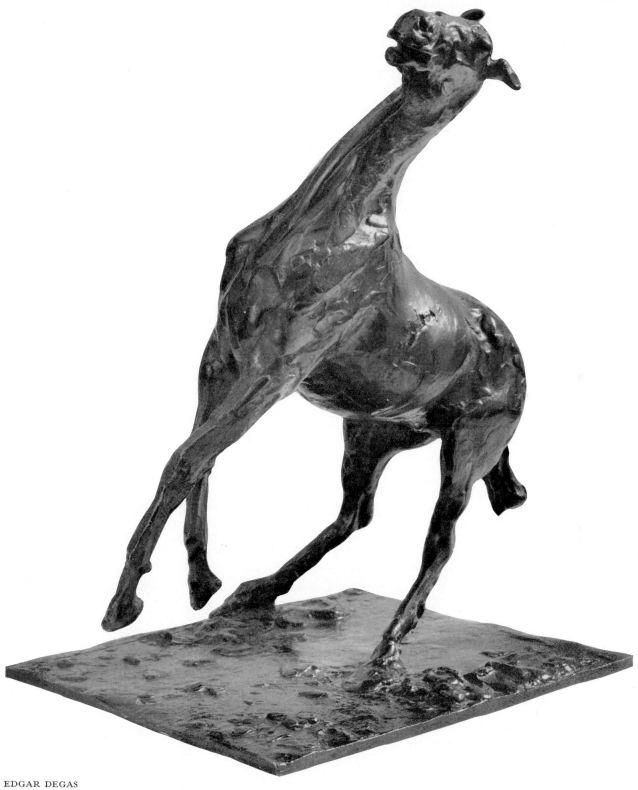

EDGAR DEGAS
*Cheval se Cabrant.*
Bronze, signed and stamped with the foundry mark 'A. A. Hebrard'.
London £18,500 ($51,800) 26.IV.67.

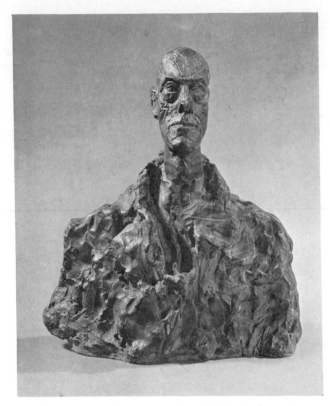

ALBERTO GIACOMETTI
*Tête de Diego.*
Signed and numbered 1/6 and
inscribed *Susse Frères, Paris.*
Bronze, greenish black patina.
Executed *circa* 1961.
Height: 15½ in.
New York $25,000 (£8,929) 5.IV.67.
From the collection of the late
Ethel Stener Epstein, New York.

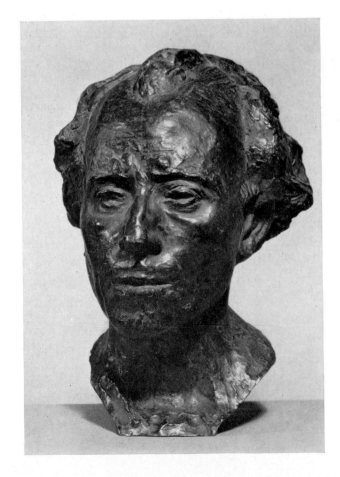

AUGUSTE RODIN
*Gustav Mahler.*
Signed twice; stamped Alexis Rudier,
Fondeur, Paris.
Bronze. Height: 13¾ in.
Executed in 1909.
New York $8,500 (£3,036) 5.IV.67.
From the collection of Mrs Caryl
Meuhlstein, New York.

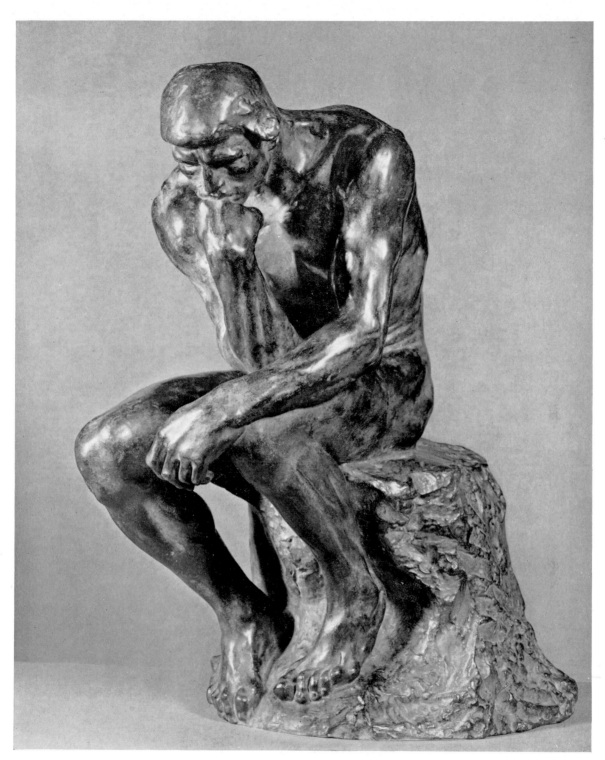

AUGUSTE RODIN
*Le Penseur*.
Signed; stamped *Alexis Rudier, Fondeur, Paris*.
Bronze. Height: 28 in.
The original model for this sculpture was executed *circa* 1880.
There are probably less than ten casts in this size of which one is
in the Metropolitan Museum, New York and another is in the
Fogg Museum of Art, Cambridge and a third is in the Rodin
Museum, Philadelphia. The Musée Rodin, Paris and the
Montreal Museum of Fine Art, Montreal, Canada, also possess casts.
New York $40,000 (£14,286) 5.IV.67.

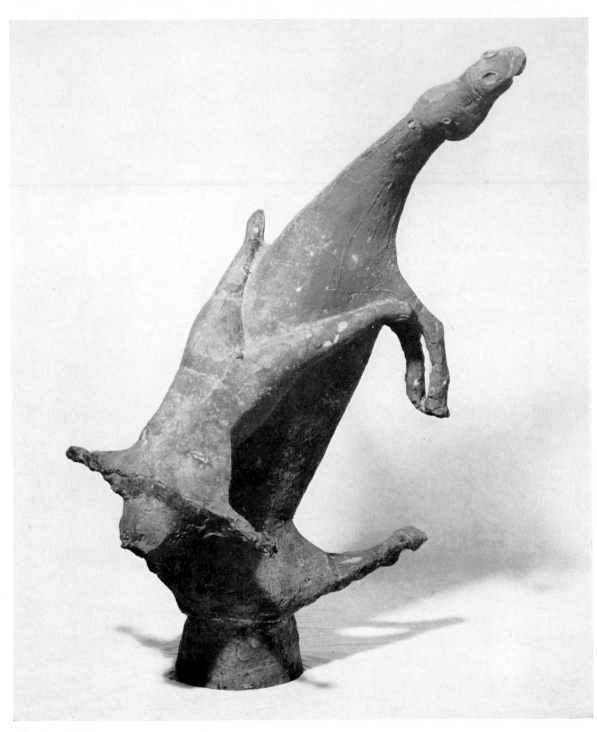

MARINO MARINI
*Cavallo e Cavaliere.*
Signed with initials. Bronze. Height: 59½ in.
New York $23,000 (£8,214) 5.IV.67.
From the collection of the Olsen Foundation.

CONSTANTIN BRANCUSI
*Le Baiser.*
Signed, inscribed and dedicated on the base.
Plaster. Height: 11 in. Executed *circa* 1908–10.
New York $23,000 (£8,214) 5.IV.67.
From the collection of Gordon Farquhar, Boulder, Colorado.

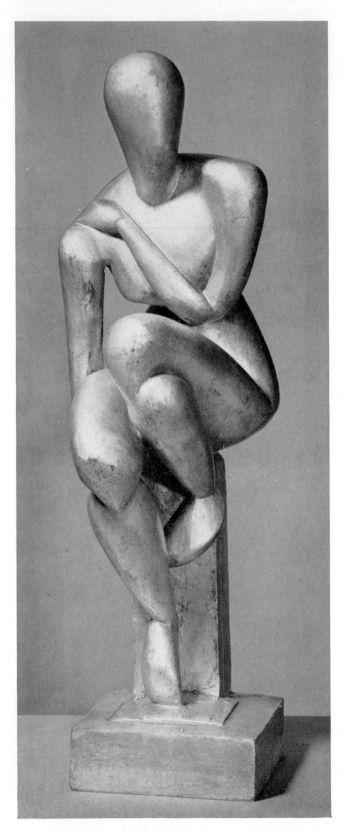

RAYMOND DUCHAMP-VILLON
*Femme Assise.*
Signed; stamped Roman Bronze
Works, N.Y. Sold with the original
drawing for the sculpture.
Bronze. Height: 28 in.
The original plaster from which this
was cast was executed in 1914.
New York $25,000 (£8,928) 5.IV.67.
From the collection of
Arthur B. Spingarn, New York.

# American Painting

The 1966–7 season at Parke-Bernet was notable for the large number of works sold which were by artists associated with a particular geographical area of America.

In October, thirty paintings and drawings by the well-known contemporary artist, Morris Graves, brought a total of $60,700 (£21,680). All were from the Charles Laughton–Elsa Lanchester Collection and most dated from the 1940's—a period in Graves' career much esteemed by collectors of his work. The high prices $6,000 (£2,143) for *Surfbird*; $5,750 (£2,054) for *Fish Reflected Upon Outer and Mental Space*) were indicative of the success of this 'one artist' sale—the first such by a living painter in many years at Parke-Bernet.

In May, a collection of watercolours by the 19th century painter, Vincent Colyer, brought $15,770 (£5,931). These depictions of the flora, fauna, topography and inhabitants of the American West, were done in 1869–71 when the artist travelled extensively for the Board of Indian Commissioners.

WILLIAM M. HARNETT
*Still Life*.
Signed and dated 1877. 9 in. by 12 in.
New York $5,750 (£2,054) 16.III.67.

ERNEST LAWSON, N.A.
*University Heights, New York.*
Signed. 25 in. by 30 in.
New York $7,200 (£2,571) 17.XI.66.
From the collection of Hans H. Buhr, Vancouver,
British Columbia.

*Opposite page:*

*Above*  JOHN SLOAN
*A Gloucester Day.*
Signed. Titled on the reverse. Painted in 1915. 20 in. by 24 in.
New York $5,500 (£1,964) 16.III.67.

*Below*  CHILDE HASSAM, N.A.
*Rockport.*
Watercolour. Signed, titled and dated September 10, 1919.
15 in. by 22 in.
New York $6,000 (£2,143) 4.V.67.

ANDREW WYETH, N.A.
'Iron Age.'
Watercolour. 21 in. by 29 in. Signed.
Painted circa 1950.
New York $12,000 (£4,286) 17.XI.66.

THOMAS HART BENTON, A.N.A.
*Weighing Cotton.*
On canvas, mounted on panel. Painted in 1939. 31 in. by 38 in.
New York $17,000 (£6,072) 16.III.67.
From the collection of the Billy Rose Foundation, Inc., New York.
This is one of a series of three paintings depicting regional American agriculture; *Roasting Ears* is in the Metropolitan Museum of Art, New York and *Cradling Wheat* in the City Art Museum of St Louis.

MILTON AVERY
*The Red Dress.*
Signed and dated 1960. 48¼ in. by 34 in.
New York $6,000 (£2,143) 16.III.67.
From the collection of the late Ethel Steuer Epstein, New York.

JOHN MARIN
*Landscape*
Watercolour. 17½ in. by 14¼ in.
Signed and dated '16.
New York $2,800 (£1,000) 17.XI.66.

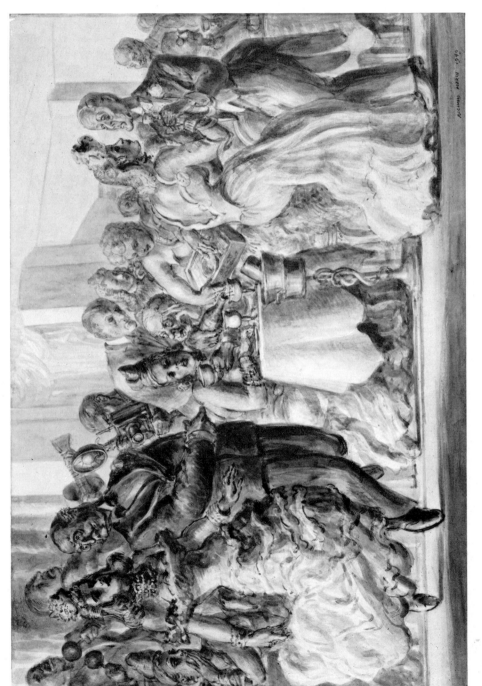

REGINALD MARSH, N.A.
*Memories of the Stork Club.*
Watercolour. Signed, titled and dated 1940. $26\frac{1}{2}$ in. by $39\frac{3}{4}$ in.
New York $6,750 (£2,411) 4.V.67.

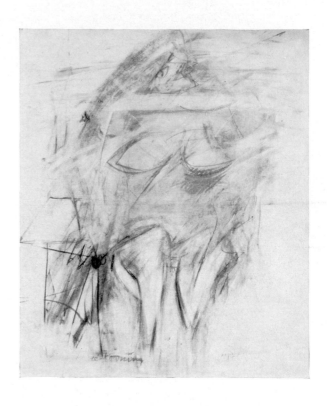

WILLEM DE KOONING
*Woman.*
Signed. Executed *circa* 1952. Pastel
and watercolour. 16¼ in. by 13½ in.
New York $7,750 (£2,768) 4.V.67.
From the collection of the late Ethel
Steuer Epstein, New York.

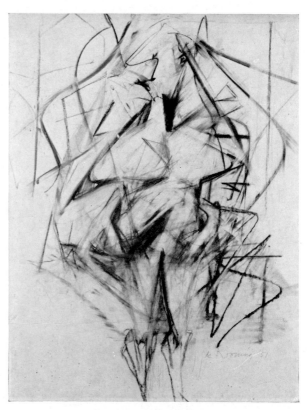

WILLEM DE KOONING
*Woman, First Version.*
Signed and dated '51. Charcoal,
pastel and crayon. 21½ in. by 16 in.
New York $6,500 (£2,321) 6.IV.67.
From the collection of the late
Alfred M. Frankfurter, New York.

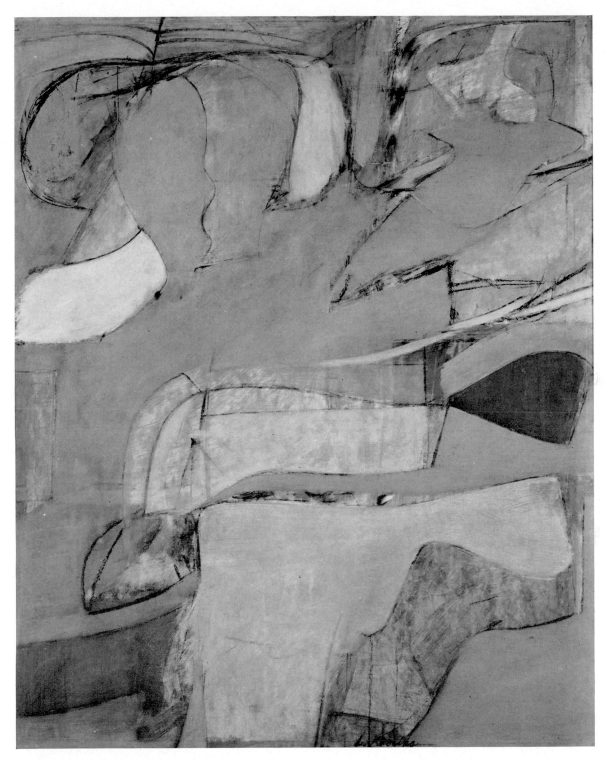

WILLEM DE KOONING
*Composition*
Signed. On masonite. Executed *circa* 1939. 28¼ in. by 22½ in.
New York $17,500 (£6,250) 12.IV.67.
From the collection of the late Ethel Steuer Epstein, New York.

NEWELL CONVERS WYETH, A.N.A.
*Train Robbery.*
44 in. by 33 in.
New York $7,750 (£2,768) 16.III.67.
From the collection of the late Dr Thomas A. McGraw, New York.

FREDERICK J. WAUGH, N.A.
*Surf on the Roaring Main.*
Signed, also inscribed on stretcher.
30 in. by 40 in.
New York $4,500 (£1,607) 20.V.67.

MORRIS GRAVES
*Surfbird.*
Tempera and watercolour. 23 in. by 27½ in.
Signed, titled and inscribed. Painted *circa* 1940.
New York $6,000 (£2,143) 20.X.66.
From the Charles Laughton–Elsa Lanchester Collection
(the property of Mrs Charles Laughton).

# Old Master Drawings

When Ingres was a young man and poverty stricken in Rome he kept himself going by doing pencil drawings of visitors. Two of these visitors in 1816, when Europe was once more open to English travellers, were the brothers Thomas and Joseph Church. These portraits by, according to a note on one of the frames, 'an Italian artist', were sold for £10,500 and £9,000, a record for an Ingres drawing. The previous highest, also at Sotheby's, was £8,500. A brilliant drawing by Goya, *Unholy Union*—a grotesque woman, probably a caricature holding above her head a figure, perhaps a monk, returned to where it came from across the Atlantic at £5,000. Two little pen and ink scraps by Fra Bartolomeo, *The Angel of the Annunciation* with a view of a town on the back, and a study of the Virgin Mary made £4,900 between them, an illustration to the story of Ovid's *Fasti* by Pietro da Cortona, of *Tullia driving her chariot over her father's body* £1,200, a delicious gouache on vellum by Simon Bening—*The Rest on the Flight to Egypt*—the same sum and a black chalk drawing of a village by Jan van Goyen £700.

It is perhaps worth noting that in this sale, as in dozens of others in the past of a similar quality, while seven items accounted for as much as £32,500, the remaining one hundred were dispersed for a total of £12,000 at prices from £10 to £850. In a later sale of drawings a pen and ink and watercolour winter landscape by Jacob van Stry sold for £300, a pair of 1777 by the scarcely known Hendrik Meijer for the same amount, and a view of Lambsheim by Matthaeus Merian the Elder for £370. The majority of the others were Italian—a study of a page holding a lance for instance, attributed to Francesco del Cossa made £1,700. *A Roman Sacrifice* by Castiglione in brown, green and red oilpaint heightened with white on buff paper £2,800, a sheet of studies of drapery by Il Parmigianino (Francesco Mazzola) £1,650 —studies for the painting in the Uffizi, *The Madonna dal Collo Lungo*.

A sale of fifty-eight Old Master Drawings early in July provided a mild sensation for those who are fascinated by record sums of money and enormous pleasure for those who just enjoy superlative draughtsmanship. The *clou* of the sale was no doubt the Rembrandt drawing of a *seated man* (a study of his head on the reverse) supposedly an English actor from a company which frequently performed in Amsterdam during the 1630's. Most of us imagined that with the £16,000 paid a year ago for the drawing of *Lot and his Daughters* we had reached the limit for Rembrandt's pen and ink work for sometime to come—but the English actor drawing was sold for £23,000. An *Avenue in a Park* by Hubert Robert went for £2,800—this seems a record price also—and a lovely Boucher study of a young woman's head in black, red and white chalk made £5,500 (the previous highest for a Boucher drawing £2,800) while the well-known catalogue of the sale of the collection of M. de Julienne, 1767, with its delightful marginal vignettes by Gabriel de St Aubin of the contents of the house and men and women in the rooms, fetched £5,000. It had been sold, also at Sotheby's, in 1959 for £4,000. Among many other surprises was the £6,500 cheerfully paid for

a *Mountain Landscape* by Jacob de Gheyn II—an almost exact replica is in the National Museum at Stockholm, perhaps by Goltzius. *A study of a man playing a viola* by Pier Francesco Mola went up to £800—again a record for a drawing by this decidedly minor artist—and a *study of a stag* by Lucas Granach the Elder, drawn with brush and brown washes and heightened with white—a *tour de force* in its way by a painter whose talents were normally used in other directions—made £10,500.

The final half hour during a memorable morning—total for the fifty-eight was £156,175—was devoted to two dozen drawings by Giovanni Domenico Tiepolo, one of the two gifted sons of the greatest of 18th-century decorators, Giovanni Battista Tiepolo, whose fame has suffered a good deal from the overwhelming reputation justly earned by his father. These were four scenes from the life of Punchinello, the remainder scenes of Venetian life—vivid and charming and amusing. They were dispersed for £72,100.

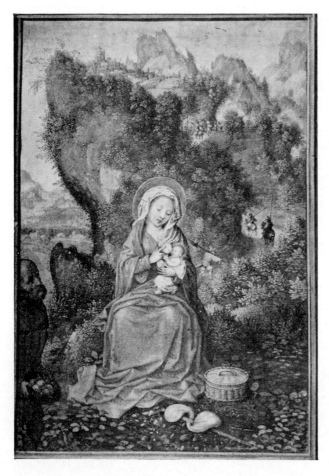

*Opposite page:*
ENGLISH SCHOOL,
16TH CENTURY
*An Ancient Briton.*
Watercolour and gouache, on vellum.
10¼ in. by 7½ in.
London £3,000 ($8,400) 6.VII.67.
From the collection of
F. G. Guth, Esq., of New York.

SIMON BENING
*The Rest on the Flight into Egypt.*
Gouache, on vellum, laid down on a
wood panel. 4¾ in. by 3½ in.
London £1,200 ($3,360) 1.XII.66.
From the collection of
J. A. Church, Esq.

GIOVANNI BENEDETTO CASTIGLIONE called IL GRECHETTO
*A Roman Sacrifice.*
Drawn in brown, blue, green and red oilpaint heightened with
white on buff paper. *Circa* 22½ in. by 16½ in.
London £2,800 ($7,840) 20.IV.67.
From the collection of Sir Kenneth Clark, K.C.B., C.H.

FRANCESCO MAZZOLA called IL PARMIGIANINO
*Sheet of Studies of the Drapery of the Virgin Mary,*
for the painting Madonna dal Collo Lungo, in the Uffizi, Florence.
Pen and Ink over black and red chalk. 7¼ in. by 5⅝ in.
London £1,650 ($4,620) 20.IV.67.
From the collections of Sir Thomas Lawrence and
Miss D. E. Burnett.

PIETRO BERRETTINI *called* PIETRO DA CORTONA
*Tullia driving her Chariot over the body of her father.*
Pen and ink and brown wash, squared for transfer in black chalk. 10½ in. by 18⅞ in.
London £1,200 ($3,360) 1.XII.66.
From the collections of Jean-Denis Lempereur (sold in Paris in May 1773 for 300 francs),
Prince de Conti (sold in Paris in June 1777 for 30 francs), Baron Dominique Vivant-Denon
sold in Paris in May 1826 for 42 francs), and the late Sir George Mounsey, K.C.M.G.

109

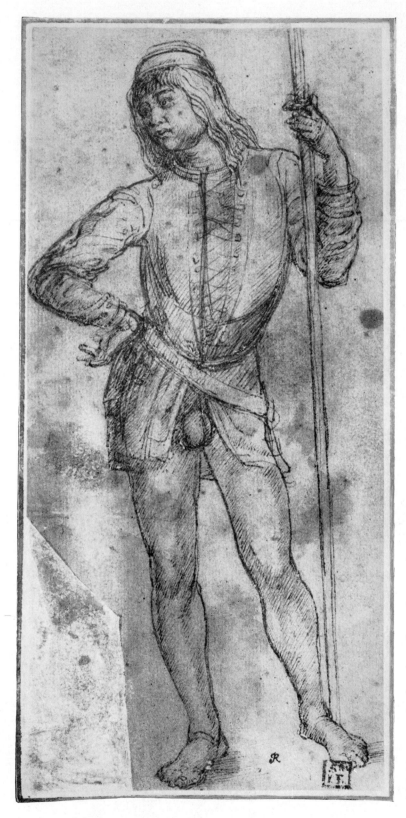

Attributed to
FRANCESCO DEL COSSA
*Study of a Page.*
Pen and Ink. 9½ in. by 4¼ in.
London £1,700 ($4,760)
20.IV.67.
Formerly in the collections of
Jonathan Richardson and
Sir Joshua Reynolds.

*Opposite Page:*
*Above*
GIOVANNI DOMENICO TIEPOLO
*Punchinello visits a Zoo.*
Pen and ink, and light brown
wash over black chalk, signed
and numbered 39.
11½ in. by 16 in.
London £5,000 ($14,000)
6.VII.67.
From the collection of Richard
Owen, Paris, and the late
Robert Goelet of New York City.

All the Punchinello drawings
come from an album privately
sold at Sotheby's in 1920
for £610.

*Below*
GIOVANNI DOMENICO TIEPOLO
*Punchinello visits a Circus.*
Pen and ink, and light brown
wash, over black chalk, signed
and numbered 38.
11½ in. by 16 in.
London £4,800 ($13,440)
6.VII.67.
From the collection of Richard
Owen, Paris, and the late
Robert Goelet of New York City.

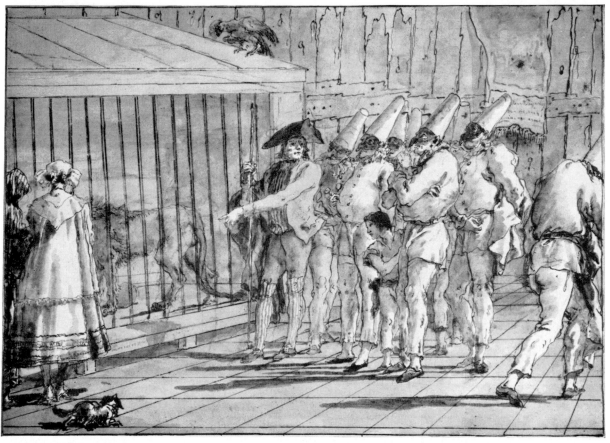

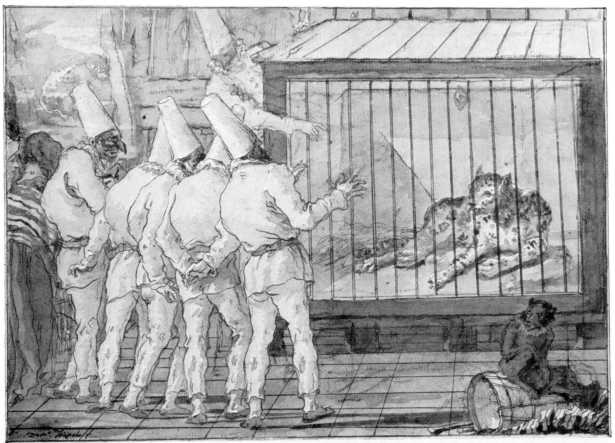

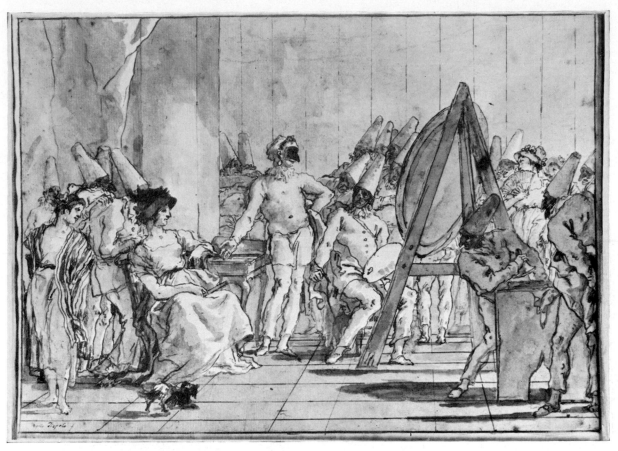

GIOVANNI DOMENICO TIEPOLO
*Punchinello as a Portrait Painter.*
Pen and ink, and light brown wash, over black chalk,
signed and numbered 70. 11½ in. by 16 in.
London £5,800 ($16,240) 6.VII.67.
From the collection of the late Robert Goelet of New York City.

*Opposite page*
At a time when his contemporaries were painting the aerial pursuits of Gods and
Goddesses and picturesque views of the canals of Venice, Giovanni Domenico Tiepolo,
between the years 1791 and 1801, made a series of drawings of the life of Venetian
peasants, bourgeois and aristocrats. A group of these drawings was sold on the 6th
July, 1967 for £53,300.

As far as the subjects are concerned, Domenico Tiepolo's drawings of Venetian
life can be divided into three main groups. Drawings from all of which were repre-
sented in the sale. From the first group, showing the life of the peasants and gypsies
of the Venetian mainland, there were three drawings of travelling showmen performing
with their dogs, monkeys and bears on the dusty roads of the Veneto. The second
group describes everyday life in Venice. Here Venetians visit the magistrates or a
pawnbroker; watch a Punch and Judy show at a nunnery; or gape in horror at a
Quack Dentist. Among the last group depicting the life of fashionable Venetian
Society, were drawings of a débutante at a dressmakers, looking at her tousled image
in a looking-glass, while a determined modiste takes the measurements for her first
ball dress, and another of the same girl having tea in an elegant drawing-room sur-
rounded by fops and flirts.

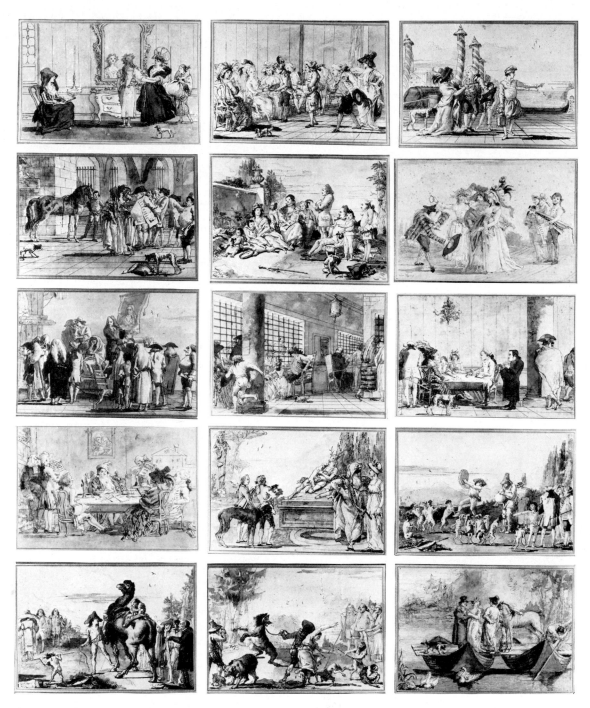

A group of fifteen drawings by Giovanni Domenico Tiepolo sold for a total of
£49,300 ($138,040) in London on the 6th July 1967.

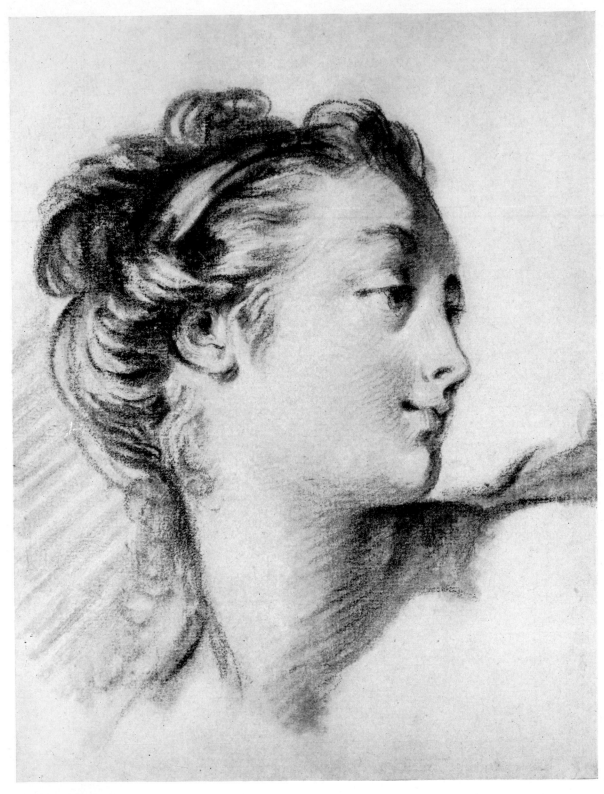

FRANÇOIS BOUCHER
*The head of a young woman.*
Black, red and white chalks, touched with grey wash.
8¾ in. by 6½ in.
London £5,500 ($15,400) 6.VII.67.
From the collection of the late Alfred E. Pearson, Esq.

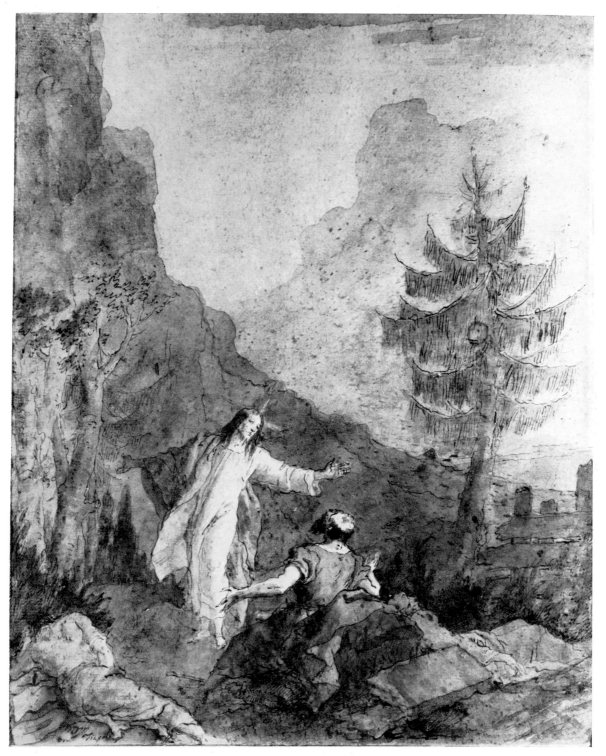

GIOVANNI DOMENICO TIEPOLO
*Christ at Gethsemane with Saints Peter, James and John.*
Pen and ink and wash over traces of black chalk.
Signed. 18 in. by 14¼ in.
London £3,500 ($9,800) 6.VII.67.

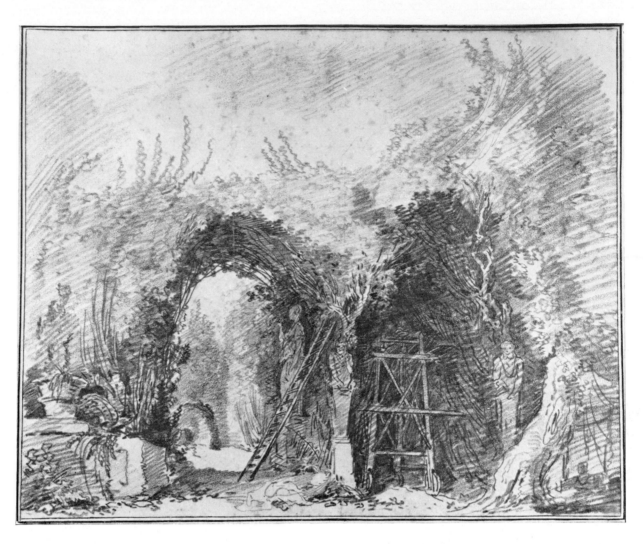

HUBERT ROBERT
*An avenue of a park*.
Red chalk. 15½ in. by 19½ in.
London £2,800 ($7,840) 6.VII.67.
From the collection of the late Robert Goelet,
New York.

MAURICE QUENTIN DE LA TOUR
*Portrait de l'artiste*.
Pastel on vellum. 15½ in. by 12 in.
New York $8,250 (£2,946) 2.III.67.

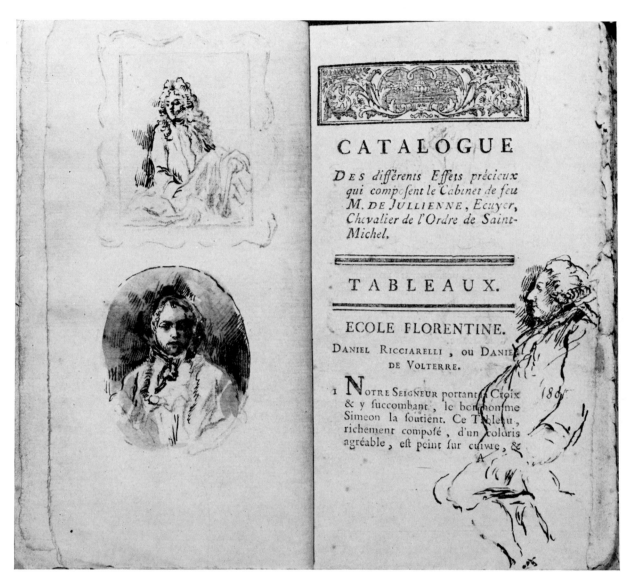

GABRIEL DE SAINT-AUBIN
A saleroom catalogue of 1767 decorated with numerous drawings by Saint-Aubin.
London £5,000 ($14,000) 6.VII.67.
From the collection of the late Madame Alexandrine de Rothschild.

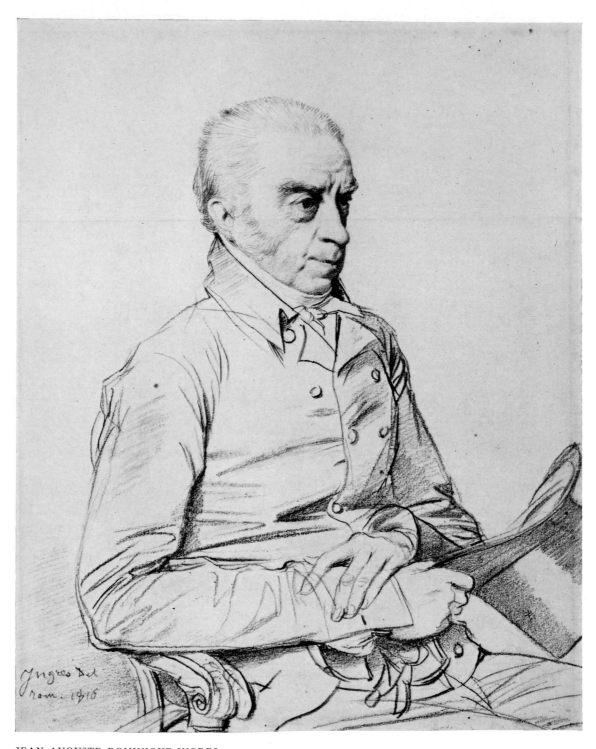

JEAN-AUGUSTE-DOMINIQUE INGRES
*Portrait of Thomas Church.*
Pencil, signed and inscribed: *Ingres del Rom* 1816. 8 in. by 6¼ in.
London £10,500 ($29,400) 1.XII.66.
From the collection of David Wilson, Esq.

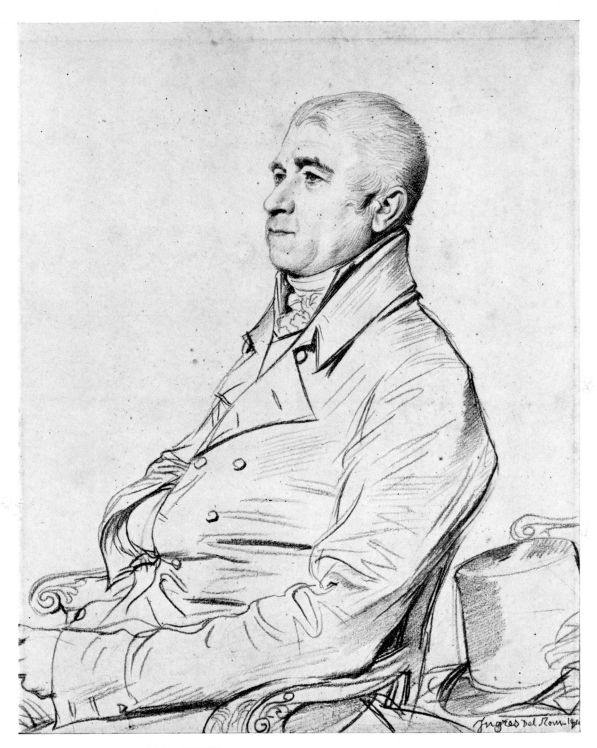

JEAN-AUGUSTE-DOMINIQUE INGRES
*Portrait of The Reverend Joseph Church, Rector of Frettenham.*
Pencil, signed and inscribed: *Rom* 181*. 8 in. by 6¼ in.
London £9,000 ($25,200) 1.XII.66.
From the collection of David Wilson, Esq.

JACOB DE GHEYN II
*A mountain landscape*.
Pen and brown ink. $11\frac{1}{2}$ in. by $15\frac{1}{4}$ in.
London £6,500 ($18,200) 6.VII.67.
From the collection of James
Murray Usher, Esq.

REMBRANDT HARMENSZ VAN RIJN
*Study of a seated actor.*
Pen and brown ink with study of the actor's head on verso. $7\frac{1}{4}$ in. by $5\frac{3}{4}$ in.
London £23,000 ($64,400) 6.VII.67.
From the collection of Mrs Dorothy Monet Rosenwald, New York.

FRANCISCO JOSÉ DE GOYA Y LUCIENTES
*Unholy Union.*
Drawn with brush and lamp-black wash. 7 in. by 5 in.
London £5,000 ($14,000) 1.XII.66.
From the collection of Miss Rada Bercovici, New York.

# Lautrec and Lithography

by Adrian Eeles

Lithography—a word derived from the Greek *lithos* (a stone), *graphis* (something written)—is a technique of printing which was invented in Germany in 1797. The process is simple: first the image to be printed is drawn by hand on the flat surface of a prepared stone, using a special type of greasy crayon. Then the stone is wetted. Next printers' ink (which is not runny, but viscous) is applied with a roller. The ink will adhere to the greasy part of the surface but will be repelled from the wet, non-greasy areas, so that in fact only the drawn image is inked. A sheet of paper is laid over the top, and this stone–ink–paper sandwich is put through the press. When the paper is peeled away it bears, in reverse, the image drawn upon the stone.

The above description has been simplified for the sake of brevity. Lithography soon developed into a very sophisticated process in which variations of technique could produce many amazing subtleties. Some of these variations will be described later.

The process was originally devised for the purpose of reproducing musical scores more easily, but the greater possibilities were soon realised. During the 19th century lithography was much used for printing plans and elevations, diagrams, maps, book illustrations, and last but not least, for creating original works of art. Many artists, particularly in France, experimented with lithography, and among the best exponents in the first two-thirds of the century were Goya, Delacroix, Géricault, Daumier, Gavarni and Manet. They demonstrated that a lithograph need not merely be a kind of multiplied drawing. A good lithograph has a style and an *éclat* all its own. It has the finish that a drawing rarely has and the depth that a drawing never can have; it has its own textures and its own set of nuances. There is something very special about rich, black ink shining out of a square of soft white paper; or the gradation of tones when velvet-black merges into mat-black into grey into pale grey; or when dark olive-green ink is printed on light, cream-coloured paper; or brick-red ink printed on a sheet of coarse, blue-grey China. Moreover, by using inks of more than one colour a vast range of new effects is made possible (although many connoisseurs have always preferred the virtues of *noir sur blanc*). The art of lithography is subtle, but it has produced many masterpieces.

In the 1890s there was a revival of interest in lithography among French artists. Renoir, Degas, Pissarro, Vuillard, Cézanne, Redon—all these and more (with the significant exception of Monet) were drawing on lithographic stones with varying degrees of success. But the most prolific lithographer (nearly 400 plates) and certainly the most successful was Henri de Toulouse-Lautrec.

124

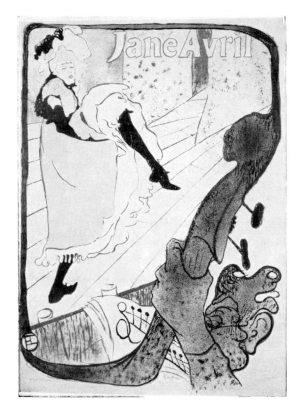

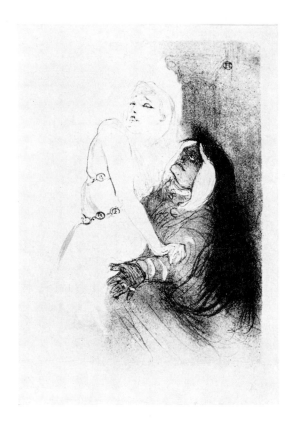

*Left: Jane Avril* (L.D. 345), 1893, lithograph printed in colours, first state before letters, 40½ in. by 35½ in. £2,100 ($5,880). Lautrec's first introduction to lithography was through designing coloured posters. Jules Chéret had shown the way with his bright, ebullient creations that plastered the walls of Paris, but Lautrec's posters had equal vigour without any of Chéret's tinkling frivolity. The distinctive silhouettes of Jane Avril, Aristide Bruant and La Goulue are said to have made a great impact on the public. There is a charming story (it could be true) of how the young Braque, at that time living in Le Havre, would watch out for the latest Lautrec posters to be pasted up on the wall across the street from his house. As soon as the bill-sticker had gone, and before the paste had dried, he would rush out into the street, peel off the poster and put it up in his own studio.

*Right: A La Renaissance: Sarah Bernhardt dans 'Phèdre'* (L.D. 47), 1893, lithograph printed in black, 13¾ in. by 9¼ in. £400 ($1,120). Growing away from the immediate charms of the large coloured lithograph, Lautrec began experimenting with more sophisticated techniques. This one is printed in fierce black ink on a sheet of very white, glossy Japan paper. First the two figures were sketched in with a lithographic crayon. Then shading was added with *crachis* or splatter—a method in which the grease is flicked on to the stone with a hard brush, or sprinkled on with a sieve. Intensity of flicking will determine intensity of shadow. Highlights were made by staging out, i.e. blocking out areas in a dark ground so that no ink will adhere. The

black touches (e.g. on Sarah Bernhardt's eyelids) are added with a brush dipped in liquid grease. The result is a brilliant impression of the great actress in full limelight: a desperate Phèdre clutching at the sleeve of her shadowy accomplice, Œnone.

*Top left: Réjane et Galipaux dans 'Madame Sans-Gêne'* (L.D. 52), 1894, lithograph printed in black, 13¼ in. by 9⅛ in. £450 ($1,260).

Réjane, the best actress in Paris after Sarah Bernhardt, is playing the part of maréchale Lefebvre, an ex-laundress whose husband has been elevated to high rank by Napoleon. La maréchale, who finds polite society uncongenial, is being taught to dance by an official of the court.

This is a consummate piece of draughtsmanship. The lithograph is executed almost entirely with a lithographic crayon. This impression is printed in black ink, but very effective ones were also pulled in olive green and *sanguine*.

*Top right: Miss May Belfort saluant* (L.D. 117), 1895, lithograph printed in black, 14½ in. by 10 in. £550 ($1,540).

May Egan, born in Ireland, appeared on the Paris scene in 1895 and the public (including Lautrec) were for a short while infatuated with her. She always wore a high-waisted smock and mob-cap and cradled a black kitten in her arms. Songs were to match. Her pose of rather depraved simplicity is well captured in this lithograph.

*Bottom left: L'Automobiliste* (L.D. 203), 1896, lithograph printed in black, 14¾ in. by 10½ in. £550 ($1,540).

A portrait of Lautrec's cousin, Dr Gabriel Tapié de Celeyran. The area of shading in the top left was produced by rubbing on the stone with the flat side of a lithographic crayon.

*Bottom right: Idylle Princière* (L.D. 206), 1897, lithograph printed in colours, 13¾ in. by 9½ in. £750 ($2,100).

The lithograph illustrated above is a trial proof. It was printed in colours and afterwards altered by Lautrec to indicate where the colour should be improved or modified. There are touches of red, green and yellow watercolour and also traces of red chalk (none of it unfortunately visible in the reproduction). Lautrec usually tore up his trial proofs but a few, like this one, were rescued from the workshop floor and pieced together. Now they provide invaluable records of how Lautrec worked, and they indicate how very fastidious he was about the results.

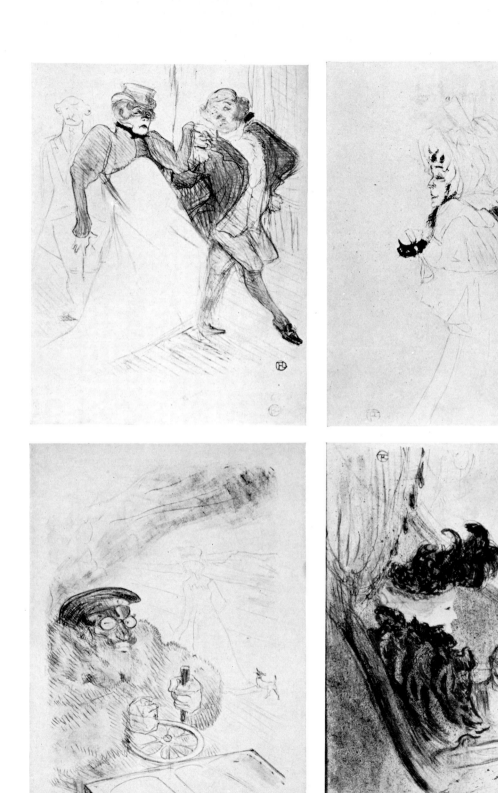

*Left : Le Jockey* (L.D. 279), 1899, lithograph printed in black, 20 in. by 14 in. £2,100 ($5,880).

Towards the end of his life Lautrec returned to the study of horses. They are drawn with the same intensity as he had drawn dancers, actresses, or prostitutes in previous years.

Impressions of this lithograph are known both in black and in colours. On the whole the ones in black ink are more successful.

*Opposite : Partie de Campagne*, also known as *Le Tonneau* or *La Charette Anglaise* (L.D. 219), 1897, lithograph printed in colours, 15¾ in. by 20 in. £3,400 ($9,520).

Commissioned by Ambroise Vollard, and the last of the series of colour lithographs. Unfortunately the edition was printed on rather inferior paper which over the years has proved very susceptible to the effects of damp and sunlight.

In the governess-cart are Misia and Charles Conder.

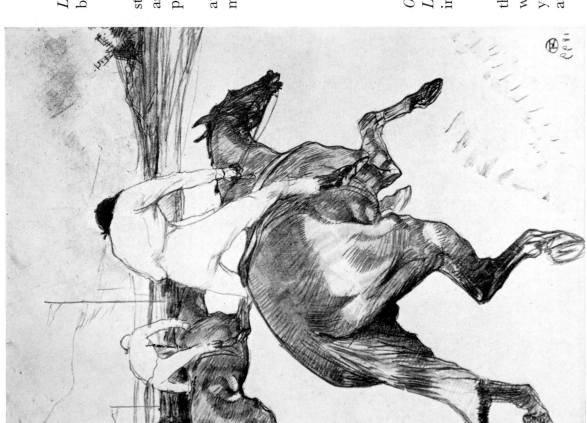

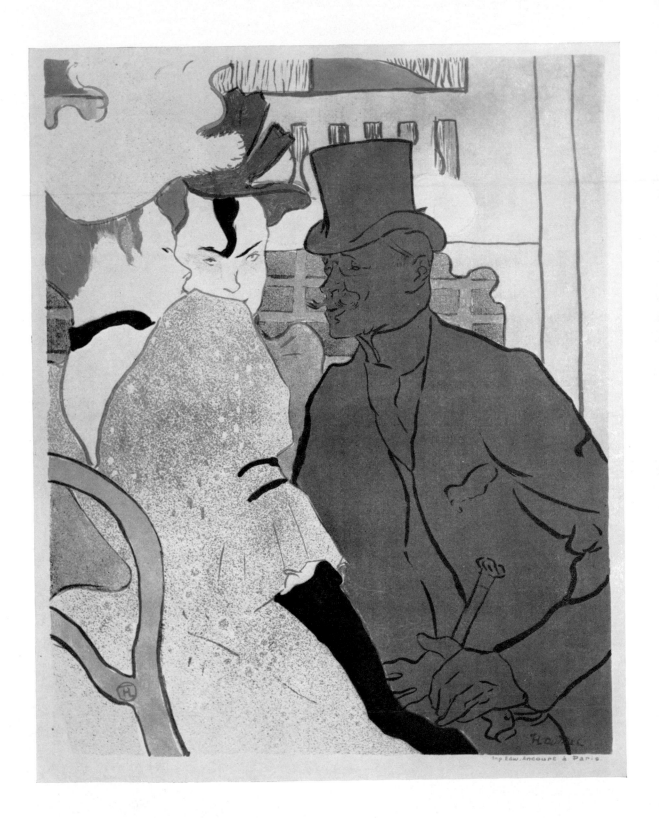

*Left:*

*L'Anglais au Moulin-Rouge* (L.D. 12), 1892, lithograph printed in colours,
20⅞ in. by 14⅞ in. £3,300 ($9,240)

This is one of the artist's earlier attempts at colour lithography, made shortly after the first posters. It has all the direct-impact qualities of a poster. In addition, with its strong linear outlines and large flat areas of colour, it suggests the style of the Japanese woodcuts, at that time all the rage in Paris.

The *Anglais* is W. T. Warrener, an impresario searching for talent in the Moulin-Rouge.

*On page 132:*

*Clownesse assise*, from the *Elles* series (L.D. 180), 1896, lithograph printed in colours, £8,000 ($22,400) for the set of ten.

This series of ten colour lithographs was published by Gustave Pellet (who also published the etchings of Félicien Rops). Possibly because of their subject-matter (*maisons closes*) they did not sell at all well. They are nevertheless among Lautrec's highest achievements in the lithographic medium.

In 1896–97 Lautrec produced a run of brilliant colour lithographs, over which he took enormous trouble. We know that he was careful to get inks of exactly the right colour, and we should also remember that for colour lithography several stones must be used, one for each colour—in this case red printed over yellow over dark green. Notice also the extremely effective use of *crachis*.

*On page 133:*

*La Grande Loge* (L.D. 204), 1897, lithograph printed in colours, 20 in. by 15½ in. £5,500 ($15,400)

Another *tour de force* of colour lithography. *Crachis* has been extensively used, also lithographic wash (e.g. to suggest the curls of the astrakhan fur cape, and the blue feathers in the other woman's hat). As lithographs of this complexity were extremely difficult to print, only a few impressions were taken: this is one of twelve.

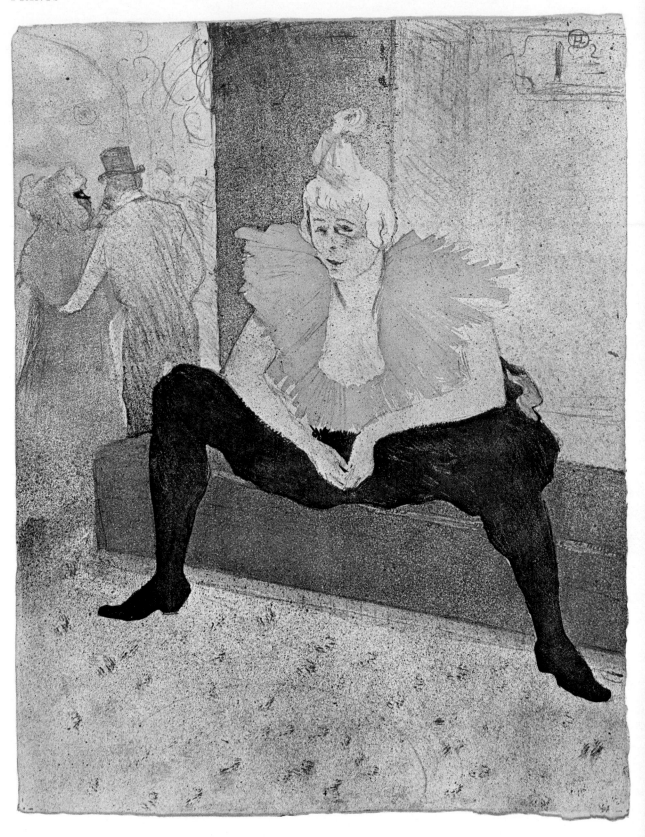

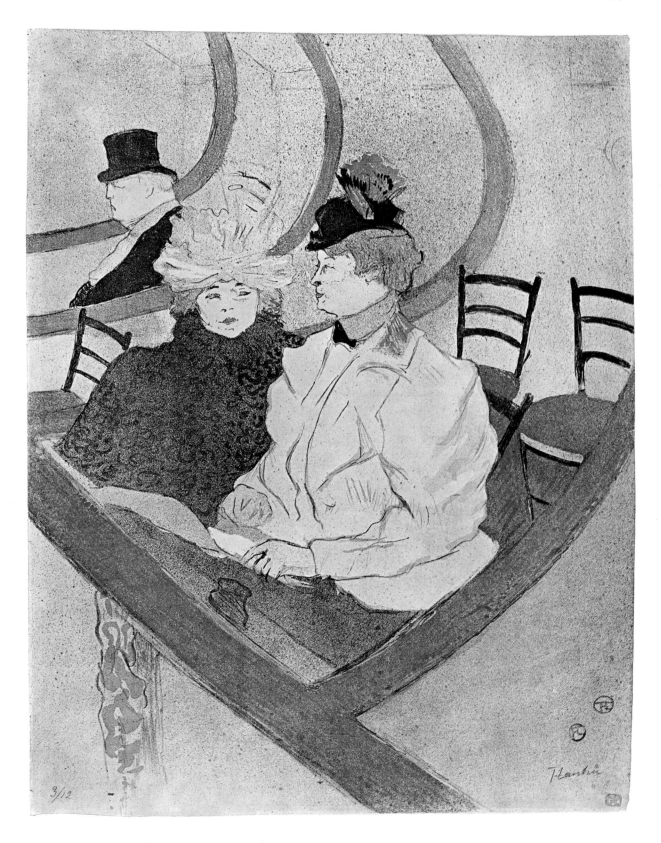

3/12

# Prints

This Department had the honour of opening the batting for the 1966–7 season and, scoring freely on what some critics thought might be a difficult wicket, made minor auction room history. The occasion was the sale of an anonymous collection of lithographs and drawings by Toulouse-Lautrec. These, sold in 184 lots and honoured by a hard-cover catalogue with a special dust jacket, realised as much as £105,535. The famous Elles, the set of ten lithographs with cover and frontispiece, published in an edition of one hundred by Gustave Pellet in 1896 sold for £8,000, the lithograph printed in black of *Le Jockey*, or *Chevaux de Courses* (a marvellous study of horses and riders seen from behind) for £2,100. (There was an edition of one hundred in black and one hundred in colours). The majestic *Grande Loge* of 1897—the man in the top-hat, the Rothschild coachman Monsieur Tom, one of the two women, Madame Brazier ('Madame Armande'), proprietress of the Hanneton, surprised some of us by reaching £5,500, and the delicious *Partie de Campagne* the most Japanese of all Toulouse-Lautrec lithographs, yet as fluid as running water, £3,400. This is the print known also as *Le Tonneau* or *La Charette Anglaise* (Governess Cart), with Misia and Charles Conder seated in the vehicle and a collie running behind. Among the brilliant posters the one of 1899, Jane Avril, and never used, made £1,050; it was printed only a month before the artist's final breakdown.

A month later in a sale of sporting Prints, that well established favourite of the early 19th century, *Orme's Collection of British Field Sports*, with its twenty coloured aquatints after Samuel Howitt made £800. A few days afterwards the record price of £30,000 was given for an exceptionally fine impression of Rembrandt's etching *The Three Crosses*; the previous highest for any Rembrandt etching was the £26,000 last season for an impression of *The Hundred Guilder Print*. *The Three Crosses* is signed and dated 1653. Some years later the artist reworked the plate and completely transformed it. Lucas Cranach's Woodcut, *The Penance of St. Jerome* went for £1,150, Rembrandt's etching, *Cottage and Haybarn* for £1,500 and the thirty etchings by Canaletto, known briefly as *The Views* for £5,000. Piranesi's *Views of Rome* made £1,400, his *Views of Paestum* £900, and, at the end of the morning, two working proofs from Goya's *Los Caprichos*, The Blow and Devout Profession, £1,300 and £1,600 respectively. Dürer's St. Eustace engraving was sold for £1,300. Another fine Old Master Print sale in the spring included the Dürer engraving of 1519, *St. Anthony Reading* with the romantic mediaeval city rising to the crest of a hill behind him, which made £1,800, followed by a good though not superfine impression of Rembrandt's etching *Christ healing the Sick* (the Hundred Guilder Print)—£4,750. The twenty-one plates, reissues on laid India paper. *Illustrations to the Book of Job*, published by William Blake in 1825, went to Italy at £600, and the set of eighty plates of Goya's Los Desastres de la Guerra, the first edition of 1863, made £2,200. An unusual item was a chiaroscuro woodcut from three blocks printed in black and two shades of ochre, *Hercules slaying Cacus*, by Hendrick Goltzius—£510.

Another print sale at the beginning of July contained both Old Master and Modern prints, when The Vampire, by Edward Munch, 1895,—a fine impression—went up to £4,100, his *Sommernatt*, of the same year to £980, and Picasso's etching of 1936, *Satyr and Sleeping Woman*—one of the Vollard suite—for £880. Among the earlier works Rembrandt's well-known portrait of his friend the goldsmith Jan Lutma fetched £900, and the endearing *St. Jerome by a pollarded willow*, with the saint's lion peeping up round the trunk—an etching which deserves to be better known—was bought for £1,200, while fifty-eight plates from the 1st edition, 1799, of Goya's Los Caprichos made £1,650 and the set of Marieschi's Views of Venice, 1741, £880.

At Parke-Bernet a delightful print of 1853, a coloured lithograph by O. Knirsch and N. Currier, *The Road—Winter*—Mr and Mrs Currier in a horse-drawn sledge fetched $2,800. Van Gogh's etching of Dr Gachet, the only print by him executed shortly before his death while under the doctor's care and printed by Gachet, went for $3,000, Rembrandt's etching of Clement de Jonghe for $3,000 and Redouté's album—*Les Plus Belles Roses*—for $2,500. Picasso's tragic *Le Repas Frugal*, 1904, published by Vollard in 1913 was bought for $5,000. Munch's *Kvinneportrett* of 1912—a woodcut—for £964.

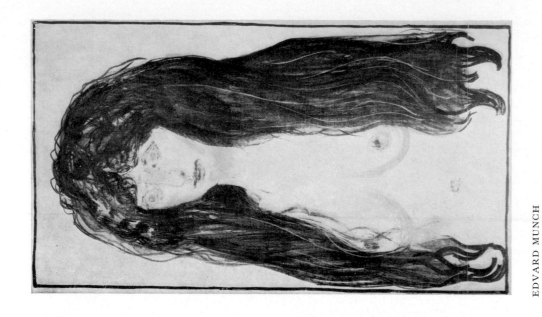

EDVARD MUNCH
*Weibliche Aktfigur—Die Sünde—Mädchen mit
Langem Roten Haar* (*Schiefler 142c*).
Lithograph printed in colours, signed. $27\frac{1}{2}$ in. by $15\frac{3}{4}$ in.
London £2,500 ($7,000) 16.III.67.
From the collection of the late Harry Rosenthal, Esq.

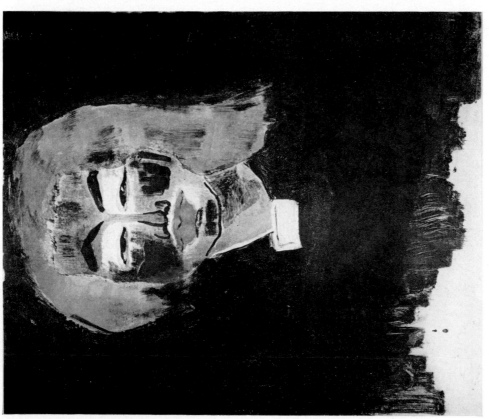

EMIL NOLDE
*Junge Dänin* (*Schiefler 58*) *1913*
Lithograph, being one of only four impressions which
have the additional hand-colouring by the artist.
$26\frac{3}{4}$ in. by 22 in.
London £1,900 ($5,320) 16.III.67.
From the collection of the late Harry Rosenthal, Esq.

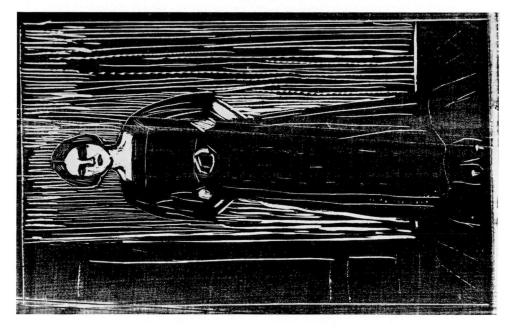

EDVARD MUNCH
*Kvinneportrett, 1912.*
Woodcut, signed in pencil. $21\frac{5}{8}$ in. by $13\frac{5}{8}$ in.
New York $2,700 (£964) 23.II.67.

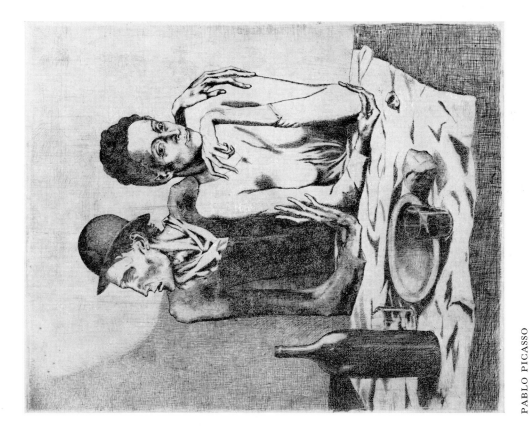

PABLO PICASSO
*Le Repas Frugal, 1904.*
Etching, second state, one of two hundred and fifty
impressions on Van Gelder paper. $18\frac{5}{16}$ in. by $14\frac{3}{4}$ in.
New York $5,000 (£1,786) 23.II.67.

F*

PIERRE BONNARD
*Paravent à quatre feuilles: promenade des nourrices, frise des fiacres.*
Lithograph printed in colours, published in 1899 in an edition of
one hundred and ten copies. 41 in. by 78 in.
London £2,500 ($7,000) 16.III.67.

*Opposite page:*

*Above*
N. CURRIER (PUBLISHER)
*The Road—Winter 1853.*
Coloured lithograph. 17 $\frac{5}{16}$ in. by 26 $\frac{1}{16}$ in.
The scene shows Mr and Mrs Currier in a horse drawn sledge;
a pair to *The Road—Summer.*
New York $2,800 (£1,000) 28.I.67.
From the collection of the late Robert Goelet.

*Below*
N. CURRIER (PUBLISHER)
*Rail Shooting, on the Delaware, 1852.*
Coloured lithograph. 12 $\frac{5}{8}$ in. by 20 $\frac{1}{8}$ in.
New York $1,900 (£678) 28.I.67.
From the collection of the late Robert Goelet.

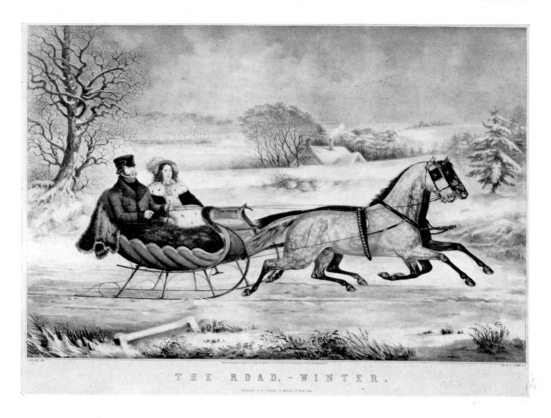

THE ROAD,-WINTER.

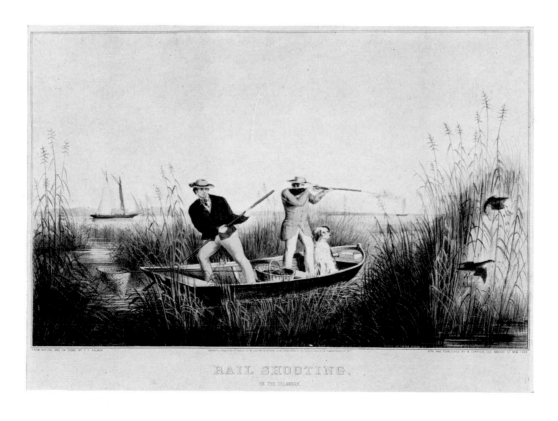

RAIL SHOOTING.
ON THE DELAWARE.

FRANCISCO JOSÉ DE
GOYA Y LUCIENTES
*Los Desastres de la Guerra.*
Etchings with aquatint. The set of
eighty plates in the first edition of
1863.
London £2,200 ($6,160) 18.IV.67.

HENDRIK GOLTZIUS
*Hercules Slaying Cacus.*
Chiaroscuro woodcut. 16⅛ in. by 13 in.
London £510 ($1,428) 18.IV.67.
From the collection of Mrs E. Fuller.

La Torre di Malgherà, from
the set of etchings called *Vedute Altre
Prese da i Luoghi Altre Ideate* by
ANTONIO CANAL called CANALETTO
London, the set, £5,000 ($14,000)
29.XI.66.

REMBRANDT HARMENSZ.
VAN RIJN
*Abraham's Sacrifice.*
Etching, only state. $6\frac{1}{8}$ in. by $5\frac{3}{16}$ in.
New York $4,000 (£1,428) 23.II.67.

REMBRANDT HARMENSZ VAN RIJN
*Clement De Jonghe.*
Etching. 8⅛ in. by 6⅜ in.
New York $5,750 (£2,053) 15-16.XI.66.

REMBRANDT HARMENSZ VAN RIJN
*St Jerome by a Pollard Willow.*
Etching, second state.
London £1,200 ($3,360) 4.VII.67.

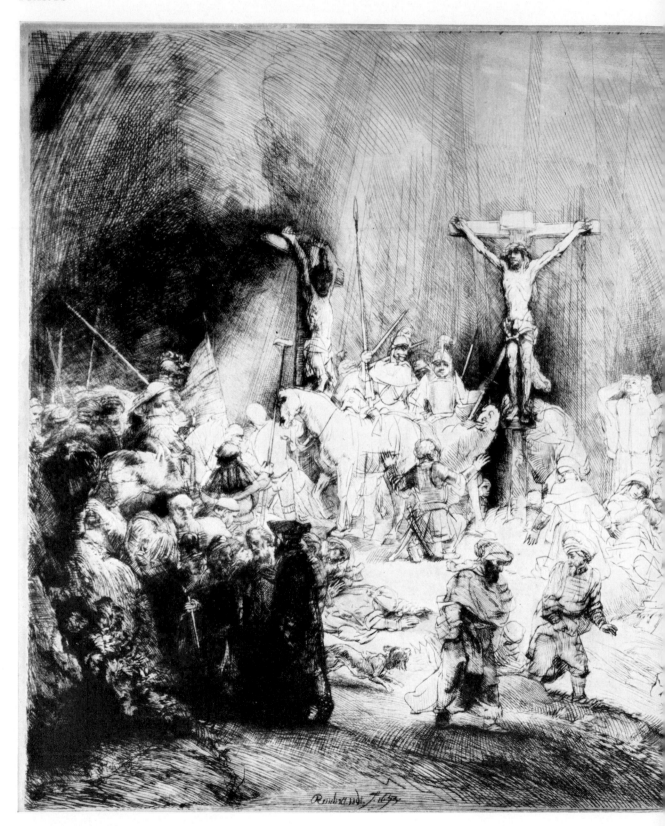

REMBRANDT HARMENSZ VAN RIJN
*The Three Crosses*.
Drypoint etching. Third state (of five). 15¼ in. by 18 in.
London £30,000 ($84,000) 29.XI.66.
A duplicate from the Albertina, Vienna.
This print is in the third, i.e. finished state with Rembrandt's
signature and the date 1653 added in the lower centre. Some
years later (probably 1660–61), Rembrandt worked over the
plate again, thereby completely transforming it.

LUCAS CRANACH THE ELDER
*The Penance of St Jerome.*
Woodcut. 13¼ in. by 9 in.
London £1,150 ($3,220) 29.XI.66.

ALBRECHT DÜRER
*St Anthony Reading.*
Engraving. 4 in. by $5\frac{3}{4}$ in.
London £1,800 ($5,040) 18.IV.67.
From the collection of Mrs F. H. Plaistowe.

ALBRECHT DÜRER
*The Landscape with the Cannon.*
Etching $8\frac{5}{8}$ in. by $12\frac{7}{8}$ in.
New York $2,600 (£928) 23.II.67.

# 18th, 19th and 20th Century Paintings and Drawings

Among numerous exceptional works this season a general favourite, both as an historical document and as a work of art, has been Rowlandson's long-lost and miraculously found watercolour *Vauxhall Gardens*. Until just after the last war this drawing had been known only from a print. Rowlandson exhibited it in the Royal Academy and it was found in a junk shop in 1945 for £1. The purchaser walked into Christie's thinking it was a print—Christie's sold it for £2,730. It came to Sotheby's from the estate of the late Alfred Pearson of Torquay. It depicts a musical evening at Vauxhall Gardens, with Boswell, Dr Johnson and Mrs Thrale at supper in an alcove and many well-known personages including the Prince of Wales, later George IV, and his mistress Mrs Robinson (Perdita) among the throng beneath the trees. On this its final appearance in the sale room, it was bought for £11,000 and is safely in the Victoria and Albert Museum. Another unique English painting, sold on this occasion for £8,000 and acquired by the National Portrait Gallery, was a self-portrait by George Stubbs, one of his experiments in enamel colours on a Wedgwood plaque —a portrait which, until 1957, was always known as that of Wedgwood himself. A few moments later a typically romantic Lawrence, a portrait of the four children of John Angerstein, son of one of the founders of Lloyds, whose collection of pictures formed the nucleus of the National Gallery, surprised most of those present by realising £23,000. Sir Alfred Munnings remains as popular as ever—and with reason, for few Englishmen have been more devoted to horses and the countryside, and fewer still have been able to transfer their affection to canvas more agreeably; a typical work by him *A Shepherd on a White Pony Driving Sheep* along a stone walled road with Exmouth beyond was sold for £6,700; another, *Leading Ponies across a Moorland*, painted in Norfolk in 1911, for £3,100. Drawings by Aubrey Beardsley, with their meticulous line and strange undertones of despair, are very rarely seen on the market; in July, *A Child at its Mother's Bed*, made £1,100. Among several drawings by Augustus John, his self-portrait of about 1901 went for £1,100; his portrait of Epstein about 1906 for £1,150; while two paintings by Stanley Spencer fetched £1,100 and £1,300 respectively. A bronze by Henry Moore, *Three Motives against a Wall*, executed in 1959, one of an edition of ten, was sold for £4,300, and two studies for sculpture by him—pencil, pen and ink, coloured chalks and watercolour, one of 1940, the other a year earlier, for £2,100 and £1,250. L. S. Lowry, by the time these words are read, will be an octagenarian and as mellow and honoured an R.A. as ever existed— and gloriously and obstinately unique. It took the picture-buying public a long time —about a half century—to recognise his peculiar quality. Two paintings by him in the most recent Sotheby sale made £1,000 and £1,300 respectively. Among several early 19th century paintings, a James Pollard of The Norwich and London Royal Mail Coach on a country road, 1824, fetched £3,000 and two equestrian portraits of 1843 by that Melton Mowbray stalwart John Ferneley, Snr, £4,800 and £3,200.

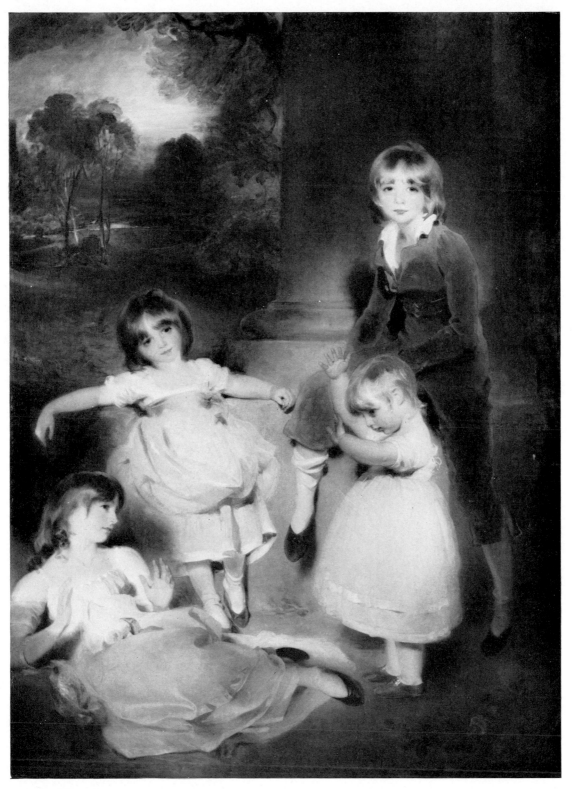

SIR THOMAS LAWRENCE, P.R.A.
76 in. by 56¾ in.
*Portrait of the Children of John Angerstein.*
London £23,000 ($64,400) 12.VII.67.
From the collections of Mrs Arthur James,
Mrs Walter Burns and Lady Carew Pole.

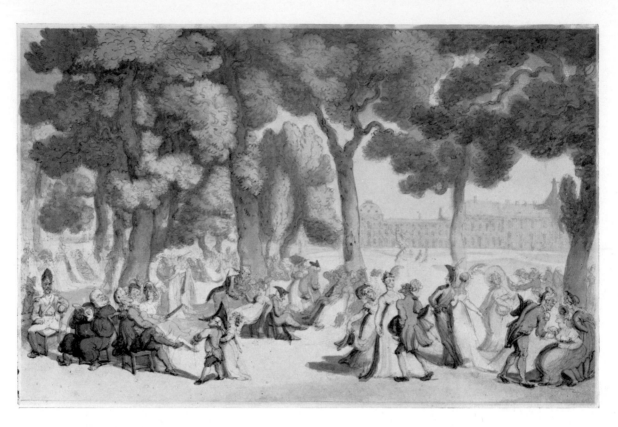

THOMAS ROWLANDSON
*The Tuileries Gardens.*
10⅝ in. by 16⅝ in. *Circa* 1800.
London £1,500 ($4,200) 23.XI.66.

Two earlier sales in November and March raised respectively over £135,000 and £94,500. In November, a characteristic full length Reynolds in his grandest manner, a portrait of the Earl of Harrington 1782, made £9,500; a pair of racing pictures by James Ward £4,000 and, among several paintings by John Frederick Herring Senior, one particularly attractive study of the Cotswold Hunt (commissioned by the seller's grandfather) £3,400, while a naïvely stiff formal portrait of a Mr Russell on his chestnut hunter by that early and endearing pioneer of the English sporting painting, James Seymour, was sold for £3,600. In March there was a notable little sepia and indian ink drawing, *Cornfield at Shoreham*, *circa* 1831–32 by Samuel Palmer, was sold for £5,800; a landscape by the mid-19th century Canadian artist Cornelius Krieghoff for £5,600, and one of J. F. Lewis' careful Cairo scenes, which so appealed to Victorian romantics, for £5,200. An amusing painting of 1843 by John Ferneley, *The Hunt Scurry*, made £1,200, and a fine view of Edinburgh from the west by Alexander Nasmyth for £4,700. James Collinson's *Answering the Emigrant's Letter*, a subject prompted by the poverty of the 1850's, has in addition a literary interest also, for Christina Rossetti was the model for one of the figures; at one time she was engaged to Collinson. This well-known picture fetched £1,550.

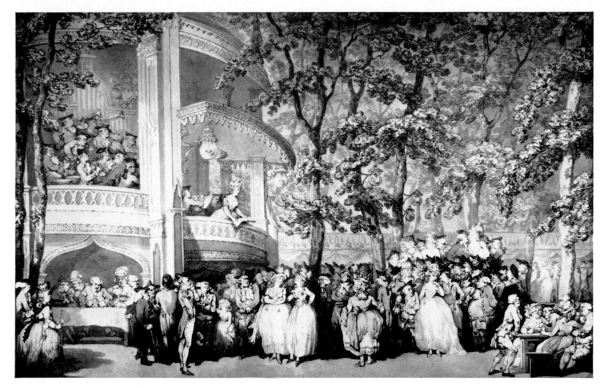

THOMAS ROWLANDSON, *Vauxhall Gardens*.
19⅛ in. by 29½ in.
London £11,000 ($30,800) 12.VII.67.
From the collections of F. A. Lawrence, Esq. and the late
Alfred E. Pearson, Esq. Now in the Victoria and Albert Museum.

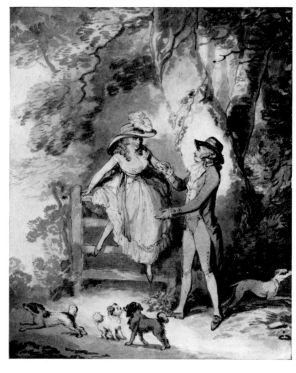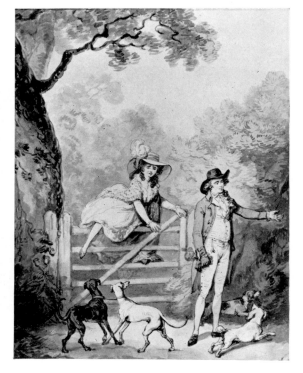

THOMAS ROWLANDSON, *Courtship and Matrimony*.
A pair. Each 14 in. by 11¼ in. London £3,000 ($8,400) 12.VII.67.
From the collection of the late Alfred E. Pearson, Esq.

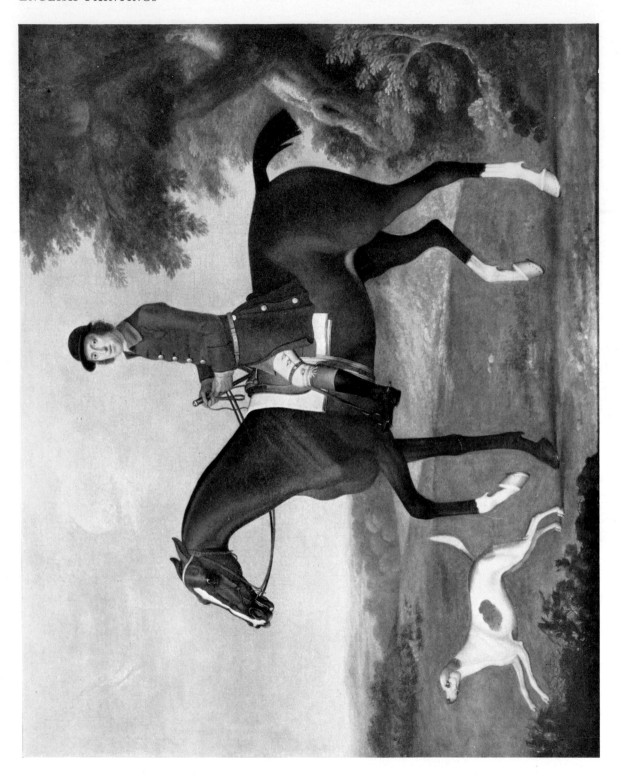

*Opposite page*:
JAMES SEYMOUR
*Mr Russell* on his
chestnut hunter with
a hound in a
landscape setting.
34 in. by 43¼ in.
London £3600
($10,080) 23.XI.66.
*From the collection of the
late C. B. Kidd*

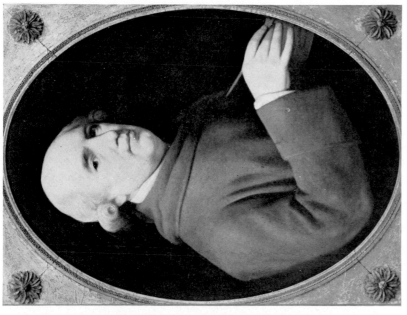

GEORGE STUBBS, A.R.A.
*Portrait of the Artist.*
Signed and dated 1781, enamel colours
on Wedgwood plaque,
oval. 26⅝ in. by 20⅛ in.
London £8,000 ($22,400) 12.VII.67.
From the collections of Sir John Astley
and Mrs Muriel S. Heely.
Now in the National Portrait Gallery,
London.

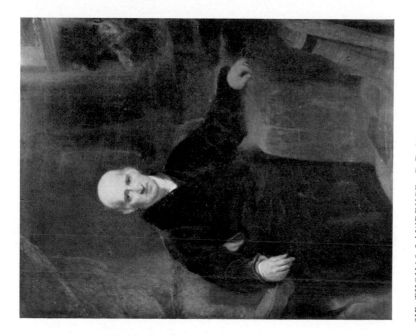

SIR THOMAS LAWRENCE, P.R.A.
*Portrait of Benjamin West, P.R.A.*
On cradled panel. Painted *circa* 1810.
60½ in. by 47½ in.
New York $10,000 (£3,571) 23.XI.66.
From the collection of the late
Cornelia H. Gerry, New York.

EDWARD DAYES
*A view of Queen Square*. London.
Signed and dated 1786. 14½ in. by 20⅞ in.
London £2,700 ($7,560) 12.VII.67.
From the collection of the late Alfred E. Pearson, Esq.

EDWARD DAYES
*Hawes Water, Westmorland*.
Signed. 11¾ in. by 17½ in.
London £850 ($2,380) 23.XI.66.
From the collections of L. G. Duke and
Frederick Nettlefold, Esq.

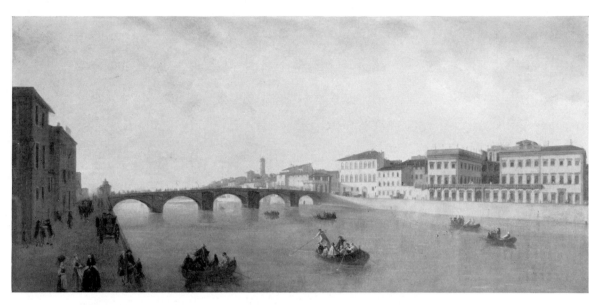

THOMAS PATCH
*The Arno at Florence.*
Signed. 37 in. by 75¼ in.
London £2,200 ($6,160) 23.XI.66.
From the collection of the late Viscount Clifden, K.C.V.O.

ALEXANDER NASMYTH
*A View of Edinburgh from the East.*
Gouache, signed and dated 1789. 13 in. by 17 in.
London £750 ($2,100) 23.XI.66.

HENRY FUSELI, R.A.
*Portrait of John Cartwright.*
Black and white chalks, inscribed. 12¾ in. by 19¾ in.
London £1,500 ($4,200) 15.III.67.

DOMINIC SERRES
*Shipping off The Coast of England.*
Indistinctly signed and dated 1750. 25½ in. by 45½ in.
New York $2,000 (£714) 26.IV.67.

THOMAS ROBINS THE YOUNGER
*Scarlet Martegon Lily, Oriental Virgins Bower and Oleander.*
Heightened with bodycolour, signed, inscribed and dated 1786.
13⅞ in. by 9⅜ in.
London £550 ($1,540) 12.VII.67.
One of a set of forty-three drawings by Thomas Robins the
Younger from the collection of The Bath and West and Southern
Counties Society sold at Sotheby's in July 1967 for £15,950
($44,500).

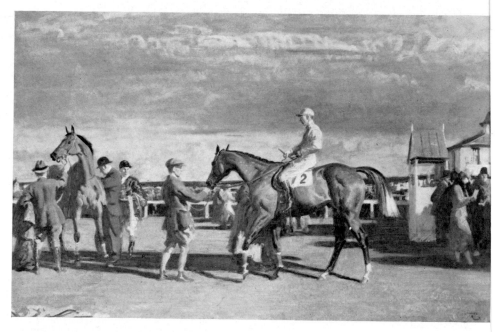

SIR ALFRED MUNNINGS, P.R.A.
*After the Race, Cheltenham Saddling Paddock.*
Signed. Painted in 1946. 40½ in. by 60 in.
London £8,500 ($23,800) 12.IV.67.
From the collection of Mrs J. T. Merry.

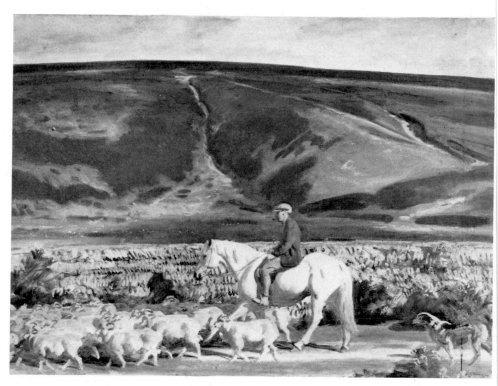

SIR ALFRED MUNNINGS
*A Shepherd on a White Pony Driving Sheep.*
Signed. 28½ in. by 38½ in.
London £6,700 ($18,760) 19.VII.67.

ENGLISH SCHOOL, *circa* 1740
*A View of Claremont House, Esher, four views of various aspects of the
gardens, and a view of the gate and stables in Esher Park.*
Set of six. Each 25½ in. by 43 in.
London £2,800 ($7,840) 23.XI.66.

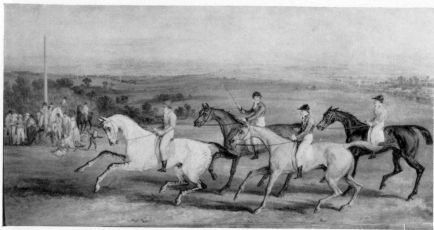

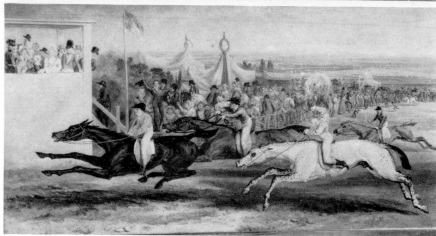

JAMES WARD, R.A. *Confidence; Depression;*
A pair, stamped on the reverse with the artist's initials.
On panel. Each 19¾ in. by 37¼ in.
London £4,000 ($11,200) 23.XI.66.

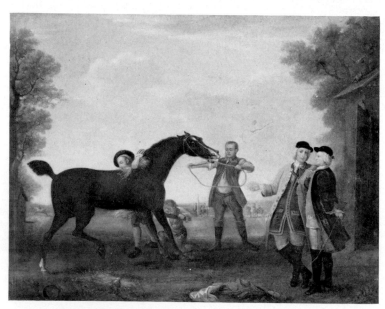

JOHN WOOTTON
*Horses at Newmarket belonging to Henry Third Duke of Beaufort
with Portraits of Sir Watkin Williams Wynn and the Third Duke.*
38¾ in. by 48¾ in. London £2,800 ($7,840) 23.XI.66.
From the collection of the late C. B. Kidd.

CORNELIUS KRIEGHOFF
*Trappers.*
Signed and dated 1856. 16⅛ in. by 25¼ in.
London £5,600 ($15,680) 15.III.67.

ALBERTO PASINI
*Courtyard Scene.*
Signed and dated 1879. 14½ in. by 17½ in.
New York $1,900 (£678) 26.IV.67.

JAMES BAKER PYNE
*A View of Venice From The Ponte Ferrovia.*
23½ in. by 33⅞ in.
New York $2,000 (£714) 26.IV.67.

RICHARD PARKES BONINGTON
*Sunset over an open landscape with figures and cattle.*
5⅜ in. by 7⅜ in.
London £1,200 ($3,360) 23.XI.66.
From the collections of A. T. Hollingsworth (1929)
and Frederick Nettlefold, Esq.

EDWARD LEAR
*A view of Sarténé, Corsica.*
Heightened with body colour, signed with monogram.
11⅞ in. by 18⅜ in.
London £450 ($1,260) 23.XI.66.
From the collection of Dr Richard Taylor, Cannondale, Connecticut.

SAMUEL PALMER, R.W.S.
*A Cornfield, Shoreham, at Twilight.*
Sepia and indian ink. Painted *circa* 1831–2. $5\frac{11}{16}$ in. by $6\frac{3}{8}$ in.
London £5,800 ($16,240) 15.III.67.
Formerly in the collections of George Richmond, R.A.
and J. W. Bell, Esq., C.B.E.

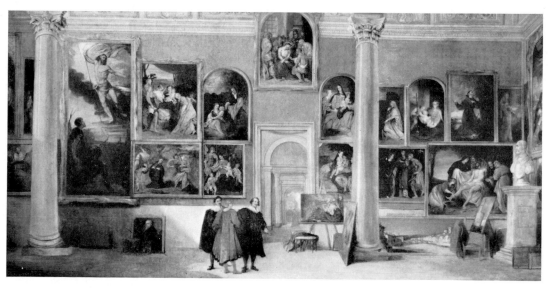

JOHN SCARLETT DAVIS
*The Art Gallery of the Farnese Palace, Parma.*
Signed with initials and inscribed Parma, and dated 1839.
$38\frac{1}{4}$ in. by $73\frac{1}{4}$ in.
London £950 ($2,260) 12.VII.67.

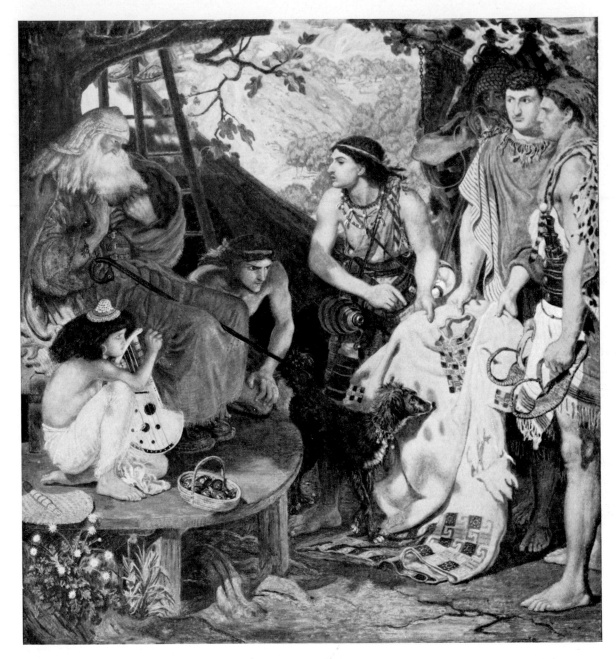

FORD MADOX BROWN
*Jacob and Joseph's Coat.*
Signed with initials and dated 1871.
London £2,300 ($6,440) 12.VII.67.

DANTE GABRIEL ROSSETTI *Paolo and Francesca*.
Varnished watercolour heightened with body-colour,
signed with monogram and dated 1862. 12½ in. by 23½ in.
London £2,500 ($7,000) 15.III.67.
From the collections of J. Leathart, Esq., T. H. Leathart, Esq.,
Sir Edmund Davis and Kerrison Preston, Esq.

JAMES COLLINSON *Answering the Emigrant's Letter*.
On panel. 22¼ in. by 30 in. London £1,550 ($4,340) 15.III.67.
From the collection of Mrs Viva King.

CARL JOHANN SPIELTER *The Auction.*
Signed and dated 1900. 25 in. by 33½ in.
New York $3,250 (£1,160) 2.III.67.

JOHN FREDERICK LEWIS, R.A.
*The Reception.*
On panel. Signed and dated 1873. 24½ in. by 29½ in.
London £5,200 ($14,560) 15.III.67.
From the collection of George Farrow, Esq.

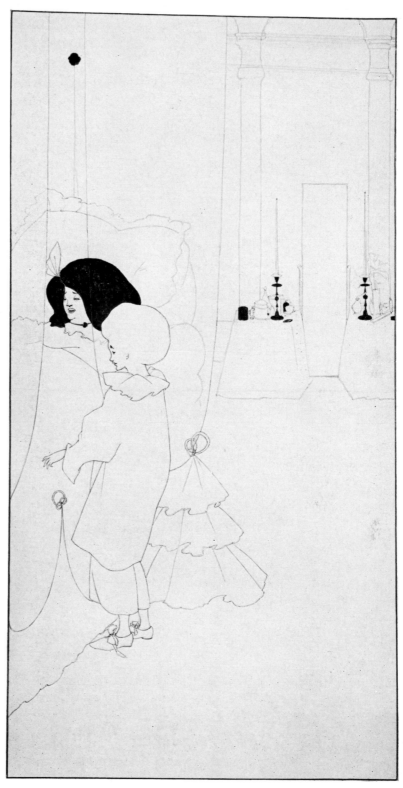

AUBREY BEARDSLEY
*A Child at its mother's bed.*
Pen and indian ink. $14\frac{5}{8}$ in. by $7\frac{1}{2}$ in.
London £1,100 ($3,080) 19.VII.67.
From the collection of Mrs Ivor Brown, Mrs B. Sandford,
and C. C. Hentschel, Esq.

AUGUSTUS JOHN *Portrait of the Artist*.
Recto black chalk. Signed. *Circa* 1901.
10¼ in. by 7 in.
London £1,100 ($3,080) 19.VII.67.
From the collection of Mrs R. Samuels.

AUGUSTUS JOHN, R.A. *Allegorical Fantasy*.
Signed. Pencil, watercolour and gouache.
21½ in. by 18¼ in.
New York $1,050 (£375) 4.V.67.
From the collection of the late Edith Wetmore, New York.

WALTER RICHARD SICKERT, A.R.A.
*L'Eglise de St. Jacques, Dieppe.*
Signed. Painted *circa* 1905. 21 in. by 18 in.
London £1,500 ($4,200) 14.XII.66.

WALTER RICHARD SICKERT, A.R.A.
*La Russe.*
Signed. Painted *circa* 1905.
19¾ in. by 15½ in.
London £1,000 ($2,800) 12.IV.67.

ARTHUR BOYD
*Bridegroom waiting for his bride to grow up 1957–1958.*
Oil and tempera. Signed. 53¾ in. by 71½ in.
London £850 ($2,380) 14.XII.66.
From the collection of Mrs Edward Gage.

*Opposite page:*

*Above*   L. S. LOWRY, R.A.
*The Obelisk.*
Signed and dated 1944, on panel. 14 in. by 18 in.
London £1,300 ($3,640) 19.VII.67.
From the collection of Mrs A. N. E. Craig.

*Below*   L. S. LOWRY, R.A.
*An Open Space*
Signed and dated 1950. 29½ in. by 39½ in.
London £3,000 ($8,400) 14.XII.66.
From the collection of Dr S. H. Foulkes.

FRANCIS BACON
*Head, 1962*
Corner cut, canvas mounted on board.
Size overall 16 in. by 16¾ in.
London £2,400 ($6,720) 14.XII.66.
From the collection of Daniel Farson, Esq.

BEN NICHOLSON
*Painting 1937*
16 in. by 21½ in.
London £1,800 ($5,040) 12.IV.67.
From the collections of E. C. Barnes, Esq., and
Mr and Mrs James H. Clark, Dallas, Texas.

DAVID JONES
*A Farmyard Scene*
19⅛ in. by 24¾ in.
London £240 ($672) 14.XII.66.
From the collections of Lt-Col A. J. L. McDonnell and the late
Æ. J. McDonnell.

DAVID BOMBERG
*Evening in the City, London 1944.*
Signed and dated. 27½ in. by 35¾ in.
London £600 ($1,680) 12.IV.67.
From the collections of John Rodker, Esq. and Miss Joan Rodker.

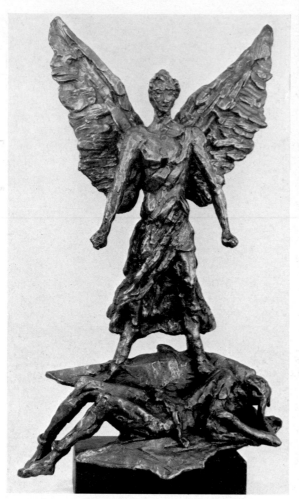 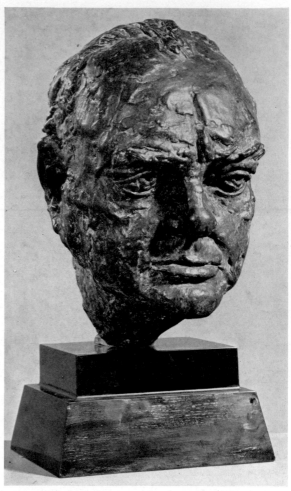

SIR JACOB EPSTEIN
*St. Michael and the Devil.*
Maquette. Bronze with a gold patina. Height overall 20¾ in.
Sculpted in 1956, this is the maquette for the large bronze on
the south wall of Coventry Cathedral.
London £1,100 ($3,080) 14.XII.66.
From the collection of Lady Cochrane.

*Right:*
SIR JACOB EPSTEIN
*Sir Winston Churchill, K.G., O.M., C.H., Hon. R.A.*
Signed. Bronze, dark green patina. Height: 12 in.
One of an edition of ten casts done after Churchill sat to Epstein
in 1946. One additional cast was authorised later for the
memorial church at Westminster College, Fulton, Mo.
New York $21,000 (£7,500) 5.IV.67.
From the collection of William B. Leeds, Virgin Islands.

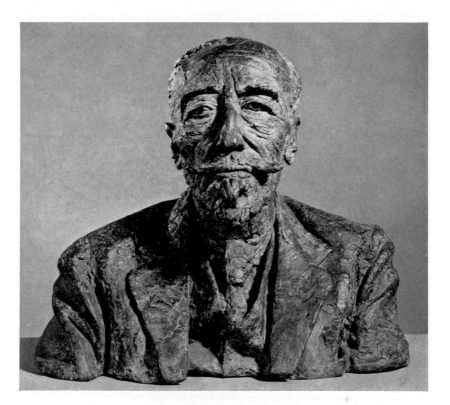

SIR JACOB EPSTEIN
*Joseph Conrad.*
Signed. Bronze, dark green patina.
Height 20 in.
New York $9,500 (£3,393) 5.IV.67.
From the collection of
William B. Leeds, Virgin Islands.

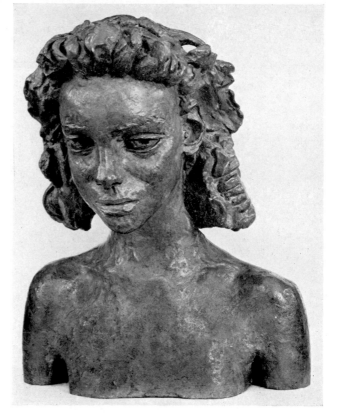

SIR JACOB EPSTEIN
*Juanita Forbes.*
Bronze with a green patina.
Height 17½ in.
Sculpted in 1942.
London £900 ($2,520) 12.IV.67.
From the collection of
Mrs Courtney Young.

177

AUGUSTUS JOHN, O.M., R.A.
*Sir Jacob Epstein.*
Drawn *circa* 1906. 8 in. by 6¼ in.
London £1,150 ($3,220) 19.VII.67.
From the collection of Mrs R. Samuels.

HENRY MOORE, O.M., C.H.
*Two Women with a Child in a shelter.*
Pen and ink, coloured chalks and watercolour, heightened with white.
Signed and dated '40. 13$\frac{1}{8}$ in. by 15$\frac{3}{8}$ in.
London £2,500 ($7,000) 14.XII.66.
Formerly in the collections of Stephen Spender and
Mrs Rex Rienits.

HENRY MOORE, O.M., C.H.
*Reclining Figures, Studies for Sculpture.*
Pencil, pen and ink, coloured chalks and watercolour,
signed and dated '40. 9$\frac{7}{8}$ in. by 16$\frac{1}{2}$ in.
London £2,100 ($5,880) 19.VII.67.
From the collection of Mrs N. Lee.

HENRY MOORE, O.M., C.H.
*Draped Seated Figure against Curved Wall.*
Bronze, dark patina. Executed *circa* 1956–7 (one of an
edition of twelve). Height: 9 in.
New York $15,000 (£5,357) 5.IV.67.
From the collection of James H. Clark, Dallas.

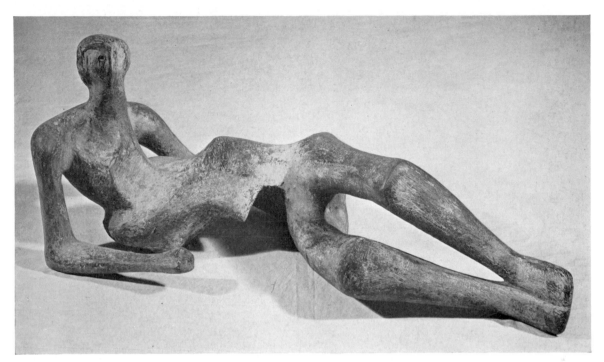

HENRY MOORE, O.M., C.H.
*Reclining Figure No. 2.*
Bronze, light green patina. Length: 36 in.
Executed in 1953 (one of an edition of seven).
New York $34,000 (£12,143) 5.IV.67.
From the collection of the Olsen Foundation, Guilford, Conn.

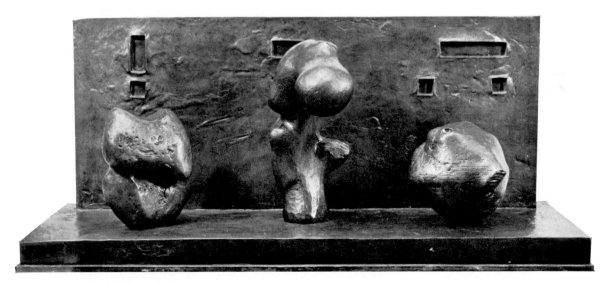

HENRY MOORE, O.M., C.H.
*Three Motives Against a Wall, No. 2.*
Bronze, signed. Executed in 1959, this is one of an
edition of ten. Length: 43 in.
London £4,300 ($12,040) 19.VII.67.

# Antiquities and Primitive Art

The word 'Antiquities' has been known to puzzle newcomers to the auction rooms, though it has long passed into current use. At first sight it is difficult to see why a Chinese bronze of, say, 1000 B.C. is not an 'Antiquity' whereas a 2000 B.C. idol from the Cyclades is—and so also is a totem from the North West Pacific coast, something from pre-conquest Peru, or a little bronze votive bull from the Greece of about 700 B.C. The answer is not academically sound but thoroughly practical. Chinese art objects from the remotest past down to our own day are numerous and it is convenient to deal with them separately. Peruvian pots and North West Pacific totems are not, nor are little bronzes or terra-cottas from Greece, so they have to be dealt with amid a vast range of objects from the South Seas to West Africa, from the Mediterranean basin to Peru. Amid all these apparently unrelated objects, a few stand out not so much because they extracted a lot of money from various pockets as because they were exceptionally fine things. A circlet of twisted gold for instance sounds a banal description for a Bronze Age gold torque (necklet) from Britain of 1000 B.C.—but to see this, and handle this, before a sale last November was something of an experience—a demonstration of how dignified, not to say noble, primitive jewellery of this type can be. This was the torque which was dug up as long ago as 1816 by a Flintshire farmer who, thinking it was merely old iron, used it as a gate fastener and then set it aside among a heap of rubbish for gipsies to take away. Luckily for him his wife happened to hear the gipsies talking together, guessed that the gate fastener was not in fact of iron, and retrieved it. It was bought then by Earl Grosvenor and now, an item in the vast Westminster estate, was sold for £16,500. Among the other objects on this occasion was a Viking gold ring of about A.D. 1100—£880—and another, a more slender gold torque, which went to the National Museum of Wales at £4,700. Later we saw a 4⅛-inch bronze of an archer, 8th century B.C., from Sardinia, sold for £1,800—a very lively personage indeed, wearing a horned helmet with bow slung over his left shoulder and with a rectangular box and vase-shaped container slung back and front—apparently a votive statuette. At the end of February two afternoons were devoted to the dispersal, for a total of £75,766, of a notable Swiss collection of Indian sculpture—bronze, stone and wood—with a few Indian miniatures. It is one of the ironies of history that while we were in control of India for two centuries we took uncommonly little interest in its art, and only began to take it really seriously after we had handed over the government. The most important objects on this occasion were the bronzes. One of them, a figure of the elephant-headed god Ganesha, from South India, 13th century—Lord of obstacles and wisdom and the most popular of deities—sold for £10,000. More readily appreciated by European eyes unaccustomed to the idea of an animal-headed god, was an 11th century bronze from Madras of Parvati, consort of Siva—a wonderfully slender, elegant figure which made £6,000. There was also a very fine South Indian bronze figure of Chandesvara, 13th century, which fetched £6,600.

A more light-hearted bronze was a figure of Krishna as a child dancing with joy after stealing a lump of butter from his stepmother's churn while she was looking the other way—an attractive work which made £1,600. In a previous sale in November a so-called 'slave-killer' from the Pacific North-West Coast, made from an antler carved with elaborate totemic designs and terminating in a bird's head, went for £1,000. In the middle of June there was the widest possible choice—Egyptian, Western Asiatic, Greek, Etruscan, Roman and Byzantine objects. There were a group of Egyptian bronze cats, all dating from the Saite period, *circa* 500 B.C., and always market favourites—the best of them a dignified, supercilious animal, obviously having just stolen the cream, found an appreciative home at £2,600. An outstanding item among some early jewellery was a 4th century B.C. Greek necklace of gold with matching earrings, the type which was probably worn from shoulder to shoulder, either pinned to the dress or hooked over two fibulae—a splendid, delicate object which fetched £3,100. Among twenty Greek terra-cottas a Tanagra figure of about 300 B.C., a young woman playing a lute, wearing a chiton and a long cloak went for £550 and a horse and rider for £500. An impressive Near Eastern bronze axehead of about 1000 B.C. found at Boghaz-Koy surmounted by the figure of a goat (oryx?)

A Greek Gold Necklace and Matching Earrings,
4th Century B.C.
London £3,100 ($8,680) 12.VI.67.

An Egyptian Bronze Figure of a Cat, Saite
Period. Height 10½ in.
London £2,600 ($7,280) 12.VI.67.
From the collection of the late Dr J. Bauer.

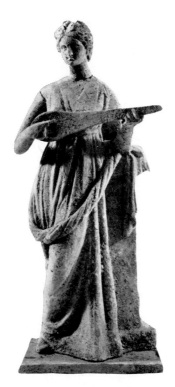

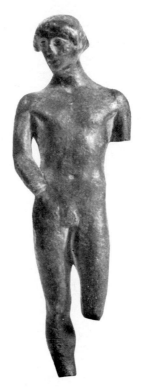

A Boeotian Terra-Cotta Figure of a
Young Woman Playing the Lute,
Tanagra, *circa* 300 B.C. Height 10¼ in.
London £550 ($1,540) 12.VI.67.
From the collection of the Countess
Adelheid Lanckoronska.

An Attic Bronze Figure of a Youth,
first half of the 5th Century B.C.
Height 4⅝ in.
London £1,300 ($3,640) 12.VI.67.
From the collection of Mrs
F. C. Pinchbeck.

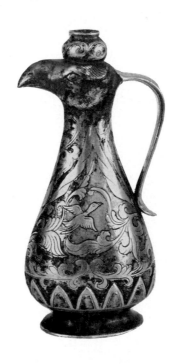

*Above*   A Campanian Black-glazed
Single Handled Cup. Early 4th
Century, B.C. Height 2¾ in.
London £68 ($190) 24.IV.67.
From the collection of Miss A. L. Meyer.
*Right*   A Sassanian Silver Ewer,
*circa* 8th Century A.D. Height 5½ in.
London £1,250 ($3,500) 12.VI.67.

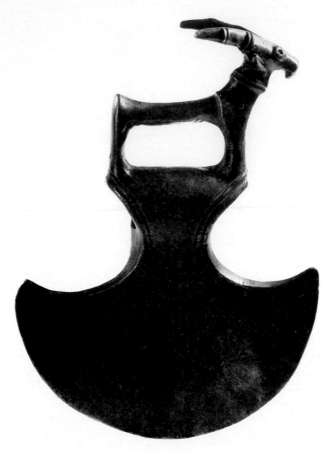

A Near Eastern Bronze Axehead, late 2nd/early 1st
Millennium B.C., found at Boghaz-Koy. Height 9 in.
London £1,400 ($3,920) 12.VI.67.

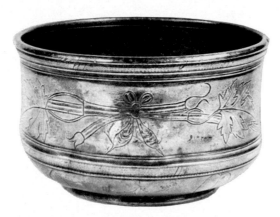

An Imperial Roman Silver Bowl, Augustan Period,
1st Century A.D. Diameter 4⅜ in.
London £1,350 ($3,780) 12.VI.67.

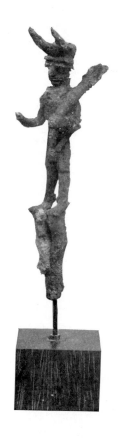

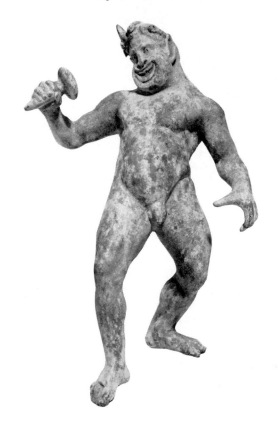

*Above left*   A Sardinian Bronze Figure of an Archer. 8th Century B.C. Height 4⅛ in.
London £1,800 ($5,040) 14.XI.66.

*Above right*   A Terra-Cotta figure of a comic Actor. 1st Century B.C., found in South Italy or Sicily. Height 9½ in.
London £700 ($1,960) 14.XI.66.

*Opposite*   A Romano-Egyptian Imperial Porphyry draped torso of Harpocrates. 2nd/3rd Century, A.D. Height 6¼ in.
London £750 ($2,100) 14.XI.66.

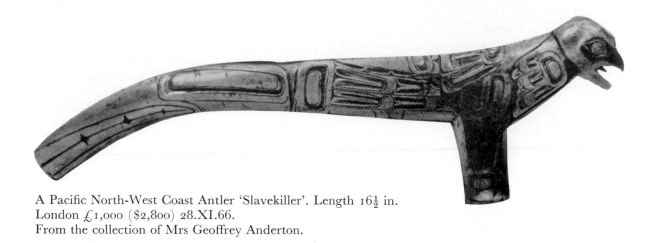

A Pacific North-West Coast Antler 'Slavekiller'. Length 16½ in.
London £1,000 ($2,800) 28.XI.66.
From the collection of Mrs Geoffrey Anderton.

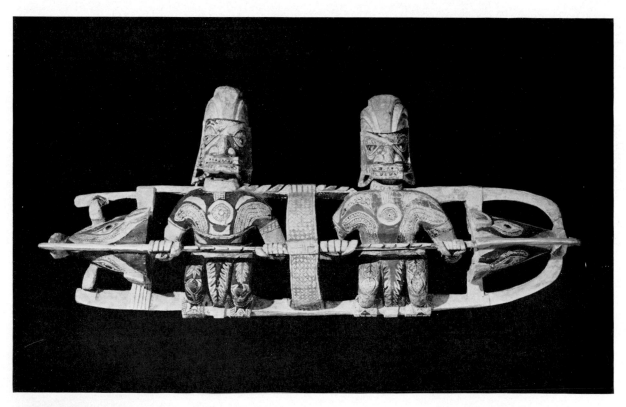

A New Ireland Malanggan Carving.
Length 38⅛ in.
New York $3,250 (£1,161) 4.V.67.

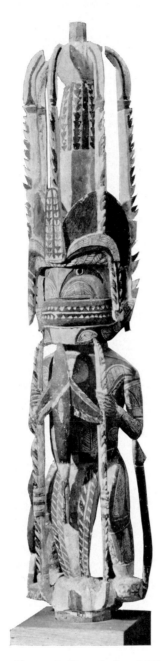

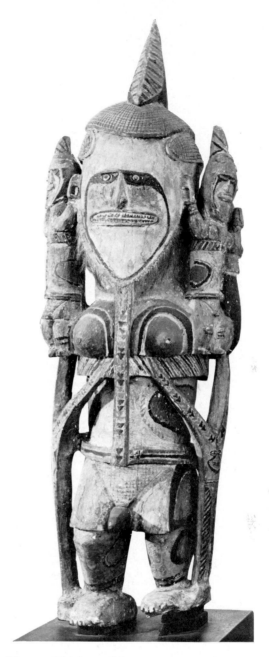

*Above*  A New Ireland Wooden Malanggan Figure. Height 72¾ in.
New York $3,250 (£1,161) 4.V.67.

*Right*  A New Ireland Wooden Uli Figure. Height 63¼ in.
New York $4,000 (£1,429) 4.V.67.
Both from the sale of duplicates from the collection of Nelson
A. Rockefeller and the Museum of Primitive Art.

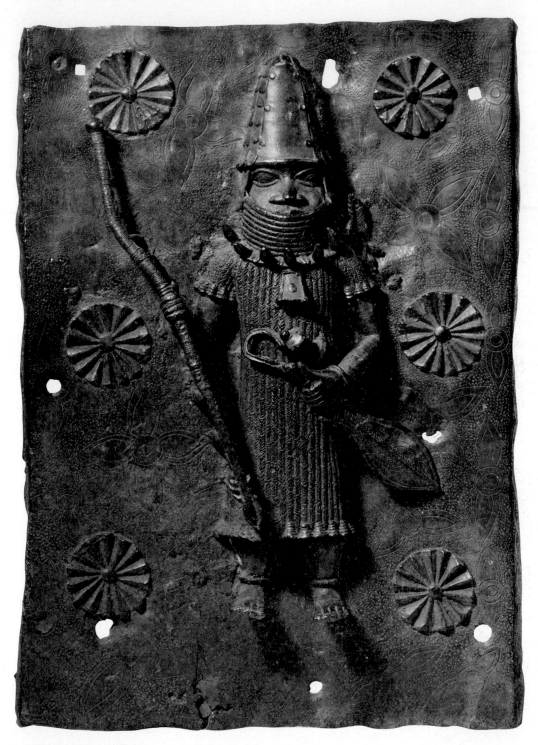

A Benin Bronze Plaque. 21 in. by 14½ in.
New York $16,000 (£5,710) 22.IV.67.
From the collection of Jay C. Leff.

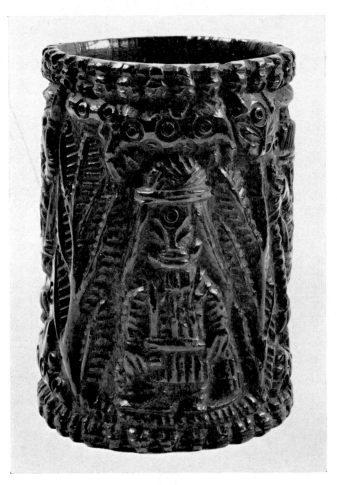

A Benin Cylindrical Ivory Armlet.
Height 5$\frac{1}{16}$ in.
London £480 ($1,344) 28.XI.66.

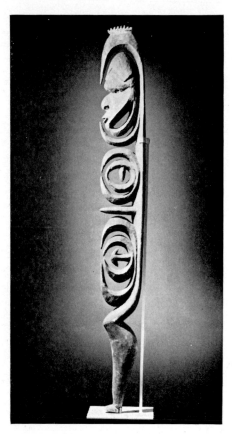

A New Guinea Wooden Yipwon
Figure. Height 74 in.
New York $2,600 (£923) 4.V.67.
From the sale of duplicates from the
collection of Nelson A. Rockefeller
and the Museum of Primitive Art.

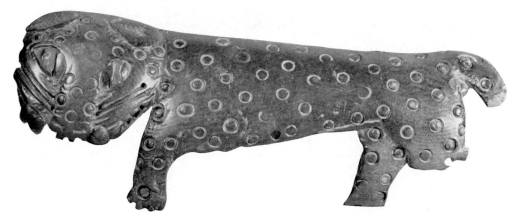

A Benin Ivory Arm Ornament.
Length 10$\frac{1}{2}$ in.
New York $2,400 (£857) 22.IV.67.
From the collection of Jay C. Leff.

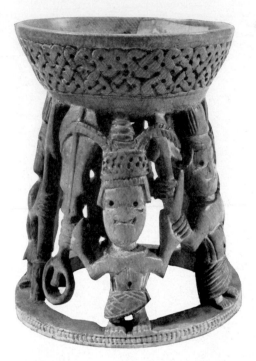

*Above*   A Yoruba Ivory Cup Stand.
Height 5⅝ in.
London £650 ($1,820) 26.VI.67.
From the collection of Major J. B.
Ready.

*Right*   A Basonge (Kifwebe) Wooden
Dance Mask.
New York $2,000 (£714) 21.I.67.
From the collection of Michel
Anstett, Paris.

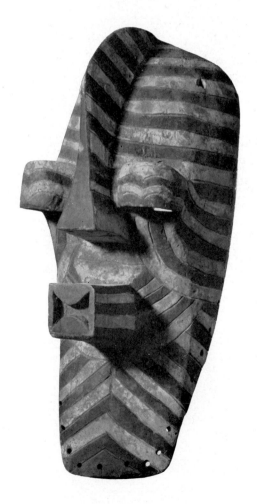

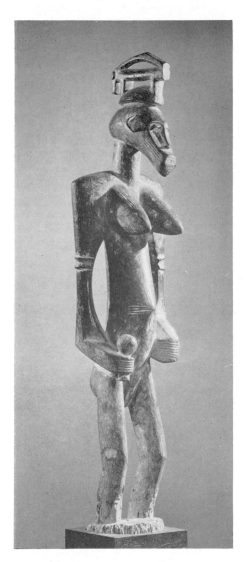
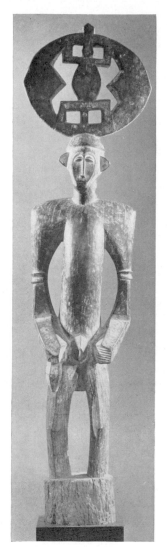
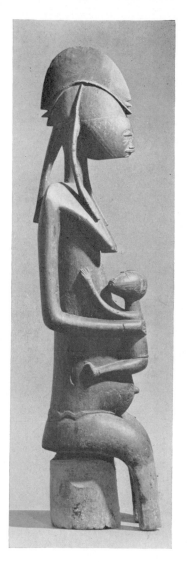

*Above and centre*   A pair of Senufo Wooden Rhythm Pounders
(Ivory Coast). Heights 38⅛ in. and 45⅝ in.
New York $7,000 (£2,500) 4.V.67.

*Right:*   A Bambara Wooden Female Figure
(Mali). Height 46½ in.
New York $10,000 (£3,571) 4.V.67.

All three from the sale of duplicates from the collection of
Nelson A. Rockefeller and the Museum of Primitive Art.

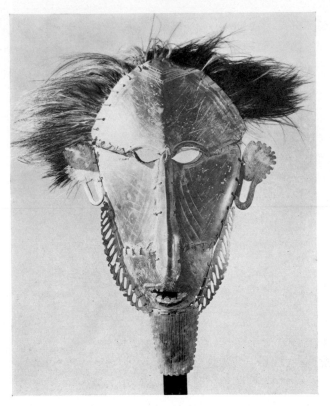

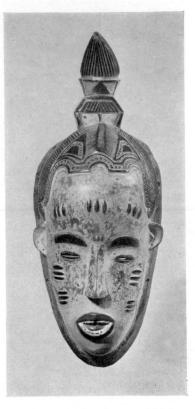

A Torres Straits Turtle Shell Mask
(Melanesia). Height 19 in.
New York $2,500 (£893) 4.V.67.
From the sale of duplicates from the collection of
Nelson A. Rockefeller and the Museum of
Primitive Art.

A Guro Wooden Dance Mask
(Ivory Coast). Height 12½ in.
New York $2,100 (£750) 21.I.67.
From the collection of Michel Anstett,
Paris.

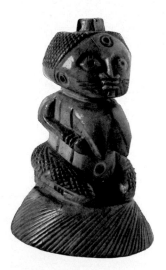

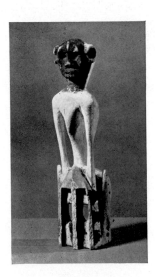

A Yoruba Ivory Female Figure
(Nigeria). Height 4⅛ in.
London £350 ($980) 28.XI.66.

A Dogon Wooden Dance Mask
(Mali). Height 20¾ in.
New York $2,900 (£1,036) 21.I.67.
From the collection of Michel
Anstett, Paris.

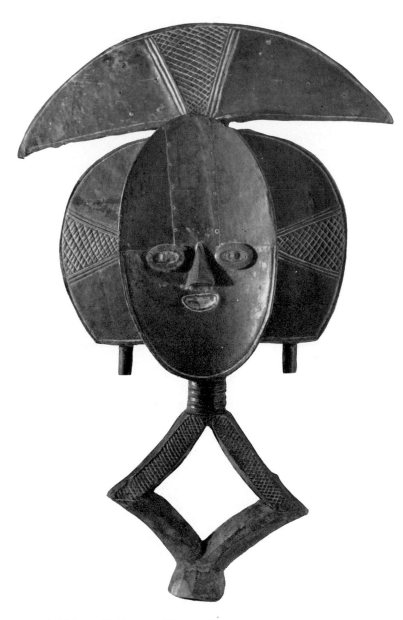

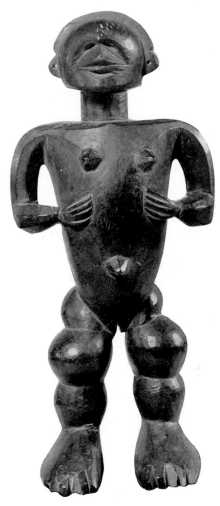

A Bakota Reliquary Figure (Congo).
Height 22½ in.
London £680 ($1,904) 26.VI.67.
From the collection of Mr Francis Olmer,
New York.

An Ababua Wooden Figure (Congo).
Height 17¼ in.
New York $2,600 (£929) 21.I.67.
From the collection of Michel
Anstett, Paris.

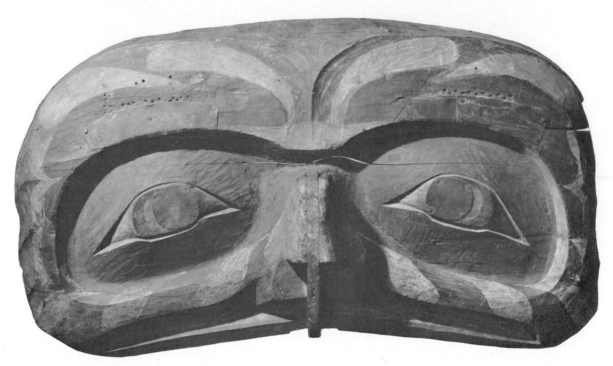

A Kwakiutl Wooden Grave Marker (British Columbia).
Width 37¾ in.
New York $2,200 (£786) 4.V.67.
From the sale of duplicates from the collection of Nelson A.
Rockefeller and the Museum of Primitive Art.

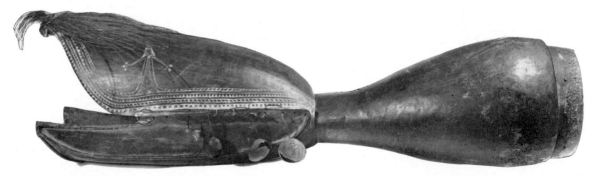

A Torres Straits Portable Drum (New Guinea). Length 36¾ in.
London £500 ($1,400) 26.VI.67.

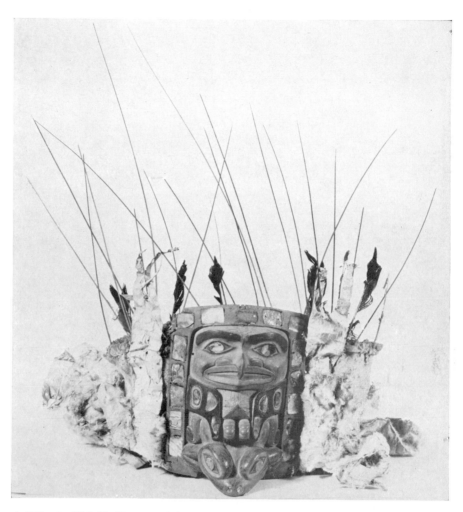

A Tlingit Chief's Ceremonial Head-dress. Overall height 19½ in.
London £800 ($2,240) 26.VI.67.

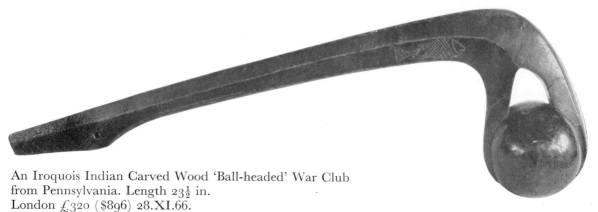

An Iroquois Indian Carved Wood 'Ball-headed' War Club
from Pennsylvania. Length 23½ in.
London £320 ($896) 28.XI.66.
The ball-headed wooden club was the classic weapon in the
hand-to-hand forest warfare of the Eastern tribes. Following the
widespread introduction of the European metal hatchet, called
tomahawk, the ball club became less popular for actual use,
surviving principally as a formal element of Indian full-dress
paraphernalia.

197

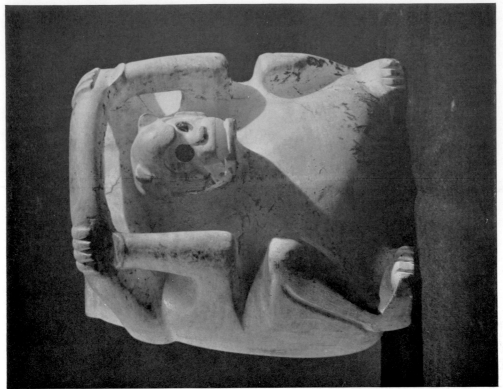

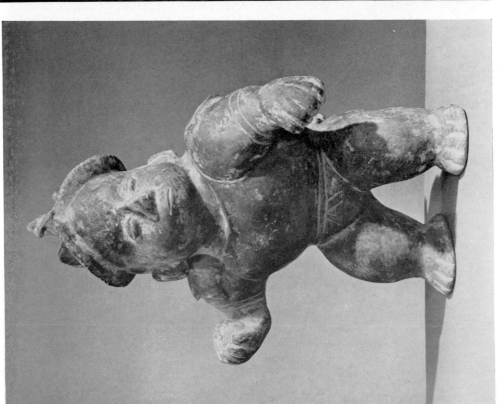

A Mixtec (?) Onyx Effigy Bowl, *circa* A.D. 900–1500
Height 7⅞ in.
New York $4,000 (£1,429) 4.V.67.

A Tarascan Pottery Male Figure, *circa* A.D. 300–900
Height 15⅜ in.
New York $2,600 (£929) 4.V.67.

Both objects from the sale of duplicates from the collection of Nelson A. Rockefeller and the Museum of Primitive Art.

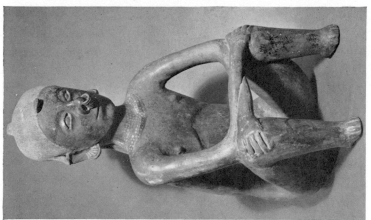

A Tarascan Pottery Seated Figure,
*circa* A.D. 300–600.
Height 22 in.
New York $2,800 (£1,000) 15.X.66.
From the Charles Laughton–Elsa
Lanchester Collection. The property
of Mrs Charles Laughton,
Hollywood, California.

An Eskimo Wooden Mask (Alaska).
Height 12½ in.
New York $1,800 (£643) 4.V.67.
From the sale of duplicates from the
collection of Nelson A. Rockefeller
and the Museum of Primitive Art.

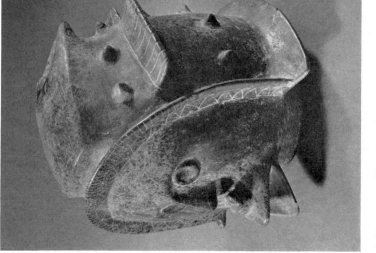

A Tarascan Clay Head Jar. Colima,
Early Classic, *circa* A.D. 100.
Height 9½ in.
New York $2,700 (£960) 15.X.66.
From the Charles Laughton–Elsa
Lanchester Collection. The property
of Mrs Charles Laughton,
Hollywood, California.

A South Indian Bronze Figure of Chandesvara.
13th Century A.D. Height 23⅝ in. London £6,600 ($18,480) 27–28.II.67.

A South Indian Bronze Figure of Parvati. Madras,
11th Century A.D. Height 26⅝ in.
London £6,000 ($16,800) 27–28.II.67.

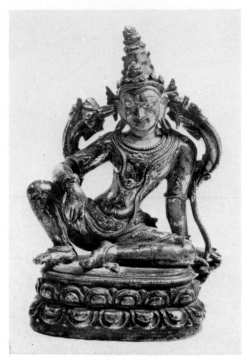

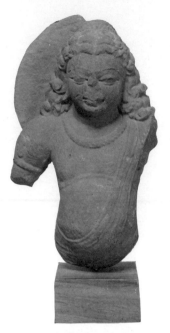

A Nepalese Gilt-bronze Figure of a
Bodhisattva. 16th Century A.D.
Height 6¾ in.
London £310 ($868) 26.VI.67.

A Gupta Reddish Sandstone Figure
of Kubera. 7th Century A.D.
Height 14½ in.
London £1,050 ($2,940) 27–28.II.67.

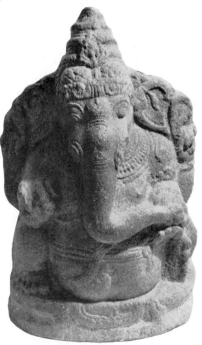

A South Indian Stone Figure of
Ganesha, 12th Century A.D.
Height 29 in.
London £400 ($1,120) 28.XI.66.

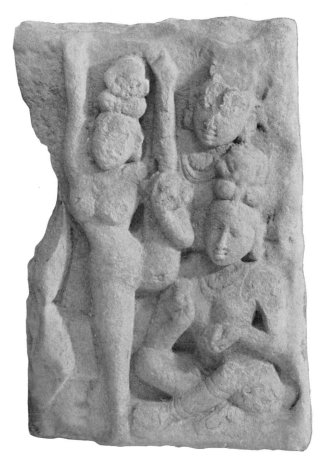

A Central Indian Pale Buff Sandstone
Stele. 8th/9th Century A.D.
London £1,000 ($2,800) 27–28.II.67.

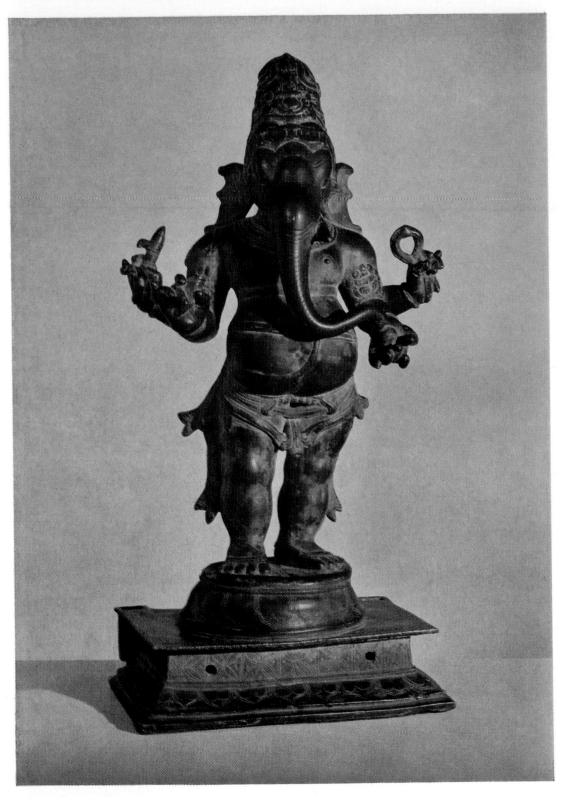

A South Indian Bronze Figure of Ganesha. 13th Century A.D.
Height 25½ in.
London £10,000 ($28,000) 27–28.II.67.

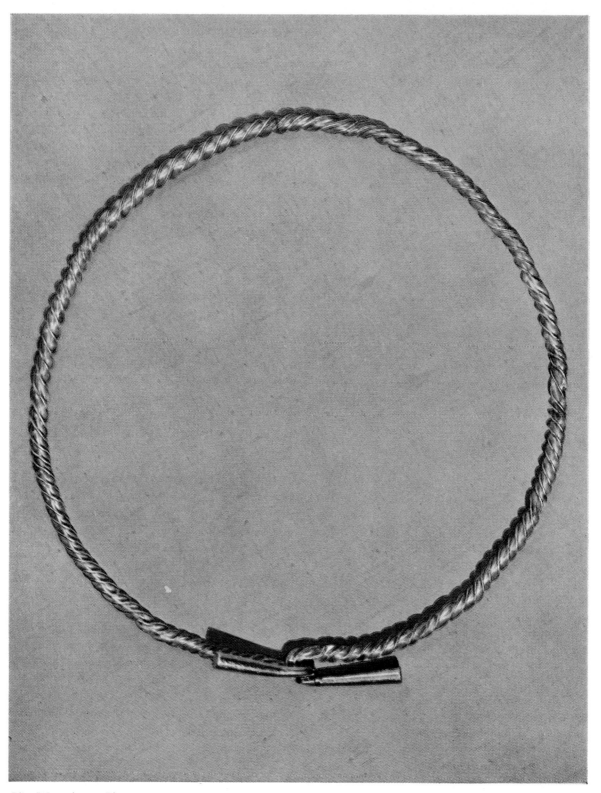

*The Westminster Torque, see next page.*
London £16,500 ($46,200) 14.XI.66.

205

*Detail of The Westminster Torque*
A Bronze Age gold circular torque, from the collection of the
2nd Duke of Westminster.
Total length 50 in. diam. 14 in., weight 24 oz. 17 dwt.
London £16,500 ($46,200) 14.XI.66.

The torque was found in 1816 at Bryn Siôn Bach, one mile from the village of Ysgeifiog, near Holywell in Flintshire, by a Mr Morris, a tenant farmer who died in 1850. Two accounts of the find are quoted by Canon Ellis Davis (1949); the first, by Mr T. P. Edwards, was an essay in Welsh sent for competition to an eisteddfod at Caerwys in 1886, where it won first prize and was printed in the local newspaper, 'The County Herald'; the second is an account by Mr John Morris, the grandson of the finder, which also appeared in the 'County Herald' in the issue of June 18, 1918.

Mr Edwards states that at Bryn Siôn Bach there was a cairn of stones between a small quarry and a lime-kiln. Whilst removing turf from a rock, Mr Morris and his brother came across 'a kind of hoop like a cauldron hook'. This they took to be made of iron and eventually threw it under the kitchen dresser with other bits of old iron that they saved for the gipsies who used to come and collect rags and scrap metal. One of the gipsy women spotted that it was gold and whispered this to her companion. The farmer's wife overheard this, and managed to recover it after a prolonged struggle. Before it had been thrown under the kitchen dresser, it had served as the fastener for the top of a gate-post.

The account of Mr Morris roughly repeats the above with the addition that the local jeweller to whom it was then shown declared it to be 'part of the accoutrements of a Roman officer', and that the Marquess of Westminster had eventually bought it at a price between £200 and £300.

The quarry is one mile east of Maesmynan where Prince Llywelyn ap Gruffyd had a residence. Canon Ellis Davis visited the place in September 1936, but could see no trace of the cairn of stones mentioned by both writers.

The case bears an ivory label with the following inscription . . . 'This golden torque was found in 1816 by a miner whilst working in a limestone quarry at Bryn Siôn, near Holywell, and about a mile distant from the reputed palace of the late princes. Earl Grosvenor gave the miner 200 guineas for it.'

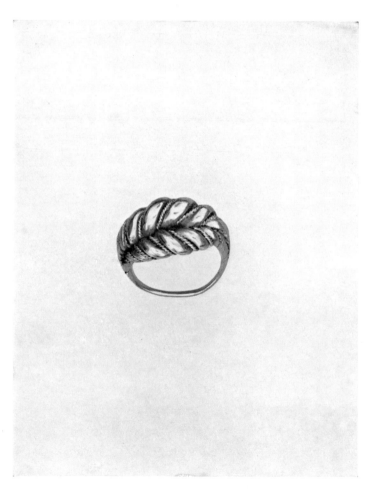

A Viking Gold Ring, *circa* 11th–12th Century A.D.
London £880 ($2,464) 14.XI.66.

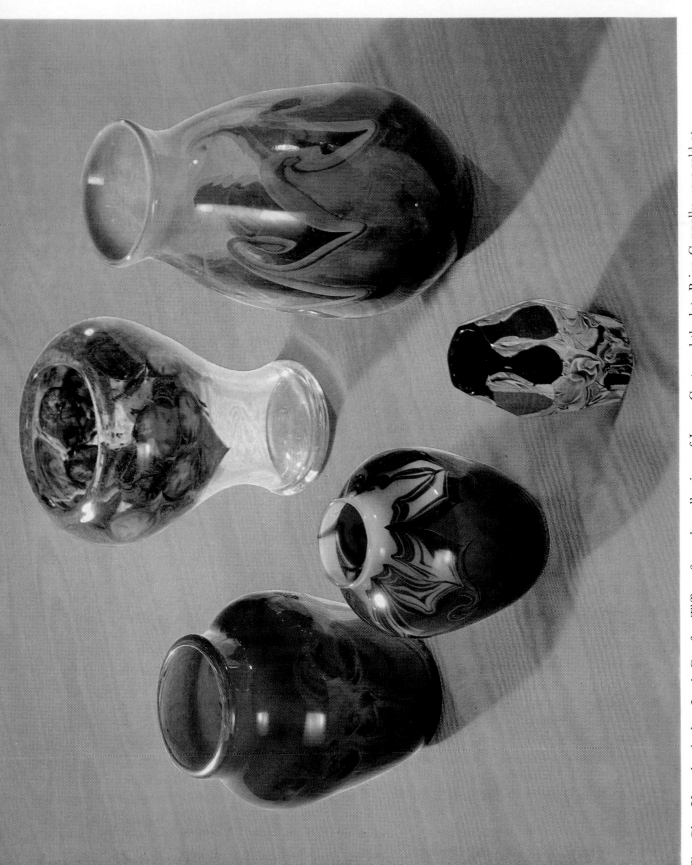

Five Glass Vases by the late Louis Comfort Tiffany from the collections of James Coats and the late Brian Connelly were sold at Parke-Bernet on October 21, 1966 for: *Left to right* Red paperweight vase $1,300 (£464); Red vase $1,300 (£983); Green and Blue Clear paperweight vase $2,750 (£983); Green and Yellow Agate vase $1,400 (£500); Green and Orange paperweight vase $2,100 (£750).

# Tiffany Glass—Up One Hundred Fold in Two Decades

by Robert Koch

The revival of Tiffany glass now appears to have gone beyond that of most decorator fads. It has even gone beyond the new appreciation for Art Nouveau as a genuine expression of values at the turn of the century. To document this spectacular increase in interest, an analysis of two auctions, twenty years apart, in which some of the same objects reappeared, can effectively show the extent of this new enthusiasm for the best examples of Tiffany's glass.

On October 21, 1966, a small but select collection of Tiffany glass was sold at auction at Parke-Bernet Galleries in New York. This was the Coats-Connelly collection which consisted of seventy-five vases and one bowl.[1] Ten of these were marked 'A-Coll.', an indication that they had originally been in the personal collection of Louis C. Tiffany. As the late Brian Connelly once told me that he had only begun to collect in a serious fashion in 1958, none had come directly from the original owner. Louis C. Tiffany died in 1933.

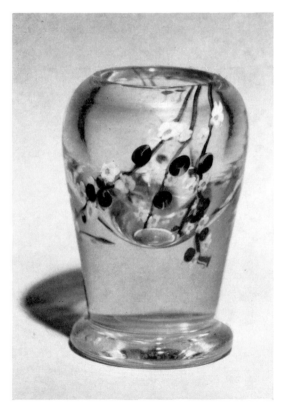

A Clear Favrile Glass Vase, by the late
L. C. Tiffany.
New York $3,500 (£1,250) 15.III.67.
From the collection of Miss Louise Meyran,
Forest Hills, Long Island.

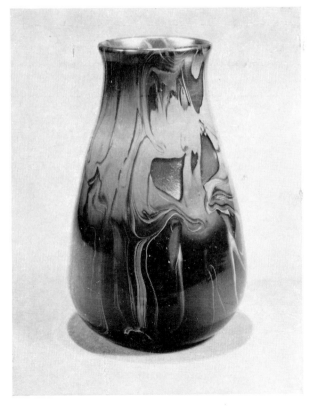

A Green Favrile Glass Paperweight Vase,
by the late L. C. Tiffany.
New York $1,900 (£671) 21.X.66.
From the collection of Tiffany Glass
belonging to James Coats and the late
Brian Connelly sold at Parke-Bernet
in October 1966 for $84,450 (£30,161).

[1] Parke-Bernet Galleries, *Tiffany Favrile Glass*, sale number 2465, New York 1966.

On September 24, 25 and 26, 1946, the collection of the Louis C. Tiffany Foundation was sold at auction at the Parke-Bernet Galleries.[2] In this sale there were about 150 lots of Tiffany glass with an average of four items in each lot. Most of these were from the 'A' collection which originally consisted of roughly 500 objects carefully selected by Louis C. Tiffany for their uniqueness of quality and design. Among these were some of the finest examples of Tiffany glass made between 1892 and 1919 while Tiffany himself was supervising the production of this ware.[3]

A comparison of the prices brought at these two auctions, exactly twenty years apart, reveals a phenomenal change in attitude towards these products in particular and to the decorative arts in general. It is a most interesting and effective comparison as the ten 'A' collection pieces in the 1966 sale were probably included in the sale conducted by the same galleries in 1946.

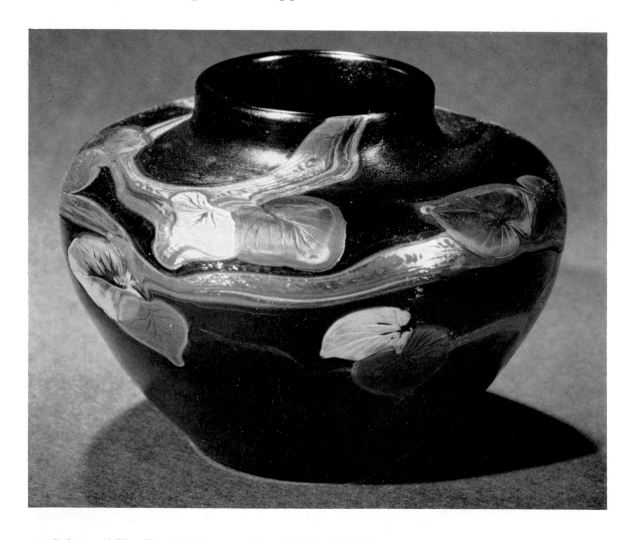

An Ochre and Blue Favrile Glass vase, inscribed L. C. Tiffany.
New York $3,250 (£1,160) 21.X.66.
From the collection of James Coats and the late Brian Connelly,
New York.

[2] Parke-Bernet Galleries, *Objects of Art of Three Continents—The Extensive Collection of the Louis Comfort Tiffany Foundation*, sale number 785, New York 1946.
[3] For facts about the life and times of Louis C. Tiffany, cf. Robert Koch, *Louis C. Tiffany, Rebel in Glass*, 2nd edition, New York 1966.

The identification of individual objects in the 1946 sale is difficult unless they are illustrated in the catalogue since the descriptions are vague and the registry numbers are not included. In this sale the prices vary from $20 dollars to $180 per lot depending upon the size and importance of the lot.[4] The top price was for lot number 10, 'Six Favrile glass finger bowls with trays . . . invested with a golden rainbow iridescence. Signed.' The lowest price, $20, was for number 285, 'Favrile glass flower vase, cylindrical with pinched neck and elongated foliage decoration in a golden and flame red iridescent ground. Signed. Height 16 inches.' Lot number 6, consisting of 'Two millefiori aquamarine glass spheres, irregularly shaped, with millefiori marine decorations, Signed, Diameters $5\frac{1}{4}$ and $5\frac{1}{2}$ inches' (paperweight collectors please note), went for $75 for the pair. One vase that was illustrated in the catalogue and sold singly, number 240, listed as a 'Favrile glass rustic baluster vase with splashed lily decoration', is in the author's collection and is appraised at more than one hundred times its original sale price of $25. It is signed '54 A-Coll. L. C. Tiffany Favrile'.

In the Coats-Connelly sale in 1966 the ten 'A' collection pieces brought a total of $18,550, even though three of them were listed as cracked or damaged. This is more than the entire collection cost in 1946. The four best of the recent sale went for $3,250, $3,000, $2,800 and $2,750 respectively. The one that brought the highest price, number 10, was described as 'Ochre and blue vase, urn form and having a wreath of slightly incised iridescent blue, ochre and brown leaves and vines at the shoulder, on an iridescent blue and brown ground. Inscribed by L. C. Tiffany Favrile 102 A-Coll. Height $3\frac{1}{2}$ inches.' It was originally part of lot number 231, described as 'Four Favrile Glass Cabinet Vases, variously shaped, with leaf and floral decorations in colors', which in 1946 sold for $70. This is much better than one hundred fold in two decades. The same rate of increase also applies to the other three vases, numbers 11, 31, and 52, that sold for more than $2,500 apiece in the recent auction.

Comparisons of similar but not identical items in the two sales indicates that some Tiffany products have appreciated proportionally even though they were never a part of the Tiffany collection. A 5-inch tall green-and-white aquamarine or paper-weight-type vase, number 37 in the 1966 sale, with a registry number 2904G, sold for $2,750 and it can be compared to a lot of two millefiori aquamarine glass vases with jonquil stems that sold in 1946, lot number 246, for $85. A green-and-white flower-form vase, 16 inches tall, registered T5458, 1966 number 4, brought $2,400, while a pair of almost the same size and shapes with even better colour, 1946 lot number 49, sold for $55. A swan-neck vase illustrated in the Tiffany Foundation sale catalogue, number 48, went for $45, whereas a smaller version, 1966 number 13, only brought $1,600, a price that may yet turn out to be a bargain.

Prices of Tiffany lamps have followed the same trend over the past twenty years. In 1946 a pair of 30-inch diameter chandeliers from Laurelton Hall, described as 'blossom-form hanging lamps with leaded panels decorated with a profusion of colorful blossoms, fitted for electricity with a suspension chain', lot number 291, sold for $50. Two Tiffany lamps were sold at a recent auction also held by Parke-Bernet Galleries.[5] On March 15, 1967, a peacock feather lamp, item number 38,

---

[4] This price range includes only those items consisting completely of Tiffany glass. Some Tiffany pottery went for less and some Tiffany lamps went for more. One ceiling light of leaded glass, six feet in diameter, brought $275 and the Peacock lamp featured on the cover of the catalogue sold for $225.

[5] Parke-Bernet Galleries, *Tiffany and Other Art Glass*, sale number 2529, New York 1967.

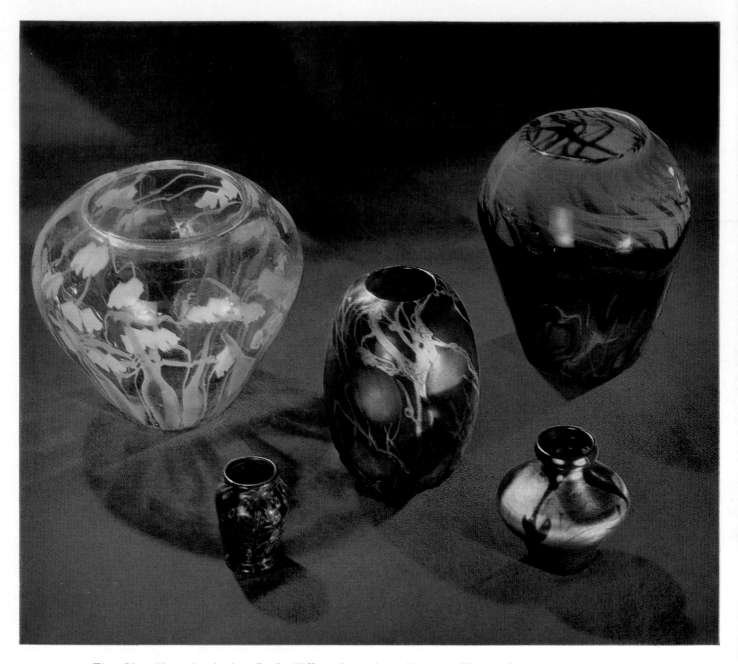

Five Glass Vases by the late L. C. Tiffany from the collection of James Coats and the late Brian Connelly were sold at Parke-Bernet on October 21, 1966 for:
*Left to right*  Green and white clear paperweight vase $2,500 (£893); Red and green miniature vase $1,400 (£500); Red vase $3,000 (£1,072); Small red vase $900 (£322); Green and brown paperweight vase $1,500 (£537).

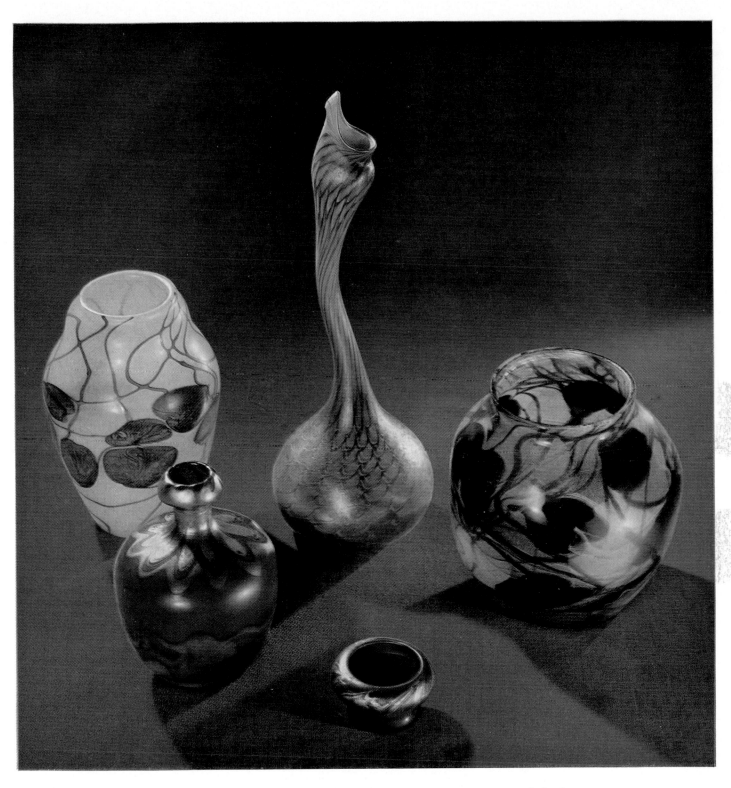

Five Glass Vases by the late L. C. Tiffany from the collections of James Coats and the late Brian Connelly were sold at Parke-Bernet on October 21, 1966 for:
*Left to right: Back row* $2,800 (£1,000); $1,600 (£572); $1,700 (£607);
    *Front row* $1,800 (£643); $800 (£286).

illustrated in the catalogue, sold for \$2,300 and a dragonfly lamp, number 103, also illustrated, sold for \$2,250.[6] At this sale an aquamarine vase, $7\frac{1}{2}$ inches high, number 68, illustrated on page 17, sold for \$3,500. Also, at this auction, a rug came up made by Tiffany Studios for the dining room of Laurelton Hall. This rug, illustrated in both catalogues, brought \$275 as item 214 in 1946 and \$1,900 as item 47 in 1967. This is a good profit but only a seven-fold increase.

Tiffany glass table ware has not kept pace with the vases and lamps. A set of six wines that sold for \$100, lot 9, in 1946 might be compared to a set of nine wines that sold for \$650, lot 20A, in 1967, an increase of less than five fold. The six sets of gold iridescent finger bowls and underplates that brought \$180 in 1946 can be replaced today for less than \$120 a set, only four times the old price.

The obvious conclusion is that today Tiffany vases and lamps in floral shapes or decorated with floral or foliate designs are being collected as works of art. Their creator, Louis C. Tiffany, began his career as a landscape painter, a pupil of George Inness, kept abreast of the new trends in the art world and saw to it that many of the artifacts produced by craftsmen in his employ conformed to his concept of beauty. Their forms and decorations, abstracted from nature, often have an aesthetic appeal equal to that of paintings by better known artists of the period.

Recognition of Tiffany's artistic achievements in glass has only developed recently. The first exhibition of Tiffany glass following his death in 1933 was at Rollins College, Winter Park, Florida in 1955. Hugh McKean, in the introduction to the catalogue, stated that 'Here are "free forms" sometimes thought of as originating in the School of Paris. The "clean line of modern art" is here too. . . In this art there is the daring and adventure of creation. These qualities keep art always new and always modern.'[7] Twenty-five of the pieces displayed at this time had been purchased by the Metropolitan Museum of Art, New York from the Louis Comfort Tiffany Foundation, eight of which were marked as having come from the 'A' collection. In 1958 the Museum of Contemporary Crafts in New York held a retrospective display of Tiffany's art showing a variety of techniques.[8] From then on his work played an important part in every publication and exhibition that touches on the Art Nouveau style. At times the appreciation of Tiffany's creations goes beyond the confines of the turn of the century. Mario Amaya refers to Tiffany lamps as 'objects of unbelievable fantasy, some of them as abstract to the modern eye as a Brancusi or an Arp'.[9]

Auction prices also reflect a new sympathy for the decorative arts. In this area Tiffany stands supreme. For flowers that never fade and have the variety that is one of the most appealing qualities of nature, nothing can match a Tiffany paperweight-type aquamarine glass vase. For accents of brilliant colour, Tiffany iridescent reds and blues are unparalleled in the history of glass. For elegance, Tiffany iridescent gold glass has an effect superior to the precious metal. For variety, Tiffany glass provides not only many free form shapes and patterns, but changes in character with every change in the direction or intensity of the light. It is no wonder that the collectors are vying with one another to acquire the finest examples of this truly artistic glass and that therefore the price keeps going up and up.

[6] This lamp, brand new, sold at Tiffany Studios in 1928 for \$195.
[7] The Morse Gallery of Art, Rollins College, *Works of Art by Louis Comfort Tiffany*, Foreword by Hugh F. McKean, Winter Park, Florida, 1955.
[8] Museum of Contemporary Crafts, *Louis Comfort Tiffany*, text by Robert Koch, New York 1958.
[9] Mario Amaya, *Art Nouveau*, page 71. Published by Studio Vista, London 1966.

# Mediaeval and Renaissance Works of Art

From among the enormous variety of all kinds of objects—glass, enamels, ivories and this and that—which can be placed conveniently in this category, my number one choice was decidedly the little 14th-century ivory carving, a mere one and a quarter inches in diameter—a mirror case—which miraculously and by some inner alchemy has preserved for future generations the last enchantments of the Middle Ages. It was no doubt a thing of little consequence when it was made, but its survival, no doubt fortuitous, provides a key to the art of perhaps a whole century. It was one among several things of comparable quality from the estate of the late Madame Alexandrine de Rothschild, which were sold in May—a man in a loose tunic with a falcon on his wrist telling the tale into the obviously receptive ear of a willowy young woman—charming little secular vignette in high relief. An endearing monster is carved at each corner, and the two holes at the top were evidently pierced for suspension at a later date. It was sold for £1,700. Another remarkable ivory from the same collection was a 10th-century casket, Hispano-Arab, made at Cordoba, its original Cufic inscription cut away, probably when it passed into Christian hands for use as a reliquary. Date and origin are determined by its resemblance to a circular casket in the Louvre, in which the theme of a lion mauling an ox, and parrots, griffins and horsemen also occur, and which was made for Prince al-Mughira in 968. It fetched £8,000.

Another item of unusual interest was a latten candlestick of the 13th century from the valley of the Meuse—which made £2,100. Later works that same morning included an impressive bronze attributed to Giovanni de Bologna, a lion attacking a horse and apparently the only example in which the two animals form a group, which went for £7,600; a lively little butting goat from 16th-century Padua, £1,600; a Florentine gilt bronze figure of Neptune attributed to Bartolomeo Ammanati—£3,400 and a gilt-bronze figure of Hercules attributed to Baccio Bandinelli, £2,800.

St. Thomas à Becket was, not unnaturally, a popular subject in the art of the 13th century. An unrecorded Limoges enamel chasse turned up on this occasion, the front enamelled with the Saint's martyrdom below and Christ in Majesty above. St. Thomas is shown mitred standing before the altar, attacked by two knights. It was sold for £1,900.

An unusual 14th-century German ivory diptych, school of Cologne, turned up in a sale just before Christmas, a little 4¾-in. composition divided into four panels depicting the Legend of St. Catherine of Alexandria. The great majority of such objects, whether French, Flemish or German, are carved with scenes of the Passion. This was sold for £900. From a later age there was a pair of carved ivory relief miniatures of George II and Queen Caroline by the Brussels artist Van der Hagen for £1,250 and two bone ship-models for £1,250 and £1,350. A fine mixed sale this, for it included also a violin by Joseph Guarneri, 1731, which made £8,800 and another by Antonio Stradivari, 1722, which was bought for £10,000.

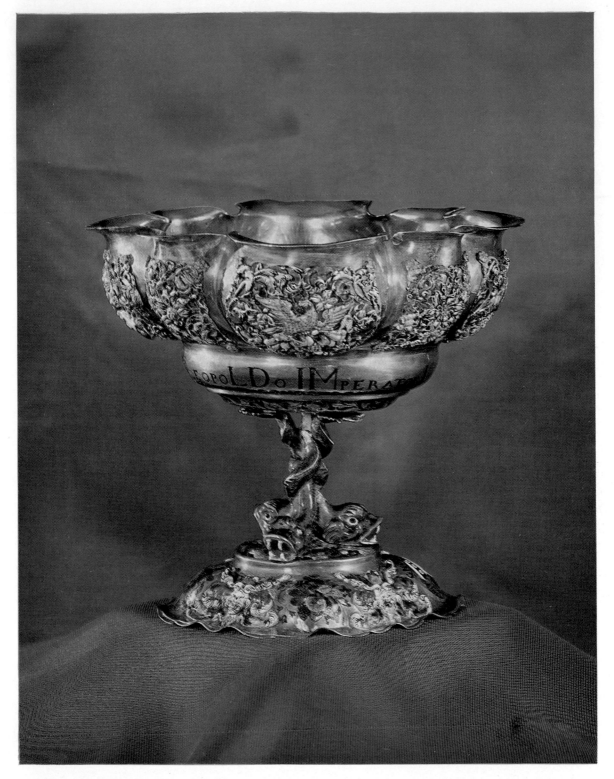

An Enamelled Gold Commemorating Cup of the Counts von Rosenberg, Vienna, dated 1665.
New York $50,000 (£17,857) 9.XII.66.
From the collection of the late Helen M. de Kay. This cup was made for Count von Rosenberg
in commemoration of the peace signed with the Turks at Vasvar in 1664.

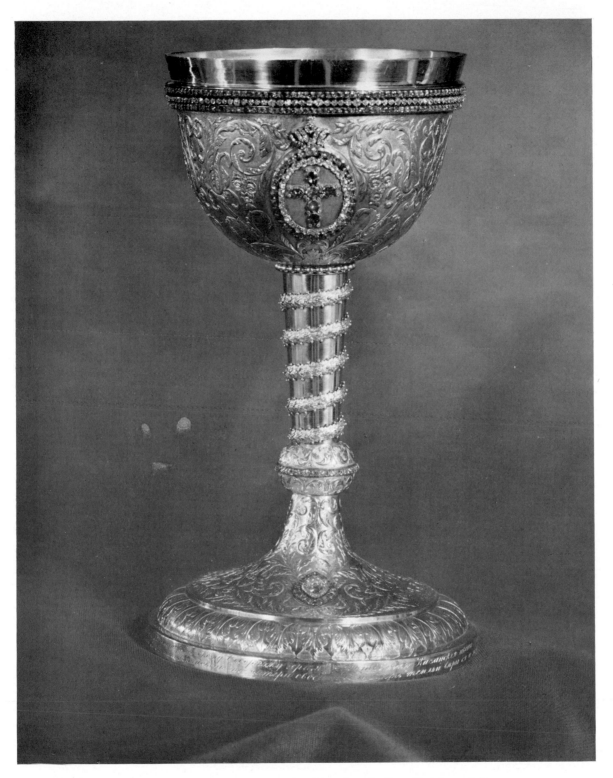

A Russian Gold Chalice, set with diamonds and rubies, dated 1824. Height 10½ in.
New York $15,500 (£5,535) 9.XII.66.
From the collection of the late Helen M. de Kay.

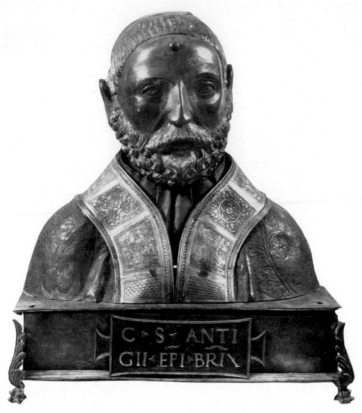

An early Renaissance reliquary bust of Saint Antigius,
Bishop of Brescia, in silver and copper gilt. North Italian,
second half of 15th century.
Height 18½ in.
London £1,050 ($2,940) 18–19.V.67.
From the collection of Mr Robert Bahssin, New York.
Now in the Victoria and Albert Museum.

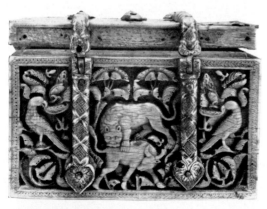
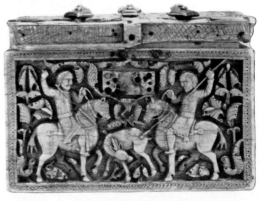

A Hispano-Arab Ivory Casket, Cordoba, *circa* 960–70. Height 6 in.
This casket is one of a small group of similar pieces produced in the Palace Workshops at Cordoba
or Madinat az-Zahra within a short period of years. The inscription which has been cut away,
probably when the casket passed into Christian hands for use as a reliquary, would have given the
date and occasion of its manufacture.
London £8,000 ($22,400) 18–19.V.67.
From the collection of the late Madame Alexandrine de Rothschild.

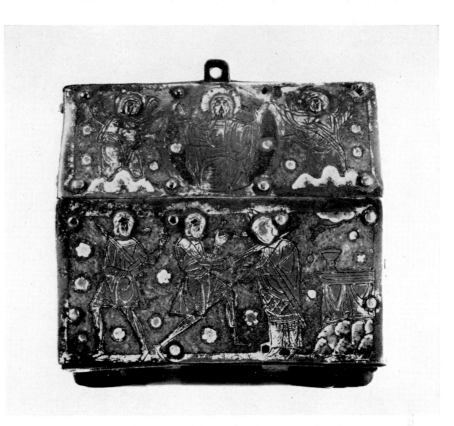

A Limoges Champlevé Enamel Chasse, first quarter of 13th century.
Height 4½ in. London £1,900 ($5,320) 18–19.V.67.
From the collection of Mrs B. Silvertop.

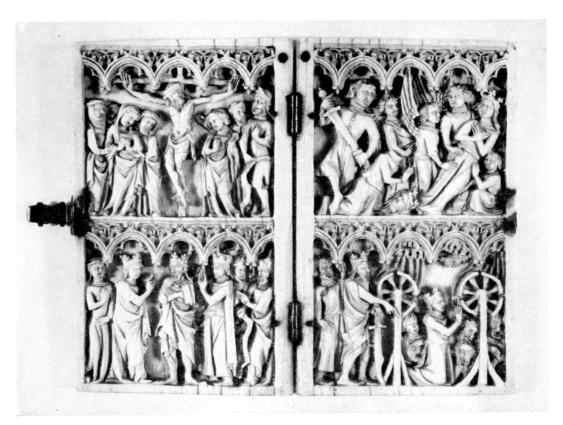

A German Ivory Diptych, Cologne, mid-14th century. Height 4¾ in.
London £900 ($2,520) 5.XII.66. From the collection of Mrs G. E. M. Clarke.

An Italian Bronze Group, early 17th century. Height 14½ in.
London £7,600 ($21,280) 18–19.V.67.
From the collection of Michael Jaffé, Esq.

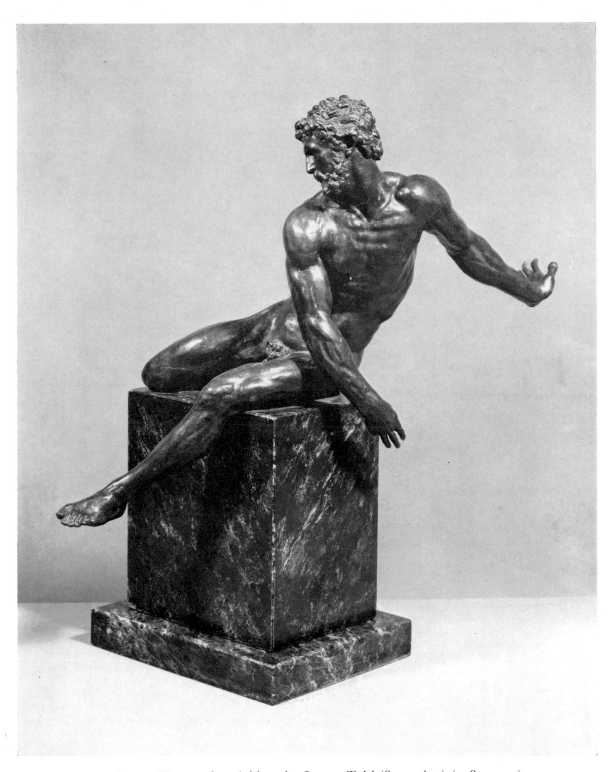

A 16th Century Bronze Figure of an Athlete, by Jacopo Talti (Sansovino) (1485–1570).
New York $17,000 (£6,070) 30.IX.-1.X.66
From the collection of the late Sarah Mellon Scaife, Pennsylvania.

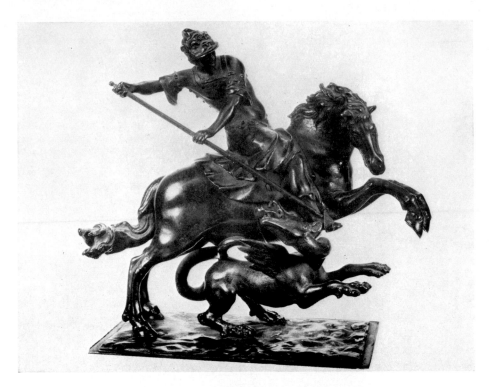

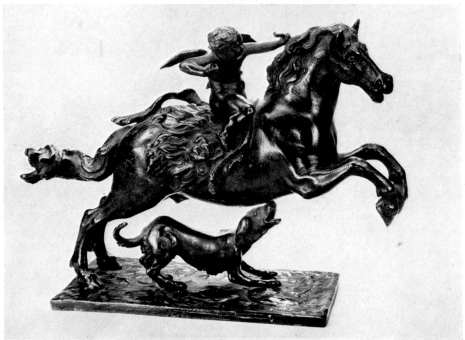

*Above* An Equestrian Group of St George and the Dragon, by Francesco Fanelli, first half of the 17th century. Height 8 in.
London £680 ($1,904) 10.IV.67.
*Below* An Equestrian group of Cupid, by Francesco Fanelli, first half of the 17th century. Height 7¼ in.
London £800 ($2,240) 10.IV.67.

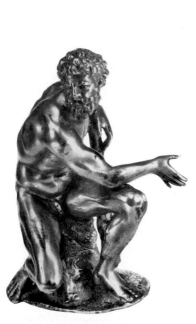

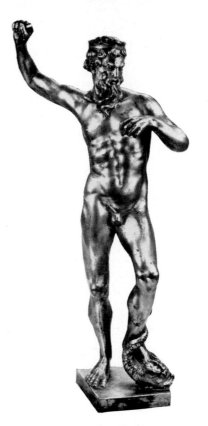

A gilt-bronze figure of Hercules
in the manner of Baccio Bandinelli,
second quarter of 16th century.
Height 6¼ in.
London £2,800 ($7,820) 18.V.67

A Florentine gilt-bronze figure of
Neptune attributed to Bartolomeo
Ammanati, mid-16th century.
Height 9¼ in.
London £3,400 ($9,520) 18.V.67.

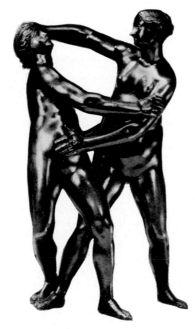

A late 16th-century Italo-Flemish
Bronze Group. Height 8¼ in.
London £4,800 ($13,440) 18–19.V.67.
From the collection of Michael Jaffé, Esq.

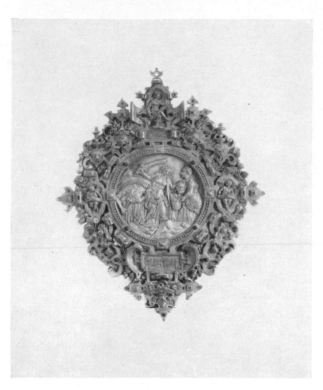

An Augsburg Boxwood Hand Mirror Frame,
*circa* 1570–80.
London £1,600 ($4,480) 13.VII.67.
From the collection of the late Samuel Z. Yellin,
Philadelphia.

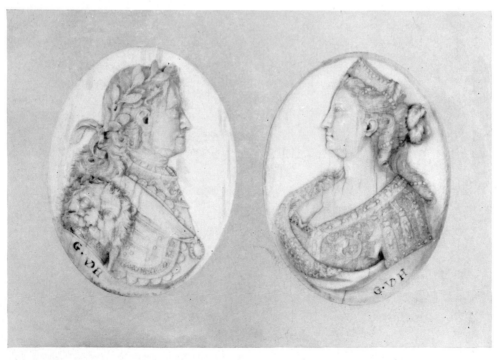

VAN DER HAGEN
A Pair of Oval Carved Ivory Portrait Miniatures of George II
and Queen Caroline, mid-18th Century.
London £1,250 ($3,500) 5.XII.66.

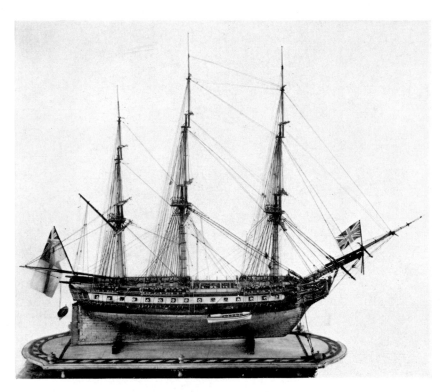

A Ship Model of a 36-gun Frigate, late 18th century.
London £1,250 ($3,500) 5.XII.66.

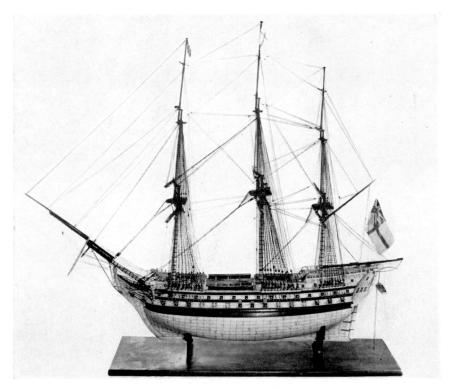

A Bone and Ebonized Wood Prisoner-o'-War Ship Model of the
Frigate 'Vengeur', *circa* 1800.
London £1,350 ($3,780) 5.XII.66.

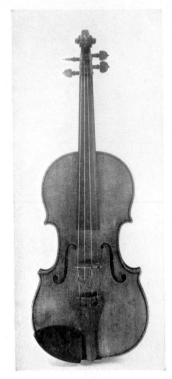
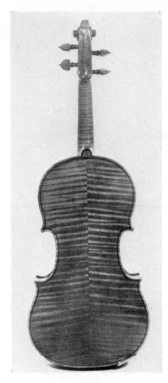
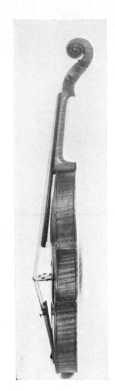

A Violin by Antonio Stradivari called the Partello, made 1690.
London £9,500 ($26,600) 16.VI.67.
From the collection of Mr C. H. Dragert, Dallas, Texas.

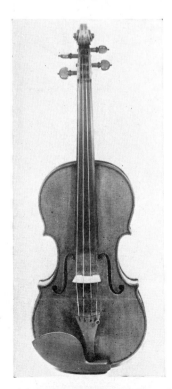
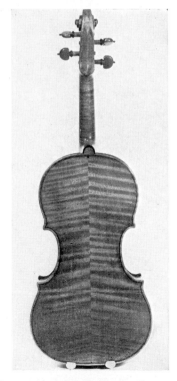
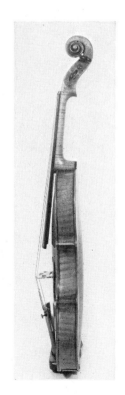

An Italian Violin by Joseph Guarnerius del Gesù, made 1731.
London £8,800 ($23,800) 5.XII.66.

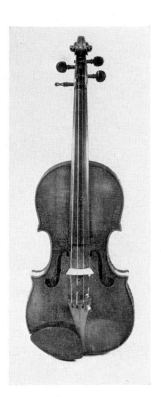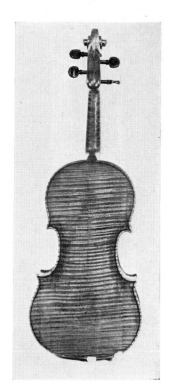

An Italian Violin by Antonio Stradivari, made 1722.
London £10,000 ($28,000) 5.XII.66.
From the collection of the late J. R. Payne, Esq.

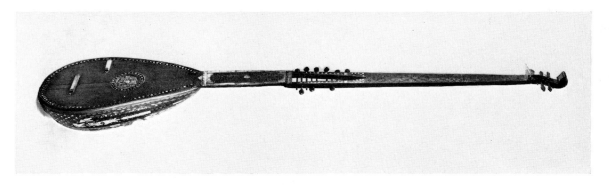

An Italian Chittarone or Arch-lute, probably Venetian.
Early 17th Century.
London £75 ($210) 16.VI.67.

# Art Nouveau

This vaguely defined movement in the arts which caused so much astonishment at the turn of the century can now be looked at in perspective and for some time past has attracted the attention of several erudite, earnest commentators. The many odds and ends—table-lamps, ash trays, book cases, chairs (of quite singular discomfort) and what have you—which can reasonably be labelled Art Nouveau reached Bond Street and Victoria and Albert Museum status several years ago, and sales devoted to them are likely to multiply in the future, with prices following suit. In England one can label almost anyone who happened to be working round about the 1890's as belonging to the movement—artists for instance as different in character and style as Burne-Jones and Aubrey Beardsley—but to most of us the real innovators are first Emile Gallé of Nancy who played such subtle tricks with glass and who greatly influenced Tiffany in New York, secondly René Lalique, not perhaps quite so original an artist but important as popularising the style, and Charles Rennie Mackintosh of Glasgow, two of whose furniture designs surprised many of us recently by realising £360 for a chair of ebonised wood and £220 for a very simple square centre table. A vase by Emile Gallé enamelled in red and gold with frogs and scrolls designed by him as long ago as 1878 and reproduced by him for the International Exhibition of 1900 made £100 and a bowl of 'marquetrie-de-verre' *circa* 1900 £260, a remarkable technical achievement with an amber-coloured body suffused with light green inlaid with anemones and foliage in mauve, orange and green. Another vase in the same technique marbled with swirling horizontal streaks shading from mauve to violet and inlaid with flowers in tones of pink, yellow, green, mauve and brown, went for £300. Two other objects which neatly epitomised the whole movement had already attracted attention a few months previously—a three-tiered étagère by the well-known furniture manufacturer at Nancy (a neighbour of Emile Gallé) Louis Majorelle, decorated with tulips and branches in tulipwood against pale fruitwood, cost £210, and an enamel, diamond and moonstone brooch formed as two carnations by Lalique, £510.

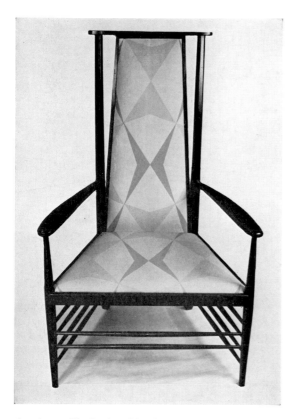

An Arm Chair, by Charles Rennie
Mackintosh.
London £360 ($1,008) 17.IV.67.
From the collection of David Bisacre, Esq.

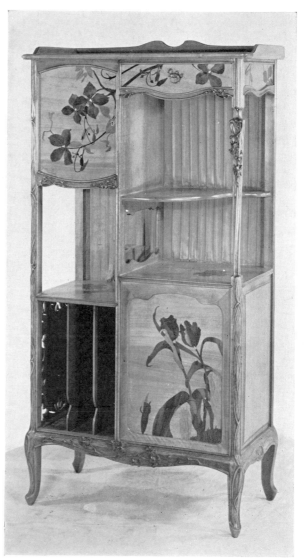

A Three-tiered Étagère, by Louis Majorelle.
London £210 ($588) 28.XI.66.

A Centre Table, by Charles Rennie
Mackintosh.
London £220 ($616) 17.IV.67.
From the collection of David Bisacre, Esq.

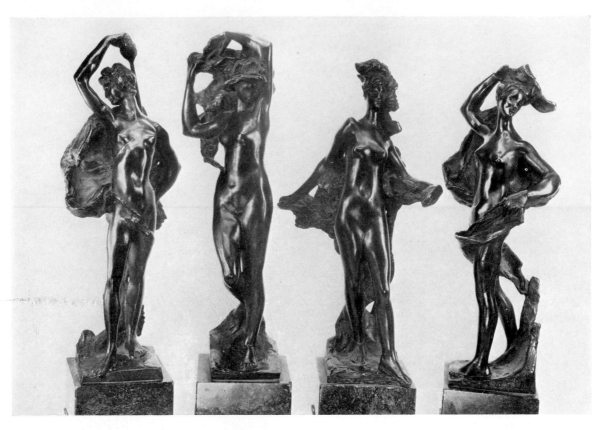

The Four Seasons, by Derwent Wood.
London £300 ($840) 17.IV.67.
From the collection of Mrs Francis
Derwent Wood.

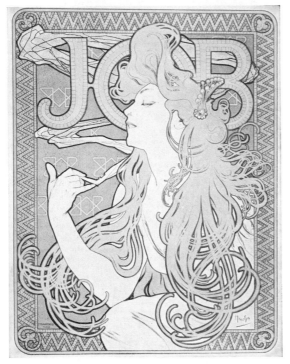

ALPHONSE MUCHA
*Job, 1897.*
Lithograph, printed in colours.
$20\frac{1}{4}$ in. by $15\frac{5}{16}$ in.
New York $425 (£152) 23.II.67.

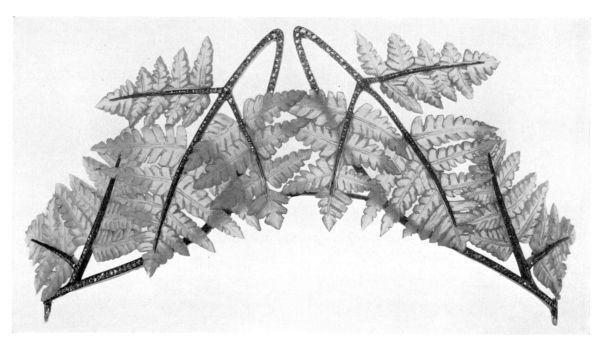

A Diamond-set Tiara, by René Lalique.
London £250 ($700) 17.IV.67.

A Diamond and Moonstone Brooch,
by Lalique.
London £510 ($1,428) 28.XI.66.

A 'Marquetrie-de-Verre' Vase, by
Emile Gallé, *circa* 1900.
London £300 ($840) 17.IV.67.

*A Young Man with Chin Whiskers.*
A Daguerreian portrait, *circa* 1845.
$260 (£93).

# The photograph as objet d'art

by David Lasswell

In the Will Weissberg sale of photographica at Parke-Bernet Galleries, May 16, 1967, a single Daguerreotype portrait of a young American working man, taken about 1845 (see opposite) sold for $260, an extraordinary sum for a small portrait of an unknown subject by an unknown photographer—an object that usually sells for much, much less in undistinguished lots at country antique shops. Since the subject is entirely anonymous and of no particular documentary value, the photograph presumably was acquired for its qualities as a work of art; in fact its purchaser, the photographer Ivan Dmitri of New York, said it had been a question of 'esthetic spirit and fine craftsmanship.' An entirely new departure in collecting has taken place with the recognition of the high quality of portraiture often attained by the early Daguerreotype photographers during those first twenty years of photography.

The elements that constitute beauty in an old photograph are difficult to specify, but are hinted at in such details as an ephemeral bouquet of garden lilies that has survived for 120 years. Perhaps the central fact of a photograph from the earliest period is that now, for the first time in history, man can see himself distantly in time. Only now do we really know what people looked like a century before our day. Daguerre revealed his invention in 1839.

The recognised masters of Victorian photography maintain their prestige. The most exciting lot in the Weissberg Sale appears to have been an album containing 34 calotype prints of various subjects from about 1850. They sustained their attribution to David Octavius Hill and were knocked down for $1,850 to the Israel Museum in Jerusalem where they will form a basic part of the photography collection at that institution. These rare calotypes (the earliest negative–positive process) are in an album that was put together by the English water-colorist William Henry Hunt (1790–1864); his drawings and sketches had long ago been removed from the album, but the rudely printed photographs he used in his work remained to catch a later collector's eye. Hunt and Hill had in common an interest in peasant, juvenile, and fisherfolk subjects, and not surprisingly traded ideas.

The work of Julia Margaret Cameron, that wonderful eccentric, was well represented in the Weissberg Collection. Mrs Cameron took up photography in about 1863, at the age of 48, and in her headlong rush at art managed to create some of the best Victorian portraits, mainly of her friends, who were often among the most distinguished people of her time. A single print of her portrait of Alfred Lord Tennyson fetched $350. Among the material in the collection relating to Mrs Cameron was a letter from her dear friend, Sir John Herschel, the great astronomer and the subject of one of her most admired portraits. The kind old scientist, himself an important figure in the history of photography, found it necessary to chide dear Julia for her

JULIA MARGARET CAMERON  *Portrait of Alfred, Lord Tennyson.*
Print from the original collodion plate.
$12\frac{1}{8}$ in. by $9\frac{3}{4}$ in., mounted. 1869. New York $350 (£125)

D. O. HILL  *A New Haven Sailor.*
One of a group of 34 calotypes, *circa* 1845–52. New York $1,850 (£660)

*A Girl with Lilies.*  A Daguerreian portrait, *circa* 1850. $35 (£12 10s)

*A Praxinoscope-Théatre*  Patented by Emile Reynaud, Paris, *circa* 1880. New York $550 (£190)

wildly dangerous practice of cleaning her hypo-stained hands in lashings of cyanide.

The Weissberg collection was significant for its range through the history of photography. Besides rare photographs, Will Weissberg collected early projection devices, early cameras, and other machines that constituted a tangible record of the technology that underlies today's cinema, television, and other forms of photography (see above). But it was the pictures of people—Will Weissberg himself was a portrait photographer—that revealed the collector's true passion.

# Sales of Oriental porcelain and pottery since the 1930s

by Gerald Reitlinger

The rise in Ming has ceased to be a mere collector's topic. It has acquired the proportions of news. In 1966, when the first of the two great early 15th century blue and white 'moon flasks' was sold in London, a harassed reporter rushed to the telephone and a stop-press item in one of the evening papers proclaimed that someone had bought a *mink flash* for 24,000 guineas. Somehow, it seems, the stream of consciousness just worked that way.

Yet how far this was from being an object in Ritzy taste. To most observers the moon flask with its white dragons on blue appeared eccentric and to some repellent. Its last owner was reported to have kept it well tucked away under a sideboard. How different the situation in 1905 when, just as in 1966, the dearest single ceramic object ever to have come under the hammer turned out to be another example of Chinese blue and white, but one of the most conventional kind. For Louis Huth's famous 'blue hawthorn' jar and cover of about the year 1700 was something that anyone could recognise from the top of an omnibus. Yet it was sold for £5,900 and that was not far off £45,000 in terms of today's money. These two sales illustrate perfectly the revolution which has overtaken the higher reaches of the Oriental art market. It is no longer the décor of rival millionaire homes that decides these tournaments but the competition of museums in their search for the rare and scholarly. In 1967 the blue hawthorn jar might fail to make two-hundred devalued pounds, should its romantic history be concealed from the bidders. On the other hand, in 1905, the £25,200 moon flask, recognisable only as a rather barbarous and unclassifiable object, might well have gone for thirty shillings.

This does not mean that *all* the decorative export porcelain, made in the reigns of K'ang Hsi (1662–1722) and later emperors, has declined in the same proportions as the famous blue hawthorn jar, nor does it mean that only the art of earlier periods is now in demand. On the contrary, *famille verte* and *famille rose* and even examples of the over-produced K'ang Hsi blue and white have multiplied in value at least eight times in the past decade, many times faster than the general pace of inflation. The dethronement of certain types which only multi-millionaires could afford, has not affected the immense popularity of later Chinese porcelain. But whereas the recovery of this market since the depressed levels of thirty years ago may be expressed by a general multiple of ten or less, the rise of Early Ming in thirty years can be measured in multiples of a hundred and more. Even a five-hundred fold increase is not unusual.

This is something more spectacular than the rise in French impressionist paintings and far less easily explicable, since the highest rises of all have been achieved by objects in the strictest of Confucian taste, sparse and austere and of a refinement that

235

is far from betraying itself at the first glance. Such are the imperial bowls and dishes with a single dragon as skinny as a lizard and the incised white wares. A plain white stem cup, 4½ inches high, which cost the Rijksmuseum, Amsterdam, £2,600 in 1960 on account of its unique reign-mark of the emperor T'ien Shun (1457–64) might have escaped notice altogether in the 1920s. And yet it can hardly be said that the higher reaches of the market are generally governed by such nice discrimination, now that two export dinner services in the gaudy, mass-produced tobacco leaf pattern can make more than £30,000 each. If the possession of a piece of porcelain in the severe imperial taste of the 15th century shows signs of becoming a status symbol, much of that must be due to the income tax and death duty concessions available to owners of objects, popular with museums in more countries than one.

The process by which the predilection of a few devoted specialists turns into a status symbol, is not smoothly apportioned over the years but advances by sudden leaps at arbitrary intervals. This fitful progress can best be traced from a base line exactly thirty years ago. Some very famous early Ming pieces had reached the sale-rooms in 1933 and 1935 in the Stephen Winkworth and Charles Russell dispersals, but it was the Wu Lai Hsi sale of May 26, 1937, which first saw Early Ming wares of the imperial kind placed on the European market in appreciable numbers. Catalogued by Sotheby's as 'the property of a well-known collector, formerly resident in Peiping', it was not a very noticeable or exciting event. There were 110 lots which made less than £2,000 all told. Yet each item was meticulously described, while 35 of them were illustrated. To Wu Lai Hsi, who had spent years assembling this material, the results must have been sadly disappointing. From a visit to him in Peking in 1936 I recall that he was then asking higher prices. The adventure of bringing these rarities to the doorstep of the few Western devotees was bound to be a failure, for the great economic depression which began with the Wall Street slump of 1929, ended only with the inflation of the post-war years. In 1933 and 1935, when the downward drift was less pronounced, prices for early Ming porcelain had been appreciably higher.

The richness of the material in the Wu Lai Hsi sale was only matched by the cautiousness of the attributions. To buy or sell a piece of blue and white with the coveted mark of the emperor Hsüan Tê (1426–35) seems to have become a more self-confident exercise in 1967 than it was in 1937. Of the 110 lots there were 15 that proclaimed themselves 17th or 18th century, 35 whose reign marks were not supported in the catalogue and only 60 which passed as 'mark and period'. While on the one hand several of the doubtful 35 would be accepted today, the most expensive object in the sale, a blue and white moon flask with the bird and bough pattern at £140, later fell from grace and was on offer in 1951 at £45 as an 18th-century copy.

There would be no hesitations today over the Hsüan Tê marked tankard which failed to receive the full certificate, apparently because of its links with the Turkish faience tankards made at Isnik in the early 16th century. In fact it made £56, one of the higher prices, as had a similar tankard on which the same observation had been passed in the catalogue of the 1935 Russell sale. In 1962 the experts in glaze bubbles,

a new science, were able to overcome such difficulties, as well as the fact that the survivors were quite formidable in number, considering that they were more than 500 years old, and considering that the Hsüan Tê reign had lasted only nine years. The glaze bubbles did indeed reveal more than one blood group, but the blood groups they maintained were all of the 15th century. In the words of Miss Margaret Medley, 'After the death of the emperor (Hsüan Tê) the mark continued to be used because it was the only one known and in regular use'. Apparently it took thirty years to hit on an explanation so simple and so rational, thirty years in which the Hsüan Tê mark had meant precisely nine years at the beginning of the 15th century or else an 18th-century copy. In this way the most impressive object in the Wu Lai Hsi sale, an 11-inch jar and cover,* now in the Fitzwilliam Museum, failed to obtain the full certificate because of some later affinities, and made only £22. Nowadays the late 15th century appearance of the painted dragons bothers no one. In November, 1964, a similar jar with lions, lacking its cover, was sold for £3,700.

Nor would it be the most valuable of the Wu Lai Hsi pieces today. At the Eumorfopoulos sale of 1940 there was a blue and white bowl, less than 6 inches wide, bearing the reign mark of Ch'êng Hua (1465–87) and painted with an elegant meander somewhat resembling an iris. At that time it was not realised that Ch'êng Hua-marked blue and white, worthy of any confidence, was very much rarer than the Hsüan Tê-marked, though the Ch'êng Hua reign lasted more than twice as long. In the fateful week of Dunkirk the bowl made £36, to rise to the unprecedented price of £16,500 at the Herschel Johnson sale of February, 1967. At the Wu Lai Hsi sale there were two closely comparable bowls that made £108 between them. Should they be considered as worth £30,000 or £35,000 today? That this is probable may be gauged from the record of a very much less elegant Ch'êng Hua marked bowl, decidedly overcrowded, which was sold for as little as £16 among the Wu Lai Hsi pieces in 1937. It made £2,700 in March, 1963, after the death of the purchaser, the late H. R. N. Norton, who also obtained at this sale an unmarked lobed baluster vase, $7\frac{1}{2}$ inches high, for £11. And this in 1963 made £3,400.

The miniature cups, painted in soft enamels, with the mark of Ch'êng Hua, have risen a little less because their extreme rarity was already recognised in 1937. There were no less than four acceptable examples in the Wu Lai Hsi sale, ranging from a cracked and discoloured stem cup at £28 to a well-known $2\frac{1}{2}$-inch eggshell winecup at £66 which rose to £720 in 1954. However, at the Aykroyd sale of May, 1966, a cup less than 2 inches high achieved £6,000. Conceivably the Wu Lai Hsi wine cup could be worth £8,000 on the same price-scale.

How far will the £2,000 Wu Lai Hsi collection have advanced in thirty years? Evidently one must allow for a number of pretenders, though some of them will have been discounted by the doubted pieces which no longer inspire doubt. It is even within the bounds of possibility that the two birdseed-holders, $3\frac{1}{2}$ inches long and Hsüan Tê marked, which made £2 10s 0d between them, might now pass muster. In that case they would be worth fully £2,000. On the other hand, the rather stereo-typed unmarked blue and white 'palace dishes' will have advanced at a relatively

* The cover has since been agreed to be a later replacement.

slower pace. There were eleven of them in the sale, costing from £19 to £34. The one unusual example, a 14½-inch dish painted with a fruiting melon vine, may have advanced from £28 to more than £3,000, the others to rather less. Yet it would not be unrealistic to put the present value of the £2,000 collection at close on £200,000.

On the eve of the Second World War the Chinese 15th century was interesting only as half-way house between the Sung period, the taste of purists, and the intense virtuosity of the Ch'ing dynasty, the late 17th and 18th centuries which provided the normal and correct channel for expendable wealth. Being nearer in spirit to the Ch'ing period, the 16th century was preferred to the 15th. As to the 14th century, one of the two vases of the David Foundation which bear the date 1351, was actually acquired in 1935 for the very high price of £360. Notwithstanding which, porcelain in this style did better under 16th-century labels because it seemed too sophisticated for so early a date. At the first Winkworth sale in 1933 a huge bowl, painted in underglaze red, and the well-known David Foundation jar with the meshed underglaze red panels made £170 and £350—but under the attribution of the period of Chêng Tê (1506–21). At the great Burlington House exhibition of 1935 the pieces from Istanbul, which are now considered 14th century, all received 15th-century labels.

Since the entire *objets d'art* market was depressed throughout the 1930s, it could not be expected to respond easily to novelties. Objects in orthodox 18th-century export taste could be a great deal dearer. In 1938 a pair of K'ang Hsi jars and covers, enamelled on a yellow ground, could still make 1,500 guineas, perhaps a sixth of their value on the exalted New York millionaire market of 1914. The promotion of Early Ming had therefore a long way to go. The stages can easily be followed because there exist certain standardised types, varying in size but of a fairly even quality. The most common of these 'yardstick' pieces are the blue and white palace dishes with unglazed bases. There are four standard patterns, a cluster of waterplants bound with a flowing ribbon, a dangling grape vine which is really a gourd vine, a geometric and somewhat Islamic arrangement of formal blossoms on tendrils and finally, the prettiest and least common, a single spray of two peonies.

| Palace dishes: grape-vine pattern | | £ |
|---|---|---|
| 1933 Winkworth. 17½ inches | | 72 |
| 1936 Unnamed. With petalled rims, 16 inches (see 1961) | 2 for | 136 |
| 1937 Wu Lai Hsi. 14¾ inches (see 1940 and 1954) | | 28 |
| 1940 Eumorfopoulos. 14¾ inches (see 1937, 1954) | | 20 |
| 1954 Martin Button. 14¾ inches (£175 paid in 1947) | | 180 |
| 1958 Unnamed. With mark of Moslem owner, 14¾ inches | | 385 |
| 1961 Mackenzie. 15 inches | | 1,155 |
| 1963 At Phillips, Son and Neale. 16 inches (see 1936) | 2 for | 3,800 |
| 1964 Evill. 14¾ inches (rim reduced) | | 1,200 |
| 1966 Unnamed. 15 inches | | 3,200 |
| 1967 Hoskyns. With petalled rim, 17¼ inches | | 3,200 |

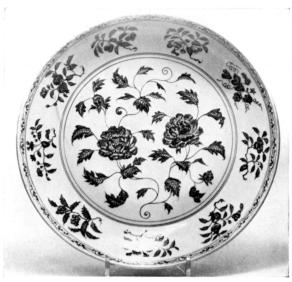

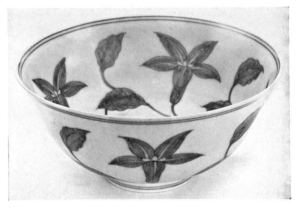

A 15th-Century Blue and White Palace
Bowl. Ch'êng Hua period.
London £16,500 ($46,200) 21.II.67.
From the Eumorfopoulos collection
(sold at Sotheby's in May 1940 for £36).

A 15th-Century Early Ming Blue and
White Saucer Dish.
London £2,500 ($7,000) 3.XII.63.

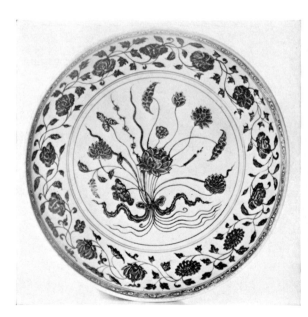

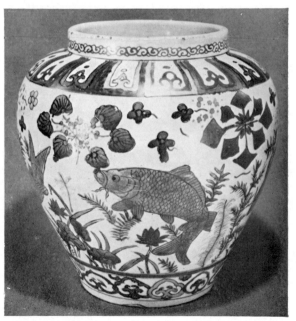

An Early 15th-Century Ming Blue and
White Saucer Dish.
London £2,600 ($7,280) 30.XI.65.
From the collection of Chinese porcelain
and works of art belonging to the late
W. A. Evill, Esq., sold at Sotheby's
in November 1965 for a total of
£31,680 ($88,704).

A Ming Wu T'sai Jar.
London £4,200 ($11,760) 27.XI.62.
From the collection of Mr and Mrs
R. H. R. Palmer.

239

Palace dishes: Waterplants and ribbon pattern      £

| | | |
|---|---|---|
| 1937 | Wu Lai Hsi. 17½ inches and 16 inches (see 1945) | 32 and 34 |
| 1938 | Stephen Winkworth. 16 inches | 37   10s |
| 1945 | Seligman. 17½ inches (see 1937) | 105 |
| | Joshua. 16 inches (see 1937) | 92 |
| 1946 | Lindsay Hay. 16 inches | 88 |
| 1954 | Woodthorpe. 11 inches | 190 |
| 1956 | An American collector. 16 inches | 260 |
| 1959 | Scott-Taggart. The same dish | 520 |
| 1960 | Rosio. 19½ inches, bought in | 220 |
| 1963 | Norton. 10¾ inches | 1,450 |
| 1964 | Wistrand. 15½ inches | 1,900 |
| 1965 | Unnamed, 10¾ inches | 700 |
| | Evill. 13 inches | 2,600 |

Stylised blossoms in geometrical arrangement      £

| | | |
|---|---|---|
| 1937 | Wu Lai Hsi. 13¼ inches, petalled rim | 19 |
| | 17½ inches, plain rim | 32 |
| 1946 | Lindsay Hay. 13½ inches | 56 |
| 1953 | Hedley. 15¼ inches | 136   10s |
| 1956 | Unnamed. 15¼ inches, petalled rim | 370 |
| 1960 | Unnamed. 15¼ inches | 580 |
| 1962 | Palmer. 17 inches | 2,600 |
| 1963 | Norton. 16 inches | 1,800 |
| 1964 | Unnamed. 16¼ inches (chipped) | 750 |
| 1965 | Wistrand. 16½ inches | 1,250 |

Spray of two peonies      £

| | | |
|---|---|---|
| 1946 | Parfitt. 15¾ inches | 170 |
| 1959 | Hubrecht. 14¾ inches | 230 |
| 1960 | Rosio. 14¾ inches | 800 |
| 1963 | Scott-Taggart. 17½ inches | 2,500 |

The Ch'êng Hua marked blue and white palace bowls with the delicate meander can also be plotted as a standard type, but they seem to have disappeared from the salerooms for thirteen years on end. When four of them could be seen in the same sale, their rarity was not appreciated. All are about 5¾ inches in diameter with little variation in their fine quality

     £

| | | |
|---|---|---|
| 1935 | Charles Russell. Fruiting melon vine (see 1967) | 62 |
| 1937 | Wu Lai Hsi. Lilies (?) | 56 and 52 |
| 1940 | Eumorfopoulos. Irises (?) | 366 |
| 1945 | Lionel Edwards. Narcissus (?) See 1964 | 100 |
| 1946 | Lindsay Hay. The two Wu Lai Hsi bowls (see 1937) | 150 and 115 |
| | Two other bowls with varying designs | 112 and 115 |
| 1951 | Woodbridge. The same two bowls | 100 and 280 |
| 1964 | Unnamed. Narcissus (?) See 1945 | 4,800 |
| 1967 | Herschel Johnson. Irises (?) The 1940 Bowl | 16,500 |
| | Fruiting melon vine (compare 1935) | 5,000 |

One more group is worth following because it probably fits compactly into the first quarter of the 16th century, though it displays reign marks varying from Hsüan Tê (1426–35) to Chia Ching (1522–66). All are saucer-dishes from 8 to 12 inches in diameter, painted in a bolder, looser style than the palace dishes. They have generally a paler underglaze blue, the white spaces having been filled-in with a translucent overglaze yellow enamel. Considering that they already exhibit some decadence from the palace dishes, it is remarkable how much extra has been paid for a bit of yellow. At the time of the Wu Lai Hsi sale not everyone trusted the yellow enamel. The group was not represented in the Russell and Lindsay Hay sales.

|      |                                                                             | £     |
|------|-----------------------------------------------------------------------------|-------|
| 1937 | Wu Lai Hsi. Mark of Hsüan Tê, $10\frac{3}{4}$ inches, repaired              | 8     |
|      | Chêng Tê mark (1506–22) $8\frac{1}{2}$ inches                               | 24    |
| 1947 | Constantinidi. Hung Chih mark (1488–1505)                                   | 190   |
|      | Chêng Tê mark                                                               | 150   |
| 1953 | Clark. Hsüan Tê mark, but Chêng Tê period, $11\frac{1}{4}$ inches           | 380   |
| 1960 | Keastey. Chêng Tê mark, $8\frac{1}{2}$ inches                              | 750   |
|      | Unnamed. Chêng Tê mark, $11\frac{3}{4}$ inches                              | 1,050 |
| 1961 | Unnamed. Chêng Tê mark, $11\frac{3}{4}$ inches                              | 1,070 |
| 1962 | Colin Smith. Hung Chih mark, $8\frac{7}{8}$ inches                         | 1,600 |
|      | Palmer. Chêng Tê mark, 8 inches                                            | 1,800 |
|      | Chêng Tê mark, $11\frac{1}{4}$ inches, very strong blue                     | 5,500 |
| 1965 | Evill. Chêng Tê mark, $11\frac{1}{2}$ inches (damaged)                      | 800   |
| 1966 | Unnamed. Hung Chih mark, $11\frac{1}{4}$ inches                             | 3,800 |
|      | Mark ground off, $10\frac{1}{4}$ inches                                     | 860   |

Among the 14th-century wares close repetition is much less common. The massive dishes and jars display the liveliest variety. There is, however, a class of ware which may have been meant for official or imperial use and is sufficiently uniform to serve as a price-table. It is a platter, less than 8 inches in diameter, sometimes in underglaze red, sometimes in underglaze blue, sometimes with a smooth rim and sometimes with a petalled rim. Many of them have a raised ring in the centre and all have fiery pink bases. Since they were scarcely recognised as 14th-century pieces before 1952 when Professor Pope published his study of the collection in the Topkapu Sarayi in Istanbul, the market started late. Thereafter the little platters which could have been bought for £4, moved very fast.

|      |                                                       |        | £     |
|------|-------------------------------------------------------|--------|-------|
| 1935 | Charles Russell. Underglaze blue                      |        | 4     |
| 1946 | Parfitt. One in underglaze red and one in blue        | 2 for  | 38    |
| 1957 | Unnamed. Underglaze red                               |        | 360   |
| 1958 | Unnamed. Underglaze red                               |        | 490   |
| 1961 | Sir Percival David (see 1964)                         |        | 780   |
| 1962 | Palmer. Underglaze blue (see 1946)                    |        | 1,400 |
|      | Underglaze red (see 1946)                             |        | 1,300 |

| | | |
|---|---|---:|
| 1964 | Max Robertson. Underglaze red (see 1961) | 1,700 |
| 1965 | Pollen. Underglaze blue, probably 15th century | 800 |
| | Fuller. Underglaze red (see 1964) | 2,100 |
| 1966 | Stephens. Two in underglaze blue | 800 and 1,000 |
| | Unnamed. Underglaze blue, probably 15th century (chipped) | 550 |

Costly as these unspectacular platters may seem, they are but poor relations, compared with the larger vessels which display the same delectable red. A 13-inch ewer with a long spout in the Palmer sale of 1962 made £8,800, but there are a few 20½-inch jars with the underglaze red decoration, dispersed among Chinese and Western museums and in Japan, which could be worth £20,000 and even more, if the recent sale of the two 18-inch 'moon flasks' of the 15th century for £25,200 and £17,850 should be found to have established a new price scale. This is not in the least surprising in the light of the history of the Chinese art market. In July, 1924, at Christies' an early 16th-century double gourd vase, 13¾ inches high, enamelled in meshed relief on a turquoise ground, made £4,310 at the Robert H. Benson sale. Two 15-inch bottles in somewhat plainer relief, reached £6,720, and a jardinière, 18 inches wide £2,205. In terms of the purchasing power of the 1967 pound the price of the gourd vase alone works out at little short of £20,000.

These examples of the style which is nowadays called *fa hua*, were probably made not later than the reign of Chêng Tê (1506–22) and are therefore contemporary with some of the costliest Early Ming rarities on today's market. It is a matter of astonishment, not that two moon flasks and a little bowl should cost from £16,500 to £25,200 but that it has taken them so long to catch up with a price paid in 1924 for Ming wares of a lesser quality. *Fa hua*, however, represents a totally different aesthetic to the contemporary imperial and official taste. It was amazingly suited to the late 19th century. It was imitated by Martin and other potters and it may have helped to inspire *art nouveau* with its exuberant reliefs and frequently sombre backgrounds. At the time of the Wu Lai Hsi sale the market for *fa hua* was already in decline, along with the tastes and fashions with which it had harmonised. A tall *mei p'ing* vase in meshed relief made only £35 at the 1940 Eumorfopoulos sale to recover to £800 at the Bruce sale of 1953. Recently something like the old prices have returned. A *fa hua* potiche jar in the first Norton sale of 1963 made £2,000, and another in 1964 £2,200 but these, of course, are devalued pounds.

It is the 16th and early 17th century wares, enamelled in three colours or five on the white glaze, which seem more likely than *fa hua* to rival the universal cult of Early Ming in imperial taste. There is an insatiable appetite in Japan for the bigger jars and vases, perhaps because they are so much in the spirit of early Arita and Kutani wares. A 17½-inch pear-shaped bottle with the mark of Wan Li (1573–1619) made £200 at the Lindlay Scott sale of 1945, but a 22-inch specimen of this style at the Clark sale eight years later cost £1,400. At the same sale an ovoid wine jar with its cover, 18½ inches high, enamelled in three colours and bearing the mark of Chia Ching (1522–66) made £1,900, having fetched the then very high price of £136 10s at the Trevor Lawrence sale of 1916. However, at the Palmer sale of 1962 a jar of

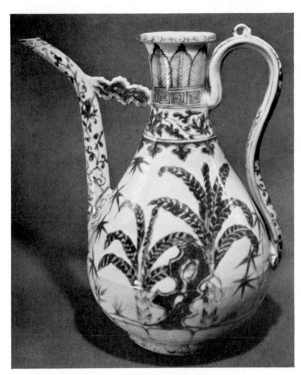

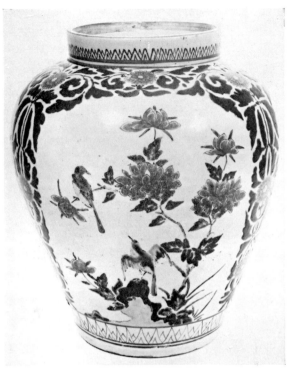

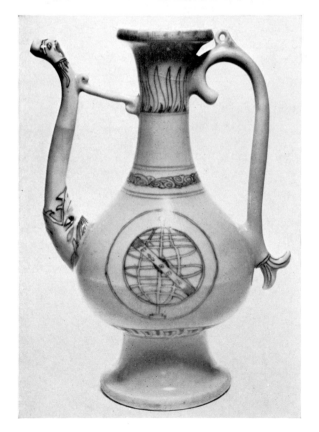

*Above left*   A 14th-Century Copper
Red Wine Ewer.
London £8,800 ($24,640) 27.XI.62.
From the collection of Ming porcelain
belonging to Mr and Mrs R. H. R. Palmer,
sold at Sotheby's in November 1962
for a total of £50,748 ($142,094).

*Above right*   A Late 17th-Century Arita Jar.
London £850 ( $2,380) 21.VI.65.
From the collection of Mrs E. Gandon.

An Early 16th-Century Sino-Portuguese
Wine Ewer, Hsüan Tê period.
London £5,000 ($14,000) 7.II.67.

this kind with a similar decoration of swimming carp and waterplants made £4,200, though only 9 inches high and lacking its cover—an inexplicable price since a 12-inch example of this pattern, less brilliant in colour but generally more attractive, made no more than £1,300 in the second Norton sale of 1963. It is said that important examples of the three-colour and five-colour 16th-century styles cost several times as much in Japan.

Before quitting the subject of Ming wares, of which there are many other highly esteemed varieties, one group, the so-called 'Sino-Portuguese', is worth recording as a curiosity. This is a class of blue and white, made possibly in the province of Fukien, in an attractively rough style which sometimes includes Portuguese inscriptions, much garbled, sometimes royal devices such as the armillary sphere and sometimes the year of manufacture in European numerals. Made between the years 1516 and 1550 at the very beginning of the European seaborne trade, these venerable survivors have immense romantic appeal. Since, moreover, some of them have returned in recent years to Portugal, patriotism has created a singularly lively market.

| | | £ |
|---|---|---|
| 1959 | Holiday. 13-inch ewer, unidentified arms, mark of Chia Ching (1522–66) | 340 |
| 1961 | Duke of Leeds. 10-inch bowl, arms of Portugal and armillary sphere. 'Ave Maria gratiae plena' | 1,800 |
| | Damaged pear-shaped bottle, $7\frac{1}{2}$ inches high, arms of Portugal upside down. Mark of Hsüan Tê on base | 500 |
| 1964 | Unnamed. 12-inch dish with scrolling dragon. On the back armillary sphere and IHS monogram | 2,100 |
| 1967 | Unnamed. Saucer dish, $12\frac{1}{4}$ inches, arms of Portugal and armillary sphere on back | 4,200 |
| | Ewer, $10\frac{1}{2}$ inches high with armillary sphere. Mark of Hsüan Tê on base, but probably made shortly before 1520 | 5,200 |

Of the 1967 prices that of the dish is the more extraordinary since the main design is of a conventional kind. In the absence of emblems concealed at the back, it might not make much over £40 as an example of provincial 16th-century blue and white, such as can still be found in South East Asia and the countries of the Middle East.

Since the 1840s or thereabouts there have been two entirely different sorts of people to whom Chinese porcelain appealed. On the one hand there were those who hunted eagerly for a perfectly matching pair of vases and then encased them in ormolu to match the clock on the mantelpiece. Secondly, there were the very few who, like Robert Fortune, went to China collecting erroneous information, and who speculated on the meaning of the porcelain marks. Gradually the second category developed a sinologist's attitude towards collecting. In the early 1920s when the Oriental Ceramic Society was founded, these sinologically minded collectors were more pre-occupied with the Chinese middle ages, the art of the T'ang and the Sung dynasties, than with the first blue and white and enamelled wares. Furthermore the Parisian *avant garde* had ruled that the only Orientalia which the enlightened could

be permitted to collect, must end strictly with the Sung or perhaps the Yüan dynasty, the dreadful alternative being the company of *famille rose* with seven borders or brocaded Satsuma. From this phase dates the necessity for a T'ang horseman or a set of girl musicians in each really smart drawing room. In the next phase, the Chinese middle ages became the preserve of the small collector, particularly in England. There were such wonderful opportunities for dispensing with the services of experts. By limiting one's portfolio to the well-known types of monochrome one did not have to be a judge of drawing or the styles of painting. It was more like guessing the nature of minerals. It may be added that the ordinary excavated wares are even now plentiful; modest bowls from modest graves for modest means.

The pattern emerging from this sequence is that of extremely high prices in the days when excavated ceramics from China were still novelties, followed by no very severe fluctuations till more than a generation later, when the Japanese became competitors for the types most esteemed in China. Thus in 1921 an example of the once so much sought-after 'numbered Chün' ware, a jardinière, made £962 at the famous *sequèstre* Worch sale in Paris. A similar piece in the Benson sale of 1924 cost £1,890 equivalent to close on £8,500 in today's money. Nevertheless the last example of numbered Chün to come under the hammer, a 9-inch bulb bowl, made no more than £1,000 in 1963 at the Randolph Hearst sale in New York.

Between the Benson sale of 1924 and the Bruce sale of 1953 which began the era of inflation prices, the market for high-class Sung wares was never seriously depressed, though it soared to no new heights. Even at the Eumorfopoulos sale in the week of Dunkirk Chün pieces could still make from £310 to £520, while a rare bottle of lavendar *Ju* ware achieved £900. In 1943, a less depressing year, Sir Daniel Hall's octagonal *kuan* ware bottle, a famous piece, made £550. It was this bottle which started the new prices in 1953 when it made £2,400. In 1948, a shift in fashion rather than a general rise of the market was registered by an 8-inch conical bowl of moulded white Ting ware, bought in 1931 for £290 and now sold for £860. The highest recorded saleroom price for a white Ting bowl seems to be £2,300, which was paid for a 13-inch example in 1966. A normal sized bowl in the Aykroyd sale was then worth £1,600.

The Schoenlicht sale of 1955 was notable for its Chün wares, though not the crimson-blotched, numbered kind. A truly majestic *mei p'ing* vase, 16 inches high and of an indescribable pale greyish blue colour, went to the Louvre at £2,180. Something of the same indefinable colour dictated the price of a little *Ju* ware narcissus bowl, oval and on four feet, which made £2,200 in 1961. The slightly greenish ware known as *ch'ing pai* (formerly *ying ch'ing*) was hardly appreciated before the 1960s, not being singled out for special praise in the Chinese texts. However in 1962 and 1963 two very special *mei p'ing* vases made respectively £2,310 and £2,100. The 1960s also saw an astonishing rise in certain sorts of that abundant commodity, celadon ware. In 1960 an 8-inch jar and cover with solid coiled dragons of a kind much appreciated in Japan under the name of *kinuta*, made £1,750 in the last of the Charles Russell sales. This was about three times as much as any Kinuta jar had

ever made, but still more unpredictable was the price paid for a pair of Northern Sung celadon bowls of sombre olive hue with a moulded and combed decoration. These bowls, 6¼ inches in diameter, might have been worth £20 or £30 each in the 1920s and 1930s, for it was the pale clear colours of Southern celadon which were loved the most. But their price in 1960 was £2,300 the pair—and that was only the beginning of the story. At the Fuller sale in 1965 a single bowl, just over 7 inches wide and apparently neither better nor worse than the Russell bowls, astonished everyone with a bid of 7,800 guineas or £8,190. This was followed in 1966 by the Desmond Gure pair of bowls, 5⅝ inches wide, at £4,830. Yet another pair of this size, but damaged, made £2,310 in 1967. Bowls of this quality turn up with fair frequency at prices from £300 to £700, but pairs very seldom. Their price suggests that a flood of perfectly paired bowls is not anticipated.

In the 1950s a large glazed T'ang burial figure of a saddled horse used to cost from £300 to £500. Since 1964 one may reckon a glazed example upwards of 14 inches high, at £1,000 to £1,500, while an unusual polo pony, ridden at a flying gallop, achieved the record figure of £3,500 in 1964. Such prices seem daring for tomb furniture which may at any moment be excavated again in profusion, as it had been at the time of the First World War when the builders of the Lung Hai railway ploughed their way through a vast cemetery. It may be recalled that in those early days T'ang figures were freely compared with Greek sculpture, a distinction which they shared with wooden masks from West Africa. At any rate, the market was very lively. An unglazed figure of a dancing girl was sold in Paris in 1920 for about £325. At the Benson sale of 1924 a saddle horse in mottled glaze, much restored but no less than 27½ inches high, cost £577 10s, equivalent perhaps to £2,750 of our money. There followed a period of disillusionment. Towards the year 1920 there was an auction room in the City where the lots were commonly sold under this sort of designation, '24 camels, assorted sizes, ex SS *Fushimi Maru*'. The camels seemed to grow bigger and bigger and the prices to decline proportionately till they reached the neighbourhood of 30 shillings. It became evident that, after the railway builders had continued on their way, the cemetery had been succeeded by a factory. At Loyang in 1936 you could see some of its products, laid out on tables in identical dozens along the dusty straight avenue from the railway station to the town gate.

Under such adverse influences the market wilted. The best of the famous pawing horses, 16½ inches high and cream-glazed, made only £90 at the Eumorfopoulos sale of 1940. A set of six dancing maidens, today capable of fetching £5,000 and more, made £58 at the Burnet sale of 1941. The present market is well aware of the reproductive capacities of moulded objects in a rough material. Possibly the present prices, which in real terms are not nearly as high as they were in the early 1920s, have already discounted the dangers. And the buyer of a handsome, albeit standardised, prancing steed may well reflect that a wholly Europeanised mid-18th century tureen in the shape of a goose, can cost him more than £11,000.

When we come to the Ch'ing period, that is to say the late 17th, 18th and (though it is seldom *specifically* admitted) the 19th century, a different market symptom

appears and one which applies to older established markets in general. It is that the lowest categories have advanced the most. More than four-fifths of the Chinese porcelain which comes under the hammer in the leading auction-rooms of the world belong to the Ch'ing dynasty and all but a small proportion of the lots are sold for £100 or less, though a great deal has soared from the one-figure to the three-figure class. A mid-17th-century blue and white beaker or roll-wagon vase could be bought for £5 to £10 in 1957, but today it can make a hundred or two. Such increases are far less common among the eye-catching items which are reported in the press in terms of thousands. In the past two years exemption from the complications of a capital gains tax has played some part in creating this disparity in favour of cheaper objects, but the simple truth is that an enormous number of people can afford for the first time to become possessors of a few treasured objects or collectors in a small way.

The Ch'ing period is in no danger of losing its popularity, for it has something to offer everybody, from miracles of reticent taste in *famille rose*, 'soft enamels' or under-glaze red down (but not down in financial terms?) to quaint little doggies and the tobacco leaf pattern. Among the dearest objects of all are those that were mounted in France in the mid-18th century in the *rococo* taste. Two celadon beaker vases in the Harewood sale of 1965, of which only the mounts matched, made an aggregate of 14,000 guineas, while a fluted stoneware bowl in the Fribourg sale of 1963, mounted as a pot-pourri jar and cover, achieved £8,000. Strictly they should be considered French *objets d'art*, so completely have they been transformed and so small a part has the actual Chinese object played in the final price. Such pieces have in fact dominated the entire Chinese porcelain market from the time they were mounted till quite recent years, except during a brief period at the beginning of the First World War when American millionaires were persuaded that they could achieve the purest of Chinese taste by buying *famille noire* beakers at £30,000 each.

Today the supremacy of splendidly paired and mounted Chinese monochromes has been challenged not only by the market for Early Ming but by unmounted porcelain of their own period in European taste, such as tureens in the shape of birds, based on faience models. A goose tureen, 13½ inches high, made £11,000 in 1963. Other goose tureens were sold for £4,600 in 1963, £3,400 in 1966, £8,000 and £10,500 in 1967. The more habitual leaders of this not very sophisticated market are the tall paired models of birds, perched on rocks, made of a singularly coarse porcelain, enamelled in *famille rose* colours. Few realise how recent is the high market rating for this taste. The figure of £1,000 for a pair of crested birds was passed for the first time in Paris in 1903. Although equivalent to £8,000 today, this was not at all a high price at the time of the *famille noire* vogue. And, a generation later, the paired birds had already fallen victims to the great economic depression. A pair of crested birds, no less than 26 inches high, reached £1,835 10s in 1935, but between 1929 and 1945 the very best were generally to be bought for 600 guineas. In 1939, the year of the devaluation of the pound, a pair of crested birds, 14 inches high, cost only 220 guineas. The inflation market began with a pair of 16½-inch cranes at £2,520 in 1956. In 1958 a

247

pair of crested birds was sold for £4,410, while in 1960 two pheasants on rocks achieved the record price of £8,800 in London. Apparently no pairs of birds have made as much as £4,000 in 1963–7, apart from mounted examples.

In the days when the porcelain market was governed entirely by decorative qualities, when merit was determined by the elimination of open spaces, by great size and by accurate duplication, there was always a lesser appetite for eggshell and elegance. Amid the robust favourites of the Industrial Revolution, William Beckford's ruby-backed saucer dishes were worth 10s to £1 in 1823, 3 to 4 guineas in 1845. The ruby backs are the counterpart in export ware of *famille rose* in high-class Chinese taste, almost as finely painted as the best but overcrowded and addicted to female subjects, unworthy of the gravity of imperial officials. But the more they were over-decorated, the more they were liked in Europe. By 1881 Edmond de Goncourt could complain that the kind with seven borders cost 1,800 francs, a fact confirmed by the sale of a ruby back at Christies that year for £76. By 1906 a pair could cost 420 guineas, but that sort of price was not out-distanced in the London salerooms for another fifty years with possibly a single exception. At the Charles Russell sale of 1946 an 8-inch ruby back made £300, but it was a sign of the times, for the design was in pure Chinese taste, a single bird knowingly perched on a magnolia tree on an unspoilt white background.

The normal ruby backs have not, however, kept pace with inflation. Single saucer dishes made £577 10s in 1956, £924 in 1964 and £800 in 1967. Eggshell pieces in Chinese taste, both in *famille verte* and in *famille rose* enamels, have overtaken them. A well-known pear-shaped bottle with a brilliant *famille verte* version of the Three Fruits was esteemed dear at £120 at the second Winkworth sale of 1939, but today, it would certainly have passed the £2,000 mark. Another well-known vase, oviform with a poem of T'ang Yin on a lavender ground made £560 at the 1946 Russell sale, but £1,700 at the Bruce sale of 1953. A *famille verte* bowl, painted with swimming ducks, was worth £330 at the Blake sale of 1958 but had more than trebled its value seven years later at £1,100. At the first Norton sale of 1963 a *mei p'ing*-shaped *famille rose* vase with the mark of Yung Chêng (1723–35) reached £1,700. In 1953 it had been knocked down for £20, having been catalogued without any date attribution. It seems that this shape is particularly inclined to create market surprises. Thus at the Huth sale in April, 1966, a *mei p'ing* vase with a Yung Chêng mark, 10½ inches high and painted with a white dragon on an underglaze red ground of exceptional beauty, made £950. Within three weeks a replica, half an inch taller and somewhat deeper in colour, made more than double, namely £1,850. In 1933 in the far-off days of the first Winkworth sale, a 13-inch example had been sold for £23.

By all indications 'Chinese taste' of the Ch'ing dynasty is a rising market, but less prone to the competition of museums than the Ming period and therefore more limited. A much more recent competitor for the higher prizes is Japanese porcelain of the same period, which has, however, a very queer history behind it. The captivating ware which is generally called by the name of Kakiemon, despite the strong reservations of Mr Soame Jenyns, inspired the porcelain-makers of Meissen, Chantilly,

248

Chelsea and Worcester towards the middle of the 18th century, but became neglected at the beginning of the 19th. Middle-class taste favoured the strongly contrasted brick red and smokey blue of the tall garniture urns, associated with the shipment port of Imari. These reached their apogee at the Hamilton Palace sale of 1882, when a pair of 28-inch urns and covers made 400 guineas. Although the purchasing power of 400 guineas in 1882 must have been equivalent at least to £3,200 in today's money, such a pair of urns would make £100 with difficulty in 1967. In 1882 this now traditional market had not yet been depressed by such recently devised novelties as brocaded Satsuma pottery, which freedom of trade with Japan had released in bulk since the 1860s. But by the early 1900s the flood of novelties had created a thorough disgust of all things Japanese, to which Imari ware succumbed. By the 1930s there was practically no piece of Japanese porcelain, not even the great Kutani and Arita jars for which the Japanese now pay thousands, which was capable of making more than £20, while the delicate small wares, ascribed to the Kakiemon factory, could be had for a pound or less.

Some change became inevitable after the military occupation of Japan, and later on with the U.S. embargo on imports from Communist China. Eventually the tide set so strongly in favour of Japanese art that the Japanese themselves began to abandon their neglect of their own porcelain. In England some revival of interest in Japanese porcelain in 'native Taste' became apparent in 1955 when a Kakiemon style saucer dish made £100 at a small sale. From this point onwards the market for what is generally called Kakiemon can best be followed from the fortunes of the 12½-inch hexagonal 'Hampton Court' jars and covers which were copied at Meissen and Chelsea. In the early 1950s a perfect example with its cover was worth from £15 to £20, but £190 was paid for a pair in 1958, £230 in 1962, £340 for a single jar in the following year and £651 for an earlier example with figures of Geisha girls in 1966. Two recumbent figures of a doe and stag from Burleigh House, mentioned in an inventory of 1688, were sold in 1959 for £850. In the following year a more perfect pair was sold for £1,155.

In the London salerooms the highest prices have not as yet been remarkable by present-day standards. For single pieces the highest are £1,100 and £1,600, paid for a pear-shaped bottle and double-gourd vase in the Kutani style in 1967. But it is notorious that prices several times as big have been paid privately in Japan and the U.S.A. An outstanding 19-inch bottle in the style known as Kutani, which was on the market in London in 1956, was bought for the Freer Gallery, Washington, in 1962 for £800, but a comparable 19-inch bottle is said to have been sold in London to an American collector in 1966 for £4,000. The modern Japanese potter and porcelain painter are unfortunately quite alarmingly proficient in making copies. There is little doubt that a high proportion of the plausible looking smaller pieces which float round the London and New York markets have been made to meet the present demand for the Kakiemon and Kutani styles. The real article is disappearing very rapidly, much of it to its original home.

249

# Chinese Works of Art

The summer of 1940 is not easily forgotten by those old enough to remember it. Most of us were occupied fairly continuously elsewhere and had little time, or indeed inclination, to be keeping a careful watch on salerooms. Chance though brought to Bond Street what was left of the great collection gathered together by George Eumorfopoulos after the British Museum and the Victoria and Albert Museum had taken their pick of the choicest pieces. A few objects of very high quality slipped through the net, some because they were duplicates or because they were in those days not so highly regarded as they are now. One of them was a graceful palace bowl of the 15th century, which was sold in May of that disastrous year for £36; it came up again in February 1967, and made £16,500. It was painted inside and out with a continuous flower scroll and bore the six-character mark of the Emperor Ch'êng Hua. Bought in 1940 for that ludicrous sum it had become part of the collection in the United States of Herschel V. Johnson. A very low price when Europe was being over-run by the Nazis is understandable. But six years ago prices were high and interest in early Ming porcelain widespread. All the more remarkable then that as recently as 1958 a stem cup, also blue and white, also 15th century, reign of Hsuan Tê, should have been thrown in as a bonus for a purchaser of some English porcelain teapots. This 'give-away' cup was seen in a December sale and was promptly sold for £4,800. The following May the highest total yet recorded for a single morning's sale of Chinese works of art, £136,659, was achieved, thanks largely to a series of exceptional bronzes, one of which, from the estate of the late Madame Alexandrine de Rothschild, a Shang Dynasty bronze ritual wine vessel, realised £38,000—or £10,000 more than was given in 1965 for a bronze bell from nearly a thousand years later, period of the Warring states. Another fine bronze of the same period, a flask, was sold for £15,000, and a Shang bronze ritual food vessel for £8,500. As usual Ming pieces attracted a great deal of attention. When the Norton collection was dispersed in a memorable sale in 1963 a certain blue and white vase changed hands at £1,500—that same vase now made £3,200. A powder blue bowl sold for £4,200, a blue and white wine jar for £6,500—all three were 15th century; so was a blue and white fluted dish, painted with a vine branch and cluster of grapes, which went for £3,200, while a 14th-century melon-shaped lobed vase made £3,400 and a 14th-century blue and white dish painted with a leaping kylin £7,000. Among earlier ceramics an exceptional T'ang Dynasty pottery horse sold for £1,700, a groom from the same stable for £1,000. An 18th-century *famille rose* goose tureen and cover made £8,000 and one of those amusing export pieces in which the Chinese enameller interprets a European print, in this instance a print of a fox hunt round a punch bowl, went for £1,200; and an even rarer bowl, painted with the *hong* at Canton, for £2,600. New high prices were also recorded for Japanese porcelain when two Kutani vases were sold for £1,100 and £1,600. Meanwhile notable prices for jades had been achieved at Parke-Bernet, particularly the $37,000 given for an 18th-century pale green jade carving of a water buffalo and the $42,500 for a pair of Imperial moss green jade vases adapted from early bronze forms.

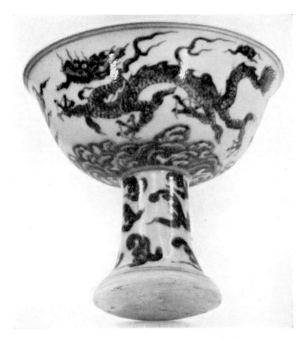

An Early 15th-Century Blue and White
Stemcup. Hsüan Tê period.
London £4,800 ($13,440) 13.XII.66.
From the collection of Sidney G. Williams,
Esq., J.P.

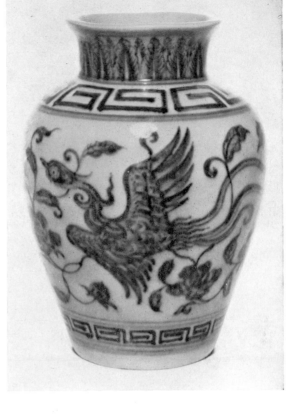

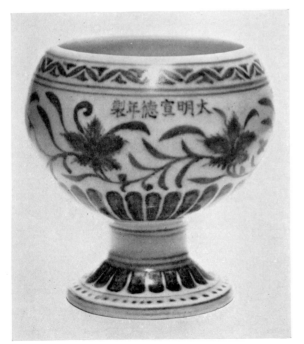

A 15th-Century Hsüan Tê Blue and
White Ovoid Vase.
London £3,200 ($8,960) 16.V.67.
Formerly in the Norton Collection,
originally purchased in Peking by the late
A. D. Brankston and sold at Sotheby's in
March, 1963, for £1,500 ($4,200).

A 15th-Century Ming Blue and White
Stem Bowl, Hsüan Tê period.
London £1,700 ($4,760) 11.VII.67.

251

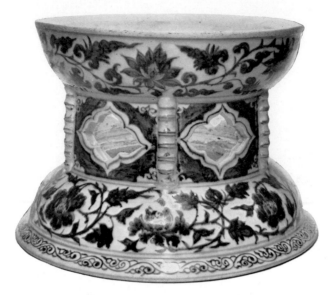

A 14th-Century Ming Blue and White
Circular Bowl Stand.
London £1,800 ($5,040) 11.VII.67.

A 14th-Century Ming Blue and White Vase.
London £3,400 ($9,520) 16.V.67.

A 14th-Century Blue and White Dish, from
the collection of Shah Jahan.
London £7,000 ($19,600) 6–7.VI.67.

An Early 15th-Century Ming Blue and
White Wine Jar.
London £6,500 ($18,200) 6–7.VI.67.

A 17th-Century Double-Gourd Vase.
London £1,600 ($4,480) 6–7.VI.67.

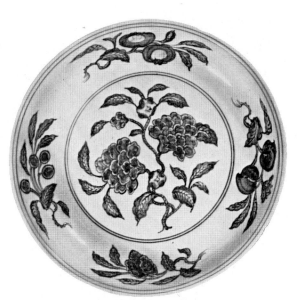

A Ming Blue and Yellow Dish.
Chêng Tê period.
London £3,800 ($10,640) 13.XII.66.

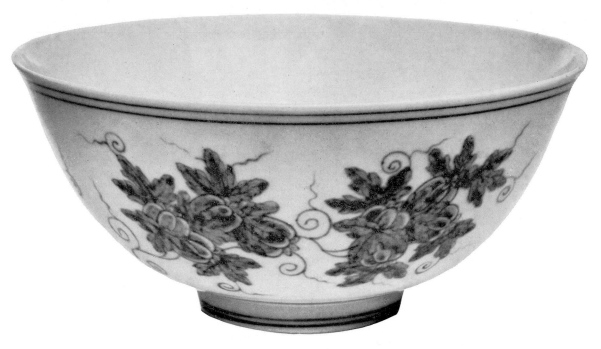

A Ch'êng Hua blue and white Palace Bowl.
London £5,000 ($14,000) 21.II.67.
From the collection of Herschel V. Johnson.

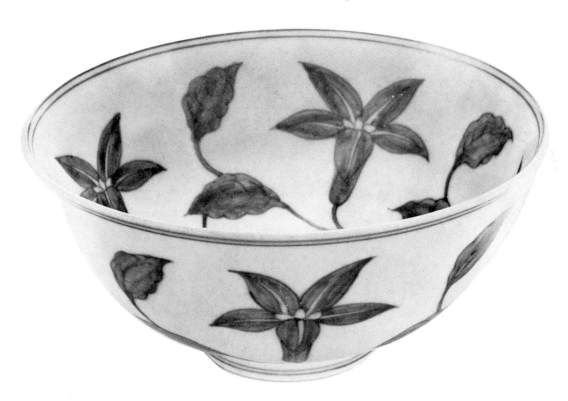

A 15th-Century Blue and White Palace Bowl. Ch'êng Hua period.
London £16,500 ($46,200) 21.II.67.
From the Eumorfopoulos collection (sold at Sotheby's in May
1940 for £36), and the Herschel V. Johnson collection
of Chinese ceramics and works of Art sold at Sotheby's in
February, 1967 for a total of £48,595 ($136,066).

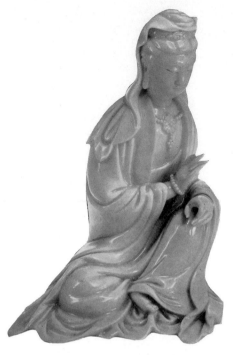

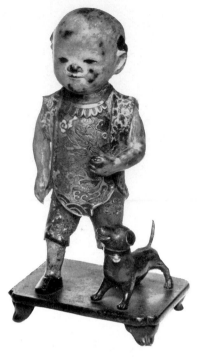

A Fukien 'Blanc-de-Chine' Figure
of Kuan Yin, Goddess of Mercy.
17th–18th Century.
London £900 ($2,520) 13.XII.66.
Formerly in the collection of
E. C. Blake, Esq., and sold at
Sotheby's in July 1958 for £430
($1,204).

A Champlevé Enamel Figure
of a Boy, 17th century.
London £420 ($1,176) 11.VII.67.

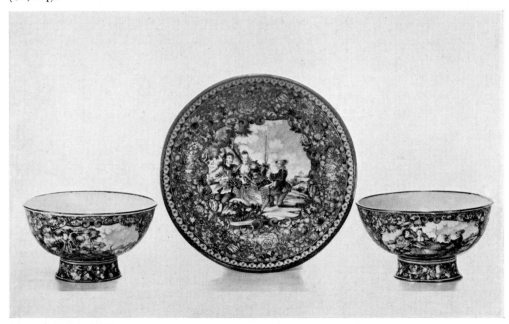

A Pair of Pekin Enamel Cups and Stands (one only shown).
Ch'ien Lung period.
London £680 ($1,904) 7.II.67.
From the collection of Sir Charles Shuckburgh, Bt.

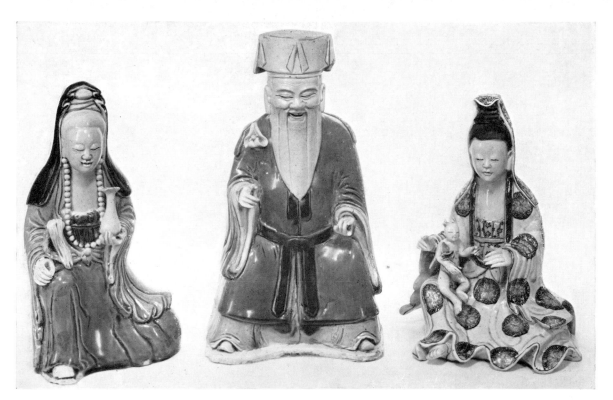

A K'ang Hsi Biscuit Figure of Kuan Yin (one of a pair).
London £720 ($2,016) 11.VII.67.
A K'ang Hsi Biscuit Figure of an Immortal.
London £280 ($784) 11.VII.67.
A K'ang IIsi Biscuit Figure of the Goddess Kuan Yin.
London £440 ($1,232) 11.VII.67.
All from the collection of Mrs F. M. E. Schlesinger.

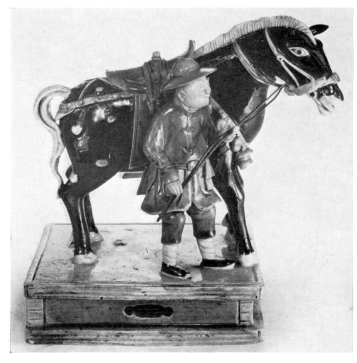

A K'ang Hsi Biscuit Group of a Horse and Groom.
London £2,700 ($7,560) 16.V.67.

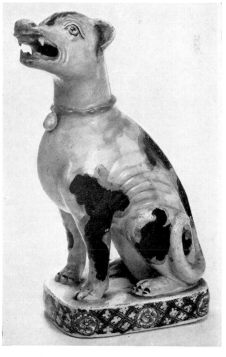

A K'ang Hsi Biscuit Figure
of a Hound.
London £800 ($2,240) 16.V.67.

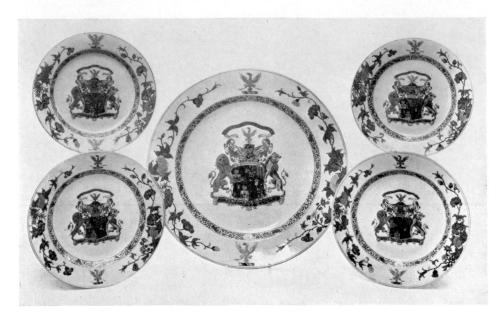

Five plates from an Early Armorial Dinner Service, comprising
fifty pieces, K'ang Hsi period.
London £3,900 ($10,920) 13.XII.66.
From the collection of the Rt Hon. Lord Torphichen.

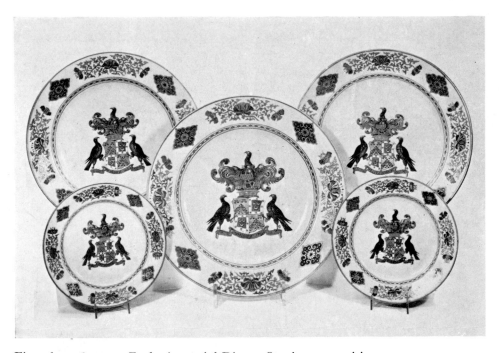

Five plates from an Early Armorial Dinner Service, comprising
twenty-nine pieces, K'ang Hsi period.
London £2,400 ($6,720) 13.XII.66.
From the collection of the Rt Hon. Lord Cochrane of Cults, D.S.O.

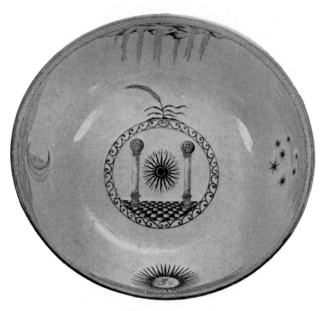

A Ch'ien Lung Masonic Punch Bowl.
London £1,000 ($2,800) 7.II.67.
From the collection of Miss G. M. T. Parsons.

A Ch'ien Lung 'Famille-rose'
Exportware Plate.
London £700 ($1,960) 26–27.VI.67.

A K'ang Hsi Armorial Dish (one of a pair).
London £750 ($2,100) 6–7.VI.67.
From the collection of the late
Walter Quennell, Esq.

A K'ang Hsi 'Rose-Verte' Armorial Dish.
London £460 ($1,288) 6–7.VI.67.
From the collection of the late
Walter Quennell, Esq.

A Pale Green Jade Statue of a Water Buffalo, 18th Century.
Length: 20 in.
New York $37,000 (£13,314) 18.XII.66.
From the collection of the late Helen M. de Kay.

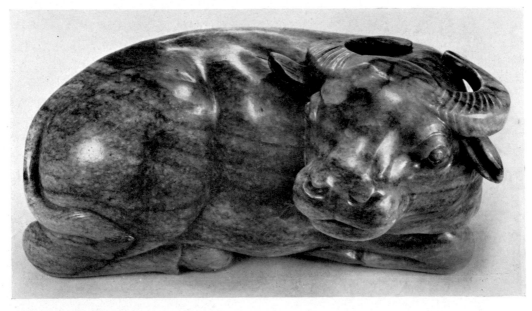

A Grey Jade Buffalo, end Ming Dynasty.
London £3,000 ($8,400) 6–7.VI.67.
Formerly in the collection of Noah Bushell (sold at Sotheby's
in March, 1962 for £3,000 ($8,400).

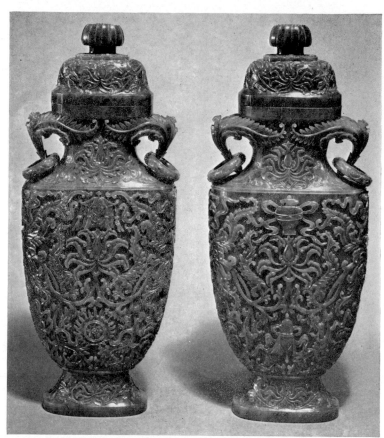

A Pair of Imperial Moss Green Jade covered Bronze-form Vases. Ch'ien Lung period.
New York $24,000 (£8,571) 8.XII.66.
From the collection of the late Helen M. de Kay.

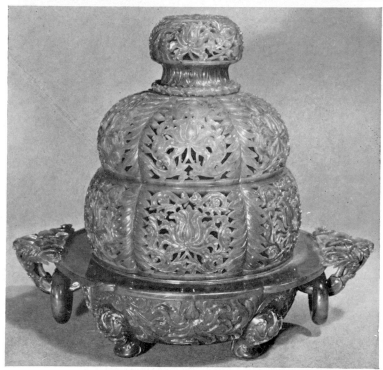

A Jade Three-part Incense Burner, Ch'ien Lung period.
New York $10,500 (£3,750) 8.XII.66.
From the collection of the late Helen M. de Kay.

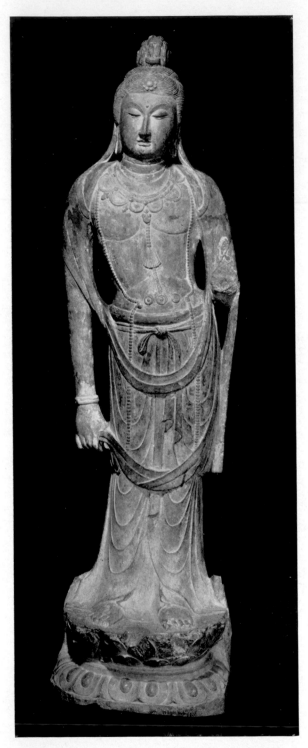

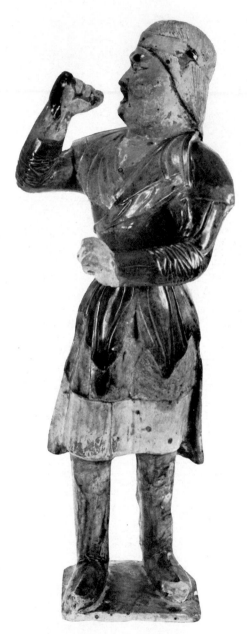

A Stone Statuette of Kuan Yin. T'ang period.
New York $40,000 (£14,285) 4–5.XI.66.
From the Kevorkian Foundation.

A T'ang Dynasty Glazed Figure
of a Groom.
London £1,000 ($2,800) 16.V.67.

A Jade Head of a Ram, Shang
Dynasty.
London £500 ($1,400) 11.VII.67.

A Grey-Green Stag Pendant, Shang or early
Western Chou Dynasty.
London £420 ($1,176) 11.VII.67.

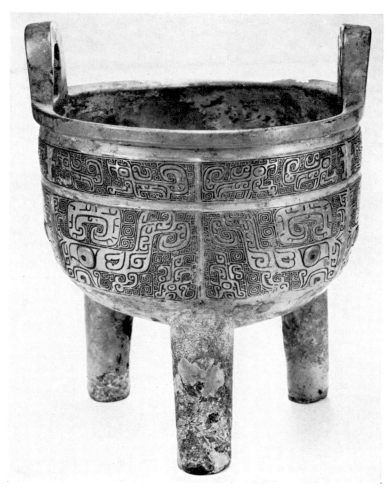

A Shang Dynasty Bronze Ritual
Food Vessel.
London £4,200 ($11,760) 16.V.67.

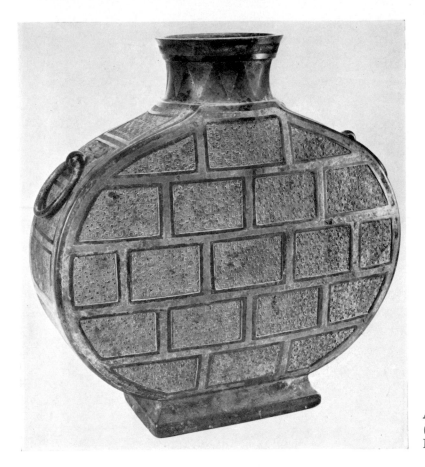

A Warring States Bronze Flask
(P'ien Hu).
London £15,000 ($42,000) 16.V.67.

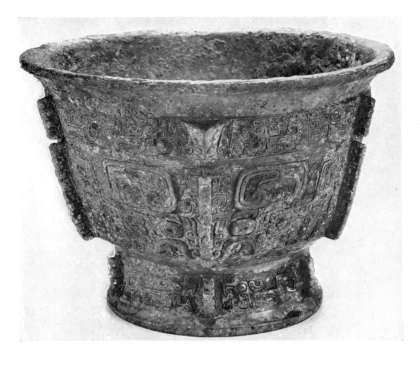

A Shang Dynasty Archaic Bronze
Food Vessel.
London £8,500 ($23,800) 16.V.67.

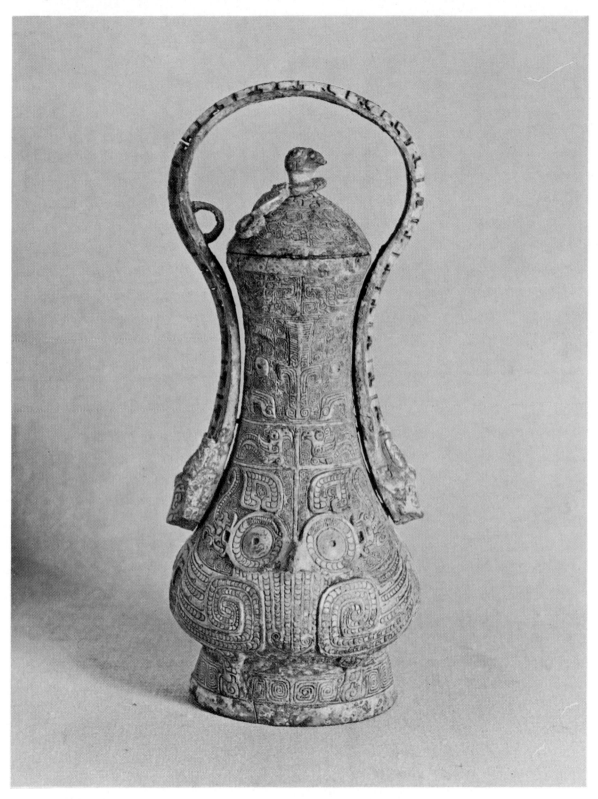

A Shang Dynasty Archaic Bronze Ritual Wine Vessel and Cover (Yu).
London £38,000 ($106,400) 16.V.67.
From the collection of the late Madame Alexandrine de Rothschild.

K*

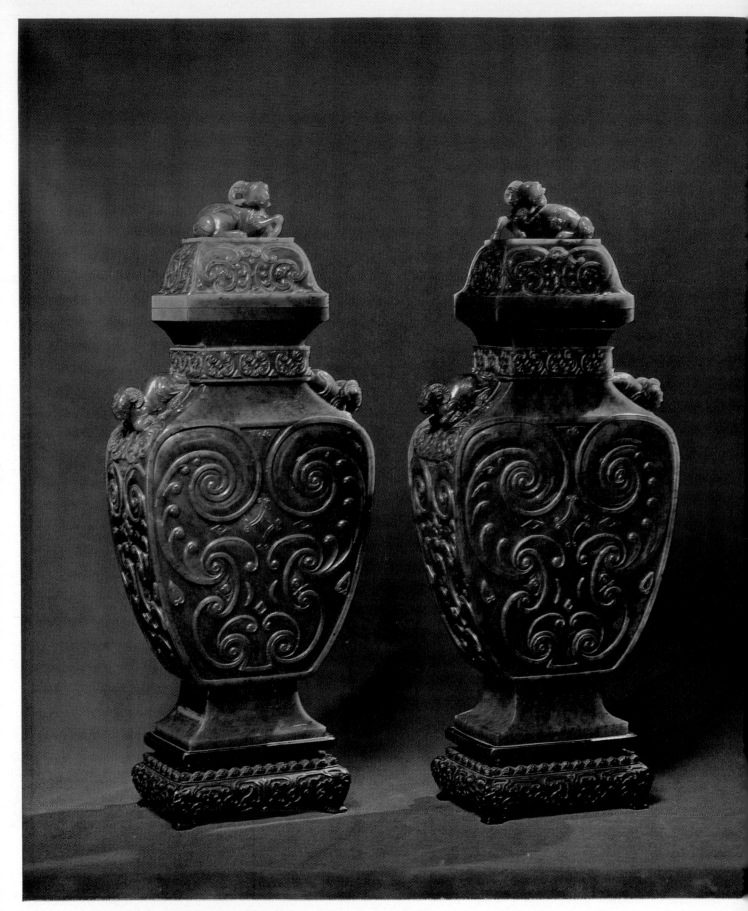

A pair of Jade Bronze-Form Vases, Ch'ien Lung period.
New York $42,500 (£15,178) 8.XII.66.
From the collection of the late Helen M. de Kay.

# Continental Porcelain

Among international hard currencies Meissen and Sèvres stand very high in the league table and, if some people thought they had during the past few years become more popular than they deserved, they were speedily reassured by the first considerable sale of the winter season, which happened to include some notable Meissen figures, and the second part of the Jack Michelham Sèvres 'Rose Pompadour' Porcelain. This last consisted of twenty-five lots only which were sold for £54,840, £11,500 of this contributed by a pair of so-called *vases hollandais* of the year 1757, while an écuelle, cover and stand of 1760 made £5,500 and a biscuit figure of Cupid seated with his forefinger to his lips—after the well-known Falconet model—in this collection because of the rose pompadour plinth—went for £5,200. A dozen dinner plates dated 1756 were sold for £5,400, a rose and apple-green ewer and basin, 1759 for £4,000, and a cup and saucer and tray, also rose and apple-green for £2,100. The Meissen came later, among the less familiar lots a delightful travelling service in a contemporary French leather case, each painted with different European birds, twenty-three plates which were sold with nine others of the same series for £4,800. Kaendler's *Frightened Harlequin* went for the same substantial sum, *Harlequin with a Pug dog* for £3,800—the model in which the dog is held under one arm while Harlequin swings the tail as if playing a hurdy-gurdy—the *Scowling Harlequin* also for £3,800, and a figure of Joseph Fröhlich, Court Jester to Augustus the Strong and often modelled by Kaendler for £1,700. A still more opulent dispersal took place in May of this year—127 lots going for £167,455—and once again Kaendler's reputation remained unchallenged—his *Harlequin* with a dated tankard, 1738, sold for £9,000 (the same sum which was paid for a similar figure in the René Fribourg sale of 1963), while a group of two harlequins wrestling which had been sold in 1952 for £950 now made £6,000. *Columbine*, also by Kaendler, was bought for £7,000, a *Scowling Harlequin* for £3,400; *Harlequin Dancing* for £7,200 and *Harlequin with a Monocle* for £5,000. As for Sèvres, or rather in this instance the parent factory, Vincennes, a little gold mounted snuff box, 1744, set with oval porcelain plaques painted with various flowers—the date letter on the gold mounts earlier than the porcelain—realised £6,000. To some at least of the audience that morning three other Italian Comedy figures, which made up in elegance what they lacked in Kaendlerish vigour, were no less interesting—all of Nymphenburg porcelain and by the gifted F. A. Bustelli; they made £6,000 between them, while a rare Fürstenberg figure of Dr Boloardo by Simon Feilner went for £2,750. The most imposing single lot was a great Berlin banqueting service of 458 pieces made between 1823 and 1825 for the marriage of Prince Frederick of the Netherlands, second son of King William I and nephew of Frederick the Great to Princess Louise of Prussia. The youngest daughter of this marriage, Princess Marie, married Prince William zu Wied, and the service came from her estate. It was bought for £18,500. This was a substantial enough price but not to be compared with the £21,935 for which the thirty pieces

*continued on p. 281*

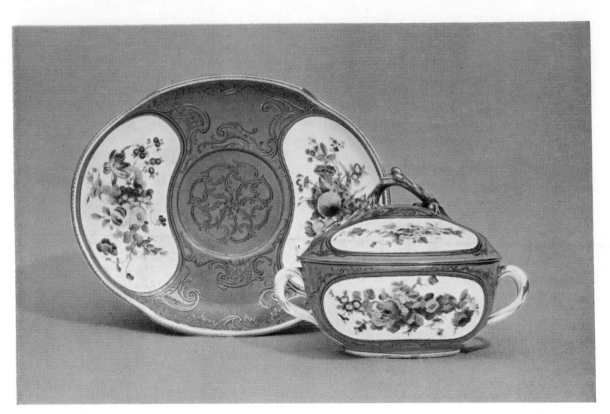

A Sèvres 'Rose Pompadour' Ecuelle, Cover and Stand, 1760.
London £5,500 ($15,400) 8.XI.66.
From the collection of the Hon. Jack Michelham.

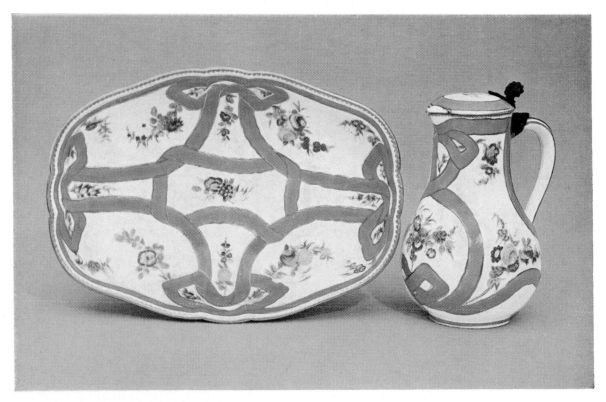

A Sèvres 'Rose Pompadour' Ewer and Basin, decorated '*à rubans*'.
London £2,000 ($5,600) 8.XI.66.
From the collection of the Hon. Jack Michelham.

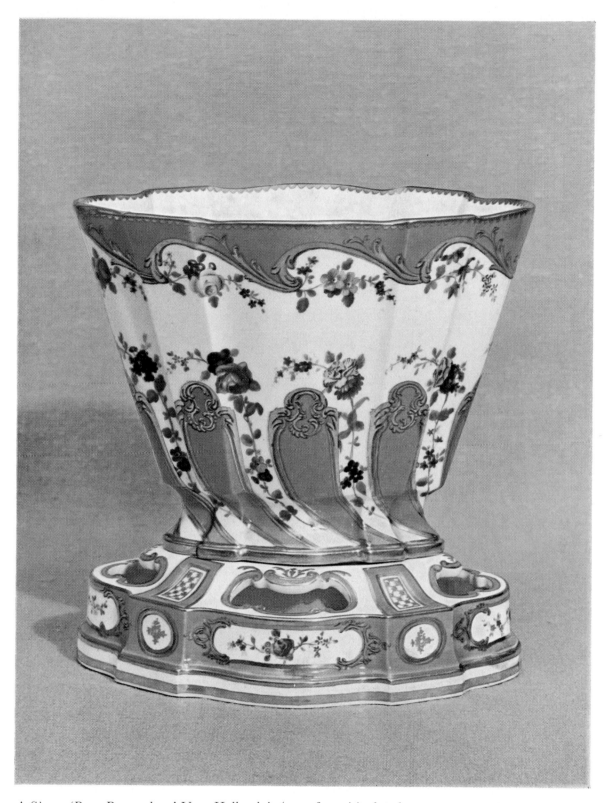

A Sèvres 'Rose Pompadour' Vase Hollandais (one of a pair), dated 1757.
London £11,500 ($32,200) 8.XI.66.
From the collections of Baron Adolphe and Maurice de Rothschild
and the Hon. Jack Michelham.

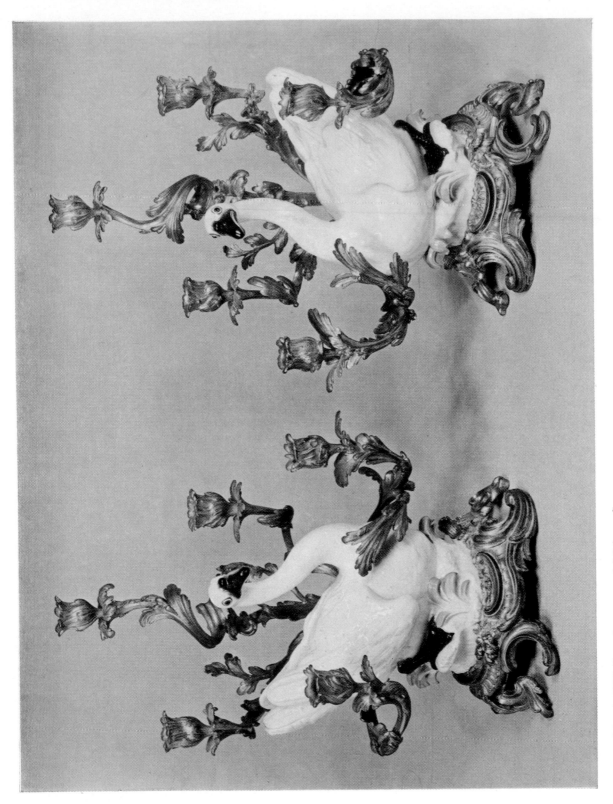

A pair of Louis XV Ormolu-mounted Meissen Swans,
by J. J. Kaendler and Peter Reinicke.
London £23,000 ($64,400) 14.III.67.
Formerly in the collections of H.R.H. Princess Arthur of Connaught,
Duchess of Fife, and His Grace the Duke of Fife.

A brightly coloured Meissen figure of the Scowling Harlequin, by J. J. Kaendler
London £3,800 ($10,640) 8.XI.66.
A Meissen figure of Joseph Fröhlich, Court Jester to Augustus the Strong,
by J. J. Kaendler, *inscribed* J:F. 1741.
London £1,700 ($4,760) 8.XI.66.
A Meissen figure of Harlequin with a Pug Dog, by J. J. Kaendler.
London £3,800 ($10,640) 8.XI.66.
The model is described in the factory records as 'A small figure, holding a
dog under his arm in place of a hurdy-gurdy, pretending to play'.

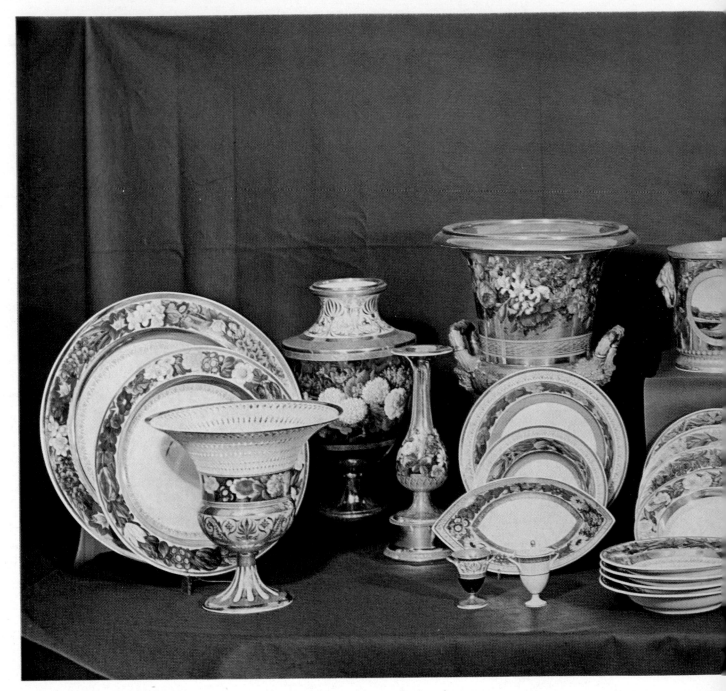

Part of a Berlin Royal Banquet Service (comprising 458 pieces)
made between 1823 and 1825 for the marriage of Princess Louise of
Prussia to Prince Frederick of the Netherlands.
London £18,500 ($51,800) 23.V.67.
From the collection of the late Fürstin Marie zu Wied,
Princess of the Netherlands.

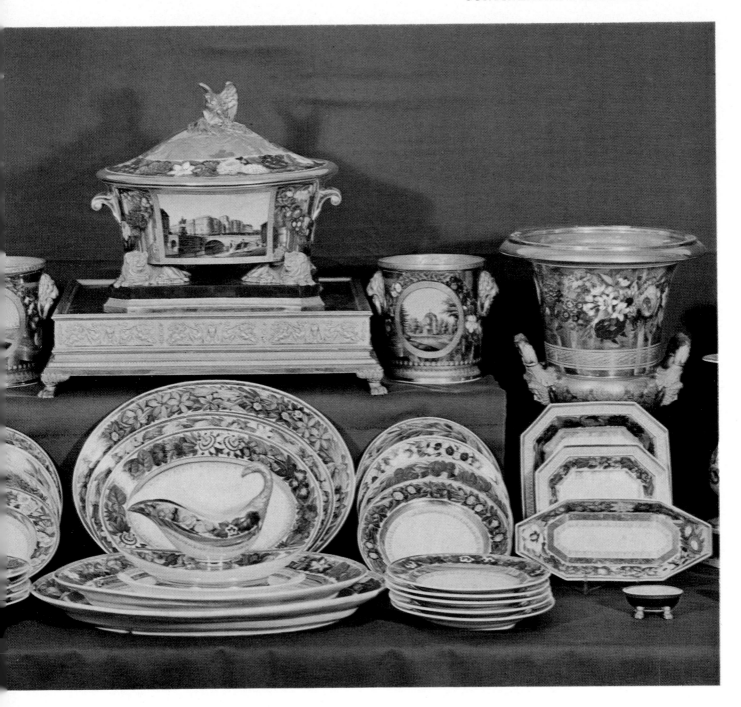

A Meissen figure of Columbine,
by J. J. Kaendler.
London £7,000 ($19,600) 23.V.67.
From the collection of the late
Alfred E. Pearson, Esq.

A Meissen figure of the Scowling Harlequin,
by J. J. Kaendler.
London £3,600 ($10,080) 23.V.67.
From the collection of the late
Alfred E. Pearson, Esq.

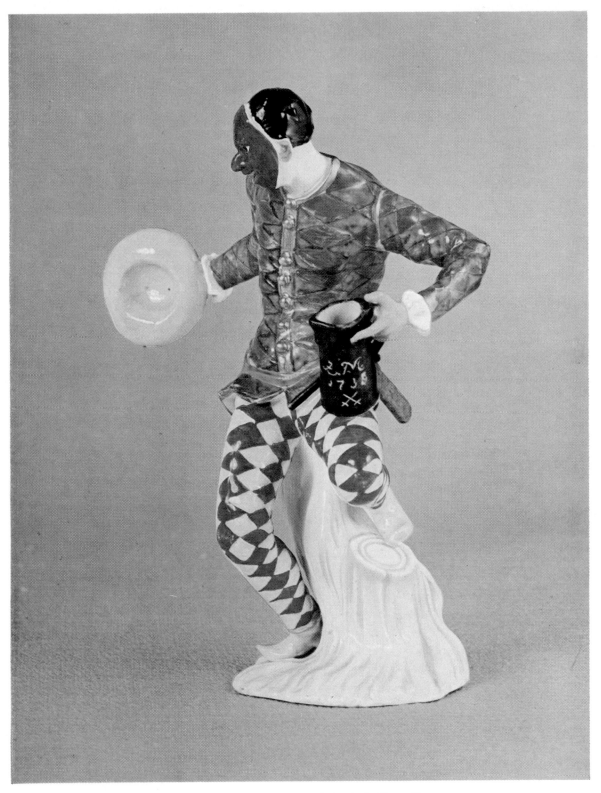

A Meissen figure of a Harlequin with a dated tankard, by J. J. Kaendler.
London £9,000 ($25,200) 23.V.67.
From the collections of Lady Carnarvon and the late Alfred E. Pearson, Esq.

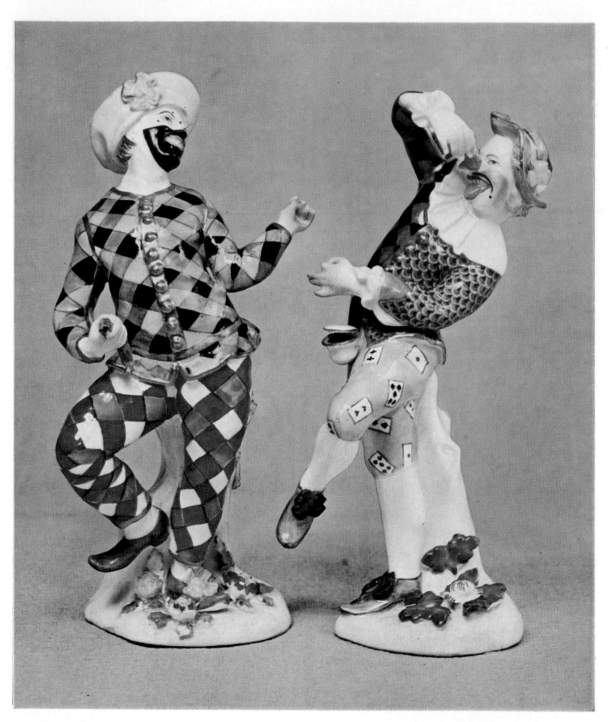

A figure of Harlequin Dancing,
by J. J. Kaendler.
London £7,200 ($20,160) 23.V.67.
From the collections of Baron Gerhard
Olmuetz, and the late Alfred E. Pearson, Esq.

A Meissen figure of Harlequin with a Monocle,
by J. J. Kaendler.
London £5,000 ($14,000) 23.V.67.
From the collections of Count Stillfried-
Mettich, Castle Moenschshof, Silesia, and the
late Alfred E. Pearson, Esq.

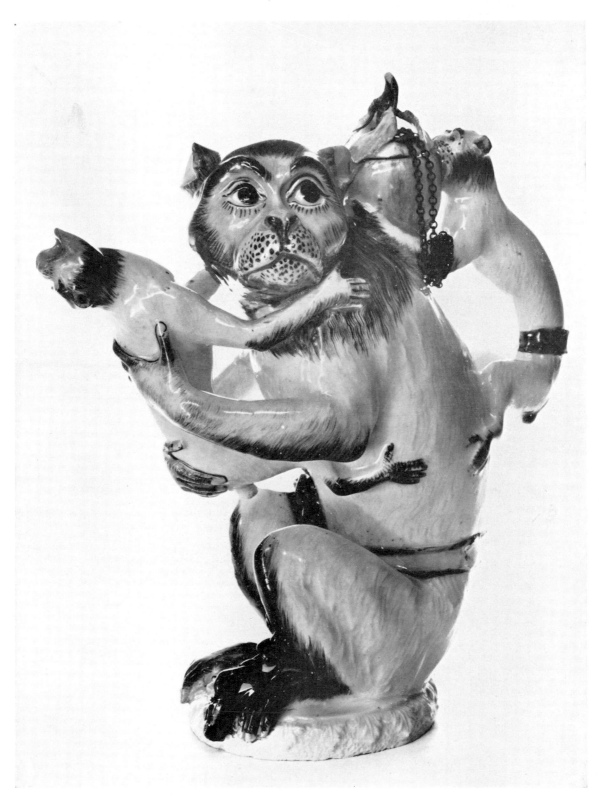

An Early Meissen Monkey Teapot and Cover, by J. J. Kaendler.
London £2,600 ($7,280) 8.XI.66. From the collection of Henry Nyburg, Esq.

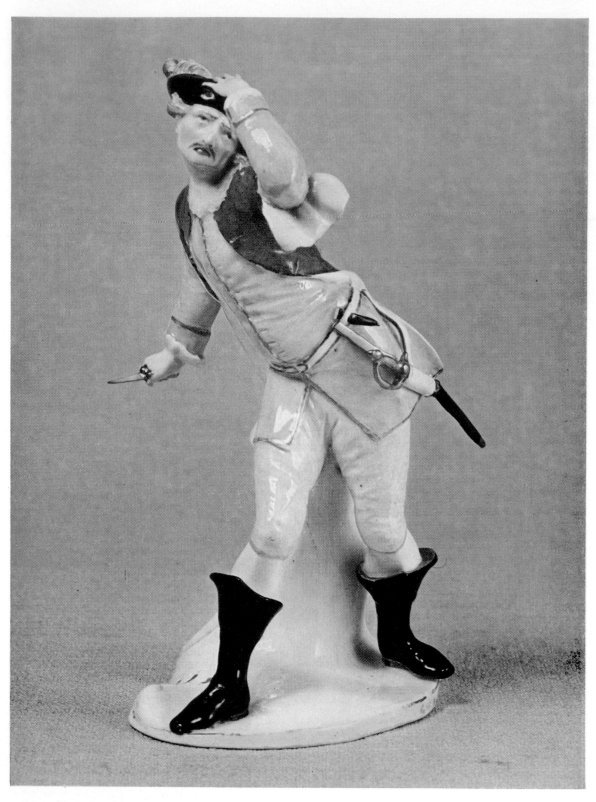

A Nymphenburg figure of Capitano Spavento,
by Franz Anton Bustelli.
London £2,200 ($6,160) 23.V.67.
From the collection of the late Alfred E. Pearson, Esq.

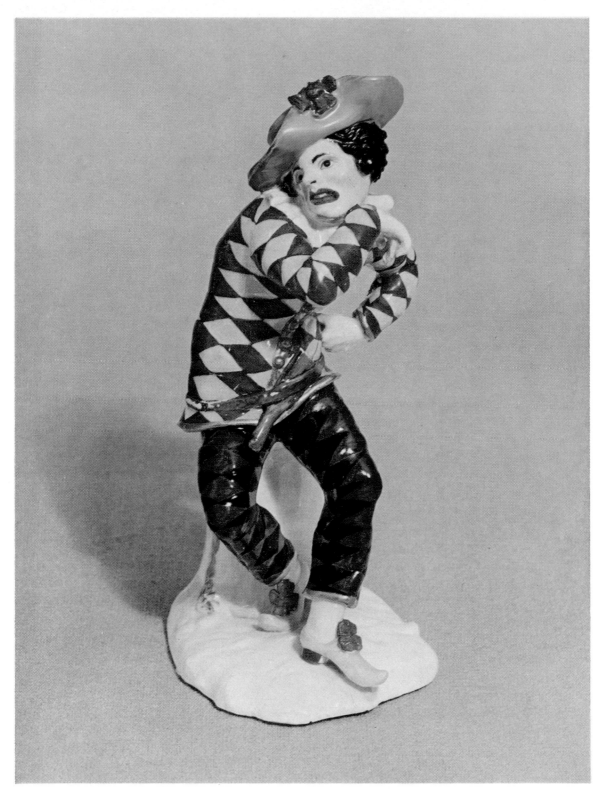

A Meissen figure of the Frightened Harlequin from the Italian Comedy,
by J. J. Kaendler.
London £4,800 ($13,440) 8.XI.66.

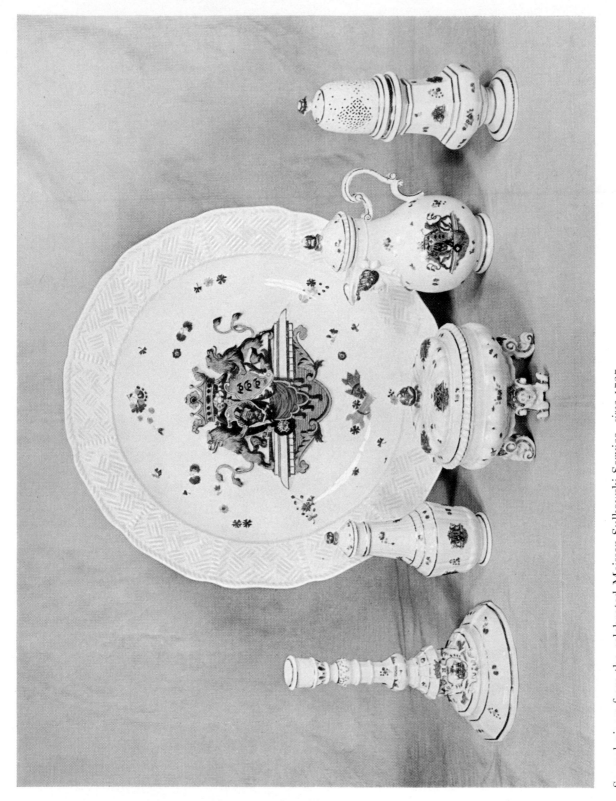

Several pieces from the celebrated Meissen Sulkowski Service, *circa* 1737.
The above illustrated items realised as follows:
One of a pair of Armorial Candlesticks £2,600 ($7,280); Flask and Cover £1,100 ($3,080); Large Dish £2,600 ($7,280);
Sucrier and Cover £1,700 ($4,760); Milk Jug and Cover £1,500 ($4,200); Sugar Caster and Cover £1,500 ($4,200).
The Service was sold at Sotheby's on the 23rd May, 1967 for a total of £21,935 ($61,418).

from the celebrated Meissen Sulkowski service had been dispersed to various purchasers a few minutes previously. These thirty pieces were survivors from the first great armorial service privately commissioned from the Dresden factory and no doubt, as the catalogue pointed out, 'inspired Count Bruhl to even greater baroque magnificence in his Swan service, whose major pieces Kaendler was designing in the summer of 1737—by which time deliveries of the Sulkowski service were complete, although extra pieces were already on order.' Graf Alexander Joseph von Sulkowski (1695–1762) was a Pole who went to Dresden as a page, found favour with Augustus the Strong and was put in charge of porcelain deliveries to the Japanese Palace until dismissed in 1738. The joint arms of himself and his wife are found on the service; the rarer lots went for £2,600 each, a noble circular dish just under eighteen inches in diameter (bought for the Victoria and Albert Museum) and a pair of table candlesticks—two out of the original twenty-eight—while another pair made £2,000, and a second, smaller dish, £1,900.

However, the highest prices of the season for anything in which Kaendler had a hand had already been obtained two months previously, when a pair of swans, modelled by J. J. Kaendler and Peter Reinicke, 1747, mounted in Louis XV ormolu to form two five-branch candelabra, the property of the Duke of Fife, and inherited from Princess Arthur of Connaught, made £23,000 and an Italian Comedy group of Harlequin and the Quack Doctor £13,000. The same morning a Meissen tankard and cover painted by Höroldt went for £3,200, and another, silver mounted, for £3,500.

The great rarity of the biscuit figure of Cupid after Falconet on a *rose pompadour* base already mentioned was given additional emphasis in the spring of this year when a pair of Cupid and Psyche, each on *bleu-de-roi* bases, came under the hammer and were sold for £950.

At the end of the season, in a deceptively modest sale, there was something for everybody and several exceptional rarities, including a delicately flamboyant Italian porcelain dish from the Doccia factory painted by Carlo Anreiter after an engraving by Jacopo Ligozzi. Six other dishes and a plate from this series are recorded, three of them in the Metropolitan Museum, New York. Colours were exceptionally attractive—the man in red headdress, puce coat lined in lime-green, blue trousers and yellow shoes; landscape background, flower sprays round the rim and a somewhat unlikely goose beside him. This went for £2,000. Another unusual lot was a pair of Louis XV ormolu-mounted candelabra, Chinese Dogs of Fo, reign of Kang Hsi, their turquoise bodies splashed with aubergine and seated beneath ormolu trees bearing Vincennes flowers,—what made this pair out of the ordinary were the plaques on the bases, not the familiar Sèvres, but Arita porcelain with pine, prunus and bamboo. They were bought for £1,450. A Meissen coffee service painted with various ore-mining figures, twenty-two pieces, each piece showing a miner doing a particular job and each with a hat with A R monogram (for Augustus Rex) went for £3,300. Whatever the faults of the Saxon Monarchy, it was proud of its miners. A marriage between German porcelain and French ormolu was celebrated earlier in the morning—two

seated swans on Louis XV ormolu scroll bases each with a tall tuft of ormolu bulrushes rising behind supporting a Meissen covered bowl, the rims mounted with pierced ormolu wreaths, the knops as fruit sprays, and the porcelain painted with a Kakiemon pattern, dragons, phoenix and flowers. In spite of the loss of one bowl the pair made £1,500. A good deal more unusual, indeed something of an oddity, was a Meissen tea kettle, Augsburg decorated, the spout a phoenix head, the handle formed as entwined dolphins, the body painted with gay little chinoiserie feasting scenes, which sold for £500.

At Parke-Bernet a jug in the form of a bird in Marseilles faïence was sold for $1,300 (£464), another for $900 (£321)—both about 1770—and a Moustiers faïence covered tureen and stand, painted with flowers, birds, animals and grotesque figures in green and orange, for $1,600 (£571), while a pair of 18th-century dishes and stands, each dish moulded as large leaves, the covers formed as pike carrying smaller fishes in their jaws made $1,300 (£464).

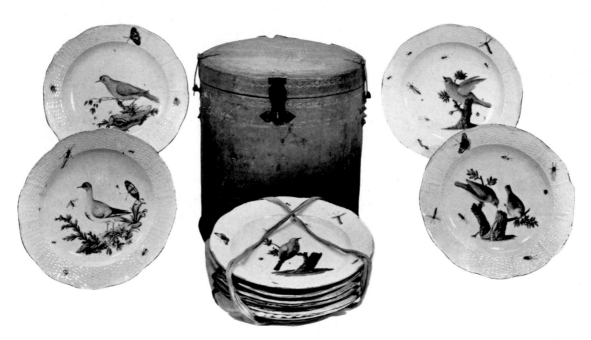

A Meissen Travelling Service of twenty-three Ornithological Plates, in a contemporary French leather travelling case.
London £3,500 ($9,800) 8.XI.66.
From the collection of Mrs J. Davies.

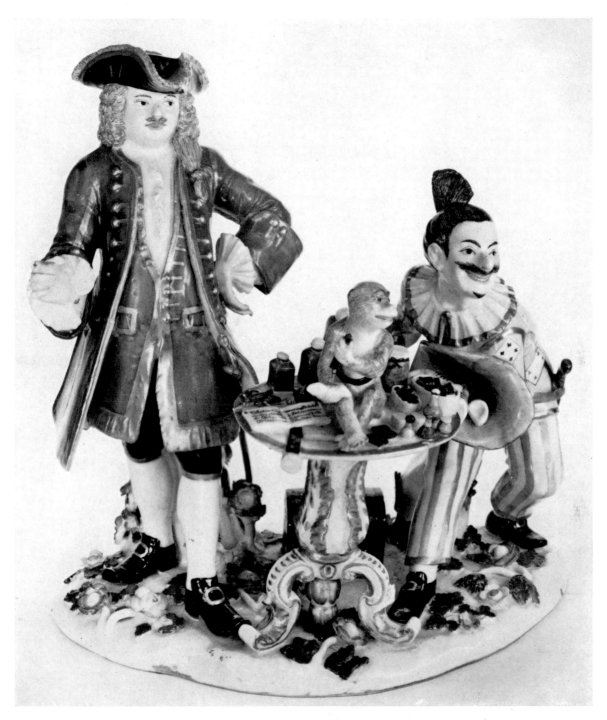

A Meissen Group of Harlequin and the Quack Doctor, by J. J. Kaendler.
London £13,000 ($36,400) 14.III.67.

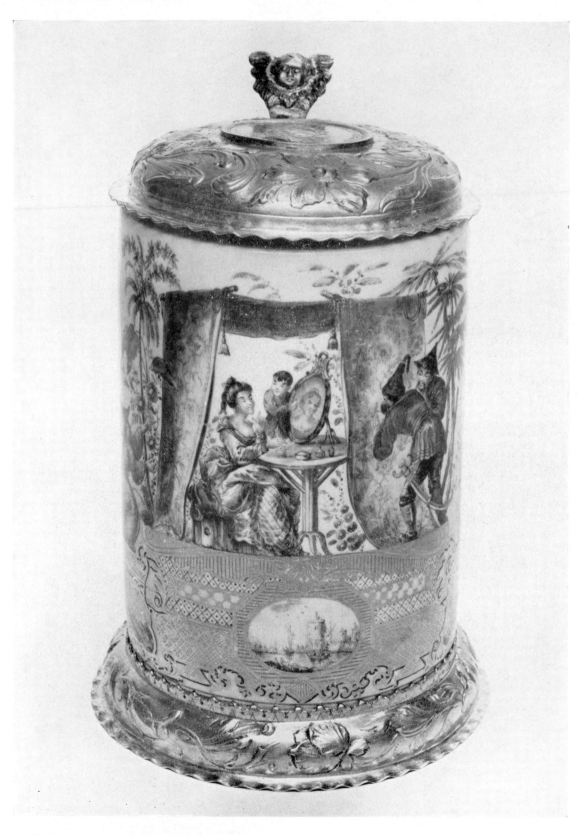

A Meissen Tankard with silver-gilt Mounts.
London £3,500 ($9,800) 14.III.67.

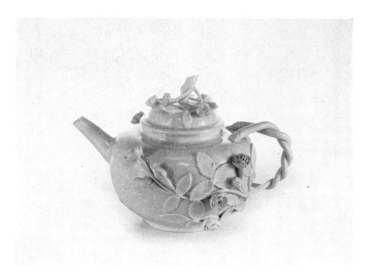

A Böttger Meissen White Teapot and Cover.
London £700 ($1,960) 14.III.67.

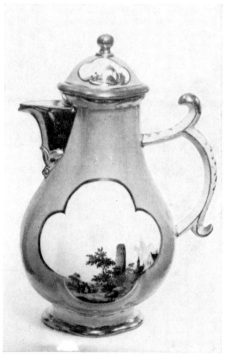

A Meissen green-ground Coffee Pot
and Cover. Height 9 in.
London £1,050 ($2,940) 14.III.67.
From the collection of Sir Charles
Shuckburgh, Bt.

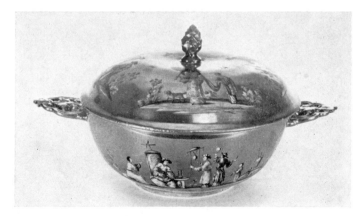

A Meissen gold-ground covered Tureen.
London £1,000 ($2,800) 14.III.67.

285

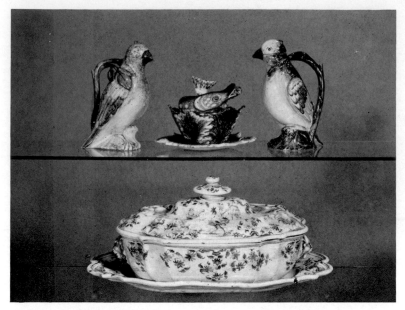

*Above left*   A Marseilles Faïence Bird Jug, *circa* 1770.
New York $900 (£321) 6.I.67.
*Centre*   A Polychrome Delft Pike Dish and Stand (one of a pair),
18th century.
New York $1,300 £(464) 6.I.67.
*Right*   A Marseilles Faïence Bird Jug, *circa* 1770.
New York $1,300 (£464) 6.I.67.
*Below*   A Moustier Faïence Covered Tureen and Stand, *circa* 1750
New York $1,600 (£571) 6.I.67.
All from the collection of the late Edith Wetmore, New York.

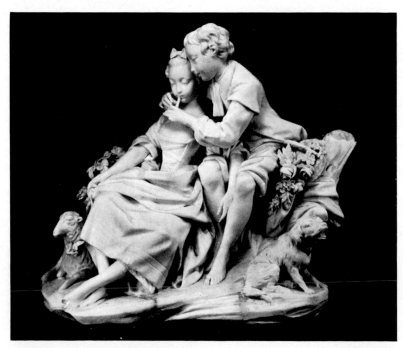

A Vincennes Biscuit Group of 'La Lecon de Flute' after Boucher.
London £860 ($2,408) 14.III.67.
From the collection of Wilfred J. Sainsbury, Esq.

286

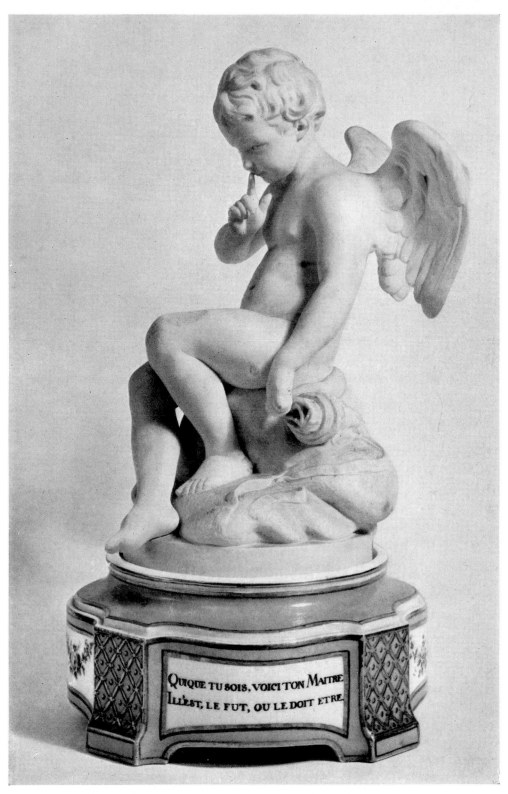

A Sèvres Biscuit Figure of Cupid on a 'Rose Pompadour' Plinth,
after a model by Falconet.
London £5,200 ($14,560) 8.XI.66.
From the collection of the Hon. Jack Michelham.

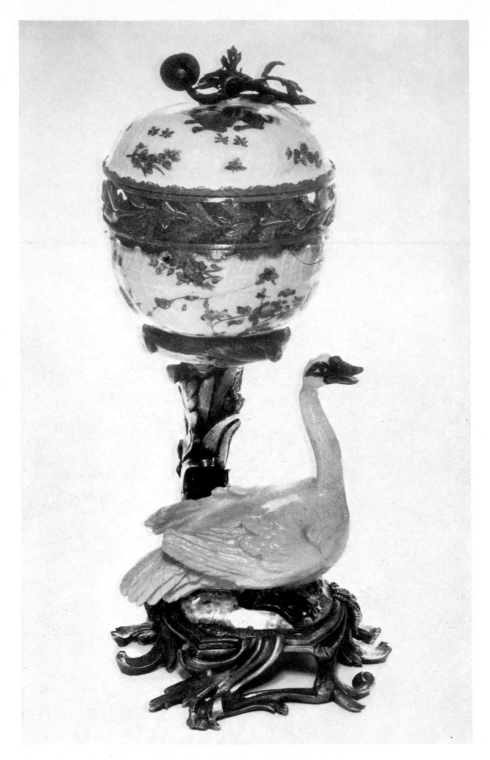

One of a pair of Louis XV Ormolu Mounted Meissen Swans.
Overall height 10½ in.
London £1,500 ($4,200) 4.VII.67.
From the collection of Mrs F. M. E. Schlesinger.

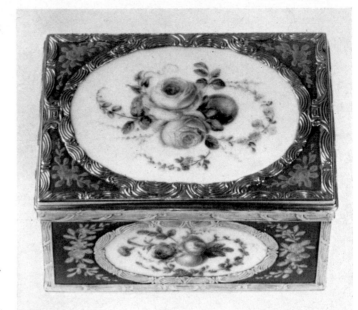

A Vincennes Apple-green Snuff Box,
mounts by Pierre Croissant, Paris 1744.
London £6,000 ($16,800) 23.V.67.
From the collection of the late
Alfred E. Pearson, Esq.

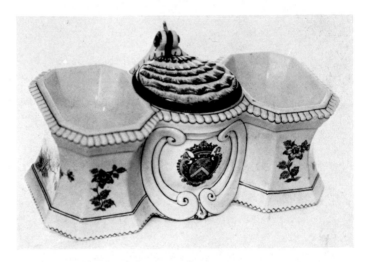

One of a pair of Chantilly Armorial
Double Salt and Pepper Boxes,
Length 6¼ in.
London £780 ($2,184) 4.VII.67.
From the collection of
C. H. Astell, Esq.

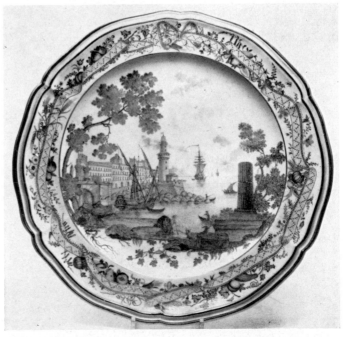

A Capo-Di-Monte Topographical Dish.
London £1,150 ($3,220) 23.V.67.
From the collection of G. Dreyfus, Esq.

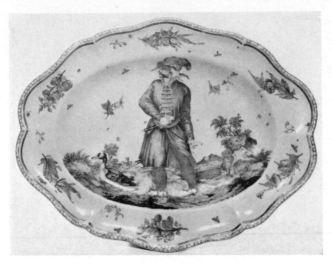

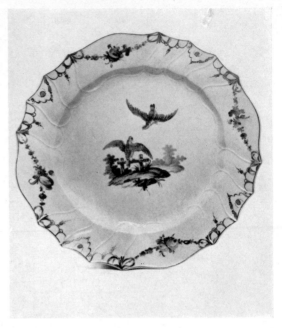

A Doccia Oval Dish, painted by Carlo Anreiter,
with the figure of a Caramanian Turk after a series
of engravings by Jacopo Ligozzi. Diameter 12⅛ in.
London £2,000 ($5,600) 4.VII.67.
From the collection of Miss Muriel Smith.

A Hague Ornithological Dessert
Plate (from a Dessert Service
comprising four oval Dishes, six
saucer Dishes and twenty-four Plates).
London £1,100 ($3,080) 8.XI.66.
From the collection of
Henry Nyburg, Esq.

A Dutch Delft Plate inscribed in the centre *Sabbath* in Hebrew.
Diameter 9 in.
London £460 ($1,288) 18.V.67.
A Nymphenburg Jewish Tray inscribed with the prayer for
biscuits and fruit in Hebrew and German.
London £1,400 ($3,920) 18.V.67.
Both from the collection of the late Madame Alexandrine de
Rothschild.

# Irish Silver

by Kevin Tierney

There is still much vagueness about Irish silver because little has been written about it. At least two books are in the process of being written, the first a general history, the second a particular study of hallmarks. Jackson's work on Irish goldsmiths has not as yet been revised, while his work on nearly all other areas of silver production has been constantly brought up to date by further research, so it seems likely that many new facts wait to emerge, some of which may contradict his attributions. This article makes no attempt to disprove accepted theories but merely lists some interesting articles sold this season in the hope of showing how rich the field is.

A copy of the Ardagh Chalice was a reminder that the great period of Irish silver production was less the 18th century than the Middle Ages from about 800 to 1200. The Ardagh Chalice was dug up in 1868 and showed a remarkable combination of engraving, filigree, cast and enamel work, which Jackson discusses at length in Vol. I of 'The History of English Plate'[1]. Its discovery inspired many copies that now decorate sideboards filled with fruit, and was used as a source of decoration for much silver in the early 20th century.

Little silver was made in Ireland from the early Celtic period until about 1700 owing to the unsettled state of the country. It reappears as a confident version of the Huguenot fashion current in England, showing a preference for certain types of articles, salvers on foot, strawberry dishes and cups with harp-shaped handles. Several good examples of such articles were sold during the season, including a particularly attractive small strawberry dish, $4\frac{1}{2}$ inches diameter, made in 1719 (see illustration) the sides of which were ribbed into twelve panels. The popularity of plain early 18th century shapes was shown in its price of £470, a figure it reached in spite of having no maker's mark. Just as plain and more rare were four plates, $11\frac{1}{2}$ inches diameter, made by Joseph Walker in 1708 (see illustration). They had been given to a Dublin Meeting House in 1709 presumably for use as alms plates, and being for a non-conformist institution bore no religious engraving beyond the recording of their gift, a fact that probably aided their price of £2,850.

Irish craftsmen seldom followed English designs exactly and often produced highly individualistic interpretations. A caster by Thomas Bolton made in 1704 (see illustration) followed a form not usually found in English silver. The body was of an elongated and inverted pear shape with spreading foot, probably based on a Chinese porcelain vase. The piece was early for a pear shape in casters, many of which in 1704 still followed the cylindrical 'lighthouse' form. When the pear shape does occur

[1] History of English Plate, by Charles James Jackson, in 2 Vols., Country Life Ltd. and R. T. Batsford, London, 1911.

at this date it is usually not inverted, a design which is much harder to manipulate successfully. The price of £580 reflected its attractiveness.

All provincial Irish silver is scarce and pieces from Kinsale particularly so. A Kinsale pint mug by J. or W. Wall made *circa* 1710 (see illustration) was therefore of particular interest, and was probably the most important piece of plate from Kinsale to come on the market since the sale at Sotheby's in 1929 of the Panter Collection which included the Kinsale Corporation plate. In shape the mug followed the standard tapered cylindrical form with moulded foot and scroll handle, but was engraved with armorials within an elaborate cartouche of scrolling foliage typical of Cork work in the early 18th century. Kinsale is only some 15 miles from Cork and it is quite likely that the same engravers did duty for both places. A feature of Cork engraving is the continuance of the spray of scrolling foliage into a full circle or spiral not unlike a snail shell, while the leafage itself has a ragged edge (c.f. a Cork snuff box by Robert Goble (lot 94 May 18)). The maker's mark of J. or W. Wall had been overstruck with another, the initials S.V., which have not yet been traced.

Irish silver of the rococo period is generally regarded as being the fullest expression of native forms. By the 1750's the helmet-shaped cream jugs, the circular sugar bowls on three supports and dish rings were standard productions, which are not generally found in England. It is often stated that the rococo period came late to Ireland, that flat-chasing is not found before 1740 and repoussé work does not occur before the mid 'fifties. A coffee pot by Christian Locker (lot 53 May 18) therefore posed a problem. Though it carried no date letter the shape of the Hibernia and Harp marks as well as the shape of the pot itself suggested a date in the 'forties and yet the surface was finely chased in relief with shells, scrolls, flowers, dolphins and bearded masks. Similar decoration was cast in the spout and handle terminals so that any theory that the chasing may have been added at a later date must be dismissed, since the decoration on the body was a necessary part of the original design. Had the piece carried a date letter it would have presented strong evidence for the existence of repoussé work probably as early as 1745; one can only wait for a fully hallmarked piece to prove the point that this piece suggests.

Irish Rococo tended towards a bewildering and often unrelated mass of decoration —chinamen may jostle with shepherdesses, classical pillars cluster round windmills, flowers and vegetables mix with birds and animals all loosely knit together by scrolls and shellwork. Sometimes the chaser used his ornament to tell a story; a dish ring sold early this season showed an aggressive swan frightening away a small boy who had trespassed too near its nest and who was forced to seek safety behind a pillar. English chasing is never handled in this way. In the hands of a good chaser, Irish Rococo ceases to be eccentric and becomes a free and rhythmic composition full of interesting shapes and detail. A particularly good example is a punch bowl by John Williamson, made about 1760 (see illustration). The bowl is chased with a wide band of scrolls, flowers, fruit and shellwork on a matted ground enclosing two scenes and two cartouches. It is sometimes said that the essence of rococo silver design is assymmetry. This statement needs some qualification: the aim of the rococo craftsman

A George I Irish Strawberry Dish, Dublin 1719.
London £470 ($1,316). 6.IV.67.
From the collection of J. W. D. Mellor, Esq.

A Queen Anne Irish Caster, by
Thomas Bolton, Dublin 1704.
London £580 ($1,624) 6.IV.67.
From the collection of
R. P. Powell Esq.

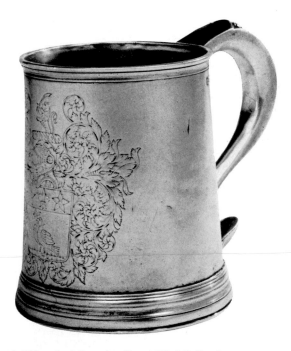

A Kinsale Mug, by J. or W. Wall, *circa* 1710.
London £340 ($925) 6.IV.67.
From the collection of Mrs D. V. Walker.

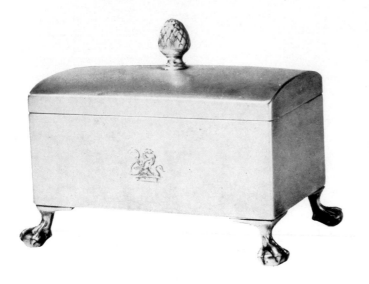

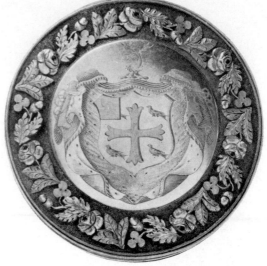

An Irish Sugar Box and Cover, by
Bartholomew Stokes, Dublin *circa* 1765
London £550 ($1,540) 6.IV.67.
From the collection of Mrs L. M. Thrale.

A Georgian Irish Freedom Box, by
Edward Murray, Dublin 1822.
London £520 ($1,456) 18.V.67.

was to make a conceit of symmetry, to delight the eye with his ingenious play on the normal rules of symmetry, without distorting proportion. Thus Meissonnier's design for a candelabrum[2]—perhaps the best single example of rococo silver design—still follows the standard proportions of an 18th-century candlestick and fulfils its function logically. In the case of the bowl one cartouche had been engraved with armorials (deleted at a later date); the complementary cartouche on the other side did not, as one might expect, carry a crest, but is engraved with a sort of still life of shells and leafage now too rubbed to be clearly visible. These cartouches alternate with the two scenes. One shows a pair of gamebirds, pheasants or partridge, beaks joined, wings outspread, at the foot of a gnarled tree, which is itself a rococo motif. The other shows a swan preening its feathers on a calm pond, with a dolphin in the background, also a rococo motif. Like the cartouches, these scenes are used to break the restless movement of the overall design but remain linked by choice of subject to the general theme. Both the swan and gamebirds are typical of Irish chasing, but the dolphin is even more so. It occurs elsewhere on this bowl; with waved tail, its mouth spouting water, it curves round scrolls and shellwork.

Interest in surface decoration did not mean that proportion and line became ignored. A plain sugar box by Bartholomew Stokes (see illustration) was surprisingly made at about the same time as the punch bowl. Shaped rather like a cabin trunk with a pine cone finial and raised on four slightly splayed claw and ball supports it was plain except for an engraved crest. In fact the piece may have been intended for the chaser's hand and it is disturbing to think that, if decorated, it would have fetched far less than the £550 which was paid for it. The punch bowl, a more important piece, sold for the same price, underlining the market's preference for simplicity of design.

[2] Published in "le Livre des Chandeliers de Sculpture en Argent" by Juste-Aurèle Meissonnier and executed by Claude Duvivier, Paris, 1734-5, for the Duke of Kingston.

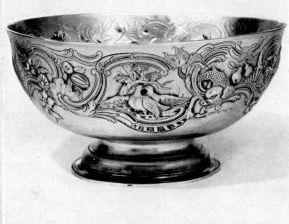

A Queen Anne Irish Circular Dish, by
Joseph Walker.
Dublin 1708 (one of a pair).
London £1,350 ($3,780) 3.XI.66.
From the collection of C. W. L. McCaw, Esq.

A George III Irish Punch Bowl,
by John Williamson, Dublin *circa* 1760.
London £550 ($1,540) 6.IV.67.
From the collection of Bernard
Gilpin Forman of Staffa.

From the end of the 18th century Irish silver tends to follow English designs more closely, though with infinite small variations which cannot be discussed in a short article. In one field above all, quality and individuality of style remained—in the production of freedom boxes. A circular freedom box by Edward Murray made in 1822 (see illustration) was engraved with the arms of the recipient and those of Trinity College, Dublin. The former was enclosed within a finely chased band of shamrocks, roses and oakleaves. The quality of this box both in design and execution was much higher than one expects at this period, which was marked by a return to rococo ornament that can result in insipid forms and lifeless chasing. The price of £520 caused some surprise, particularly as the arms of the recipient had not been traced, and was in fact more surprising than the sum of £1,550 for a gold freedom box made by David King in 1733 (lot 91 May 18), a much greater rarity.

Few new ideas in Irish design emerge during the 19th century until the revival of Celtic ornament, which was given impetus by the finding of the Ardagh Chalice. When this decoration is married to other styles current at the time the result is not often very satisfactory, but used as a border to plain designs can be pleasing. A modern octagonal tray (lot 72 April 6) had a border of Celtic inspiration formed of cast panels of entwined serpents, the centre being engraved to match. It sold for less than £1 per ounce, while a copy of a dish ring made about the same time but far less interesting stylistically, sold for close to £4 10s 0d per ounce. This preference for an 18th-century copy was as strong in the early years of this century as today and largely explains the lack of interesting designs in modern Irish silver.

# Silver

The combination of fine workmanship, the name of a famous maker and a romantic but true story proved an irresistible market attraction when a pair of silver gilt wall-sconces of about 1725 by Paul de Lamerie—that is, from fairly early in that great man's career—came up in May this year. They were well known and unusual examples of de Lamerie's work and were illustrated by P. A. S. Phillips in his life of the most consistently successful of the Huguenot silversmiths. They were formerly in the collection of Florence, Lady Trent, and were in her house in Jersey when the Germans occupied the Channel Islands in 1940. There was no time to remove them. Her chef though refused to cook for the invaders and was demoted to stoker, thereby assuming seignorial rights over an ashtip at the bottom of the garden. He was able to wheel away these sconces and other silver beneath the ashes and then to hide them in a well in the greenhouses. He was still in charge when the war ended and was able to retrieve them and replace them in their usual position by the time their owner returned to her house. Everyone knew they would fetch a considerable sum; not many guessed they would be sold for as much as £23,000. Thanks to the sconces several other things on this occasion which would have earned more space in the newspapers the following morning, received little notice, chief among them a dignified James II ewer and a 21½-inch diameter sideboard dish of 1686, inscribed 'The Gift of Sr. Tho. Wagstaffe and Frances his Wife to Edw. Bagot, Esqr. and his wife, ye 15 Apr. 1697', i.e. a wedding present to their daughter and her husband. The two, sold together, made £9,800. It so happened that in this sale about a dozen pieces were sold of which previous auction prices were available. In the Craven sale in 1961 a pair of two light candelabra by John Schofield, 1783, made £3,600 and now went for £6,200. A six-ounce wine cup of 1671, bought in 1952 for £180, sold for £1,400; a gold Irish Freedom Box, Dublin, 1733, by David King made £1,550 as against £490 in 1959. An out-of-the-ordinary racing trophy was a dignified neo-classic silver gilt punch-bowl—boldly modelled rams masks, grape vine swags etc.—and with the arms of the City of Chester engraved below. The maker was Thomas Heming, 1771, and there was an inscription 'Chester Plates Won by Fop in The Years 1769 and 1770'—a fine thing of its kind which made £6,000. If there is great magic in the name of de Lamerie, there is, for some odd reason, minor magic in that of Hester Bateman; anyway, odds and ends bearing her mark appear to command higher prices than pieces by her contemporaries. £670 was paid for three pretty but not extraordinary mustard pots by her, and £460 for a boat-shaped inkstand—all from the 1780's. Rather more exciting—perhaps endearing is a better word—was a travelling set in a brass-bound mahogany case containing pretty well everything a civilised man could require when away from home. Two coffee pots, soufflé dish, shaving brush holder, knives, forks, razors, and a pair of cut glass silver mounted inkwells etc. All the contents are by a variety of Paris makers of about 1810. The box and its contents last appeared at Sotheby's in 1925 and was bought for £140 10s. It now made £1,100.

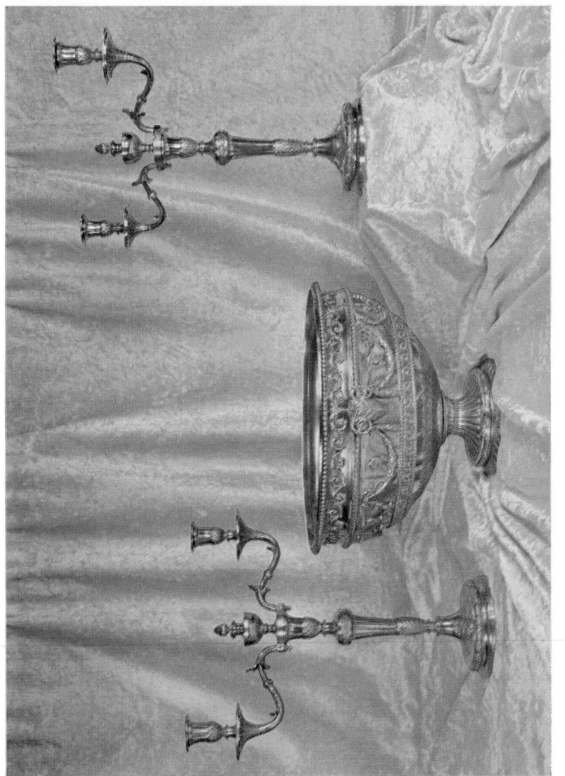

Chester Plates, 1769 and 1770. A George III Silver-gilt Punch Bowl, by Thomas Heming, 1771.
London £6,200 ($17,360) 18.V.67.

A Pair of George III Silver-gilt Candelabra, by John Schofield, 1783.
London £6,000 ($16,800) 18.V.67.
Formerly in the collection of Cornelia, Countess of Craven.

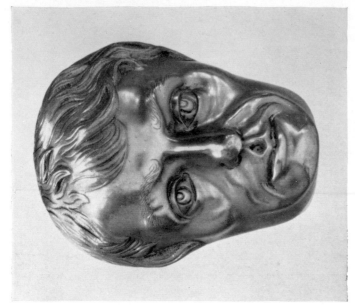

A George III Silver-gilt Snuff Box formed as the full-face mask of Horatio Nelson, *circa* 1805. London £650 ($1,820) 18.V.67.

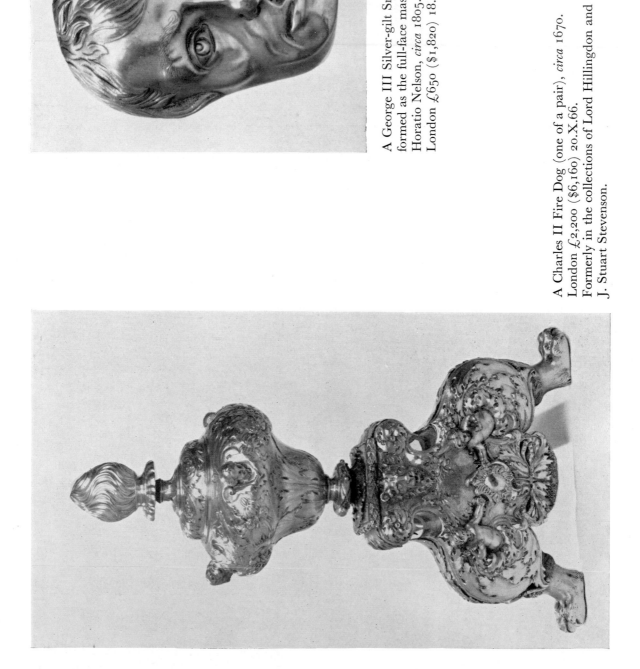

A Charles II Fire Dog (one of a pair), *circa* 1670. London £2,200 ($6,160) 20.X.66. Formerly in the collections of Lord Hillingdon and J. Stuart Stevenson.

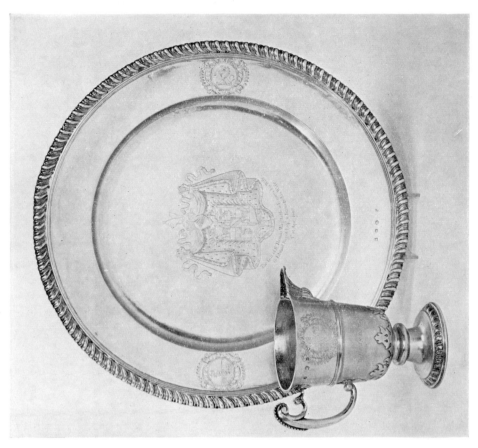

A James II Ewer and Sideboard Dish, 1686.
London £9,800 ($27,440) 18.V.67.
From the collection of the Rt Hon. Lord Bagot.

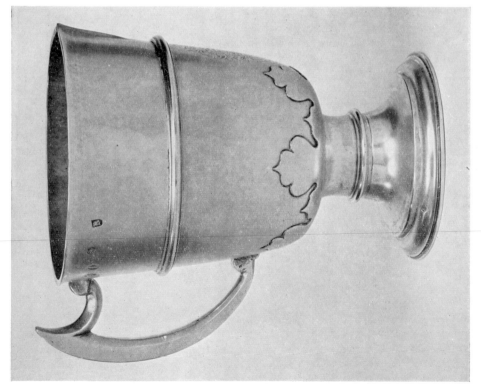

A Charles II Bell-shaped Ewer, 1674.
London £4,000 ($11,200) 18.V.67.
From the collection of the Rt Hon. Lord Bagot.

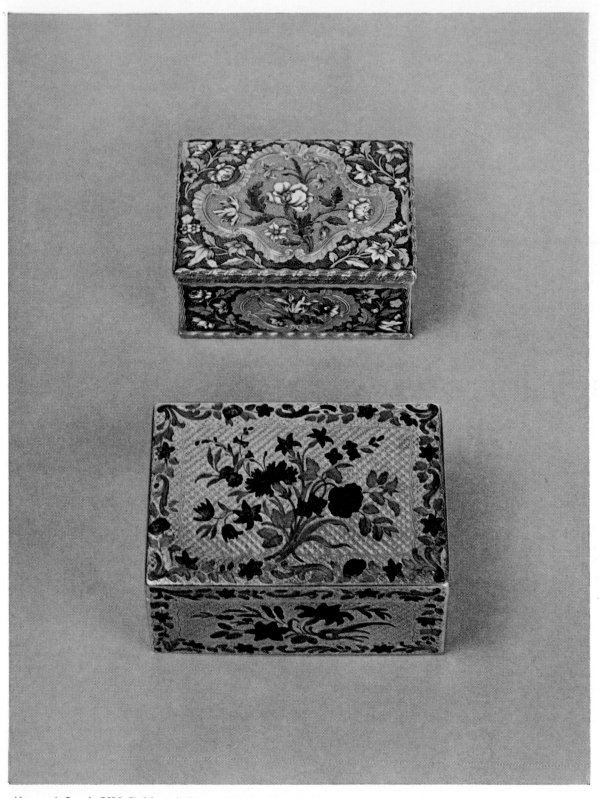

*Above*   A Louis XV Gold and Enamel Tabatière, by Jean Moynat.
London £10,500 ($29,800) 12.XII.66.
*Below*   A Louis XV Gold and Enamel Snuff Box, Paris 1752.
London £6,200 ($17,360) 12.XII.66.

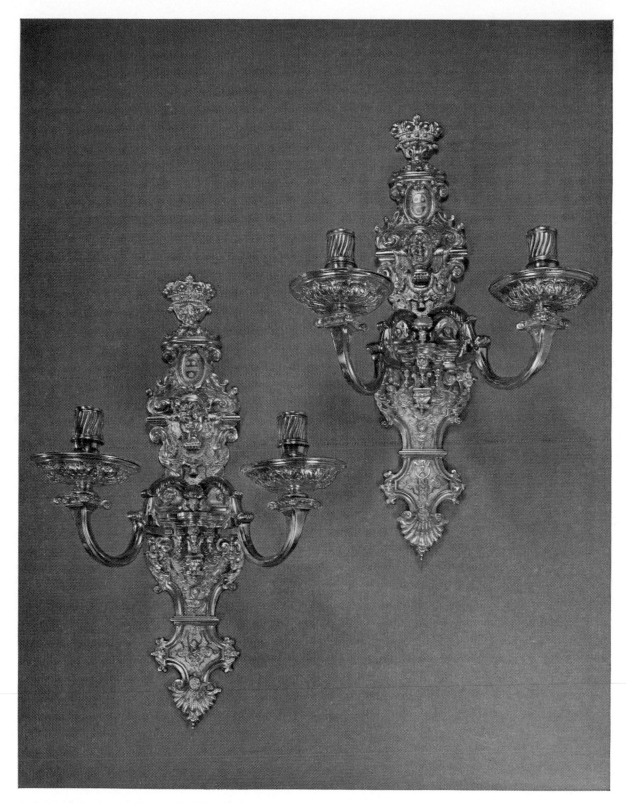

A Pair of George I Silver-gilt Wall Sconces,
by Paul de Lamerie, *circa* 1725.
London £23,000 ($64,400) 18.V.67.
From the collections of J. A. Mango, Esq., Florence Lady Trent,
and the Hon. Mrs A. M. Holman.

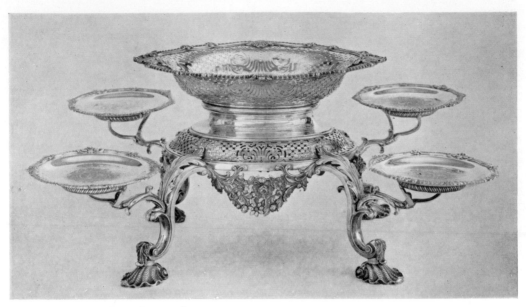

A George II Wrought Silver Épergne, by Edward Wakelin, London, 1754.
New York $5,250 (£1,875) 27.I.67.
From the collection of the late Sarah Mellon Scaife, Ligonier, Pennsylvania.

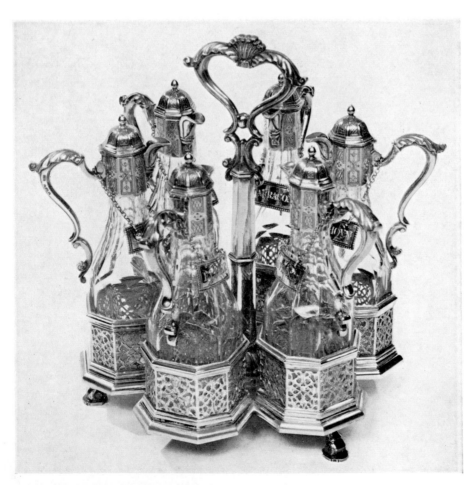

A Georgian silver-gilt Cruet-Frame (one of a set of four),
by Philip Rundell, 1822, the labels probably by John Robins,
also 1822.
London £2,600 ($7,280) 20.X.66.

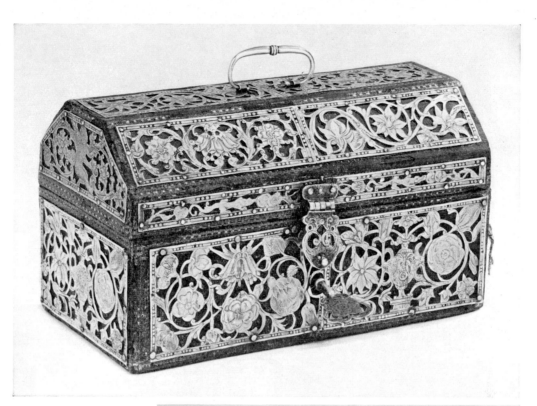

A Charles II Toilet Casket,
*circa* 1660.
London £1,050 ($2,940)
20.X.66

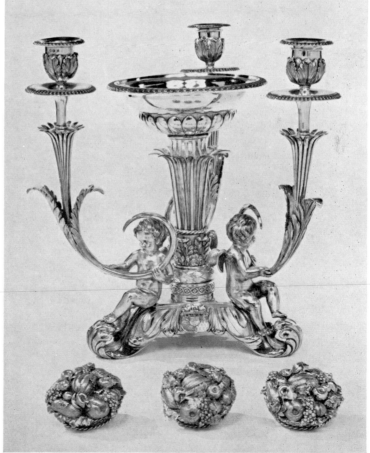

A George III silver-gilt
Épergne (one of a pair),
maker's mark, P.C., 1810.
London £1,900 ($5,320)
23.II.67.
From the collection of the late
Viscount Clifden, K.C.V.O.

303

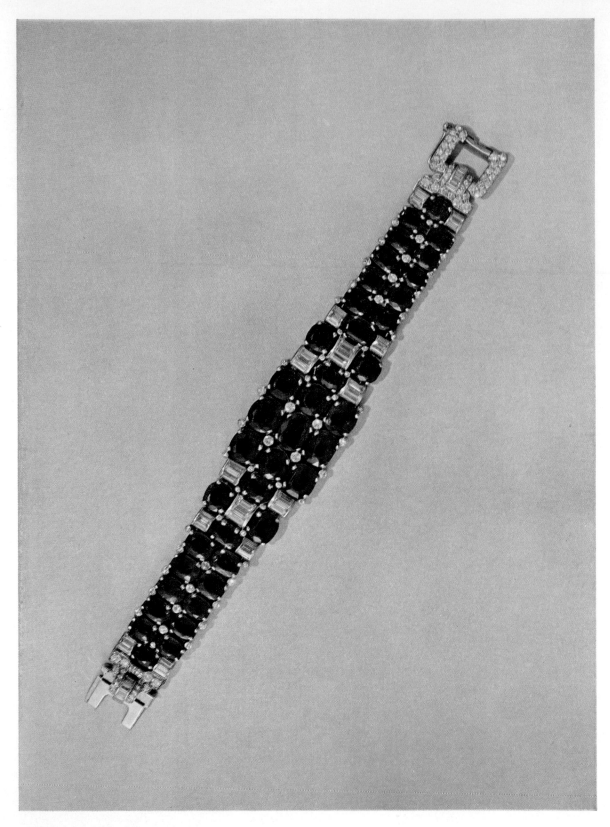

A Ruby and Diamond Bracelet.
London £19,000 ($53,200) 2.III.67.
From the collection of Mrs Michael Sieff.

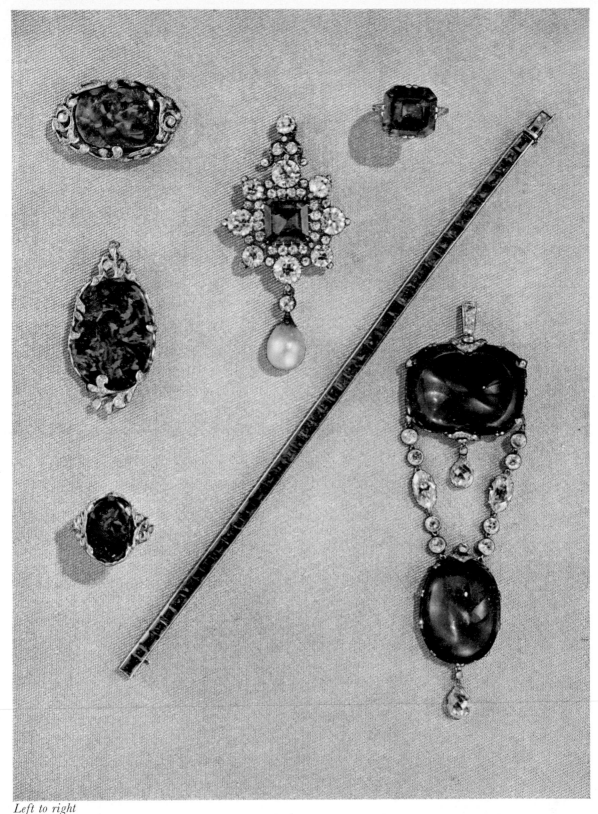

*Left to right*

An Opal and Diamond Brooch £2,500 ($7,000); An Emerald Pearl and Diamond Brooch/Pendant £8,800 ($24,640); An Emerald and Diamond Ring £5,800 ($16,240); An Opal and Diamond Pendant £2,200 ($6,160); An Emerald Bracelet £1,450 ($4,060); A Sapphire and Diamond Chatelaine Brooch/Pendant £7,000 ($19,600); A Black Opal and Diamond Ring £720 ($2,016).

The above pieces formed part of the collection of Jewellery belonging to the late Lady MacRobert, sold at Sotheby's on 9th February, 1967, for a total of £87,942 ($246,237).

# Jewels

While the well-established theory among gold diggers and other carnivores that, on the whole, diamonds are a girl's best friend still has many devoted adherents, one has to point out a very definite trend towards a greater interest in coloured stones. Examples are numerous; perhaps two will suffice. In October last a pair of sapphires weighing 46.52 carats were sold for £11,000, and in June a 7.70 carat emerald for £13,500. What can be described as outstanding jewels were such things as an emerald and diamond tiara sold by the Marquess of Reading for £15,500, and an antique diamond rivière belonging to the late Lady Katherine de la Poer Trench and her pair of pendant earrings which made £7,800 and £3,400 respectively. But the most interesting jewel sale of the season, though not of the most fashionable sort, was the collection which belonged to the late Lady MacRobert, who became famous during the last war for her courage in facing up to the most shattering personal tragedy. When the news was brought to her in 1941 that her third and last surviving son had been killed in action, she presented the R.A.F. with a bomber which she called 'MacRobert's Reply'. She followed this with four fighter planes, three of them called after her three sons, the fourth 'MacRobert's Salute to Russia'. She had led a very active life and long before this had established a considerable reputation as a geologist and mineralogist and had published several books. It was her great knowledge in this field of learning which determined the unusual character of her jewels. She was, for instance, interested in opals, and an opal pendant was sold for £2,200 and an opal brooch for £2,500. A necklace of beautifully graduated jade beads which the non-expert could easily mistake for emeralds, made £3,000, an emerald, pearl and diamond pendant £3,000, an emerald ring £5,800, an emerald, pearl and diamond brooch £8,800 and a sapphire and diamond brooch pendant £7,000. Yet more unusual were two alexandrites. (Alexandrite—'a dark green chrysoberyl discovered on the day the Tsarevich, later the Tsar Alexander II, attained his majority'—a stone which has the curious quality of becoming red by artificial light due to its finely balanced chemical composition). A diamond mounted alexandrite pendant sold for £6,500; a ring, also an alexandrite, for £1,950. A month later Mrs. Michael Sieff's ruby and diamond bracelet made £19,000, and, in a sale in May, a diamond necklace for £12,000 and an antique necklace in emeralds and diamonds for the same sum, and a late 18th-century diamond brooch for £3,400. Early in June the late Lady Dovercourt's single-row pearl necklace was bought for £5,800 and at the end of the month a three-row pearl necklace for £7,200. This last sale was remarkable for an item of outstanding interest, this was a tiara in emeralds and diamonds understood to have been a wedding present from H.M. Queen Victoria to her sister-in-law, the Duchess Alexandrine of Saxe Coburg Gotha. She was the daughter of the Grand Duke Leopold of Baden and married Ernest II, Duke of Saxe Coburg and Gotha, elder brother of the Prince Consort, in 1842. This was sold for £25,000. The other was a necklace, presumably made for an Indian prince, designed as a succession of

emerald and diamond clusters, with an exceptionally large emerald in front and three cabochon emerald drops—£40,000.

At the other end of the scale it was interesting to see a Sir Walter Scott memorial ring sold for £20 instead of the normal £2 or £3 of a few years ago. There was, too, an item of sentimental interest—a diamond and emerald ring given by Florence Nightingale in 1904 as a wedding present to her housekeeper Miss Cochrane, in 1904—£100.

*Captions to page* 308.
A Star Sapphire Brooch.
New York $15,000 (£5,357) 6–7.XII.66.
A Star Sapphire Ring.
New York $8,750 (£3,125) 6–7.XII.66.
A Sapphire and Diamond Ring.
New York $29,000 (£10,357) 6–7.XII.66.
Diamond Birds in Flight Brooch.
New York $4,250 (£1,517) 6–7.XII.676.
An Unmounted Sapphire.
New York $47,000 (£16,785) 6–7.XII.66.
A Sapphire and Diamond Pendant Clip.
New York $38,000 (£13,571) 6–7.XII.66.
A Sapphire Ring.
New York $42,500 (£15,178) 6–7.XII.66.

*Captions to page* 309.
A Diamond Ring.
New York $132,500 (£47,321) 6–7.XII.66.
A Coloured Diamond Ring.
New York $16,000 (£5,714) 6–7.XII.66.
A Diamond Lavaliere.
New York $37,000 (£13,214) 6–7.XII.66.
A Coloured Diamond Ring.
New York $16,500 (£5,892) 6–7.XII.66.
A Diamond Heart Pendant.
New York $9,500 (£3,392) 6–7.XII.66.
A Cat's-Eye and Diamond Brooch.
New York $9,000 (£3,214) 6–7.XII.66.
A Cat's-Eye Ring.
New York $13,000 (£4,642) 6–7.XII.66.
A Coloured Diamond Ring.
New York $13,000 (£4,642) 6–7.XII.66.
These lots came from the collection of Jewellery belonging to the late Helen M. de Kay sold at Parke-Bernet in December, 1966 for a total of $1,115,605 (£398,430)

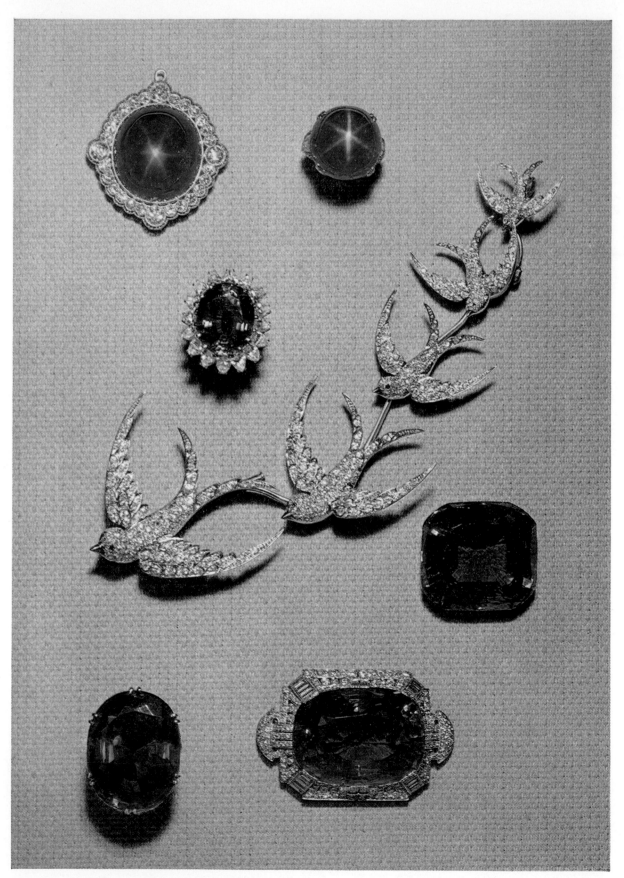

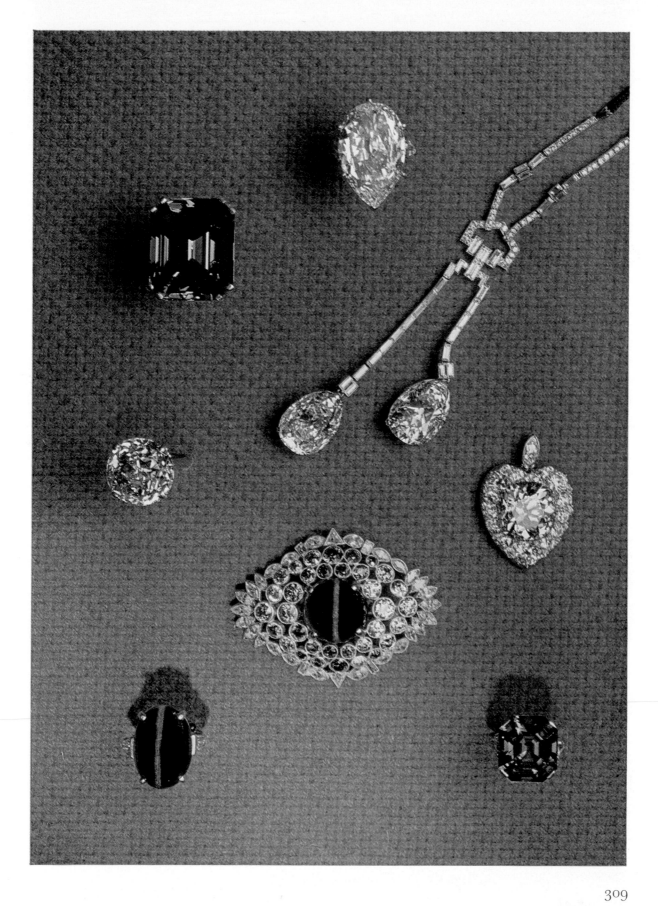

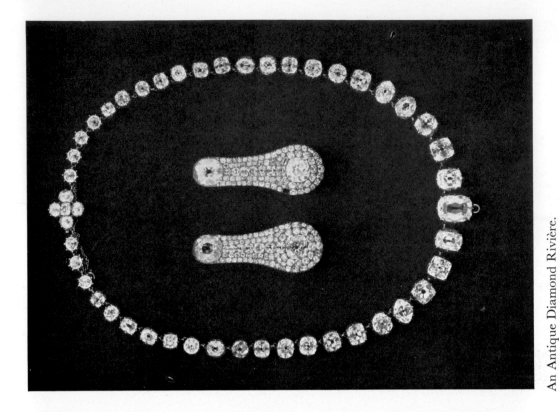

An Antique Diamond Rivière.
London £7,800 ($21,840) 8.XII.66.
A pair of Antique Diamond Pendant Earrings
adapted as Brooches.
London £3,400 ($9,520) 8.XII.66.
From the collection of the late Lady Katherine Le Poer Trench.

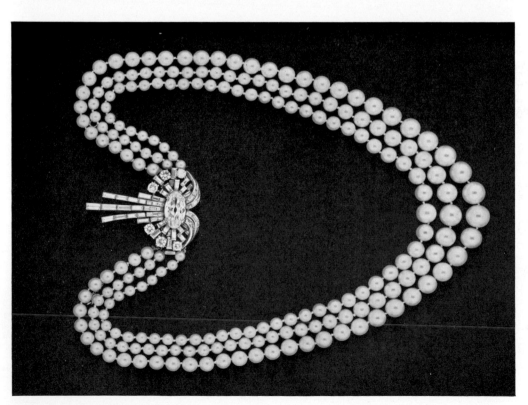

A Pearl Necklace, strung in three rows.
London £7,200 ($20,160) 29.VI.67.

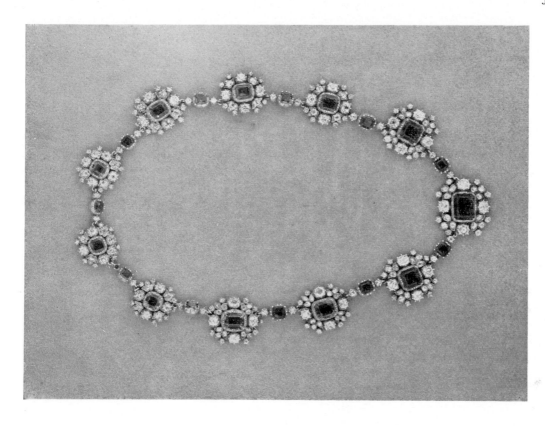

An Antique Emerald and Diamond Necklace, mid-19th century.
London £12,000 ($33,600) 4.V.67.

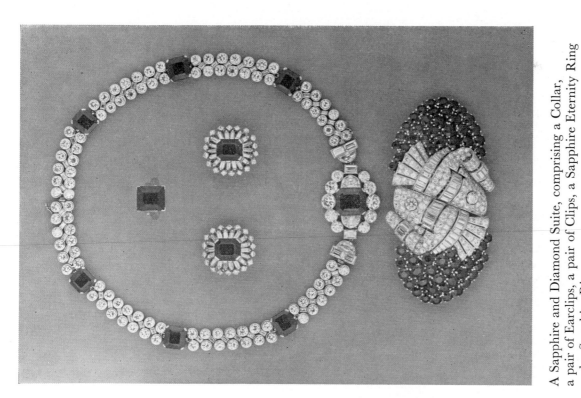

A Sapphire and Diamond Suite, comprising a Collar,
a pair of Earclips, a pair of Clips, a Sapphire Eternity Ring
and a Sapphire Ring.
London £7,900 ($22,120) 17.XI.66.
From the collection of the late Mrs John Dewar.

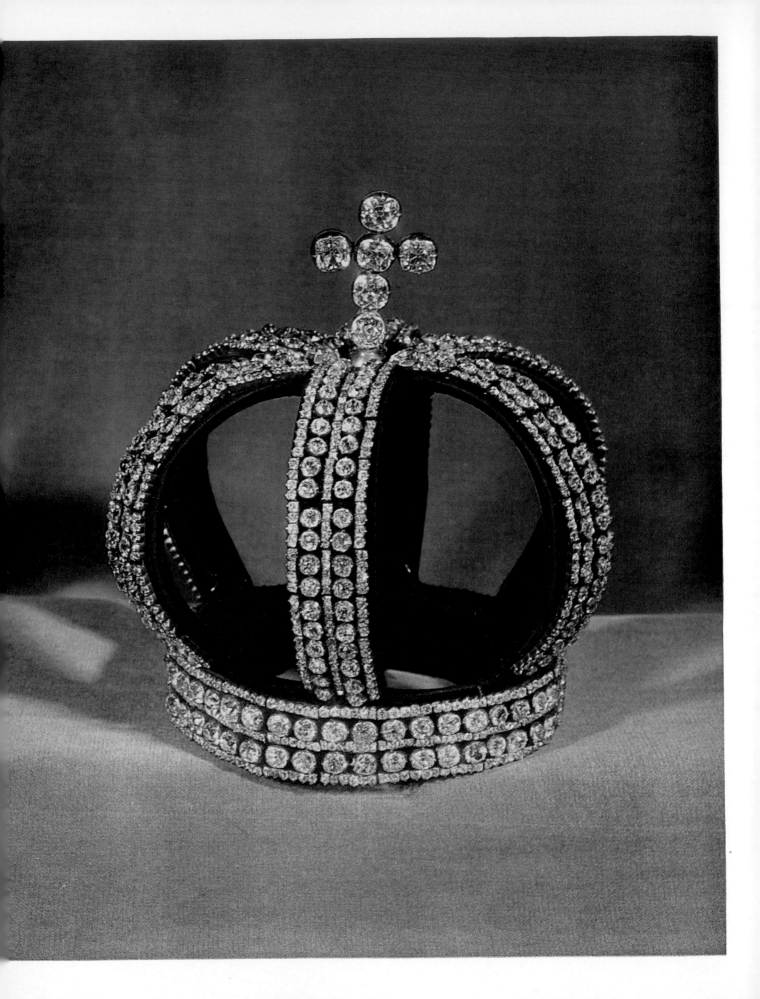

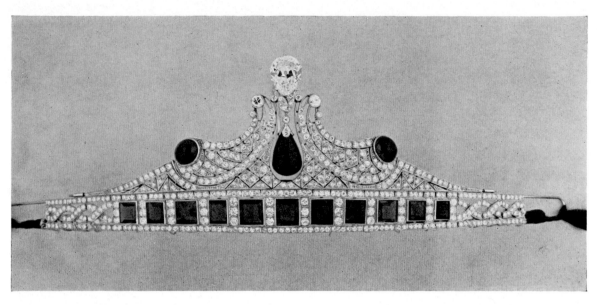

An Emerald and Diamond Tiara.
London £15,500 ($43,400) 13.X.66.
From the collection of The Most Honourable the Marquis of Reading.

An Emerald and Diamond Bracelet.
New York $39,000 (£13,930) 27.X.66.
From the collection of the late Ivy Lee Callender, New York.

*Facing page*:
An Imperial Russian Nuptial Crown.
New York $77,500 (£27,678) 6–7.XII.66.
From the collection of the late Helen M. de Kay.

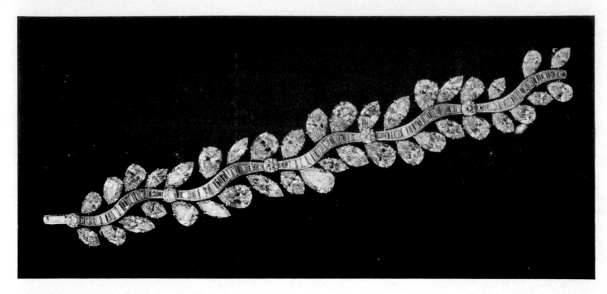

A Diamond Bracelet.
New York $75,000 (£26,783) 13.IV.67.
This bracelet won the Diamonds U.S.A. Award in 1956.
By Harry Winston.

Brooch in Sapphire and diamonds.
London £6,500 ($18,200) 13.X.66.

Pair of Sapphires.
London £11,000 ($30,800) 27.X.66.

An Antique Diamond Brooch, late 18th
century.
London £3,400 ($9,520) 4.V.67.
From the collection of Mrs Auriol S. Reid.

A Diamond Ring.
New York $32,000 (£11,428) 27.X.66.
From the collection of the late Ivy Lee
Callender, New York.

A Diamond Ring.
New York $33,500 (£11,964) 27.X.66.
From the collection of the Breyer Foundation

Emerald and diamond ring.
New York $17,000 (£6,071) 2.II.67

An Emerald Ring.
New York $14,000 (£5,000) 27.X.66.

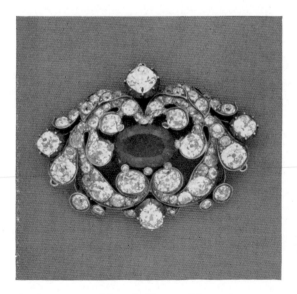

Antique emerald and diamond brooch.
Early 19th century.
London £2,400 ($6,720) 17.XI.66.

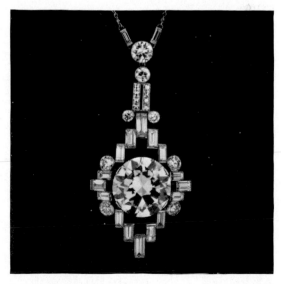

A Diamond Pendant.
London £10,200 ($28,560) 13.X.66.

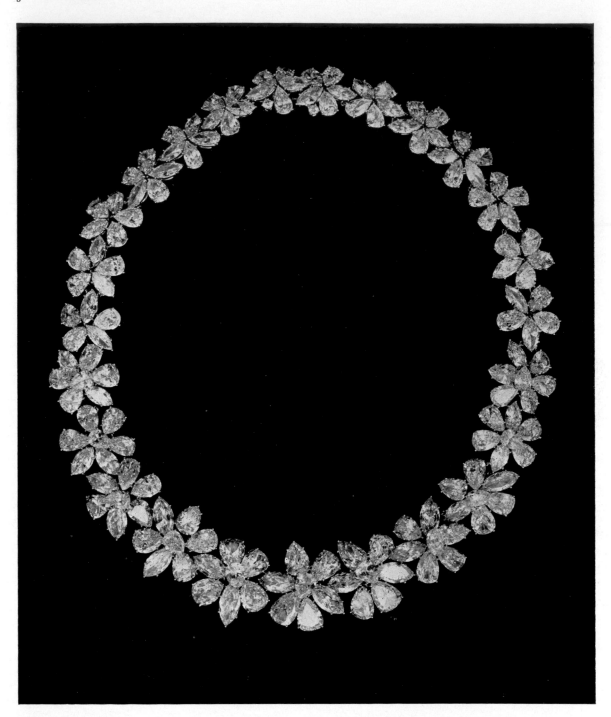

A Diamond Necklace.
New York $121,000 (£43,210) 13.IV.67.

# Snuff Boxes

by Ian Venture

The fashion for snuff-taking reached its height towards the middle of the 18th century and lasted throughout the century. This led to a very great demand for boxes of the highest quality for keeping this powder made from tobacco stalks. By the middle of the century the inherited skill, careful training and favourable social environment, resulted in the unlimited ingenuity achieved by the goldsmiths working in Europe. Every attention was given to great detail and perfection in the creation of these small objects just as it was in architecture and cabinet making of the same period. Although qualities and worth are assessed by comparisons, boxes of the highest standard are more greatly prized for their integral beauty. Condition and state of preservation are always material factors in the realisation of a high price, intrinsic worth having little bearing on the value as a work of art. Snuff-boxes have always been highly prized and as such have maintained high prices.

Among the more interesting snuff boxes which passed through the saleroom this season were such examples as a box by Jean Moynat, made in Paris in 1748 and decorated with sprays of spring and summer flowers against a chequered engine-turned gold ground, the spandrels with further sprays of flowers against a translucent green enamel background, which fetched £10,500; another fine box made in Paris in 1752, decorated with cornflowers, roses and carnations in blue and green basse taille enamel, fetched £6,200. A very unusual box made in 1798, by Joseph Etienne Blerzy, with allegorical scenes of the History of Rome from friezes from the Vatican, in *verre eglomisé*, realised £2,100. A box by Charles Le Bastier, made in 1768, with oval medallions of shepherds and shepherdesses, in the manner of Schindler, within borders of translucent green enamel trelliswork and Greek key patterns, fetched £2,200; and an outstanding four-colour gold box made by Jean Charles Ducrollay in 1761, sold for £3,100. Ducrollay was one of the finest box makers of his time and many examples of his work are to be found in the Louvre.

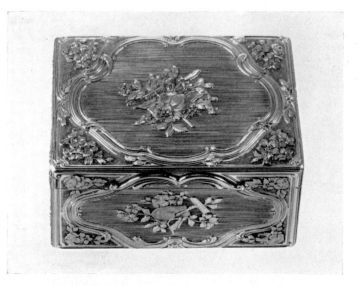

A Louis XV Four-colour Gold Snuff Box, by Jean-Charles Ducrollay.
London £3,100 ($8,680) 12.XII.66.
From the collection of Commander Colin Campbell-Johnston.

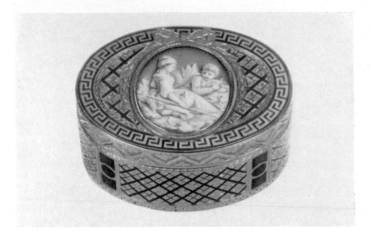

A Louis XV Gold and Enamel Snuff Box,
by Charles Le Bastier, Paris 1768.
London £2,200 ($6,160) 19.VI.67.

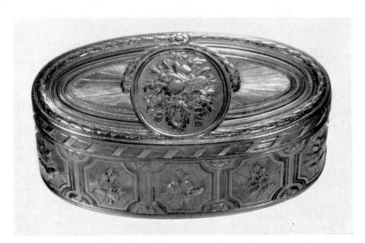

A Louis XV Three-colour Gold Snuff Box, Paris 1769.
London £1,400 ($3,920) 6.III.67.

A Staffordshire Enamel Candlestick
(one of a set of four).
London £880 ($2,464) 6.III.67.
From the collection of the Rt. Hon.
Lord Torphichen.

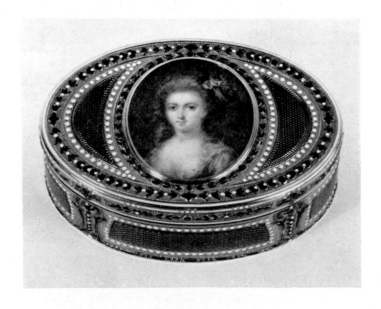

A Louis XVI Gold and Enamel Snuff Box,
by Revé-Antoine Bailleul, Paris 1778.
London £1,600 ($4,480) 3.VII.67.

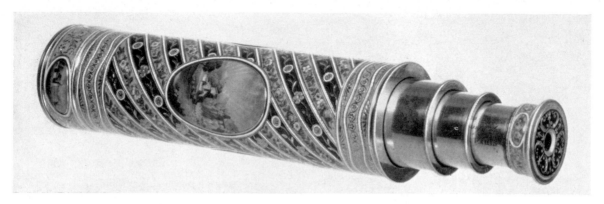

A Swiss Gold and Enamel Telescope, Paris, early 19th century.
London £700 ($1,960) 6.III.67.

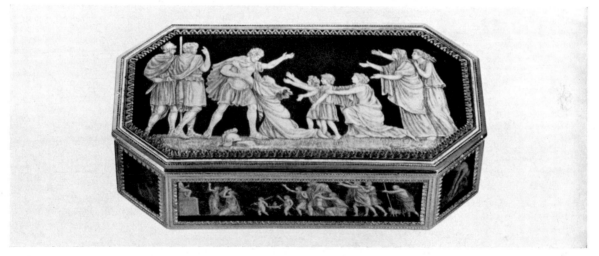

A Louis XVI Gold and Verre Eglomisé Tabatière,
by Joseph-Etienne Blerzy.
London £2,100 ($5,880) 6.III.67.

# Fabergé

Fabergé can be said to have been the inheritor of the French 18th-century tradition, to have given it a Russian accent, and to be today as popular as an international figure among a very wide circle of admirers as he was in his lifetime at the courts of Russia and Europe. He appealed exactly to the taste of his generation so that few Imperial and Royal occasions were complete without some ingenious gift from his busy work room. His little animals, his picture frames, his boxes and innumerable other odds and ends are always with us and always welcomed—more rarely the Easter Eggs he made for the Russian court. Recent examples from among dozens have been a three-inch high rock-crystal table, the rock crystal top centred with a circular opal mosaic, £1,500; an enamel and hardstone snuff-box set with diamonds £850; a gold and enamel miniature frame in the Louis XV manner, £520; and a silver and enamel desk clock, four inches square, £700.

A Fabergé Two-colour Gold Cigarette
Case, by August Hollming.
London £720 ($2,016) 12.XII.66.

A Fabergé Gold and Enamel
Miniature Frame, by
Johan Viktor Aarne.
London £520 ($1,596) 19.VI.67.
From the collection of
Miss A. L. Carr.

A Square Platinum Case entitled "Red, Hot and
Blue." Lid paved with diamond sunburst set with
diamonds, faceted rubies and sapphires.
From Verdura.
New York $4,000 (£1,429) 17.V.67.
From the collection of the late Cole Porter.

A Silver and Enamel Cigarette Case.
Lid engraved with gold letters and
a black enamel caricature depicting
George Kauffman, Moss Hart,
John Hoyt in the role of Beverly
Carlton and Monty Woolley as
Sheridan Whiteside in *The Man
Who Came to Dinner* (opened October
16, 1939). From Verdura.
New York $800 (£286) 17.V.67.
From the collection of the late
Cole Porter.

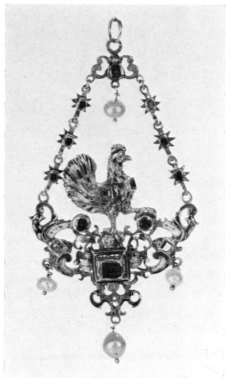

*Above left*
An English Gold and Hardstone
Nécessaire, *circa* 1760.
London £1,500 ($4,200) 12.XII.66.

*Above right*
A South German Renaissance
Enamelled Gold Pendant,
late 16th century.
London £2,800 ($7,840) 6.III.67.

An English Architectural Clock, by
James Cox. Signed. *Circa* 1760.
London £3,300 ($9,240) 3.VII.67.

# Furniture

One of the most entertaining pieces ever seen in an auction room came to Sotheby's in May 1967—a Louis XV *boite-à-dés*—a little five-inch-high ormolu-mounted kingwood box. The interior mechanism is loosely based on the repeating mechanism of a clock. Inside three dice revolve when either of two cords at the sides of the box are pulled. When the cords are released the dice rotate until all three are simultaneously locked. The box was stamped with a Louis Philippe château mark, its maker the clockmaker and scientific instrument designer Gallonde, working from 1737 to 1775. A similar example is recorded in an English private collection. This one realised £10,000. It was an item in a £423,644 sale of French furniture, tapestries and Mediaeval and Renaissance works of art, and was followed by another out-of-the-ordinary mid-18th century rarity—a pair of Japanese lacquer plaques which the French had becomingly framed in ormolu and which made £6,800. Another example of the manner in which an admired Far Eastern importation was embellished with ormolu mounts was seen a few moments later when a pair of Chinese celadon bowls, which had been made into elaborate and dignified pot-pourri vases, sold for £4,000. A suite of Louis XV giltwood seat furniture attributed to Heurtaut, two settees, a pair of large and six small armchairs, once in the Victor Rothschild house, 148 Piccadilly, went for £26,000 and the same sum was paid for a Louis XV coromandel lacquer commode by Pierre Roussel (Master in 1745), which came originally from Lowther Castle, Cumberland. An ormolu bombé black commode, unsigned and described in the catalogue with becoming reticence as merely 'good' made £14,000, a Louis XVI marquetry writing table (bureau plat) £11,000.

English furniture dispersed in London included a pair of Queen Anne walnut armchairs covered in contemporary needlework—£3,000; a distinguished mahogany commode in the French manner £6,200; a set of twelve early George III mahogany chairs and a sofa £8,000; a Sheraton satinwood bonheur-du-jour £3,400; an overmantel attributed to Chippendale and containing a portrait by Allan Ramsay—£7,000. This last was a remarkable confection, and the portrait a good example of the painter's work—so good that many a picture dealer who saw it would have liked to leave the Chippendale overmantel to the antique dealers and frame the painting in a less extravagant manner.

There were also some notable pieces both French and English at Parke-Bernet—a Louis XVI small marquetry commode for instance was sold for $40,000, a mahogany high-boy for $22,000, and eight Queen Anne carved walnut chairs for $21,000, a small Louis XV occasional table for $10,000, a pair of Louis XV bergère chairs $14,500, and an unusual rosewood and red lacquer armoire $25,000. To make a choice in so brief a note of outstanding tapestries and carpets is more than normally difficult. In London, there was a splendid Beauvais tapestry *Le Cheval Fondu* from the series of *Les Amusements Champêtres* by J. B. Oudry—£4,600 and a Koun-Kapou silk and metal thread tile-pattern carpet—£3,400. In New York, a Flemish Gothic tapestry—$8,500.

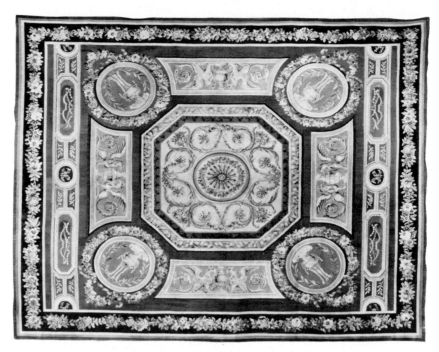

An Aubusson Carpet of Directoire Design, 17 ft. 8 in. by 13 ft. 9 in.
New York $4,700 (£1,678) 19.XI.66.

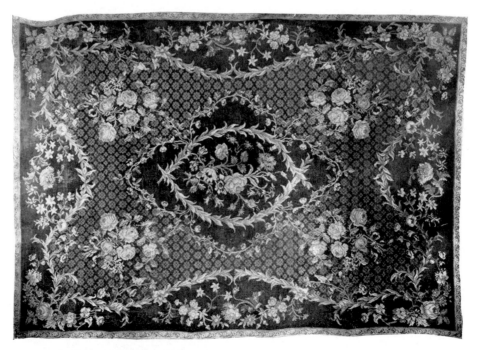

A George III Axminster Carpet.
15 ft. 11 in. by 11 ft. 2 in.
London £3,500 ($9,800) 17.III.67.
From the collection of the late Viscount Clifden, K.C.V.O.

323

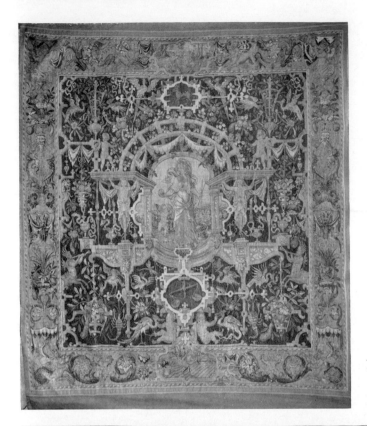

A mid-16th-century Florentine
"Grotesques" Tapestry,
11 ft. 4 in. by 10 ft. 2 in.
London £2,400 ($6,720) 7.VII.67.

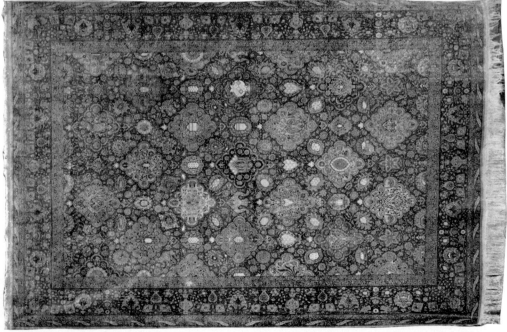

A Koun-Kapou Silk and Metal-thread Tile-pattern Carpet,
9 ft. 8 in. by 6 ft. 11 in.
London £3,400 ($9,520) 18–19.V.67.
From the collection of George Farrow, Esq.

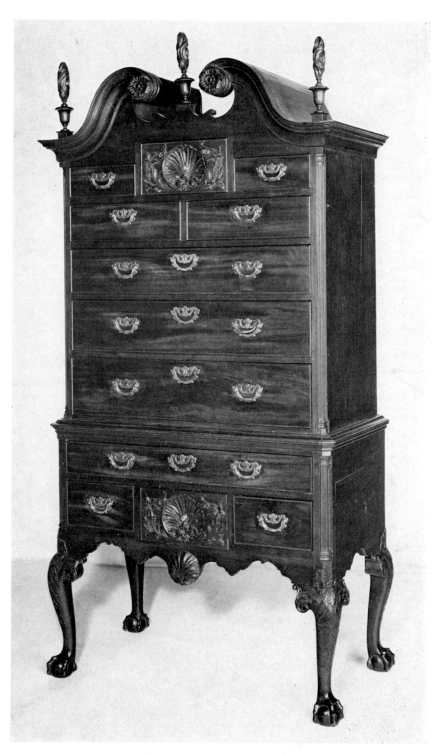

A Chippendale Carved Mahogany Scroll-top Highboy,
with claw-and-ball feet.
Philadelphia, 18th century.
New York $22,000 (£7,857) 22.X.66.

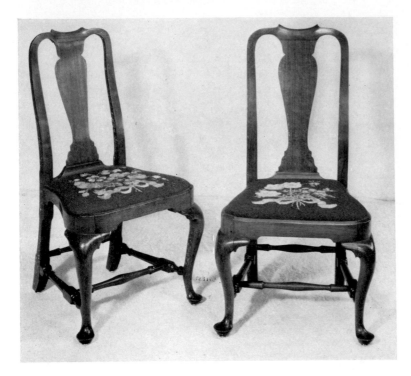

Queen Anne Carved Walnut Side
Chairs, two of a set of eight.
American, 18th century.
New York $21,000 (£7,500) 28.I.67.
From the collection of the late
S. R. and A. A. Laslochy, Riverside,
New Jersey.

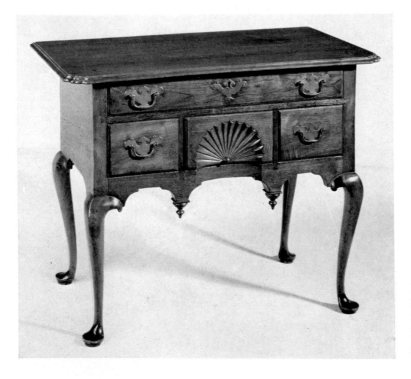

A Queen Anne Carved Walnut
Lowboy.
New England, early 18th century.
New York $4,750 (£1,696) 22.X.66.
From the collection of the late
Hugo J. Bartholomae, New York.

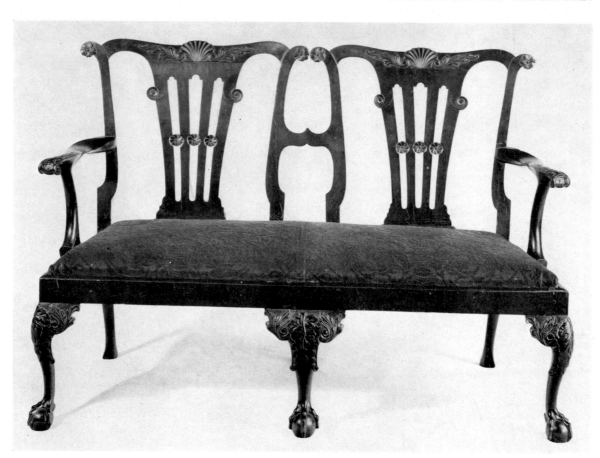

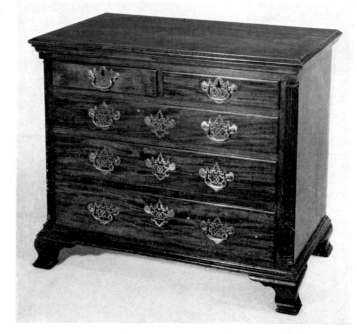

A Chippendale Carved Mahogany
Two Chair-Back Settee with
Claw-and-ball feet.
Massachusetts, 18th century.
New York $7,000 (£2,500) 22.X.66.
From the collection of Edmund
Quincy, Rockport, Mass.

A Chippendale Carved Mahogany
Chest of Drawers,
Philadelphia, 18th century.
New York $4,000 (£1,428) 28.I.67.
From the collection of
Mrs. J. Louis Forepaugh, New York.

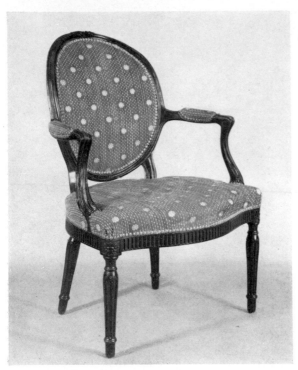

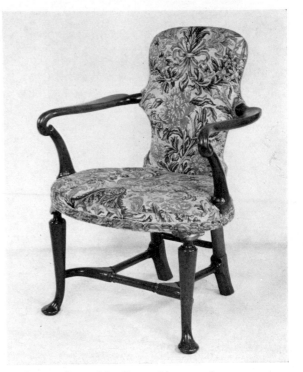

An Early George III Mahogany
Armchair (part of a suite comprising
twelve armchairs and a sofa).
London £8,000 ($22,400) 26.V.67.
From the collection of Mrs
E. H. Watts.

A Queen Anne Needlework-covered
Walnut Armchair (one of a pair),
*circa* 1720.
London £3,200 ($8,960) 26.V.67.
From the collection of the late
Alfred E. Pearson, Esq.

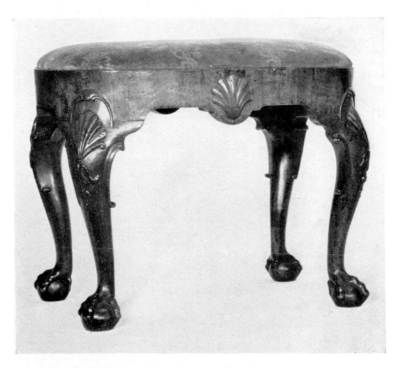

A George I Walnut Stool
(one of a pair).
London £1,650 ($4,620) 2.XII.66.

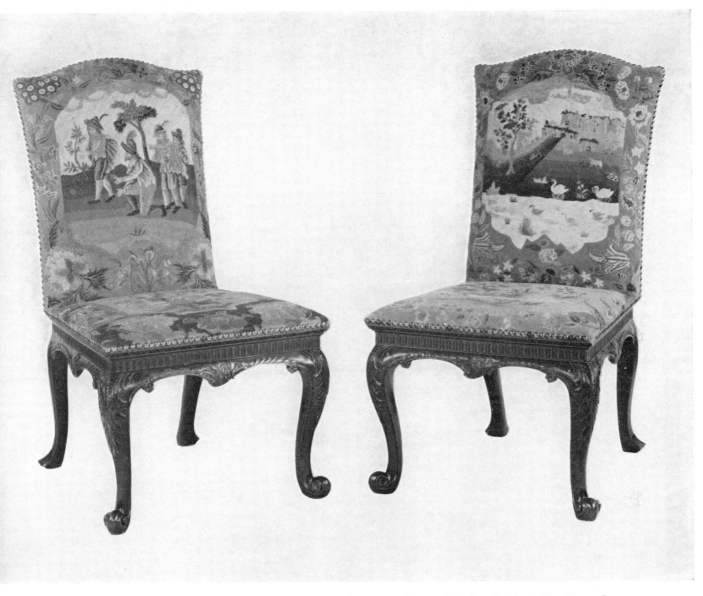

Two chairs from a Suite of George II Mahogany Seat Furniture with the Original Needlework
Covers, comprising a Settee and six Side Chairs.
London £7,400 ($20,720) 17.III.67.
From the collection of Lieutenant-Colonel E. G. V. Northey.

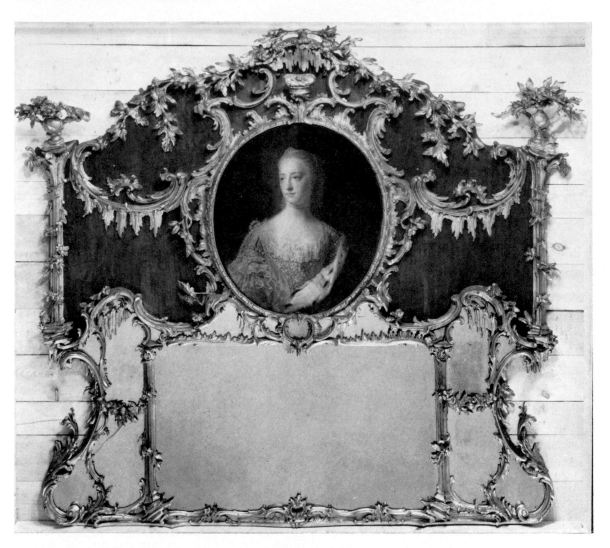

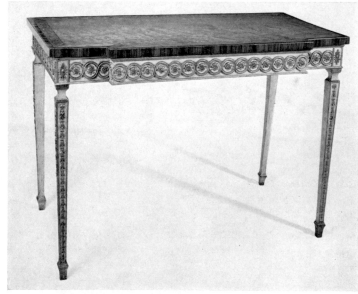

A Giltwood Overmantel attributed
to Thomas Chippendale, incorporat-
ing an oil on canvas portrait of
Willielma Maxwell, Lady Glenorchy,
by Allan Ramsay.
London £7,000 ($19,600) 2.XII.66.
From the collection of the Rt Hon.
the Lord Torphichen.

A small break-front side table in
satinwood, English, late 18th century.
New York $2,600 (£928) 13–15.X.66.
From the collection of furniture
belonging to the late Robert Goelet
sold at Parke-Bernet in October 1966
for $484,635 (£173,084).

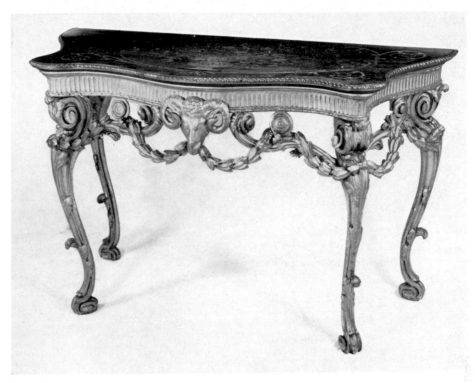

An Early George III Marquetry and Giltwood Serpentine
Side Table (one of a pair), attributed to Thomas Chippendale.
*Circa* 1765.
London £5,200 ($14,560) 17.III.67.
From the collection of Lady Stern.

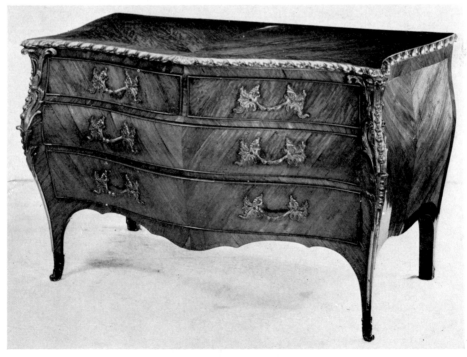

A George II Mahogany Gilt-metal mounted Bombé Commode.
London £6,200 ($17,360) 26.V.67.
From the collection of Miss G. M. Q. Armitage.

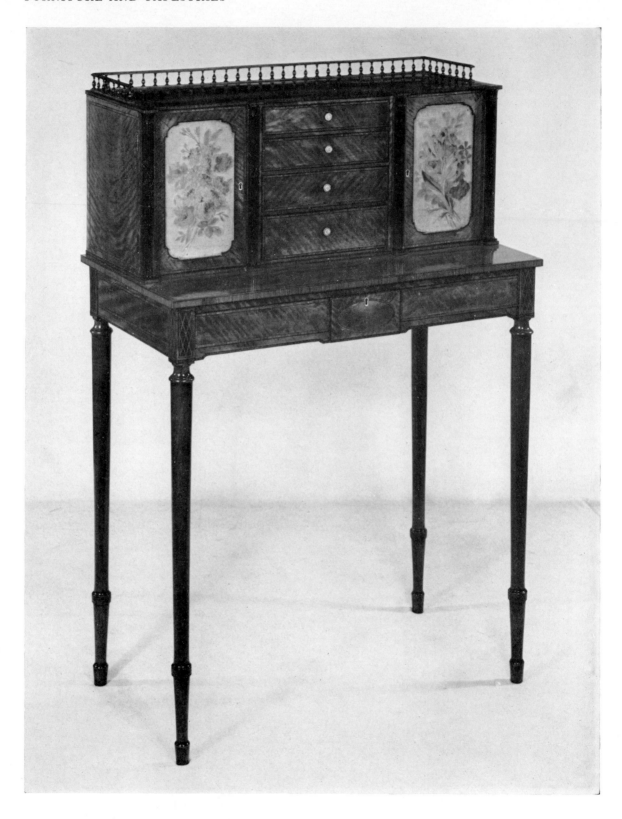

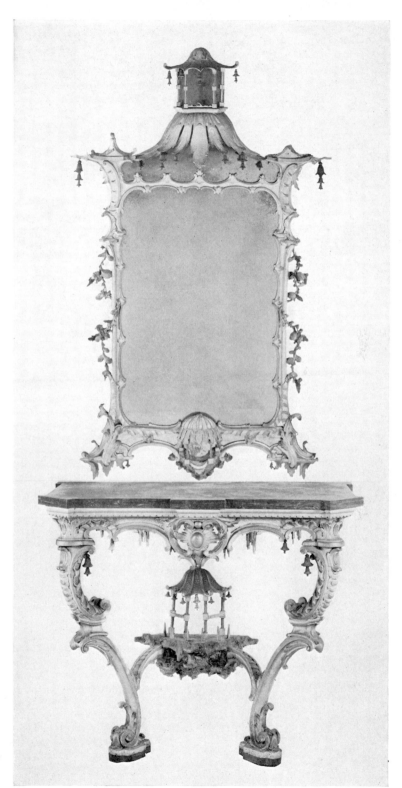

*Opposite page:*

A Sheraton Satinwood
Bonheur-du-Jour.
London £3,400 ($9,520) 26.V.67.
From the collection of the late
Alfred E. Pearson, Esq.

A Chinoiserie Pier Glass and
Console Table (a pair).
*Circa* 1760.
London £7,200 ($2,016) 17.III.67.
From the collection of the
Rt. Hon. Earl of Caledon.

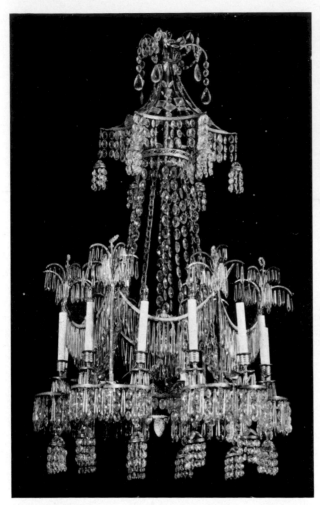

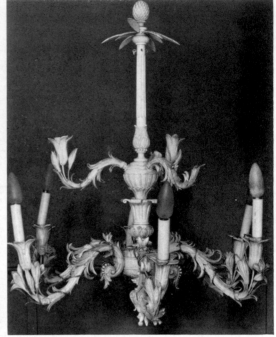

*Left*
A late 18th century Scandinavian
Chandelier.
New York $6,500 (£2,321) 18.III.67.

*Right*
An early 19th-century Ivory
Chandelier.
London £800 ($2,240) 7.X.66.
From the collection of the late
Sir Charles Lockhart Ross, Bart.,
Balnagown Castle, Scotland.

One of a set of four German or Austrian
Two-Branch Ormolu Wall Lights,
1 ft. 1 in. wide, projection 10 in.,
*circa* 1730–40
London £2,300 ($6,440) 16.XII.66.

A pair of Embossed Bird Pictures
(part of a set of four), in the
manner of Samuel Dixon.
$11\frac{3}{4}$ in. by $9\frac{1}{2}$ in.
London £700 ($1,960) 17.III.67.
From the collection of Mrs N.
Colemore.

Matthew Boulton: One of a pair of
George III Perfume Burners.
London £1,300 ($3,640) 2.XII.66.
From the collection of the late
Viscount Clifden, K.C.V.O.

A 17th-century Italian River God Side Table,
*circa* 1690.
London £3,900 ($10,920) 18–19.V.67.
From the Sala dei Fiumi, in the Ducal Palace,
Mantua.

One of a pair of Venetian Carved and Decorated
Small Chairs (Voyeuses), *circa* 1770.
New York $2,100 (£750) 12–13.V.67.
From the collection of the late Mrs Alexander
Nelidow.

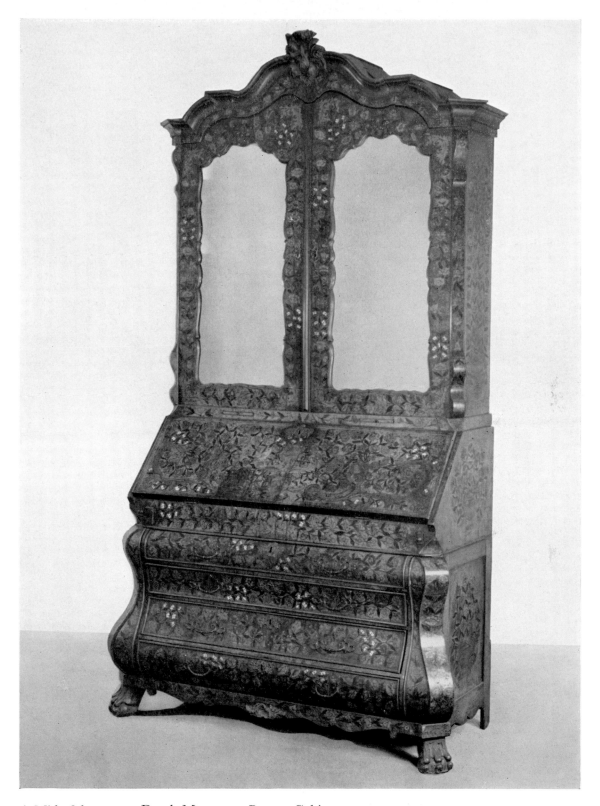

A Mid-18th-century Dutch Marquetry Bureau Cabinet.
London £1,150 ($3,220) 28.IV.67.
From the collection of the late Mrs E. Stansfeld

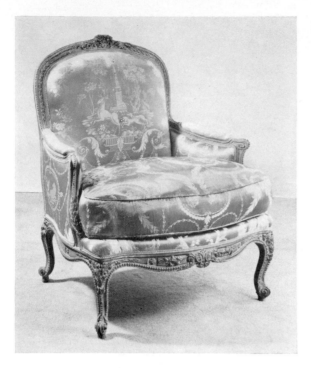

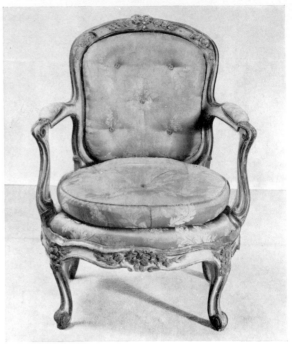

A Louis XV Large Bergère
(one of a pair).
New York $14,500 (£5,178)
13–15.X.66.

An Early Louis XV White and
Gilded Fauteuil (one of a pair),
Signed I. Gourdin.
New York $9,500 (£3,392) 13–15.X.66.

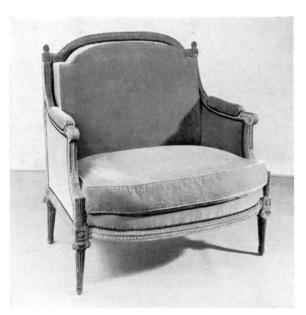

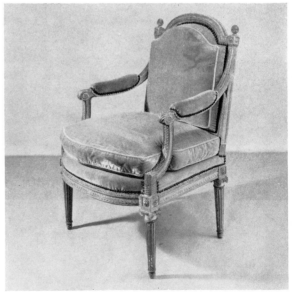

A Louis XVI Carved and Painted
Marquise (one of a pair).
New York $8,500 (£3,036) 18.III.67.

One of a set of four Louis XVI
Carved and Painted Fauteuils.
New York $7,500 (£2,678) 18.III.67.

Formerly in the collection of Baroness Stefania Von Kories Zu Goetzen.

338

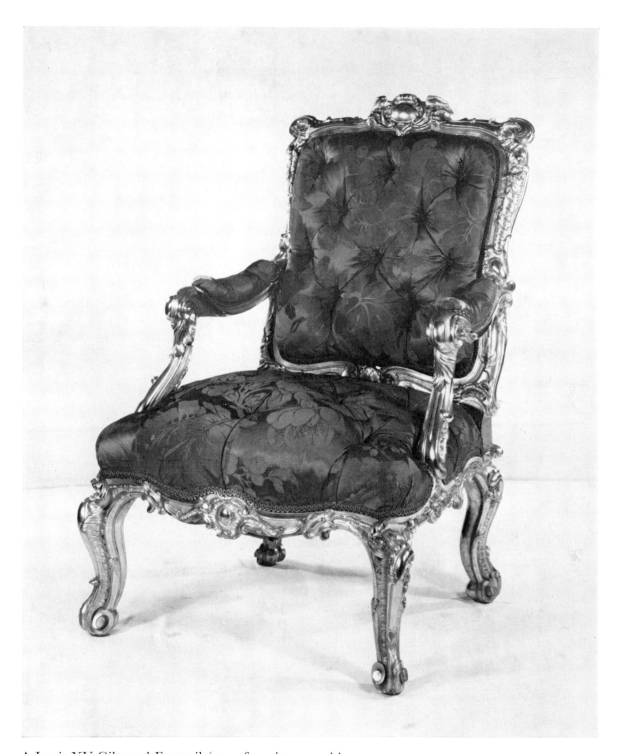

A Louis XV Giltwood Fauteuil (one of a suite comprising two
Canapés, a pair of large Fauteuils and four smaller Fauteuils)
attributed to Heurtaut.
London £26,000 ($72,800) 18–19.V.67.
From the collections of Victor Rothschild, Esq., and
Jacob Rothschild, Esq.

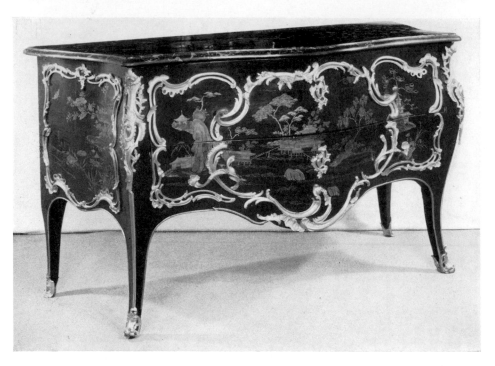

A Louis XV ormolu mounted Bombé black lacquer Commode.
London £14,000 ($39,200) 18–19.V.67.
From the collection of the late Alfred E. Pearson, Esq.

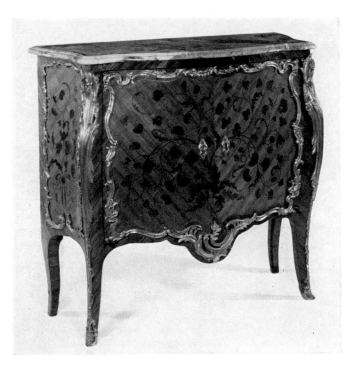

A Louis XV Bombé Marquetry Commode
à Portes.
London £7,200 ($20,160) 18–19.V.67.
From the collection of the late Alfred E. Pearson, Esq.

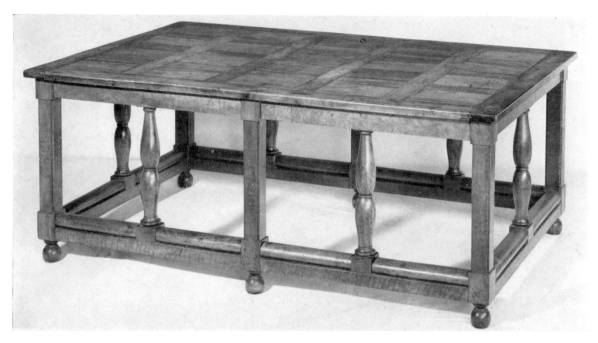

Louis XIII Walnut Library Table.
Height 29 in., length 6 ft.
New York $3,000 (£1,071) 10.XII.66.
From the collection of Mr. Ronald
Tree, New York.

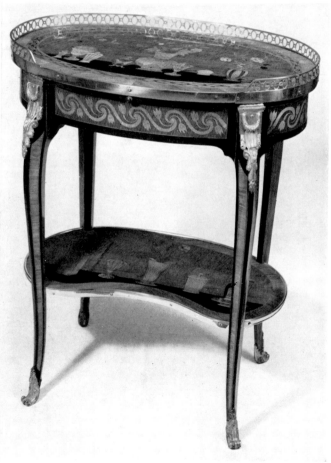

Louis XV Oval Occasional Table,
attributed to Charles Topino.
Height $29\frac{1}{2}$ in., width $23\frac{1}{2}$ in.
New York $10,000 (£3,571)
11–12.XI.66.

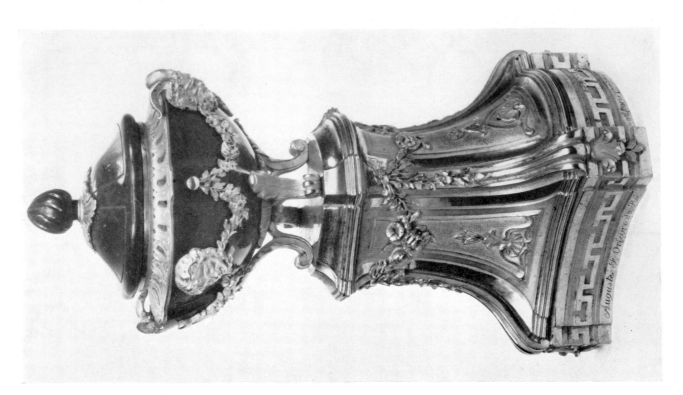

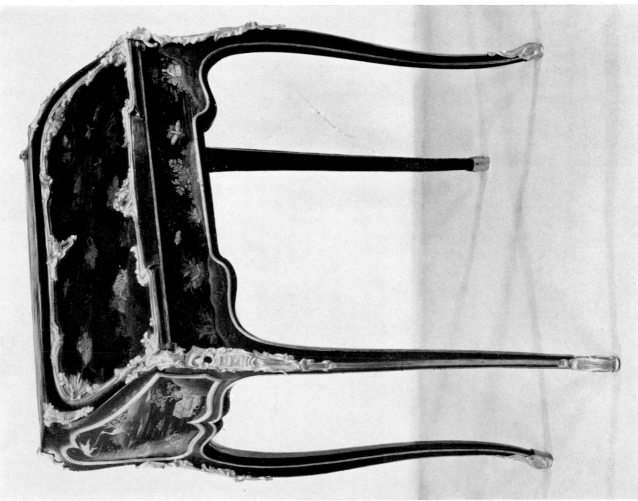

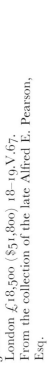

*Above*: A Louis XVI Ormolu-mounted Bloodstone Vase (one of a pair), signed Auguste F. Orfevre du Roi, Paris, 1775.
London £8,500 ($23,800) 18–19.V.67.
From the collection of the late Madame Alexandrine de Rothschild.

*Above*: A Louis XV Ormolu-mounted Black Lacquer Secrétaire en tombeau, signed Dubois. JME.
London £18,500 ($51,800) 18–19.V.67.
From the collection of the late Alfred E. Pearson, Esq.

A Louis XV Boîte-à-dés, probably by Jean Charles Gallonde, stamped with a Louis Philippe château mark.
London £10,000 ($28,000) 18–19.V.67.
From the collection of Madame Alexandrine de Rothschild.

343

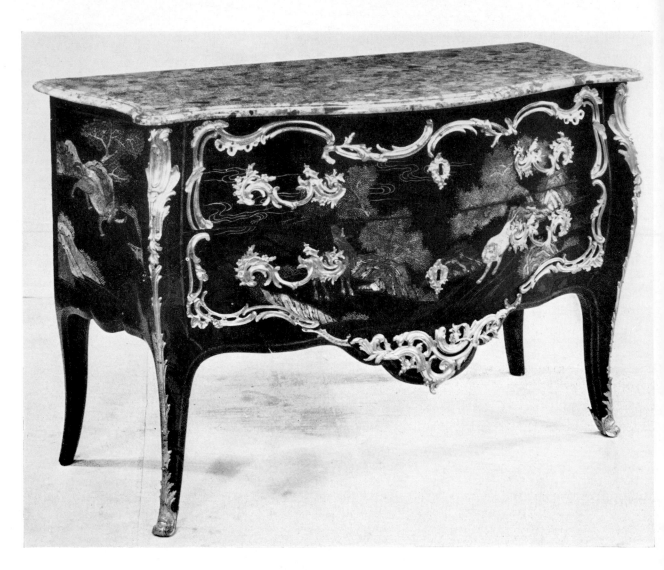

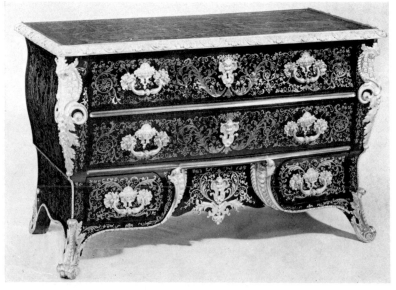

A Louis XV Ormolu-mounted
Coromandel Lacquer Commode,
by P. Roussel, JME.
London £26,000 ($72,800)
18–19.V.67.
From the collections of the Earl
of Lonsdale, Lowther Castle,
Cumberland, and George Farrow, Esq.

A Louis XIV Boulle Commode
mounted in chiseled bronze Doré
(Commode en Tombeau).
New York $18,000 (£6,428)
13–15.X.66.
From the collection of the late
Robert Goelet.

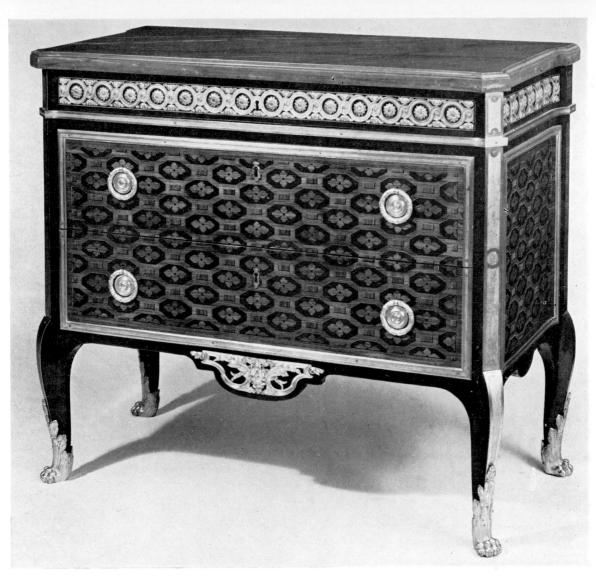

A Louis XVI Marquetry Commode, signed M. Carlin, JME.
New York $40,000 (£14,286) 13–15.X.66.
From the collection of the late Robert Goelet.

A Louis XVI Marquetry Writing
Table, signed J. F. Leleu.
London £11,000 ($30,800) 16.XII.66.

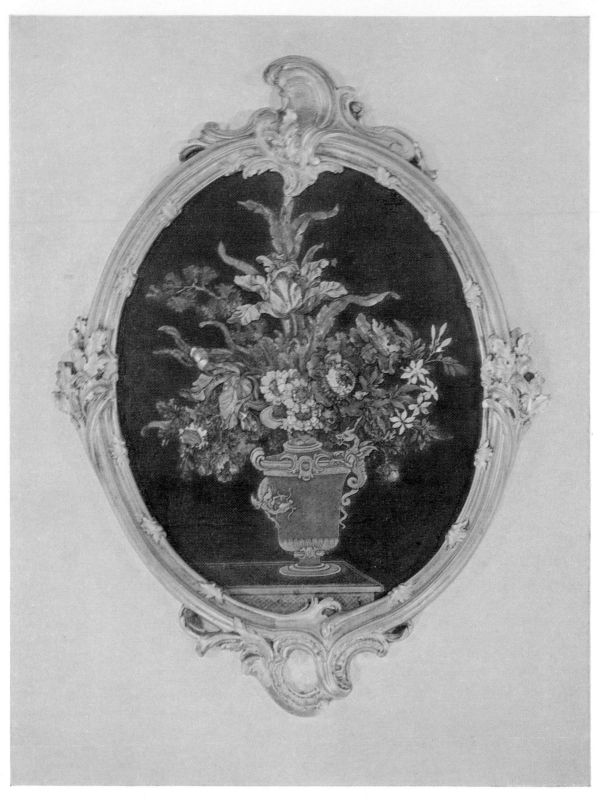

One of a pair of Japanese Lacquer Plaques in Louis XV oval Ormolu frames.
London £6,800 ($17,240) 18.–19.V.67.
From the collection of the late Madame Alexandrine de Rothschild.

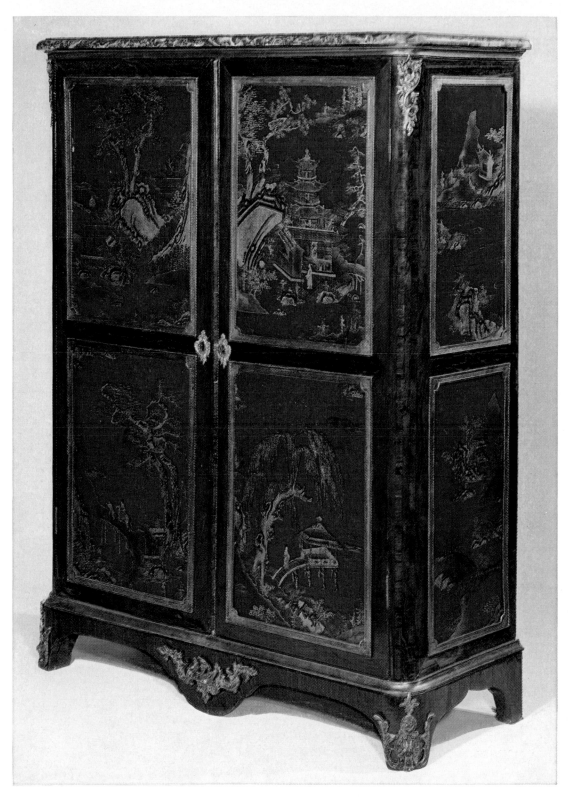

A Louis XV Lacquer and Rosewood Armoire, signed Delorme.
New York $25,000 (£8,929) 10.XII.66.

# Books and Manuscripts

Last season book sales were as entertaining as usual, but I think more various, for they alternated between the serious bibliographical section of the J. R. Abbey library and the wholly charming collection of Children's Books accumulated over several years by Bandsman Webb of Her Majesty's Brigade of Guards for the amusement of his small daughter. As a rule Fleet Street likes to talk about rarities which soar up into four, five or six figures, but this array of books for children touched the public imagination, and for a week or two the most unlikely persons went about repeating nursery rhymes to themselves and recalling superb memories as the little verses from *Marmaduke Multiply's Merry Method of Making Minor Mathematicians* such as

> Eight times ten are eighty,
> I think she's pretty weighty.

This endearing and practical educational book of the year 1817 was sold for £32. Someone gave £70 for that great engraver Thomas Bewick's *New Lottery Book of Birds and Beasts for Children*, to learn their letters by as soon as they can speak, with its forty-eight woodcuts, and someone else £50 for a dozen little books illustrated by Kate Greenaway. This unpretentious collection, gathered together with so much affection by a man who always had to keep a firm control over his purse, realised a total of £5,782. Another dispersal of a different category followed a fortnight later when the Society of Herbalists sold a portion of its celebrated collection of Herbals and Botanical Books in rather more than three hundred lots for just over £44,000. The first edition of the first illustrated Herbal in English sold for £10,000. This is the translation of 1526 largely from the French *Grand Herbier*—the translation whose title records so nobly, thus: *The grete Herball which geueth parfyt knowledge and Understandyng of all Maner of Herbes and there gracyous vertues which God has ordeyned for our prosperous welfare and helth for they hele and cure all maner of dyseases* . . . It was bound with Brunschwig's the *Vertuose Boke of the Distyllacion of the Waters of all Maner of Herbes*—the first English book on the subject—and the same author's *The Noble Experyence of the Vertuous Handy Warke of Surgeri*, the first edition in English, 1525, and translated from the Latin edition which was first published in Strassburg in 1497. Among books and letters early in the season, an anonymous Swiss collection (dispersed for £11,400) included revealing letters from Stendhal to his sister, and to his publisher—one of the latter made £650. A fortnight later five letters and a postcard from Karl Marx made £2,000, while among literary manuscripts the autograph manuscript of A. E. Housman's notable lecture on *The Name and Nature of Poetry* 1933 found its appropriate permanent home in the Cambridge University Library at £6,000. Housman had given the manuscript to the late Sir Sidney Roberts of the Cambridge University Press, who published it. A further selection from the apparently inexhaustible store of documents and manuscripts from the Sir Thomas Phillipps collection attracted the customary international gathering on the last day of November. Forty-four manuscripts from the 9th to the 17th centuries realised £78,780. An Upper Rhine Manuscript of about 1520, including a copy of a Register of high officials of the Roman

Empire *circa* A.D. 400, *De Rebus Bellicis* and 103 watercolour drawings crossed the Atlantic at £4,500, and a translation of the Roman Missal, about 1400, into mediaeval Croat, was sold for £4,000.

A further selection from the celebrated library of Major J. R. Abbey occupied three consecutive mornings in June and realised £162,925. This brought up the total so far to £355,410. Bindings alone would have made this a memorable occasion for there were no less than seven Jean Grolier bindings, one for the later and scarcely less famous bibliophile De Thou, and a Greek New Testament in a superb pre-fanfare binding bearing the arms of Charles IX. The earliest lot was a manuscript on vellum, the *Apocalypse* in Latin, in a Paris binding of about 1150 which made £9,000 while, of the seven Groliers, one of about 1555—a quarto—went for £7,500, another for £4,200; a third, a set of five volumes of the works of St. John Chrysostom, sold purely as bindings, for £5,500. Coming down to the 19th century Redouté's *Les Roses*, octavo, honoured by a memorable binding by Duplanil, 1834—the spines of the volumes inlaid with coloured roses, and a sunk central panel inlaid with a bouquet in natural colours—an exceptionally happy marriage of contents and cover—went for £6,200. Among distinguished book owners was Queen Christina of Sweden, represented by a sumptuous binding made for her after her abdication in Rome. As nearly all the surviving books from the Queen's library are in the Vatican library or in Swedish collections, this was a rarity and made £2,000. The three volumes of Gibbon's Miscellaneous Works which belonged to Beckford made £950.

A further selection of documents and manuscripts from the Sir Thomas Phillipps collection was sold in June, which included a series of sixty-five letters written to Sir Philip Sidney from continental scholars during his Grand Tour of Europe in the years 1572–1575. As he was only seventeen when he set out and was not yet twenty-one when he returned, it is extraordinary what impact he made; as the catalogue pointed out 'he achieved a reputation from Italy to the Low Countries, from France to Poland, such as no previous Englishman had ever approached and which only Byron among English poets has ever equalled. He was accepted by experienced statesmen as the future leader of Protestant Europe and was regarded by eminent scholars as a worthy patron to whom they might address their dedications.' These letters are all apparently unpublished and have been unknown hitherto; they were sold for £5,200.

*Page 350*    *Notitia Dignitatum* and *De Rebus Bellicis*
Two works in one volume, manuscript on paper, with 103 watercolour drawings, Region of Basle, *circa* 1520–30.
A register of the high officials of the Roman Empire, and a treatise relating to the Roman army.
London £4,500 ($12,600) 29.XI.66.

*Page 351*    *Messale Glagolithicum*
Illuminated manuscript on vellum, Western Croatia, *circa* 1400–10.
A translation of the Roman Missal into Croat, written in the Glagolithic alphabet. Manuscripts in which this alphabet is used are extremely rare.
London £4,000 ($11,200) 29.XI.66.

# COMES ARGENTORATENsis.

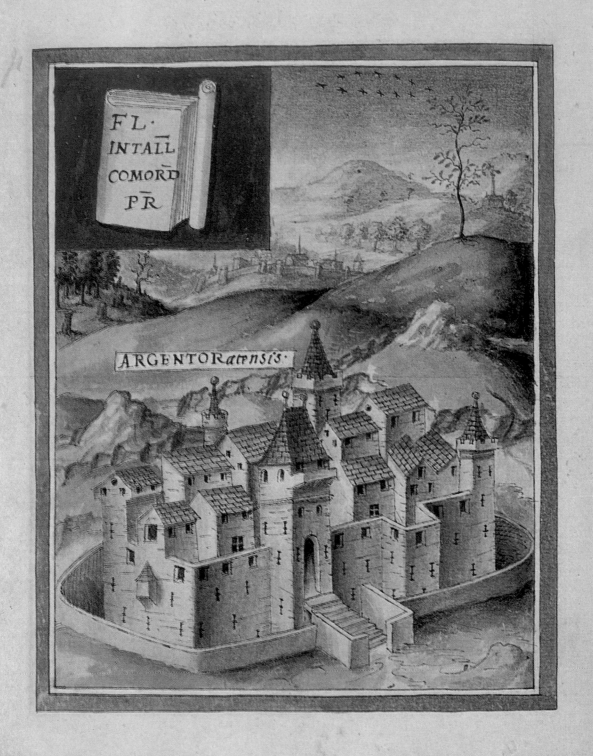

FL·
INTAII
COMORD
PR

ARGENTORatensis·

Sub dispositione uiri spe,
ctabilis comitis Argentoratesis.

Tractus argento,
ratensis·

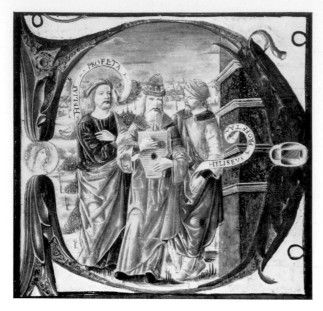

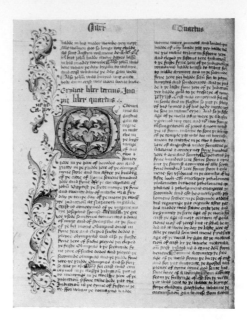

*David playing the psaltery between the prophets Elija and Elisha*
Historiated initial D from an illuminated manuscript, probably by the artist of the 'Arcimboldi Missal', Milan (?) last quarter of the fifteenth century.
London £700 ($1,960) 10.VII.67.

JOHN DE TREVISA
*Higden's Polychronicon*
in English. Illuminated manuscript on vellum *circa* 1400–20. Manuscripts of Trevisa's chronicle of Universal and English history are of great rarity.
London £1,800 ($5,040) 12.XII.66.
From the library of Canford School, Dorset.

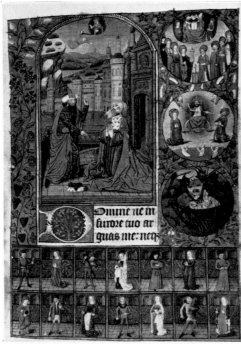

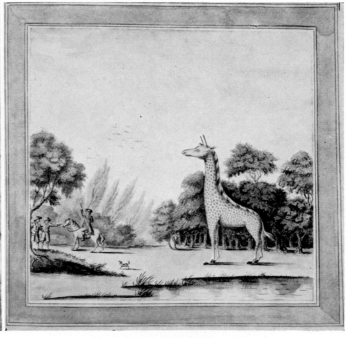

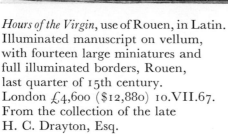

*Hours of the Virgin*, use of Rouen, in Latin. Illuminated manuscript on vellum, with fourteen large miniatures and full illuminated borders, Rouen, last quarter of 15th century.
London £4,600 ($12,880) 10.VII.67.
From the collection of the late H. C. Drayton, Esq.

JAMES FORBES *A Voyage from England to Bombay.*
13 volumes folio manuscript, illustrated with over 500 watercolour drawings by the author.
London £2,200 ($6,160) 7–8.XI.66.
The first section of a Series, compiled for his grandson, Charles de Montalourhert, by the author of *Oriental Memoirs*, 1813–15.
From the library of Oscott College.

*Missal*, in Latin.
Illuminated manuscript on vellum,
written for Etienne de Longwy,
Bishop of Mâcon, with two full-page
miniatures, Macon (?), *circa* 1485.
London £5,000 ($14,000) 10.VII.67.

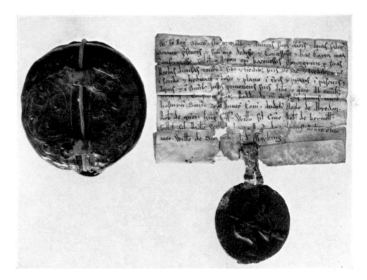

DAVID, EARL OF HUNTINGDON
(brother of William the Lion,
King of Scotland).
Grant to Gilbert, nephew of Andrew,
the first Bishop of Caithness.
Manuscript document on vellum,
*circa* 1172, with its medieval seal-case
in cuir cisele.
London £450 ($1,260) 26.VI.67.

Bible, in French.
Octavo, Geneva 1567.
Contemporary French needlework binding.
London £1,700 ($4,760) 19–21.VI.67.

*Opposite page*    QUINTUS CURTIUS *De Rebus Gestis Alexandri Magni*
RAPHAELUS VOLTERRANUS *Commentariorum Urbanorum*
SAINT AMBROSIUS *Opera* (five volumes in two.)
Seven volumes in all, bound in three, Basle, 1538–45.
Each volume with the fore-edge painted by Cesare Vecellio.
London £3,200 ($8,960) 19–21.VI.67.

Both from the collection of Major J. R. Abbey.

354

ABRAHAM ORTELIUS
*Theatrum Orbis Terrarum*
Folio, Antwerp, 1573, with seventy
double-page maps, coloured by hand.
Fine contemporary Lyonnese sunk-
panel binding.
London £4,400 ($12,320) 19–21.VI.67.

*Vita di S. Tomaso da Villanova*
Quarto, Rome, 1658.
Contemporary Roman red morocco
by the Rospigliosi Bindery for
Queen Christina of Sweden.
London £2,000 ($5,600) 19–21.VI.67.

*English Bible*
Folio, Cambridge, 1659.
Bound by the Samuel Mearne
Bindery. An exceptionally handsome
example, which at one time possibly
belonged to Charles II.
London £1,400 ($3,920) 19–21.VI.67.

ROBERT ADAM *Ruins of the Palace of the
Emperor Diocletian at Spalarto*
Folio, 1764, with sixty plates by
Bartolozzi and Zucchi. Splendidly
bound to the author's design,
incorporating the arms of George III.
London £1,500 ($4,200) 19–21.VI.67.

*Apocalypse*, in Latin.
Manuscript on vellum, octavo, Paris, *circa* 1150.
Bound in Paris, *circa* 1150. Blind-
tooled calf over wooden boards, from
the Benedictine Abbey of Admont in Styria.
London £9,000 ($25,200) 19–21.VI.67.

STEPHANUS NIGER *Translationes*
Five parts in one volume, quarto,
Milan, 1521.
Bound in Paris, *circa* 1555, for Jean
Grolier.
London £7,500 ($21,000) 19–21.VI.67.

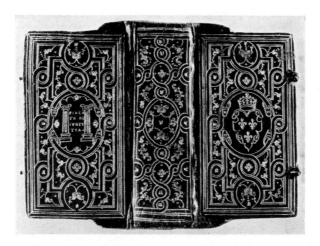

*Greek New Testament*
Two volumes, printed on vellum,
octavo, Paris, 1568.
Fine contemporary Parisian bindings
'à la Grecque', with the arms of
Charles IX on upper covers, probably
presented to him by the printer
Robert Estienne.
London £4,400 ($12,320) 19–21.VI.67.

All from the collection of Major J. R. Abbey.

357

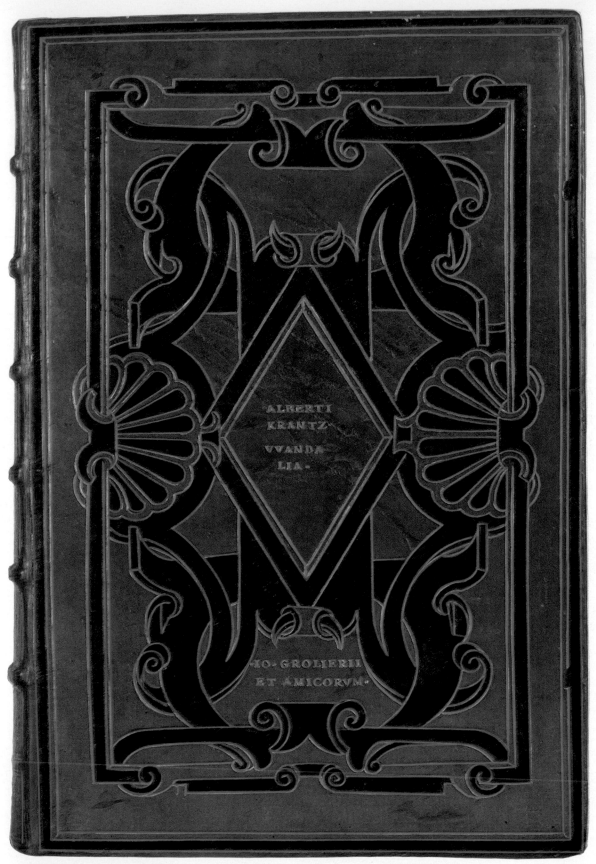

ALBERT KRANTZ  *Wandalia*
Folio, Cologne, 1519.
Very finely bound in Paris, *circa* 1555, for Jean Grolier.
London £4,200 ($11,760) 19–21.VI.67.
From the collection of Major J. R. Abbey.

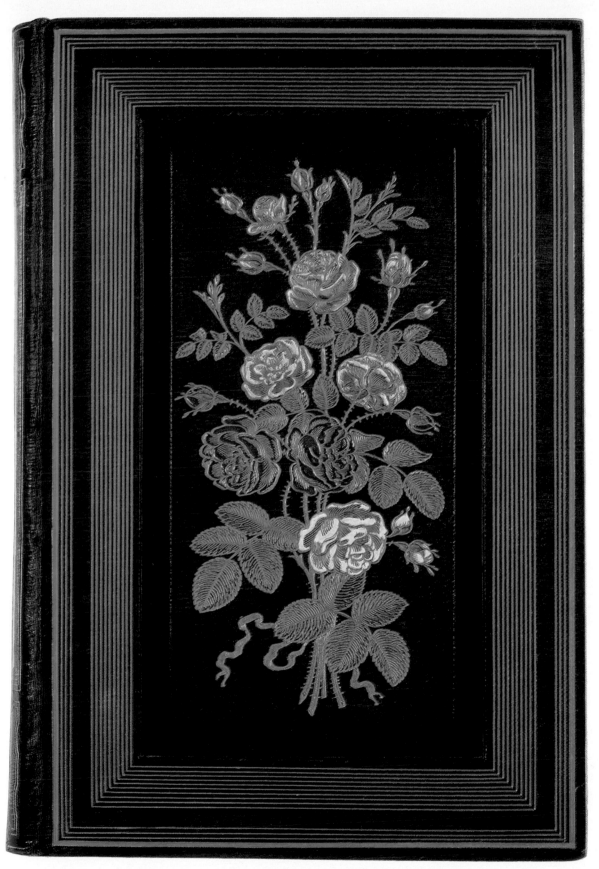

PIERRE-JOSEPH REDOUTÉ and C.-A. THORY  *Les Roses*
Three volumes in two, with coloured frontispiece and 183 coloured plates, octavo, Paris, 1828–30.
Finely bound, the centre panels inlaid with a bouquet of roses in natural colours.
London £6,200 ($17,460) 19–21.VI.67.
From the collection of Major J. R. Abbey.

*A youth seated cross-legged on the ground*
A finely painted miniature, Isfahan,
*circa* 1635.
London £300 ($840) 27.VI.67.

*The disappointed heroine casting off
her jewellery*
A finely painted miniature, Kangra,
*circa* 1810.
London £300 ($840) 27.VI.67.
From the collection of Mrs Raymond
Lister.

FIRDAUSI
*Shahnameh*
Persian manuscript with eighty-nine
fine miniatures, Khurasan, 1694–95.
London £1,300 ($3,640) 27.VI.67.
From the collection of The Devon
and Exeter Institution

*Majnum visited by Layla*
A finely painted Mughal miniature,
beginning of 17th century, from a
manuscript of the poems of Nizami.
London £750 ($2,100) 12.XII.66.

The Grete Herball, 1536, bound with *The Vertuose Boke of the Distyllacyon of the Waters of all Maner of Herbes*, 1527, and *The Noble Experyence of the Vertuous Handy Warke of Surgeri*, 1525, both by Hieronymus Brunschwig. Three works in one volume, folio. The volume contains the first English illustrated herbal, the first English book on distillation and the first work in English on surgery. All are of the greatest rarity. London £10,000 ($28,000) 13.III.67.

*Right:* OTTO BRUNFELS *Herbarum vivae Eicones ad Naturae Imitationem* Three volumes in one, with 242 woodcuts by Hans Weiditz, folio, Strassburg, 1532–36. The finest early illustrated herbal. London £1,400 ($3,900) 13.III.67. A portion of the Society of Herbalists' Collection of Herbals and Botanical books was sold at Sotheby's on March 13, 1967 for £44,043 ($123,320).

CRISPIN DE PAS
*Hortus Floridus*
Five parts in one volume, oblong
quarto, Arnhem, 1614–17 and n.d.
The finest of early engraved flower
books, with engraved title and
178 plates.
London £700 ($1,960) 13.III.67.

*Left:* WILLIAM TURNER *A New Herball wherein are conteyned the names of Herbes in Greke, Latin, Englysh, Duch, Frenche*, bound with *A Most Excellent and Perfecte Homish Apothecarye* by Hieronymus Brunschwig. Four parts in one volume, folio, 1551—Cologne, 1562. London £1,200 ($3,360) 13.III.67.

JOHN EVELYN *Silva: or, A Discourse of Forest-Trees*. Folio, 1729. The poet Thomas Gray's copy, with his signature and marginal annotations. London £650 ($1,820) 20–21.III.67. From the collection of the Rt. Hon. the Earl of Powis.

*Right:* HUGO GROTIUS *De Iure Belli ac Pacis*. Quarto, Paris, 1625, first edition, third issue. Presentation copy from the author to Lord Herbert, with the latter's note to this effect. London £2,000 ($5,600) 20–21.III.67. From the collection of the Rt. Hon. the Earl of Powis.

CLAES JANSZ VOOGHT *De Nieuwe Groote Lichtende See-Fakkel*. Folio, Amsterdam, 1684–88, with 136 double-page hand-coloured maps. London £2,000 ($5,600) 3–4.VII.67.

*Right:* FRANCESCO BERLINGHIERI *Geographia*. Folio, Florence, 1482, first edition, first issue. The third atlas to be issued with copperplates, the thirty-one maps fully hand-coloured. London £5,500 ($15,400) 14.III.67.

MECHANICK EXERCISES:
Or, the Doctrine of
**Handy-works.**
Applied to the Art of
**Printing.**

The Second VOLUMNE.

By *Joseph Moxon*, Member of the Royal
Society, and *Hydrographer* to the King's
Most Excellent Majesty.

LONDON.
Printed for *Joseph Moxon* on the West-
side of *Fleet-ditch*, at the Sign of
*Atlas*. 1 6 8 3.

# OBSERVATIONES.

*Left*
JOSEPH MOXON
*Mechanick Exercises or the Doctrine of
Handy-works.*
Two volumes quarto 1683 (–77)
volume 2 the first edition.
The second volume is the first manual
of printing in any language.
London £1,400 ($3,920) 22–23.V.67.

*Right*
LUCA PACIOLI DE BORGO SEPOLCRO
*Divina Proportione Opera a tutti
Glingegni Perspicaci e Curiosi Necessaria*
Folio, Venice, 1501.
The section on the design of solid
bodies was inspired by the author's
friend Leonardo da Vinci.
London £1,500 ($4,200) 22–23.V.67.

JOHANNES HEVELIUS
*Machinae Coelestis Pars Prior;
Pars posterior.*
Two volumes folio, Danzig, 1673–79,
first edition.
Almost certainly the rarest of all
books in the history of astrology. This
copy is inscribed by Hevelius in
Latin to Edmund Halley 'my most
acceptable friend and honoured guest'.
London £4,200 ($11,760) 24–25.X.66.

*Le Neptune Francois ou Atlas Nouveau
des Cartes Marines.*
Large folio, with 104 engraved titles,
plates and maps coloured by hand,
some heightened with gold, Paris, 1693
London £4,200 ($11,760) 14.III.67.

JOHN NAPIER
*Mirifici Logarithmorum Canonis Descriptio.*
Quarto, Edinburgh, 1614, first edition.
This book contains the famous
announcement of the author's
invention of logarithms.
London £1,800 ($5,040) 22–23.V.67.

PEDRO NUNEZ
*Tratado da Sphera com a Theorica
do Sol & da Lua.*
Folio, Lisbon, 1537, first edition.
The most famous of all early Portuguese
works on navigation, of great rarity.
London £6,000 ($16,800) 28.XI.66.

JOHN WESLEY
*Explanatory Notes upon the New Testament.*
Quarto, 1755.
Proofs for the first edition, with
numerous manuscript corrections
and notes, some of which are in the
hand of the author.
New York $5,500 (£1,964) 29.XI.66.

JAMES SOWERBY
*Flora Luxurians*, or *the Florist's Delight*,
1789–91, bound with *Icones Pictae
Plantarum Rariorum* by Sir J. E. Smith,
1790–93.
Two works in one volume, folio,
with thirty-six hand-coloured plates.
London £1,400 ($3,920) 10–11.IV.67.

ROBERT THORNTON
*New Illustration of the Sexual System
of Carolus von Linnaeus.*
Three parts in one volume, including the
*Temple of Flora*, with the thirty flower
plates in first or early state, folio, 1807.
London £2,400 ($6,720) 20.II.67.

NICOLAUS JOSEPH VON JACQUIN
*Selectarum Stirpium Americanarum Historia.*
Large folio, Vienna, *circa* 1780,
with title and 264 coloured plates,
all drawn by hand, one of not more
than eighteen copies so issued.
London £3,800 ($10,640) 10–11.IV.67.

HENRI BEYLE 'STENDHAL'
*Rome, Naples et Florence.*
Two volumes octavo, Paris, 1826,
the first complete edition.
Stendhal's own copy, interleaved
with unpublished autograph notes.
London £2,600 ($7,280) 7–8.XI.66.
The important collection of books
and letters of Stendhal in which
this appeared totalled
£11,403 ($33,928).

ROBERT S. SURTEES
*Sporting Novels.*
Five volumes, 1853–65, first editions,
extra-illustrated with 110 drawings
for the plates and woodcuts by
Leech and H. K. Browne.
London £1,000 ($2,800) 10–11.IV.67.
From the collection of Sir Alfred
N. Aykroyd.

58    The Cries of London.

Carrots, Cabbages, fine Savoys; nice
curious Savoys.

ROBERT'S first interview with Mr. STOPS.

Beauty in the Enchanted Palace.

The Progress of the Quartern Loaf.

THE SOWER.

With steady hand the Sower throws
That seed on which so much depends;
Following the plough's deep track he goes,
And plenty every step attends.

Nature the precious gift receives,
The treasure now, is all her own;
From time, to time, puts forth its leaves,
Until the full formed Ear is grown.

*Above   Old Mother Hubbard and her Dog*, 1806. £40 ($112); *New Lottery Book of Birds and Beasts for Children*, Newcastle 1771. £70 ($196);
*Opposite   Cries of London*, 1775. £12 ($33); *Punctuation Personified*, circa 1820. £20 ($56);
*Beauty and the Beast*, circa 1811. £24 ($67); *The Progress of the Quatern Loaf*, 1814 £22 ($61).
London 27.II.67.
From the collection of Children's Books formed by Albert Webb.

BEATRIX POTTER
The eighteen pen-and-ink drawings to illustrate *The Peter Rabbit Music Books* published 1935.
London £1,200 ($3,360) 27.II.67.
From the collection of Christopher Le Fleming, who composed the music for the books.

KATE GREENAWAY
The twenty-eight water-colour drawings to illustrate *The Queen of the Pirate Isle*, by Brct Hartc, *circa* 1886.
London £1,800 ($5,040) 27.II.67.

LUDWIG VAN BEETHOVEN
Autograph letter (to Cajetan
Giannatasio del Rio, Vienna, 1816).
London £1,200 ($3,360) 15–16.V.67.

SAMUEL TAYLOR COLERIDGE
The highly important autograph
poetical manuscript comprising
material for his volume *Poems on
Various Subjects*, 1796.
One of the most important poetical
manuscripts of Coleridge in existence.
London £17,000 ($47,600) 15–16.V.67.

FRANZ SCHUBERT
Autograph music for *Morgenlied*
and *Abendlied*, 1816, first published in
the *Gesamtausgabe* in 1895.
London £1,100 ($3,080) 15–16.V.67.

ELIZABETH I, QUEEN OF ENGLAND
*The New Year's Gift Roll for the
Year* 1596[7].
A detailed record of the gifts
exchanged between the Queen and
her Court on New Year's Day, signed
by the Queen in three places.
London £2,000 ($5,600) 14.III.67.

HEINRICH HEINE Nine autograph letters to his wife Mathilde, in French, October—December 1843. London £2,400 ($6,720) 10–11.IV.67. The property of the late Madame Alexandrine de Rothschild.

*Right:* A. E. HOUSMAN *The Name and Nature of Poetry*, 1933. The autograph manuscript for the most widely known of Housman's few public lectures. The only substantial prose manuscript by him known to exist today. London £6,000 ($16,800) 6–7.XII.66.

KARL MARX A series of five letters and one postcard, 1873–78, to the English social reformer Thomas Allsop. London £2,000 ($5,600) 28.XI.66.

GEORGE BERNARD SHAW A collection of letters, manuscripts and privately-printed rehearsal copies, relating to the revision, casting, production and performance of *Heartbreak House*, *Back to Methuselah*, *Saint Joan*, *The Apple Cart*, *Too True to be Good*, *Geneva*, and *In Good King Charles's Golden Days*, 1929–39. London £2,000 ($5,600) 11–12.VII.67.

JUAN DE TORQUEMADA *Primera Parte de los Veynte y Un Libros Rituales y Monarchia Yndiana.*
Three volumes folio, Seville, 1615, first edition. New York $13,000 (£4,642) 25–26.X.66.
From the collection of Americana formed by the late Thomas Winthrop Streeter.

*Right: Holy Bible.* Two volume folio, Oxford, 1935. A fine example of typography by Bruce Rogers, sold
with relating material. Only 400 copies of the Bible were printed. New York $2,100 (£750) 2.XI.66.

ANTONIO PIGAFETTA *Le Voyage et Navigation faict par les Espaignolz es Isles de Mollucques.* Octavo,
Paris, *circa* 1525. A description of Magellan's voyage round the world, written by one of his
companions. New York $56,000 (£20,000) 25–26.X.66. From the collection of Americana formed
by the late Thomas Winthrop Streeter.

*Right:* ROBERT DUDLEY, DUKE OF NORTHUMBERLAND *Arcano del Mare.* Two volumes
folio, Florence, 1661; second edition with numerous engraved charts, maps and diagrams.
New York $10,500 (£3,750) 25–26.X.66. From the collection of Americana formed
by the late Thomas Winthrop Streeter.

# Americana sales at Parke-Bernet

by Jerry E. Patterson

The continuing advance in prices of printed and manuscript Americana which has been a phenomenon of the book collecting world since the late 1950s received new impetus during the 1966–7 season at Parke-Bernet. The offerings in this field were unusually numerous and important.

The sale of the Collection of Theodore W. Kheel of New York on November 1, 1966, brought two outstanding prices: the highest price ever fetched by a single plate from the Audubon *Birds of America*, 'The Great American Cock Turkey,' $3,700. Volumes I–XV of *The American Turf Register and Sporting Magazine*, the earliest publication on the breeding and performances of thoroughbred horses in America, lacking but one issue, brought $2,400.

A sale of manuscripts for The Art Institute of Chicago and other owners contained a fine George Washington letter, one of the last ten written by him, Mount Vernon, December 8, 1799, which brought $1,500. A large group of George Rogers Clark material relating to lands in Illinois brought $3,250.

In the sale held December 13, 1966 for The Telfair Academy of Arts and Sciences of Savannah *et al.* a copy of Gunn's *New Map and Hand-Book of Kansas & the Gold Mines* (Pittsburgh 1859) brought $1,250. A copy of the most famous of all American Bibles, the Eliot Indian Bible (Cambridge, 1661–3), closely trimmed but in a contemporary binding, brought $21,000.

In the first sale of duplicates and out-of-scope works from the collections of The Maryland Historical Society, Baltimore, several rarities in the Western American field brought outstanding prices, including a rebound second edition of Felix Wierzbicki's *California as It Is and as It May Be* (San Francisco, 1849), considered the first descriptive work written and printed in California, which made $1,750.

The sale on March 28, 1967, of 162 items from the stock of Edward Eberstadt & Sons of New York, the well-known Western Americana dealers, saw a very high level of prices, the sale fetching a total of $121,115. While there were many important printed items, attention was centred on the manuscripts. The highest price in the sale was $9,000 for a signed holograph manuscript by Father Junípero Serra written at Monterrey, California, March 1, 1777. A letter by another famous missionary of the Southwest, Father Eusebio Francisco Kino, written in the region which is now Arizona on November 30, 1690, made $6,000. Manuscripts of unusual importance for the history of The Church of Jesus Christ of Latter Day Saints (Mormons) fetched high prices, a brief document in the hand of Joseph Smith the Prophet making $1,300. Four lots of manuscripts by or about James Jesse Strang, 'King of Beaver Island,' one of the most extraordinary characters in all American history, brought a total of $13,250.

Alexander III of Russia.
Desk Calendar for 1894, with sixteen pages of the Emperor's manuscript
notes, recording daily activities. New York $1,500 (£536) 9.XI.66.

*Plan of the fort at De Troit*
Signed and dated W.B. Albany [New York,] Augt. 18th, 1761
London £1,900 ($5,320) 3–4.VII.67.

CHRISTOPHER COLUMBUS
*Epistola de Insulis Indie supra Gangem
nuper invetis.*
Quarto, Rome, Stephan Plannck, 1493
An account of his voyages, written
by Columbus of the homeward voyage.
New York $30,000 (£10,714)
25–26.X.66.

The Library of the late Dr Thomas A. McGraw sold on April 11, 1967, was primarily devoted to the history of science and English literature, but among several pieces of Americana a copy of the late President Kennedy's *As We Remember Joe* (Cambridge, 1945), inscribed by the President, made $1,800.

The two sales of the Library of the late Henry O. Havemeyer, Mahwah, New Jersey, held on March 21 and May 9, 1967, consisting primarily of Naval Americana, books and prints, while lacking great rarities, made a total of $49,935.

The high point in American manuscripts during the season was reached in the sale on May 16, 1967, of a collection of letters and documents by the Signers of the American Declaration of Independence, in which 71 lots made a total of $74,790, the highest price being $20,000 for a fine George Washington L.s., written in New York on July 4, 1776. This is the highest price ever fetched by a Washington letter. A fine Franklin A.L.s. made $2,250, and a document bearing the signatures of no less than seven of the Signers made $3,250.

The most important Americana sale of this season, and indeed of any season since 1878–93 (the Brinley Library), was Parts I and II of the Celebrated Collection of Americana formed by the late Thomas Winthrop Streeter of Morristown, New Jersey. Part I, sold October 25–26, 1966, made $618,115 for the 609 lots and Part II, sold April 19–20, 1967, made $874,195 for the 685 lots. Outstanding prices were $80,000 for the Cambridge Platform of 1649, $56,000 for Antonio Pigafetta's account of the voyage of Magellan (circa 1525), $39,000 for *The Atlantic Neptune* of Des Barres (1774–9), $25,000 for the Villegagnon account of Brazil (1557), $30,000 for the Columbus Letter (1493), $23,000 for the first sheet music of *The Star-Spangled Banner* (1814), and $20,000 for Governor John N. Goodwin's Arizona Territory proclamation (1863?). At the end of the 1966–7 season approximately one third of the Streeter Collection had been sold.

# Glass

The most important piece of glass sold at Sotheby's last season was a beaker with a strange history, whose place of manufacture is still a subject of a mild and learned controversy. Its origin revolves round Fatimite Egypt about A.D. 1,100, Persia, Iraq, Georgia and, more recently, on the strength of the recent discovery of some fragments, in the neighbourhood of Kiev; the theory which has most adherents seems to be that it was made in Egypt. About fifteen beakers cut in this manner have been recorded and all are known as Hedwig glasses because the saint of this name, who died in 1234, is traditionally said to have owned one which is in the Museum at Breslau; some of them still retain their 13th-century mounts. The one in this dispersal was discovered as long ago as 1820 during repairs to the Sacristy of the Cathedral of Halberstadt. For a time it belonged to a Police Commissioner and then to a bookbinder in Harzburg who used it as a paste-pot. Surviving this workaday hazard it passed into a private collection in Berlin, that of Frau Generalmajor von Röse and then to that of the Duke of Gotha. The modest bookbinder in the little German town, were he alive today, would be surprised to learn that his pastepot was sold for £19,000.

Not surprisingly, nothing else so obviously out of this world was seen during the past season, nor indeed is likely to appear in the near future. Among English glasses the most interesting was a posset pot of about 1676 by George Ravenscroft, bearing his seal of the Ravens Head and made by him either at his experimental workshop at Henley-on-Thames or at the Savoy Glasshouse. This was a well-known example by the man who, after Verzelini in the previous century, most deserves the honour of a permanent memorial, and had been seen as recently as 1960 in the same rooms in the collection of Sir Hugh Dawson and was bought for £1,200. A few years previously it had changed owners for about half that amount. It now made £2,600. The same morning an early 18th-century Nuremberg bowl engraved with a view of the town and mounted in silver-gilt, was bought for £920, while six weeks previously a late 17th-century ruby glass tankard, also with Nuremberg silver-gilt mounts, made £750, and, much earlier in the season, an English rummer of about 1685 found a new home at £780. £1,000 was given for two opaque-white glass tea caddies from Staffordshire, enamelled with birds and flowers—the type of glass deliberately made in its day to compete with the newly fashionable porcelain and among the most charming products of the English mid-18th-century glass houses. It is only comparatively recently that the market has woken up to the comparative rarity of this so-called milk and water glass, for the same pair was sold as lately as 1955 for £190. Among many Irish pieces a canoe-shaped cut glass fruit bowl made £240, and, among 19th-century glass, a 'Fairy Pyramid' night-light stand in Webb's 'Burmese' glass surprised many of us and surely delighted its owner by selling for £350. The enthusiastic world of paperweight fanciers found endless entertainment throughout the year. Notable examples were a St. Louis encased pink overlay weight at £3,400, a St. Louis clematis weight at £1,250, and a Clichy dahlia weight at £1,750.

A 'Hedwig' Glass, beaker shape.
Height 3¾ in., diameter at rim 2⅝ in.,
diameter at foot 2¾ in.
Fatimite, 11th–12th century.
Discovered during repairs to the
Sacristy of the Cathedral of Halberstadt
in about 1820, it was then acquired by
a Commissioner of Police and sub-
sequently belonged to a bookbinder in
Harzburg, named Stolle, who is said to
have used it as a paste-pot. Later it was
in a private collection in Berlin, that of
Frau Generalmajor von Röse, and in the
collection of the Duke of Gotha.
London £19,000 ($53,200) 18–19.V.67.
From the collection of the late Madame
Alexandrine de Rothschild.

A Sealed Posset Pot, by George
Ravenscroft, *circa* 1676. Height 3¾ in.
London £2,600 ($7,280) 3.IV.67.
From the collection of Mrs C. R. Plesch.

One of two Staffordshire
Opaque-White Tea Caddies
with gilt-metal tops. Height 5⅝ in.
London £1,000 ($2,800) 8.V.67.

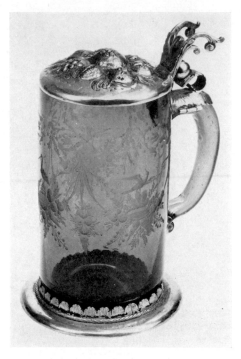

A Ruby Glass Tankard, with
silver-gilt mounts, with a Nuremberg
hall mark (maker unknown),
late 17th century. Height 6⅛ in.
London £750 ($2,100) 20.II.67.

A Nuremberg Topographical
Covered Bowl with silver-gilt mounts.
Height 7¾ in.
London £920 ($2,576) 3.IV.67.

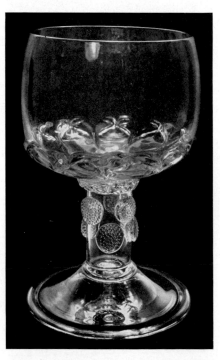

A Large Early Rummer, *circa* 1685.
London £780 ($2,184) 10.X.66.
From the collection of Henry Nyburg,
Esq.

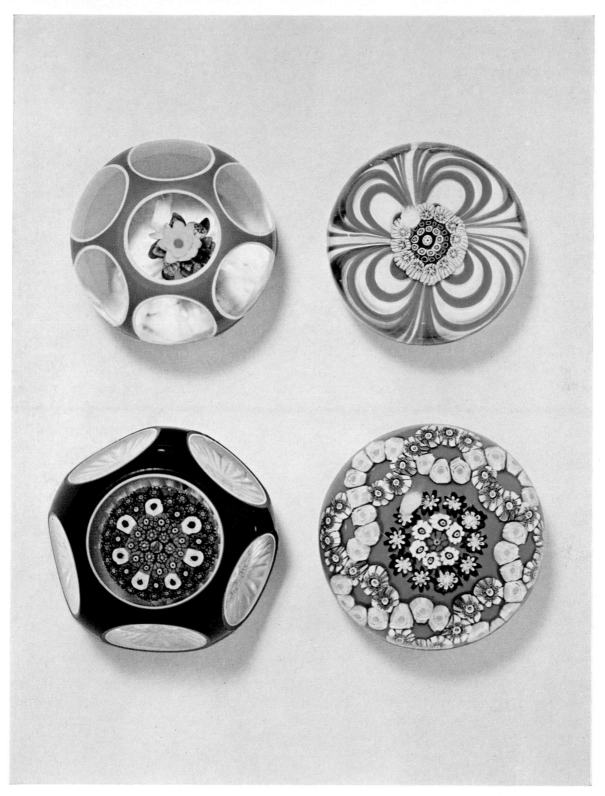

*Above*　A St. Louis Encased Pink
Overlay Weight. Diameter 2⅞ in.
£3,400 ($9,520)

*Below*　A Clichy Opaque-Blue Overlay
Weight. Diameter 3¼ in. £1,200 ($3,360)

*Above*　A St. Louis Marbrie Weight.
Diameter 2⅞ in. £1,800 ($5,040)

*Below*　A Clichy Opaque Turquoise
Colour-ground Weight. Diameter 3¼ in.
£170 ($476)

All from the collection of Signor Ing. Manuel Gonzáles de Cosío of Mexico, sold at Sotheby's on the
3rd July 1967 for a total of £30,356 ($84,997).

# English Pottery and Porcelain

When one realises that ever since Lady Charlotte Schreiber combed Europe for English porcelain and thought herself very hardly done by if she had to pay as much as £5 for anything, dozens of expert, hawklike eyes have been probing unlikely places for similar discoveries, it is extraordinary that we have had to wait until 1967 to see a Worcester coloured bird group. Figure models from the factory are rare enough, the Turk, the Gardener, and the Sportsman, each with his young woman —but birds are, or rather were, almost unknown until the appearance of the two canaries—unless one cares to take into account a pair of billing doves on the cover of a tureen seen at Sotheby's in 1963. The Sportsman and his girl must nearly resemble this canary group; the same central shell on the base, similar flowers and 'hot-cross bun buds'. The date is about 1770 and the group was sold for £4,800; the highest sum yet recorded at auction for a single piece of English porcelain. Other rarities on this occasion included an early Derby figure of a street-seller, lantern in hand and basket hanging from a strap over his shoulder which made £1,950; a Worcester *bleu celeste* teapot stand painted in James Giles' workshop went for £1,050 and a delightfully subtle sucrier and cover convincingly attributed to the 'Girl in a Swing' factory for £1,300. This is the mysterious factory not yet identified and so far known only for its production of fine quality scent bottles. The only known comparable piece is a gold mounted porcelain cachet containing four glass scent bottles illustrated by Kate Foster in her book *Scent Bottles*. The highly glazed grey-green porcelain is very similar and also the treatment of the pink roses and green leaves.

This was an April sale which has remained so vividly in the memory that two or three earliest dispersals of no less interest are almost and unforgivably lost in a pre-Christmas fog, which is absurd considering their variety. For among them was a Chelsea figure of the Doctor from the Italian Comedy, a straight indeed an inevitable crib from the Meissen of J. J. Kaendler, the Italian Comedy maestro *par excellence*, which made £3,500, a Chelsea Chinaman with long black moustaches which sold for more—£4,200, and a beggar £2,000. These three figures had remained together since 1755 when they were sold as stock from the factory. Then there were several Chelsea Botanical plates at £900 and £1,000 apiece, a blue scale Worcester chamber candlestick at £920, a Worcester armorial teapot and cover at £1,250. A pair of Chelsea 'Hans Sloane' vases at £3,000, a Chelsea scopolendrium teapot and cover at the formidable sum of £3,800, a peach-shaped Chelsea cup and saucer for £1,600 and a fluted dish at £1,300, were among other quality pieces which formed the final part of the Parkinson collection.

The most unusual offering of the season was, I suppose, the herd of Staffordshire and Yorkshire cow creamers, those engaging if unhygienic milk receptacles in most if not quite all the colours of the rainbow, which were so numerous that they were dealt with in three separate sales, a fourth and final part to follow in the autumn.

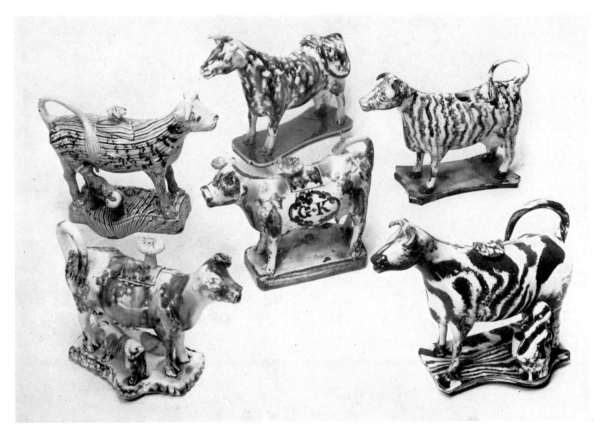

*Above left to right* An Early Astbury Whieldon Cow Creamer £330 ($924); a Whieldon Cow Creamer £220 ($616); and a St. Anthony Cow Creamer £90 ($252).
*Below left to right* A Whieldon Cow Creamer £165 ($462); a Whieldon Cow Creamer £140 ($392); and a Staffordshire solid agate Cow Creamer (one of a pair) £230 ($644).
All from the collection of the late Captain C. B. Kidd.

They made uncommonly high prices—that is, the most unusual animals—up to £410 for a giant creature, splashed with manganese and ochre and up to £330 paid for an Astbury-Whieldon example. Several went for over £150 each, and one possibly from the Leeds factory of the ware known as solid agate (not of course to be taken literally) for £310. In a different category, though no less good humoured, was an equestrian figure of King William III by Ralph Wood—an impressive combination of rustic naïvety soft greens and vigorous modelling (£1,200). Of all the porcelain models from the Bow factory, the pair always known as the Dismal Hounds, are as endearing as anything ever seen at Crufts. I have never been able to understand why they have been called dismal—to me they are young pointers, not yet wholly in control of their limbs. One can easily imagine them getting up and galumphing along in the manner such immature creatures do. Anyway, dismal they are known among *afficionados* and dismal they will no doubt remain. These two turned up at the end of January and made £1,250. A similar pair, also at Sotheby's had been sold in 1961 for £730, and another pair last year for £950.

# Thirty Years of English Porcelain Collecting

by Kate Foster

What motivates the collecting of porcelain? Is it the power of possession, the power of money, or a most complex disease of the mind? The desire to possess has affected people of all ranks in the social scale, from kings to fish-and-chip shopkeepers, the one aided by the ready possession of wealth and the other urged on by the ever-increasing love of the pieces that he has been able to assemble.

Generally speaking the collecting of pictures, furniture and silver until recently, and indeed even now, has been the occupation of the landed gentry, furnishing the town or country house and adding to the grand style already installed by his illustrious ancestors. Very few were those who cared about the academic whys and wherefores connected with porcelain making, though many were aware of its quality as a form of decorative craftsmanship. Where England differed from the rest of Europe at the outset of porcelain making in the mid-eighteenth century was that the English porcelain factories did not enjoy the patronage of royalty, whereas the continental factories were run and heavily subsidised by the local members of royalty and noble houses. Thus, where one found most of the finest German, French and Italian porcelain concentrated in the palaces and castles of those countries, in England many of the rarest and finest pieces of porcelain were retained by the families of those who ran or worked in the factories. This point of members of a totally different social scale becoming knowledgeable and successful collectors is one which makes the field of English porcelain collecting so interesting and different to that of any other country.

This article is concerned with collecting during the last thirty years and in order to capture the atmosphere of the situation at the beginning of this period it is important to consider a few of the collections which initiate the war period, when so many of today's collections were formed. Values are impossible to analyse, and the task would be a boring one. I believe that it is more valuable to form an idea of the taste which has dominated the most important collections which have been dispersed during the last thirty years, to see the predominance of a certain type of porcelain, whether it was Chelsea, Worcester or another factory primarily in vogue, whether there has been any basic change in the fashion of porcelain collecting and finally, what economic considerations could with wisdom be brought to the attention of today's and tomorrow's collectors.

The first great collection to be sold during the period covered by this article was the one formed by Wallace Elliot. The three days in 1938 were allotted for this highly representative collection of English pottery and porcelain: early slipware, Ralph Wood and Whieldon figures and wares, and a magnificent group of white and coloured saltglaze, Lund's Bristol and early Worcester, Bow, Chelsea, Derby, Liverpool,

*Above*   An Early Chelsea Scolopendrium Teapot and Cover, raised anchor period.
London £3,800 ($10,640) 11.X.66.
Previous prices realised; 1941—£17; 1945—£85; 1962—£1,150.
*Below*   A Chelsea peach-shaped Cup and Saucer, raised anchor period.
London £1,600 ($4,480) 11.X.66.
The collection of porcelain belonging to the late Selwyn Parkinson, Esq. (of which the above two lots were a part) was sold at Sotheby's in three sales for a total of £132,662 ($371,423).

Lowestoft, Longton Hall and Bristol. Many of the pieces came from well-known collections and were illustrated in standard works, and most were to feed the well-known collections of the future. The total of just over £8,000 for the sale seems a very low figure, although a number of the finest pieces were acquired before the sale by the Victoria and Albert and British Museums.

Three years later came the collection of Dr. Bellamy Gardner (collecting porcelain seems to afflict the medical profession more than any other group!). This collection contained an exceptional series of early Chelsea figures and wares, the like of which today, on the rare occasions they reappear on the market, bring groans of nostalgia to those who witnessed the disastrously war-affected prices of June 1941. On that day the buyers were fortunate indeed to acquire pieces from what is generally considered the finest collection of Chelsea porcelain to be assembled by one person. Evidence of some of of the prices will emerge as compared with later prices as this article progresses.

The Hurlbutt collection in 1945–46 was of a very general character, containing both academically interesting and fine pieces from all the 18th-century factories. The first sale which consisted of 164 lots totalled £6,527. 10s, the second sale of 150 lots bringing £5,842 and the final sale of 134 lots £3,335. Some slight upward change in prices appears, but the war still affected the amount of money available. The only comparative value being the Lund's Bristol figure of Lu Tung Pin, which was in the Wallace Elliot sale in 1938 for £42, fetched £62.

In the Cochrane sale of 1946, in a mixed sale a small and select collection of Worcester colour-ground porcelain appeared, of a quality to stagger present collectors. Most celebrated in that sale was lot 133, a yellow-scale tea service with bird decoration, consisting of thirty-three pieces which sold for the then lordly sum of £700. It is interesting to note that the teapot, cover and stand from that service returned to the sale room in 1966 in the Parkinson collection to be carried away for £3,800. Each cup and saucer from that service is now worth probably as much as the whole service originally made.

On March 29, 1949 porcelain belonging to Sir Bernard Eckstein was sold for a total sum of £18,842. This sale marks the beginning of the upward trend in the prices of good quality English porcelain. A Worcester blue-scale chocolate cup and saucer, decorated with Chinese musicians, fetched £295; a Duke of Gloucester service plate £180; a pair of shagreen plates £200 (£1,500 and £1,150 in 1966) and a pair of Worcester figures of gardeners £700, though a yellow-scale spoon tray only made £70 (£2,800 in the Parkinson collection 1966); a pink-scale cup and saucer with Teniers figures £115. On the other hand a pair of Bow blue-ground saucer dishes with Giles decoration made the high price of £440; a pair of Bow figures of cooks which had been bought in the Radford sale in 1934 for £88 now made £240, and a pair of Bow pheasants (1946 £95) £400. Among the Chelsea was a pair of Girl in a Swing groups of Ganymede and the Eagle and Europa and the Bull. These were in the Bellamy Gardner collection and were sold in 1941 together for £18; in the Eckstein sale they were sold separately, the first for £165 and its companion for £130. The Chelsea white head of a boy was sold for the large sum of £640 and a pair of coloured Girl

A Chelsea white head of a baby boy,
raised anchor period. Prices realised;
1941—£15; 1947—£50; 1949—£630;
1961—£500; 1962—£2,000 and
£1,240.

A Worcester plate from the Duke of
Gloucester service. Prices realised;
1949—£180; 1952—£140;
1954—£190; 1957—£210;
1960—£420; 1965—£775;
1966—£1,045.

in a Swing figures with grapes for £650. Four masqueraders of the gold anchor period fetched £130, £200, £300 and £150 and two figures of the Nourrice, modelled from the Palissy original, made £520 and £540. All in all the Eckstein collection can be regarded as the last of the large 'old fashioned' collections in its wide range of interest, its inclusion of the ornate gold anchor Chelsea wares and figures and of its possession of the then recent 'trouvailles', the Worcester gardeners and the Girl in a Swing groups.

In 1955 came the first part of the teapot collection formed by the Rev. C. J. Sharp. A highly entertaining subject for a collection, the teapot allows a far wider scope for the collector than many general collections of porcelain. Not only porcelain, but tea also was enjoying a new vogue, and Mr. Sharp was in the enviable position of being able to offer himself tea out of at least one teapot on every day of the year. The first sale, consisting of 120 lots was very carefully selected, not only with an eye for quality, but also for condition. Any teapot that was not in good condition was rejected and the result was a sale totalling £5,659 of which only eight lots fetched over £100. Almost exactly nine years later, in 1964, the second part of the collection was dispersed in 144 lots, this time consisting of the 'throw outs' of the original collection, and made a total of £9,713, twenty-two teapots fetching over £100. As this article goes to press the remainder of the Sharp Collection is being catalogued for sale.

May 1956 saw the dispersal of the Simon Goldblatt collection, consisting not only of English porcelain but also of Continental porcelain. They were practically all pieces of academic interest, none of them in notably good condition and most inexpensively

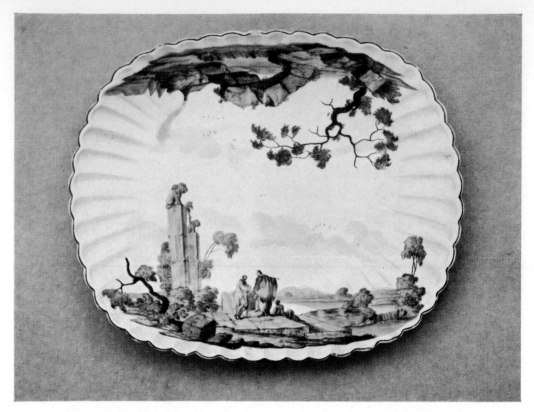

A Chelsea Fluted Dish, by Jefferyes Hammett O'Neale. London £1,300 ($3,640) 11.X.66. From the collections of Lady Rotherwick (sold at Sotheby's in November 1961 for £620 ($1,736) and the late Selwyn Parkinson, Esq.

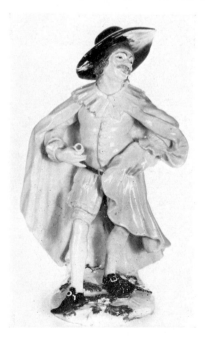

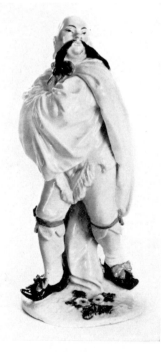

A Chelsea Figure of the Doctor,
*after the Meissen model by J. J. Kaendler,*
red anchor period.
London £3,500 ($9,800) 24.X.66.
Only two examples of this model
appear to be recorded.

A Chelsea Figure of a Chinaman.
London £4,200 ($11,760) 24.X.66.
Only one other example of this
model appears to be recorded, though
three examples of the companion
figure are known.

The above two figures were sold with one other, having remained intact as a group since 1755 when they figured in Mr Ford's sale catalogue.

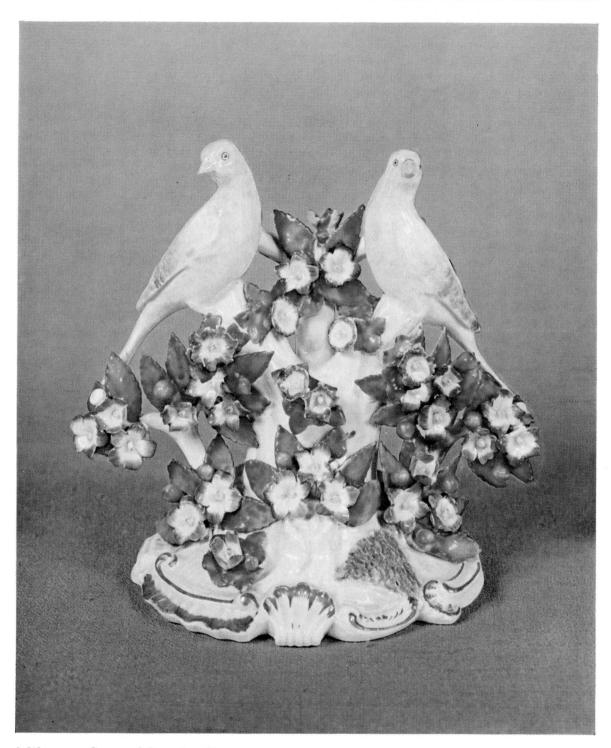

A Worcester Group of Canaries. *Circa* 1770.
London £4,800 ($13,440) 18.IV.67.

bought. Sensational in price was a pair of Girl in a Swing coloured figures of a boy with a fish and a girl with a basket, these being sold for £2,500.

In 1957, having written the definitive books on Chelsea and others on Worcester, Plymouth and Bristol porcelain, Dr. Severne Mackenna disposed of his collection consisting mostly of pieces from those factories, and disappeared from the collecting world. Prices were at a steady high level and the well-documented collection totalled £18,857. The following month was notable for the dispersal of a fine collection of Worcester belonging to Edmund d'Arcy Taylor, in which there was a generally very high level of quality. A Duke of Gloucester plate made £210, a blue-scale chinoiserie cup and saucer £310 and a coffee pot with Teniers figures £770, a pink-scale mug with similar decoration £740 and two teabowls and saucers with the same figures £400 and £430; a yellow-scale cup and saucers with bird decoration £340, a yellow-ground teapot with flowers £620 and a pair of yellow junket dishes £550.

1961 was distinguished for the first of a quantity of first-quality porcelain to be sold by Mr. and Mrs. James MacHarg. Occasioned by the merger of the two collections, the first sale was effectively a weeding out, although the quality was nevertheless very high. A Chelsea white head of a boy which had been purchased in the ill-fated Bellamy Gardner sale in 1941 for £16 made £520; an early Chelsea white Chinaman tea jar (1951 £850) made the same sum and a fable teapot, decorated by O'Neale and bought from the Moseley sale in 1946 for £62, made the astonishingly high price of £1,000. This was brought about by an auction room phenomenon of there being in the room two people equally determined to possess the object and afford the price.

A collection which was very specialised in nature and which could boast the widest range of table wares made at the Bow factory, was formed by Dr. John A. Ainslie. An unprecedented occasion for the Bow enthusiast to add to his collection, at more than previous prices, even though only four lots made over one hundred pounds. Bow has never equalled in price the equivalent pieces made at Chelsea and Worcester, but in its own way the Ainslie sale set a new standard for Bow porcelain.

Following in 1962 came the second instalment of MacHarg porcelain, resulting in the same scramble for pieces that had happened at the earlier sale, and in the same appearance of high prices. A small Derby owl bought in 1952 for £260 made £640, a Longton Hall melon (1947 £18) £900, a Bow shepherd dated 1757 fetched £700 and his companion £520, having been bought together in 1947 for £140 when the date was not noticed on the bagpipes. A Chelsea triangle-period strawberry jug made £1,300; this has an interesting saleroom history having been sold in 1866 for £8 and in the Sotheby heirloom sale in 1955 for £950. Another high price was for another Chelsea white head of a boy (Eckstein 1949 £640) £2,000, and a Chelsea eel tureen £1,300 (a pair of these was in the Bellamy Gardner sale for £36).

Frank Arnold, of Leamington Spa, was one of the 'true' collectors, who assembled with great taste and knowledge a collection largely from the sales discussed earlier in this article. This collection was sold in 1964. Among the wide range of factories almost the most remarkable was the Lowestoft which contained a number of documentary pieces. The 'Rob. and Mary Godfrey 1782' teapot from the Crisp collection

A Chelsea asparagus tureen and cover, red anchor period.
Prices realised: 1941—£30; 1947—£135; 1950—£620;
1951—£620; 1952—£480; 1953—£650; 1955—£820 and £1,250;
1959—£400 and £620; 1962—£950; 1963—£1,450; 1965—£580;
1966—£700.

A Chelsea coloured 'Goat and Bee'
Jug, triangle period. Prices realised:
1938—£15; 1941—£10; 1943—£15;
1953—£350; 1955—£410; 1957—
£320; 1960—£330; 1963—£380;
1966—£500.

(1935 £15) fetched £240 and the 'Maria Camm 1771' mug made £230 (Wallace
Elliot 1938 £26). An early Chelsea jug with decoration, influenced strongly by
Vincennes porcelain which was in the C. King collection, sold in 1938 for £18. 10s,
made £1,050; a Worcester mug printed with the Children's games after Gravelot
made £200 and a Bow mug with the same print £65 (1938 £5); a Derby transfer-
printed coffee pot £100 (1938 £4. 10s) a Lund's Bristol teapot £460 and a vase from
the same factory £410. Bristol plaques, all highly documented, made £160, £240, and
£200 (1938 £9, £18, and £15).

'Birds of a feather flock together' is certainly endorsed by the collection of porcelain
birds collected by Mrs. Edward Hutton of New York, which flew the Atlantic to be
sold in London in 1965. Nesting between the Bow, Chelsea, Derby and Plymouth
birds were their European cuckoos, as always disrupting the peace and making
generally higher prices. Some of the English birds, however, managed to hold their
own, especially a brilliant small green Chelsea parakeet at £2,000 in spite of having
a broken tree-trunk, and an enchanting small yellow canary made at the Girl in a
Swing factory fetched £800; a pair of Bow pheasants, bought from the Eckstein col-
lection in 1949 for £400 made £2,600 and significantly a small owl made only £300,
the MacHarg one having fetched more than double the price three years earlier.

To return to the academic collections, one which caused interest not only to porce-
lain collectors but also to enamel and print enthusiasts, was the Capell collection
of transfer-printed porcelain, as one might expect consisting chiefly of Worcester,
but also of Bow and Liverpool. To re-emphasize the possibilities for beginners to
buy at auction, only eight per cent of the lots fetched over £100 and the average

A Staffordshire Rodney Jug.
London £680 ($1,904) 2.V.67.
From the F. S. Berry Collection
and from the collection of Constance
Viscountess Mackintosh totalling
£15,074 ($42,207).

A Rodney Jug modelled as an officer.
London £1,050 ($2,940) 2.V.67.
From the S. Hooker Collection and
the collection of Constance Viscountess
Mackintosh.

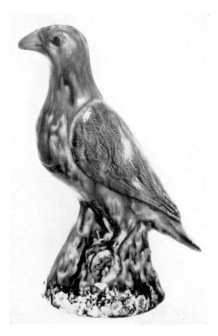

One of a Pair of Whieldon Figures
of Pigeons.
London £2,000 ($5,600) 20.VI.67.

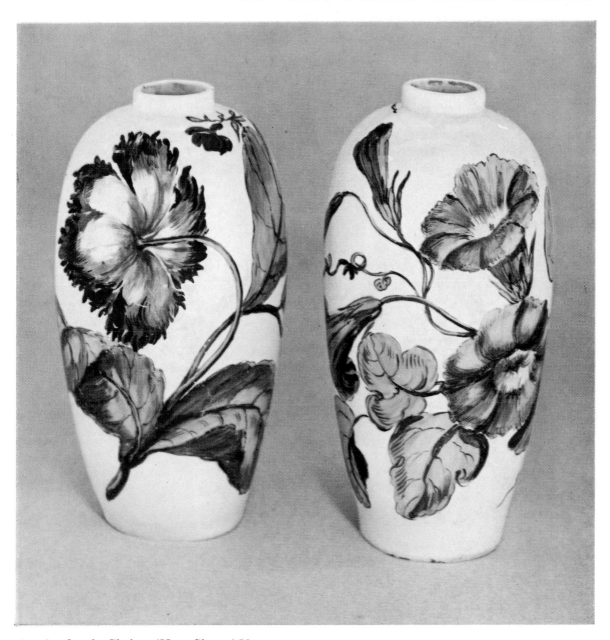

A pair of early Chelsea 'Hans Sloane' Vases.
London £3,000 ($8,400) 11.X.66.
From the collection of the late Selwyn Parkinson, Esq.

*Opposite page left*   An Early Derby
Figure of a Street-Seller.
London £1,950 ($5,460) 18.IV.67.
From the collection of the late
Alfred E. Pearson Esq.

price per lot was just over £50. In my introduction I mentioned that the collecting mania had affected all types of collectors from kings to fish-and-chip shopkeepers. One collection, formed with little financial resources but great flair and an eye for the unusual, belonged to Ernest Allman of Liverpool, who assembled this fascinating collection of pottery and porcelain in the back room of his shop. Pieces from his collection have filled many a gap in leading collections. The sale totalled £12,126.

The sale of the Eric Sanders collection was an eye-opener to up-to-date Worcester values, one which necessitated the re-valuation of many a good Worcester collection. A Duke of Gloucester plate made £780, a blue-scale broth bowl £850 and an apple-green coffee pot realised the amazing sum of £2,200. Other wild prices in the tense saleroom were £1,100 for a yellow coffee pot, the same price for a yellow-scale bowl and £1,300 for a puce-scale saucer dish with Teniers figures.

These prices on their own may not seem very significant, particularly as high prices can often emerge unexpectedly out of a tension-fraught room. However, on the appearance of the Parkinson collection of Worcester and Chelsea in 1966, it was proved that it was not an isolated case, and prices in the Sanders collection were seen to be the norm rather than an exception. Collected with an ever-increasing pleasure and knowledge of the porcelain which he was buying, Mr. Parkinson always bought with the excellent advice of chiefly three first-rate dealers the top quality, very often at the top market prices. Here a very good lesson may be learnt. If a collector can afford to do so he must always buy top quality, in perfect condition, if necessary at high prices. It is, of course, possible to overstep the mark of just how high to go, but here again it is vital to be properly advised by the best people, and so be in a position to build up a first-class collection.

The outstanding price in the first Parkinson sale, which contained the cream of the Worcester, was £3,800 paid for the yellow-scale teapot, cover and stand mentioned earlier as coming from the now famous Cochrane service. Two blue-scale fable dishes were sold for £2,700 each (1947 £135 and £200), a Duke of Gloucester plate £1,050 (1954 £190), a pink-scale teabowl and saucer with Teniers figures £1,500 (Eckstein 1949 £115), a yellow junket dish £1,250 (1956 £175) and pairs of fable plates and dishes between £680 and £1,150. Among Chelsea prices in the second and third sales were some equally interesting comparative prices. A teaplant coffee pot fetched £1,200 as opposed to £600 in 1963 and £46 in 1938; a dish sold as a duplicate from the British Museum in 1961 for £440 made £620, and a peach-shaped cup and saucer with the Kakiemon pattern of the Lady in a Pavilion made £1,600, possibly the same one which with other items in the same lot in 1940 made £14. Other pieces of Chelsea made about the same price or slightly below what had been paid for them in the years 1962–3, but the most interesting Chelsea piece was the scolopendrium teapot which fetched £3,800, having progressed from £17 in the Bellamy Gardner sale in 1941 to £85 in the Hurlbutt sale in 1945, to £1,150 in MacHarg 1962. Another Chelsea teapot, with the acanthus leaf moulding and the Kakiemon red dragon pattern, was carried off by its proud purchaser for £3,100.

A subject which cannot be ignored when discussing values since the war is that of

Chelsea scentbottles. These small trivialities have been the heroes and victims of many different moods, particularly during the last seven years, and one or two points are worth remembering. In 1960 and 1961 one of the greatest collections of porcelain to be formed this century was dispersed, that of Otto and Magdalena Blohm of Hamburg and Caracas. A large part of their attention was drawn to the workmanship and charm of the Chelsea bottles, and having an unfailing eye for the best quality in everything, the Blohm scentbottles were of a very high standard. As the price lists relate, prices were very high indeed, single bottles topping the thousand pound mark and others making very little under. However, not everyone buying on those occasions was buying judiciously, and this had a very adverse effect on the scentbottle market, some of those same bottles appearing on the market within too short a time of the original sale, and fetching considerably lower prices. This was also responsible for the fact that when the Sassoon collection of bottles, a collection in every way as great as the Blohm collection, was offered for sale in 1965, the prices were not all up to the same level as the Blohm prices.

No particular pattern emerges from the foregoing summary. When Chelsea prices were at their peak Worcester prices were down. Now that generally Worcester is very highly valued much Chelsea appears cheap. For one thing, Worcester was made originally in large quantities as domestic services. Now that it is collected by a great number of people it is still available through the splitting up of these services, while Chelsea, which was never made in such large quantities, is harder to find, and so fewer people decide to collect it. One thing is certain, Bow and early Derby porcelain, which have never reached the same level as the fore-mentioned factories, are bound to increase in value. People may say that the reason for this failure to mount in value is because it is inferior porcelain, nevertheless they both in their own particular way possess a charm which merits more attention. Great advances have been made in the value of blue and white porcelain of the 18th century, and in the view of some experts it has even reached a point where it is fetching more than it is worth. Perhaps the greatest strides have been made in the 19th-century porcelain, especially in the field that falls in the category of 'Regency' porcelain. Flight and Chamberlain's Worcester, particularly when decorated with feathers or shells, botanically decorated Derby services, Derby, Worcester and Minton plaques and services generally have all risen astronomically in value in recent years. It seems clear that with the growing scarcity of 18th century porcelain, collectors will show far more interest in the 19th century, where there is a large supply and much to learn.

So it can be seen that collecting porcelain is beset with the same problems as collecting anything else. It is always subject to fashions, availability and common sense. He who takes pleasure in acquiring knowledge before putting his hand in his pocket will not as a rule lose financially, nor can he who takes the trouble to obtain the best possible advice. As long as there remains porcelain to collect there will exist the people who are prepared to fall prey to its charm, but in order for this to continue it is vital that those who have had pleasure themselves in collecting should realise that it rests with them to allow the next generation a similar pleasure, and not to increase the problems of Museums by making their vaults overflow the more, thus bringing collecting to a halt.

# Treasure of the Spanish Main

by Howard Ricketts

Until ten years ago the most successful salvage of Spanish sunken treasure had been accomplished in 1678 by William Phipps who recovered over a million dollars in silver bars and coins from a galleon in the Caribbean. His reward was a knighthood and governorship of Massachusetts. Since then others have made the occasional find but not in any way to be compared with Phipps'. This position remained unaltered until a few years ago when a retired builder stumbled across what was to be the most important find of sunken treasure since the 17th century.

Since the very first Spanish Plate Fleet sailed from the New World for Seville, laden with gold and silver mined in the newly-won Spanish colonies and minted at Mexico City, Cuzco and Lima in Peru, and Santa Fe de Bogota in Columbia, greedy-eyed foreign powers had attempted to divert this steady stream of wealth into their own exchequers.

Before 1715, when the ill-fated Spanish Plate Fleet set sail for Cadiz, the Casa de la Contraction, the Spanish Governmental body responsible for giving contracts to merchantmen trading with the New World, had had 213 years of experience in organising such shipments.

From the start theirs had been a strict policy of only permitting merchantmen sailing in armed convoys: thus piracy was discouraged. This discipline had paid off handsomely, but in the mid-17th century conditions deteriorated for the Spaniards in the Caribbean. In this thousand mile stretch of water, which represented the last stage of the outward journey before reaching the safety of Vera Cruz or Cartagena, stragglers stood little chance of survival. For half a century before the 1715 Fleet sailed it was the Buccaneers who did the most damage to Spanish shipping and property. But their status rather depended on British and Dutch support which was given quite readily until such a time as both these great maritime nations would be able to openly oppose Spain in the Indies.

Within four years of the turn of the century, when Spain went to war over its own succession, their opportunity occurred. Charles II had died without an heir in 1701 and the crown passed to Philip V, Louis XIV's grandson. The English and the Dutch, worried that this alliance would disrupt the Balance of Power in Europe, supported a Hapsburg candidate. Europe was engulfed in war and Spain's navy was pitched against the superior maritime forces of Holland and England. Allied initiative was stepped up in the Caribbean and Spain had to give up any hope it had entertained of maintaining its steady supply of treasure from America. For a decade the Plate Fleets were more or less suspended.

*Opposite page:*
The Captain-General's emblem of office, consisting of a gold whistle in the form of a dragon, with tapering body terminating in an ear probe; the dorsal fin enclosing a hinged toothpick; the whole suspended from a gold chain of 2,176 links. Chinese, early 18th century, made for the European market. This personal badge of office made for Captain-General Juan Esteban Ubilla, Commander of the Fleet, was recovered on the beach opposite the 'Cabin Wreck' south of Sebastian Inlet, Florida, by the Real-8 Co., Inc. and sold at Parke-Bernet on the 4th February, 1967 for $50,000 (£17,857).

When European hostilities finally petered out in 1712, the English Government, accepting that Philip V could not be dislodged, turned their minds to a trading agreement in exchange for recognition of the Spanish crown. The Spaniards granted the South Sea Company the slave trade *Asiento* and permission for that company to send a shipload of merchandise to the Indies every year. So, under duress and with extreme misgiving, the Spanish government created a breach in their well-guarded autocratic commercial system. The only way to put matters right was to re-establish their economy; the Treasure Fleets must sail again. The war ended with the Treaty of Utrecht in 1713. Already, in 1712, encouraged by the first signs of reduced allied aggression in the Atlantic, plans were laid for a completely 'safe' outward and return voyage. Two separate fleets would be sent out, and having sold their cargoes at the various fairs and trading ports in the Indies, would join forces and return to Spain, heavily guarded and bearing the accumulated wealth of the last three years.

But the best that could be scraped together at that time was a pitiful *flota*—two despatch vessels and an old provisions ship described as the *Urca de Lima*, guarded by two warships. The Commander was Captain-General Juan Esteban Ubilla. His instructions were to land quicksilver, vital for the production of bullion, and pick up gold and silver at Vera Cruz; both fleets would then meet in Havana for the return voyage.

The *Casa* gave the contract for the second fleet to a commercial magnate from Northern Spain, Antonio de Echeverz. He bought or chartered "register-ships" to carry his export goods out to the ports in the Caribbean. But the delays, which eventually contributed to the destruction of the combined fleet, started as soon as Echeverz's fleet dropped anchor in the first port. With Spanish trade cut down to the barest minimum in recent years, other traders had stepped in and were successfully selling lower priced goods. It took the Captain-General three years to sell off his cargoes, often at a loss. At Cartagena the ships were loaded with bullion from the Colombia mints and 166 chests of emeralds from the mines in Potosi. In spite of these delays, Echeverz's fleet was the first to arrive at Havana.

Possibly Ubilla was held up by the late arrival of the infrequent consignments of oriental goods in Vera Cruz. Chinese export porcelain was loaded on his ships which had been taken by junk from Macao to Manila and from there to Acapulco on the 'Manila Galleon' which did this tortuous journey in two months. On one such journey a passenger complained that 'there were so many maggots, that they swam at the top of the broth, and the Quantity was so great, that beside the loathing they caused, I doubted whether the Dinner was Fish or Flesh'. At Acapulco the oriental silks, gold objects and porcelain were loaded on pack mules and brought across the mountains to Vera Cruz.

Finally, laden with tons of coinage from the mint in Mexico City which formed part of the 'Royal Fifth', that is one-fifth of all the gold and silver minted in the New World which annually was paid as tribute to the Spanish Royal Treasury, the fleet sailed for Havana. Ubilla was fully aware of the dangers of sailing late from Havana; early hurricanes had hit shipping before then; and he was most anxious to clear Cuba as soon as possible. The same fears were prevalent in Havana itself. The Governor

Examples of bar shot, cannon balls and grape shot. The cannon balls fetched up to $28 (£10) each, one bar shot $175 (£62), and the grape shot $90 (£32) for twenty.

A large anchor of base metal. Overall length 11 ft 10 in. Recovered from the cabin wreck and thought to be from the flagship. $1,000 (£357).

Four blue and white Chinese Export Porcelain Cups, K'ang Hsi (1612–1722). These cups before being shipwrecked had crossed the Pacific by junk from Macao to Manila and then by galleon to Acapulco. From there they crossed over to the Caribbean loaded on pack-mules to join Register ships or galleons bound for Europe. Prices from left to right: $600 (£214); $450 (£160); $450 (£160); $600 (£214).

of Jamaica, Lord Archibald Hamilton, received a spy's report and relayed the following message to the Lords of the Admiralty on April 26, 1715. 'My lords . . . By late advices from the Havana I am told the Galleons from Vera Cruz were dayly expected there in order to join two Spanish ships of war, one of which was the Hampton Court, who are said to have great Treasure on board for old Spain.'

This was Hamilton's first reference to the fleet but by no means his last. He followed the course of the 1715 Silver Plate Fleet with more than idle curiosity. Just over 150 feet long, the 'Hampton Court' was built in Deptford in 1687 and carried eighty cannon. She had been captured off Beachy Head by the French in 1709 and given to the Spanish, who renamed her. A contemporary drawing of the vessel by Van de Velde shows us the ship to which Ubilla transferred his flag and in which the most important treasure was stored.

Although dangerously behind schedule there were more delays to come. Ubilla fought hard to avoid taking 'Le Grifon'—a French ship, under his protection. But the senile Governor of Havana forced his hand. At the eleventh hour the most paradoxical delay of all occurred. Philip V had married Elizabeth Farnese and had promised her a magnificent present of jewels from the Spanish Colonies. These reached Havana just as the fleet was about to set sail and were laboriously listed and put on board the vessels alongside the King's bullion. There were eight chests in all including a necklace of one hundred and thirty matched pearls, an emerald ring weighing 74 carats and a pair of earrings each of fourteen carat pearls. This day or so lost in preparing bills of lading and stowing was to prove costly to the King and Queen.

The Fleet sailed on the morning tide on July 24 and made for the Gulf of Florida and the open Atlantic. The going was good until July 29 when the fleet, in close formation found itself becalmed off the coast of Florida. The night passed uneventfully and the galleons were in the same inert state at dawn. The sun seemed not to have risen and a thin mist hung over the ships. Visibility got worse; at noon Ubilla instructed each vessel to light the poop lanterns and to follow those of the ship in front. In the afternoon it got still darker; the wind increased first from the south-east but then moving round to east-north-east. Rapidly it reached gale force and deck cargoes and fittings were swept overboard by the seas. Worse was to follow. Later it was so violent that the water 'flew in the air like arrows, doing injury to those it hit, and seamen who had ventured much said they had never seen the like before.' This was recorded by the Chaplain to Don Antonio de Chevas, the Admiral of the Freighters. By nightfall the wind blew in gusts of up to 100 knots; the flagship lost its mizzen mast and the closely formed fleet was scattered with the hurricane blowing all but the Frenchman 'Le Grifon' onto the Florida reefs. The first to be destroyed in the outer reef opposite Sebastian Inlet was the old 'Hampton Court'. It was a little after 2 a.m. on July 31, and one by one the remaining vessels were destroyed .

As the man-o'-war grounded Ubilla ordered the sailors to make for the shore. But the undercurrent lifted the ship clear, drew it out and again smashed it against the reef. The poop deck was torn from the hull and washed ashore. Ubilla and over two hundred of his men were drowned.

Echervez's galleon met with a similar fate; the General and 124 of his passengers and crew were flung onto the reef and died. The only ship that was moderately fortunate, a charter ship 'La Holandesa', was propelled towards the reef at such a rate that she was carried over the rocks and cast up several hundred feet from the high water mark.

In spite of the ferocity of the storm there were several hundred survivors. At dawn they were huddled on the dunes taking stock of their situation. On this hostile shore there was little drinking water and the only form of shelter had to be constructed from salvaged timbers. The senior surviving officer was Captain Franco Salamon who ordered a group of survivors to take a repaired lifeboat and sail up the coast to the nearest town, St. Augustine, forty miles northward—and bring back provisions and arms. It took three days, but before they arrived, Salamon set off in another boat laden with some of the salvaged treasure. His voyage was short-lived; the boat capsized and the captain was drowned. With no effective leader a group of survivors took it upon themselves to steal as much bullion as they could carry, and braving the hostile Indians of the Seminole tribe, attempted to reach St. Augustine by land. They, too, were thwarted by the commander of the garrison town who ordered the execution of anyone found with the King of Spain's treasure on his person. The survivors were eventually taken off. But their plight was of secondary interest to the colonial Government in Havana, who were mainly interested in the millions of pesos of gold and bullion that lay within easy reach of the shore off Sebastian Inlet. But the Spaniards were not the only interested parties in the treasure.

News of the disaster had reached the English Colonies. Quite independently Lord Archibald Hamilton and the Governor of Virginia were trying to sound out White-hall for an opinion on the ownership of the sunken treasure. In October 1715 the latter reported to London 'here is advice of a considerable event in these parts, that the Spanish Plate Fleet richly laden, consisting of eleven sail, are, except one, lately cast away in the Gulf of Florida to the southward of St. Augustine, and that a Barcolongo sent from the Havana to fetch off from the Continent some passengers of distinction, who were in that Fleet, having recovered from the wrecks a considerable quantity of plate, is likewise cast away about forty miles to the northwd. of St. Augustine.' Yet this was Spanish treasure, lying on the sea bed a couple of hundred feet off a Spanish colony. Why was it of interest to London? The answer is given us by the Governor of Virginia in his next sentence . . . 'I think it my duty to inform His Majesty of this accident, which may be . . . to the advantage of His Majesties subjects if encouragement be given to attempt the recovery of that Immense Treasure.' London did not appear to give the colonists the encouragement, and before long the Spanish salvage team arrived in Florida to start work. The leader of the Spanish salvage team was the Sergeant-Major of Havana, Don Juan Solozano. He set up camp and employed Indian divers, using a rudimentary but somewhat lethal form of diving bell, to descend between ten and thirty feet, two hundred feet out, braving shark and barracuda, to forage around in the mass of broken timbers and rigging for treasure. About a fifth of the treasure was recovered and restored for safe keeping in a

block-house protected by cannon. Meanwhile, Lord Archibald Hamilton, bored with the lack of response from the Lords of the Admiralty took it upon himself to investigate the effectiveness of Solozano's salvage work. He equipped a fleet of sloops led by Captain Henry Jennings and commissioned them to sail from Kingston to 'suppress pirates'. His unofficial orders made it quite clear that the destination was to be Sebastian Inlet, and by December the fleet had reached its objective. Don Juan Francisco del Valle in his official complaint to the British Government recounts the first raid. 'Anchored in the Canal of Bahama near the Spanish camp, under Spanish colours, they laid still till night, and then landed their people, who next morning march'd to the camp with their arms; upon which the Spanish Commanding Officer asked them if it was war, they answered no, but they came to fish for the wrecks, to which the officer said that there was nothing of theirs there, that the vessels belonged to his Catholick Majesty (Philip V) and that he and his people were looking for the said treasure; but that seeing that his insinuations were of no use, he proffered them 25,000 pieces of eight, which they wouldnt not be satisfied with, but took all the silver they had and stripped the people, taking likewise away four small cannon, two of them brass, and nail'd two large ones (all of which were to defend a parapet they had thrown up to defend themselves from the Indians). They carried away 120,000 pieces of eight.'

Six months later Hamilton sent out fourteen sloops manned by 3,000 mariners 'to go a wrecking' on the sunken fleet. Again they were successful. Hamilton's enemies in Jamaica brought these exploits to the notice of the Lords of the Admiralty in London and the Governor was recalled to England to face trial. Jennings, however, reluctant to give up such a lucrative job joined the nest of pirates in Providence Island and continued to 'go a-wrecking'.

By now at least one third of the treasure had been recovered. The most accessible vessels had been searched most thoroughly. Season after season saw a slackening of salvaged coins and cargoes. By 1719 the salvage teams, handicapped by primitive equipment, had come to a complete standstill. Camp was broken and the Spaniards retired to Havana.

On the sea bed the wrecks were left to rot, untouched, for over two-hundred years. They would have remained that way if it wasn't for the determination of a retired builder, Kip Wagner, whose tenacity and single mindedness puts him on a par with Sir William Phipps.

In 1949 a friend of his stumbled across some oxidised silver coins on the beach at Sebastian Inlet. This caught Wagner's imagination and he decided to make a thorough investigation into the source of these coins. He bought a government surplus mine detector and set to work beach combing. Soon he had amassed a collection of about 100 silver pieces-of-eight and gold doubloons and noting that each one was dated prior to 1714 correctly surmised that a ship or a number of ships had been sunk off the Inlet around that date. Dr. Kelso, a friend of Kip Wagner's, joined in the research and found the vital document in Washington which confirmed their suspicions. Written against the stretch of coast in question by an English cartographer in 1775

*Above*   Gold ring-like setting, possibly the mount from a baton of office, 17th century. $650 (£232).

*Middle*   Gold ring, probably Dutch, late 17th century, possibly belonging to the Captain-General. $800 (£286).

*Below*   Diamond-set Gold ring, Spanish, 17th century. $2,300 (£821).

A Gold and Enamel Devotional Pendant and Chain originally having contained miniatures of the Holy Family, Spanish, 17th century. Recovered from the cabin wreck, $4,000 (£1,429).

was 'opposite this river, perished the Admiral commanding the Plate Fleet of 1715, the rest of the Fleet fourteen in number, between thre and ye bleach yard.'

The Doctor and Kip Wagner returned to the beach. Using a home-made diving mask they saw the first signs of a shipwreck—hundreds of ballast stones which had been used to weigh down a lightly laden ship and nearby encrusted cannon. Having found the first ship they felt that the locations of the other wrecks in the English map were probably accurate.

Another concentrated period of research revealed the cargo manifestos preserved in the Archives in Seville. Wagner now knew what had been stowed away on board but he couldn't tell whether an earlier salvage attempt had succeeded. The Spaniards are known to have recovered six out of fourteen million dollars worth of treasure. But had anyone successfully recovered anything after 1719?

Having drawn up an agreement with the State of Florida, Wagner settled down to form a diving company and finance an expedition, The team was recruited from the skin diving club at the Cape Kennedy missile base and gradually the necessary equipment was purchased. Diving was only possible in a short season from late Spring until the hurricanes threaten in July.

During this first season the divers realised what they were up against. The water is murky and it is difficult to identify objects on the sea bed. The undertow from the reefs could drag an inexperienced diver from the wreck site and weighed down with scuba diving suits it was difficult to remain mobile. However, the first wreck site was soon located from the outline of ballast stones; no trace of the ships themselves remained, all wood had disintegrated in the two hundred and fifty years it had lain on the ocean bed. A dredge was designed and tested but the sand it cleared only obscured everything in the immediate vicinity and consequently work was slow and laborious.

Every season new finds broke surface to be catalogued on board their boat, but it wasn't until 1964 that the first major haul was brought up. On a fine May afternoon the dredger blasted a circle of sand about thirty feet in diameter and there on the sea bed lay a carpet of closely grouped gold coins. Since then cake-shaped ingots of gold have been found as well as wedges of silver.

The most remarkable object recovered was found beneath the sand on the shore itself. A gold whistle suspended on a gold chain of 2,176 links was originally the badge of office of the Captain-General of the Fleet, Juan Esteban Ubilla. It was made in China and was probably specially commissioned.

Amongst the less dramatic pieces was a group of pewter plates recovered from the wreck of the 'Hampton Court,' which had been made by Robert Morse in London around 1701 and were probably put on board when the vessel was re-equipped.

In December last many of the major objects and a representative section of the coins were exhibited in the Parke-Bernet Galleries. These were auctioned earlier this year to finance future diving operations by the Real-8 Company.

# Coins

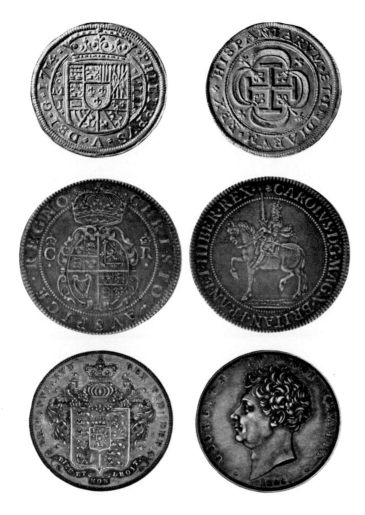

Eight-Escudo Coin, dated 1714, discovered with the Spanish Treasure, found off Florida.
New York $9,000 (£3,214) 4.II.67.

Charles I, silver crown by Nicholas Briot (1631–32), showing the King on horseback. The coin is in extremely fine condition and very rare thus.
From the collection of Douglas Harratt, Esq., of Johannesburg, South Africa, and formerly in the Wigan, Montagu (sold by Sotheby's, 1896 for £5 15s.), Dudman, Dr E. C. Carter and R. Carlyon-Britton Collections.
London £260 ($728) 17.VII.67.

George IV, by William Wyon, copied from the bust by Sir Francis Legatt Chantrey, and dated 1825. The coin is toned, and in extremely fine condition, and also extremely rare.
From the collection of Douglas Harratt, Esq., of Johannesburg, South Africa, and formerly in the Whetmore Collection.
London £300 ($840) 17.VII.67.

An Order of the Bath, Gentleman Usher of the Scarlet Rod and Brunswick Herald, gold badge, *circa* 1750.
London £230 ($644) 20.III.67.
From the collection of L. Fern, Esq.

# Arms and Armour

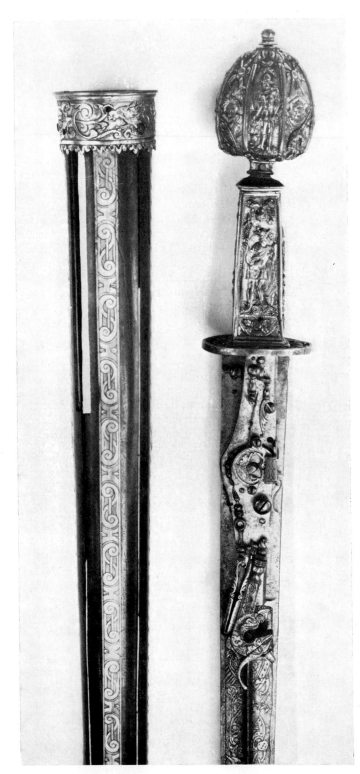

A German Combined Walking Staff,
Sword and Wheel-lock Pistol,
probably Augsburg, last quarter of
16th century.
London £3,200 ($8,960) 10.VII.67.
From the collection of the Philip H.
and A. S. W. Rosenbach Foundation.

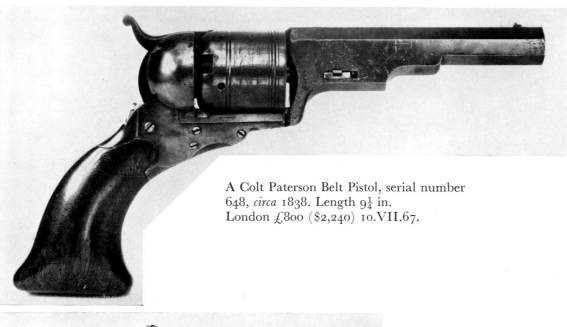

A Colt Paterson Belt Pistol, serial number
648, *circa* 1838. Length 9¼ in.
London £800 ($2,240) 10.VII.67.

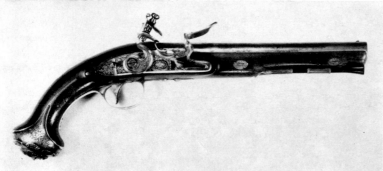

One of a pair of flint-lock holster Pistols, signed *Harrison and
Thomson, London* and hall-marked 1782. Complete in original
case.
London £1,450 ($4,060) 20.III.67.
From the collection of Mrs Charles Williams.

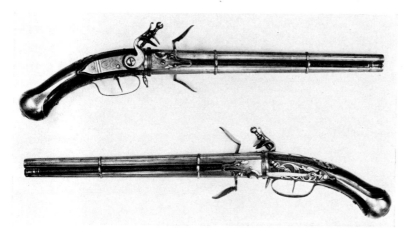

A Pair of Netherlandish D.B. Turn-over flint-lock holster Pistols,
*circa* 1690, Length 22 in.
London £1,100 ($3,080) 20.III.67.

One of an historic pair of embossed steel-plaques from the horse
bard of the so-called Snake Armour of Henry II, King of France
(reigned 1547–59), wrought in the Paris royal workshops after
designs by Etienne Delaune between 1556 and 1559.
15¼ in. by 9 in. London £1,650 ($4,620) 10.VII.67.

*Right:* A late Gothic Ceremonial Arrowhead of steel engraved and inlaid with engraved brass,
possibly the badge of office of the Captain of an Archer's Guild or the Master of a Brotherhood of
St. Sebastian, or of a Tournament Judge. Central European, perhaps Bohemian, late 15th century.
London £950 ($2,660) 7.XI.66. Now in the Metropolitan Museum of Art, New York.

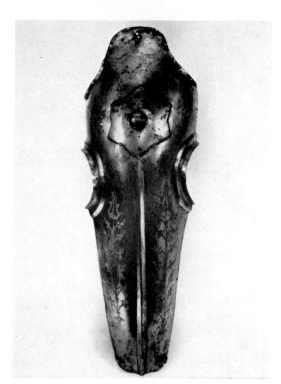

A Turkish Chanfron of Copper, the
whole surface gilt and engraved,
incised with the mark of the Mameluke
Arsenal, 16th century.
London £480 ($1,344) 20.III.67.

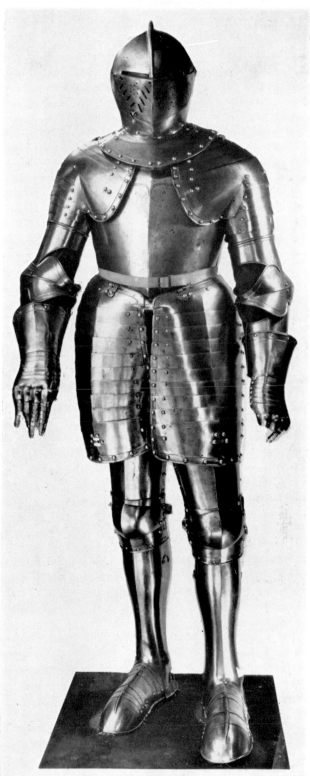

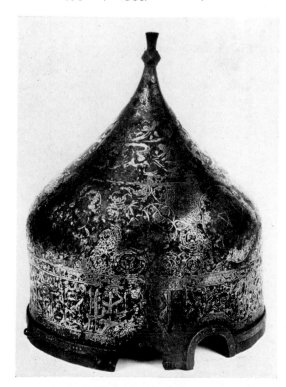

A Mameluke Helmet, the whole surface
damascened in brass and silver with the
Mameluke Arsenal mark, 15th century.
London £340 ($952) 20.III.67.

A complete set of French Armour,
early 17th century.
London £550 ($1,540) 20.III.67.

# Miniatures

One of the nicest compliments ever paid to a painter was written by the poet William Hayley to George Engleheart after seeing the miniature Engleheart painted of Mrs Hayley.     *'Dear Engleheart, with more than magic grace,*

       *With heavenly aid you exercise your art;*

       *You paint my fair one's virtues in her face,*

       *A gracious Heaven impressed them on my heart.'*

This does credit to all three, and when the miniature, signed and dated 1809, came up for sale just before Christmas, it found a new owner at £390. It was unfortunate that, after so eloquent a start Mr and Mrs Hayley—she was his second wife—separated after three years. His first wife had been painted by Jeremiah Meyer about 1770, and this miniature made £330. Another of his mother, also by Meyer, went for £320, and one of his son for £420. The same morning we saw an interesting little miniature by Richard Crosse, sold for £55—a self-portrait painted in 1758 when he was sixteen. Among earlier and more distinguished miniatures was a fine Peter Oliver of Lady Arabella Stuart—£780; a nice portrait of a woman called Elizabeth of Bohemia by John Hoskins—£460, and a Samuel Cooper of Lady Frances Cooper who married in 1650 Sir Anthony Ashley Cooper, later 1st Earl of Shaftesbury.

While everyone is familiar with the work of Cornelius Johnson as a painter of normal size portraits he did sometimes execute miniatures and a pair by him turned up in a sale in March—Mr and Mrs Peter Vandeput. The founder of the English branch of the family, Gillis van der Putte was born in Antwerp in 1576; Peter was his grandson and married Jane Hoste, daughter of Dierick Hoste of London and Sandringham. They were attractive portraits, that of Peter Vandeput perhaps the more sensitive, giving the impression that the painter found the husband a more interesting subject. They made £790. The most important miniature of the year was one of Queen Elizabeth I by Nicholas Hilliard. One would imagine that all miniatures by this first (and to most of us, greatest) of English miniature painters, would have been recorded long ago. This one appears to have been forgotten since it appeared at the Exhibition of Portrait Miniatures at the South Kensington Museum in 1865, until it turned up in a sale in June, when it was sold for £1,900. It is exceptionally small, only 1⅜ in. and is contained in the lid of a later snuff-box. The date is about 1580 and, as always, the Queen's dress is smothered in pearls and other jewels, her auburn hair is tightly curled and also bejewelled. Other details, not readily distinguishable in a photograph, are a spray of honeysuckle at the right shoulder and the ruff pinned with a white rose over the left shoulder. The Queen of England followed a later but, in the eyes of contemporaries, a hardly less imposing queen, Sarah Siddons, as portrayed in a well-known miniature by Horace Hone. This was painted in 1784, was engraved by Bartolozzi and published by Horace Hone at his house in Dublin the following year. The print was dedicated to Mrs Siddons who owned the miniature. The engraving was offered to subscribers at 5/-; to others at three half crowns; coloured impressions at half a guinea. The miniature now sold for £650.

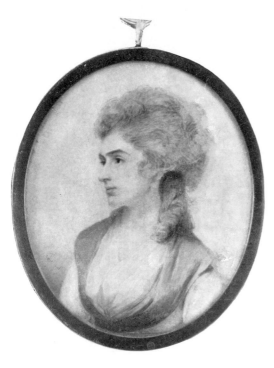

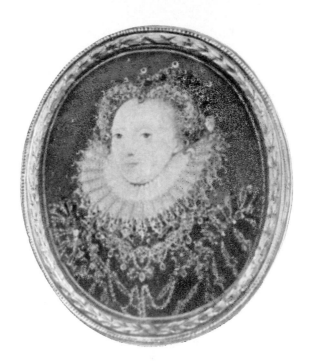

HORACE HONE
Sarah Siddons, signed and dated 1784.
Height 3½ in.
London £650 ($1,820) 19.VI.67.

NICHOLAS HILLIARD
Queen Elizabeth I. Height 1⅜ in. *circa* 1580.
London £1,900 ($5,320) 19.VI.67.
From the collection of the Rt. Hon.
Lord Bagot.

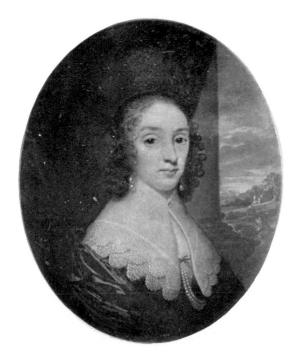

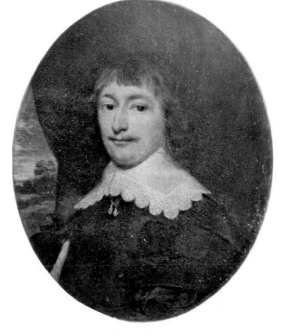

CORNELIUS JOHNSON
A Pair of Oil Miniatures of Mr and Mrs Peter Vandeput, both showing traces of a signature.
Painted on copper. Height 3⅞ in.
London £790 ($2,212) 6.III.67.

407

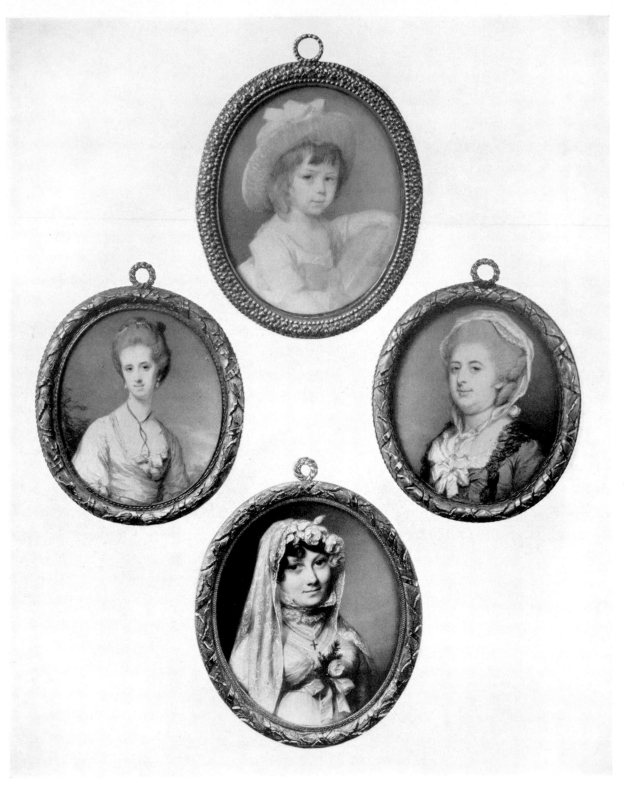

*Top*  JEREMIAH MEYER
Thomas Alphonso Hayley as a child. Height 3⅛ in. London £420 ($1,176) 12.XII.66.
*Left*  JEREMIAH MEYER
Mrs William Hayley (née Eliza Ball). Height 2¾ in. *circa* 1770. London £330 ($924) 12.XII.66.
*Right*  JEREMIAH MEYER
Mrs Thomas Hayley (née Mary Yates). Height 2¾ in. London £320 ($896) 12.XII.66.
*Below*  GEORGE ENGLEHEART
Mrs William Hayley (née Mary Welford), signed and dated 1809. Height 3⅛ in.
London £390 ($1,092) 12.XII.66.

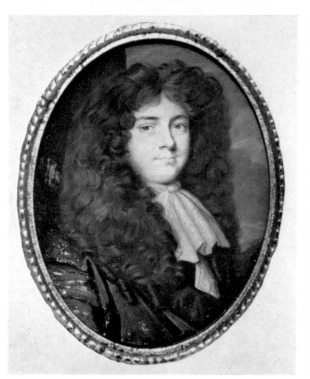

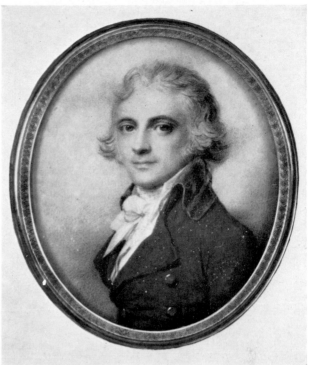

*Top left* THOMAS FLATMAN
Called *Thomas, Marquis of Wharton*
(1648-1715) Height 3 in.
London £220 ($616) 6.III.67.

*Top right* RICHARD COSWAY
*John William Hope*
Signed and dated 1796. Height 3 in.
London £520 ($1,456) 12.XII.66.

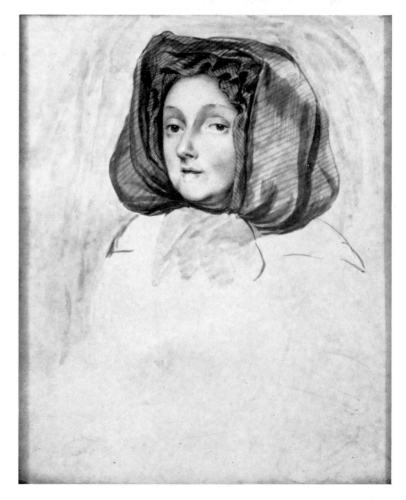

RICHARD GIBSON
Mrs. Richard Gibson (née Anna
Shepherd). Height $5\frac{1}{4}$ in.
London £210 ($588) 6.III.67.

# Diaghilev Ballet Material

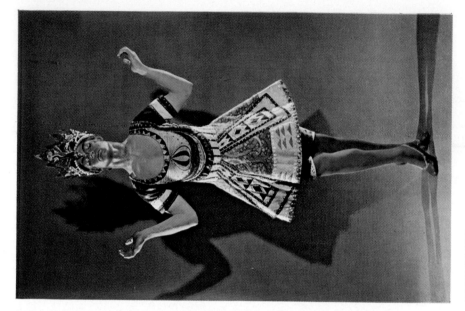

LEON BAKST
Nijinsky's costume in 'Le Dieu Bleu'.
Ballet with libretto by Cocteau, music by
Reynaldo Hahn, choreography by Fokine and
décor by Bakst, produced by the Diaghilev
Ballet in Paris, May 13, 1912.
The part of the Dieu Bleu was danced only by
Nijinsky and this costume is unique.
London £900 ($2,520) 13.VI.67
From the collection of Mrs Vera Bowen

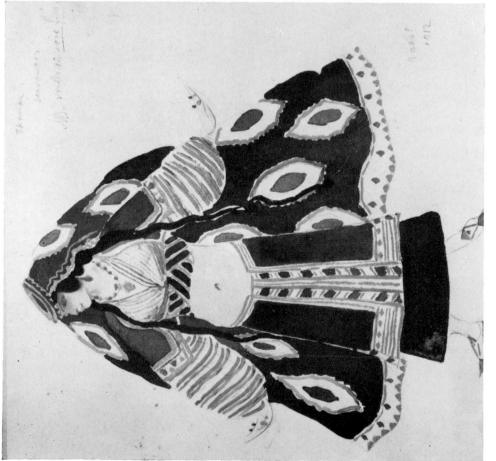

LEON BAKST
Costume design for a Servant in 'Thamar'.
Ballet with music by Balakirev, choreography by Fokine, and
décor by Bakst, produced by the Diaghilev Ballet in Paris,
May 20, 1912.
London £600 ($1,680) 13.VI.67
From the collection of Madamoiselle Lucienne Gabriel-Astruc.

PABLO PICASSO
Zverev's and Nemtchinova's costumes as the Acrobats in 'Parade'.
Ballet with libretto by Cocteau, music by Satie, choreography
by Massine and décor by Picasso, produced by the Diaghilev
Ballet in Paris, May 18, 1917.
London £300 ($840) and £200 ($560) 13.VI.67
From the collection of Mrs Vera Bowen

LEON BAKST
Nijinsky's costume in 'L'Oiseau d'Or'.
Ballet with music by Tchaikovsky, choreography by Petipa
and costumes by Bakst, produced by the Diaghilev Ballet in
Vienna, January 1913.
London £450 ($1,260) 13.VI.67
From the collection of Mrs Vera Bowen

NATALIA GONTCHAROVA
Costume design for a Seraphim in
'Liturgie'.
This ballet planned in Switzerland by
Diaghilev, Massine and Gontcharova
during the 1914 war was never realised.
London £850 ($2,380) 13.VI.67

A Meissen Group of Karsavina and Nijinsky
in 'Carnaval'.
Ballet with music by Schumann, choreography
by Fokine and décor by Bakst, produced by
the Diaghilev Ballet in Berlin, May 20, 1910.
London £380 ($1,064) 13.VI.67
From the collection of Mr and Mrs J. Burt

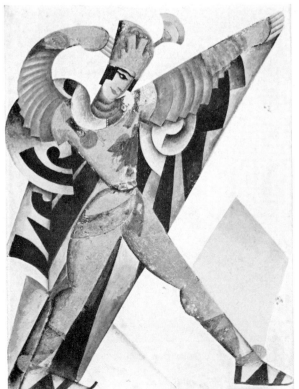

ANDRE DERAIN
One of twelve designs for the Make-up
in 'La Boutique Fantasque'. Ballet
with music by Rossini, arranged by
Respighi, choreography by Massine,
and décor by Derain, produced by
the Diaghilev Ballet in London,
June 5, 1919.
London, each frame composed of
six designs fetched £800 ($2,240)
13.VI.67
From the collection of Léonide
Massine.

PAVEL TCHELITCHEV
Costume design for a Magician, 1920.
London £200 ($560) 13.VI.67

LEON BAKST
Design for the Décor of Act I of 'Daphnis et Chloë'
Ballet with music by Ravel, choreography by Fokine and décor by Bakst,
produced by the Diaghilev Ballet in Paris, June 8, 1912.
London £1,050 ($2,940) 13.VI.67.

ALEXANDRE BENOIS
Design for the Décor of Act II in 'Le Pavillon d'Armide'.
This design was for the St. Petersburg version produced at the Maryinsky
Theatre in 1907.
London £500 ($1,400) 13.VI.67.
From the collection of Madame Anna Tcherkessov, daughter of A. Benois.

# Vintage and Veteran Cars

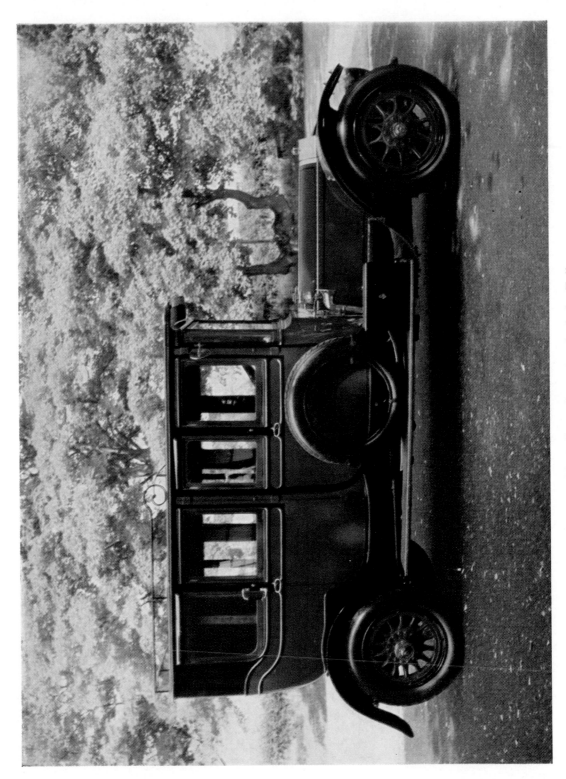

A 1910 Rolls-Royce 40-50 h.p. 'Silver Ghost' double Pullman limousine, body by Fuller.
This model is the earliest known Rolls-Royce existing with fully enclosed coachwork and full
electric lighting.
London £9,500 ($26,600) 4.XI.66.
From the collection of D. W. Neale, Esq.

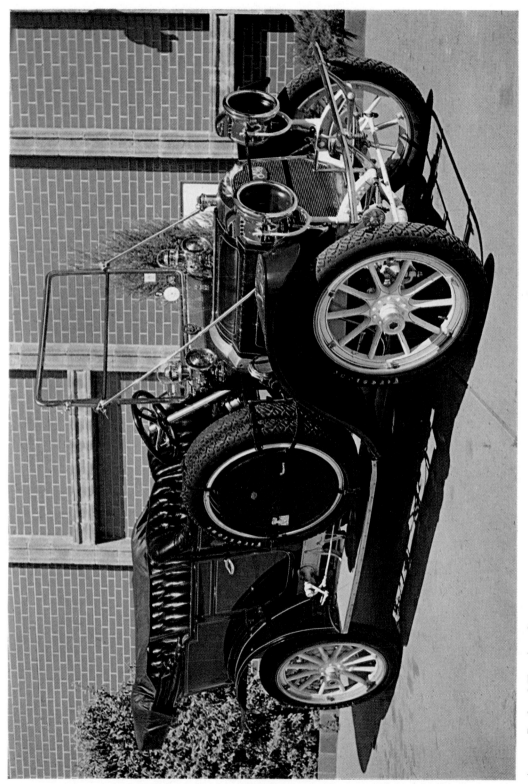

A 1910 Packard Touring Car—Model 18.
New York $14,000 (£5,000) 15.XI.66.
From the collection of Arthur G. Rippey, Denver, Colorado.

# Dorothy Doughty birds

by George Savage

Birds have been a favourite subject with porcelain designers from the days when Kändler and Kirchner modelled those of Augustus's Moritzburg aviary, and they have always been popular with collectors. But even this does not account for the success enjoyed in the United States by the birds of Dorothy Doughty, made by the Worcester Royal Porcelain Company.

We have become accustomed to seeing several thousands of pounds paid for important examples of antique porcelain, but the highest price so far paid for a pair of Doughty birds, the Quail made as recently as 1941, of $50,000 (nearly £18,000) is a surprise which almost amounts to a shock.

Although these birds have been eagerly collected in the United States since the war, it is only during the last seven years or so that they have appeared in the Parke-Bernet Galleries in New York, but almost immediately prices could be seen to be well above the original list price. Typical of prices in 1961 was the $4,000 paid for a pair of Baltimore Orioles in Tulip-trees first issued in 1938, $10,500 for a pair of Redstarts on Hemlock (the first pair to be issued, in 1935), and $6,000 for a pair of Goldfinches on Thistles of 1936. In 1962 a collection of thirty-four different models, some still in production, brought $92,350. Since that time prices have remained on a comparable level, culminating with the $50,000 mentioned for a model of which twenty-two pairs were originally issued.

The series of American birds, comprising thirty-eight pairs and seven single models, have now been followed by the first of a series of British birds, which the artist completed just before her untimely death in 1962. The popularity of the first series may, perhaps, be judged from the fact that when Her Majesty the Queen visited the United States one of her gifts to President Eisenhower was a Doughty bird.

The birds themselves are made to the most exacting standards, and reflect the traditions of craftsmanship and quality with which the Worcester factory has always been associated.

Dorothy Doughty, daughter of the Arabian traveller, Charles Doughty, and a member of a distinguished family, brought to her work a passionate interest in her subject, and a care for fidelity in modelling which led her to undertake several journeys to the United States to study the birds themselves in their native surroundings. Her designs posed problems never before faced by a porcelain manufacturer which required great ingenuity to overcome. Many were certainly more daring in their demands on the factory's craftsmen than bird models of former times, to be seen in those in flight, attached by tail or wing-tip to the accompanying flowers.

Dorothy Doughty never studied the work of her great predecessors, and she started without any preconceived notion of how her birds ought to fit into the traditional

416

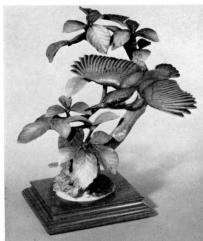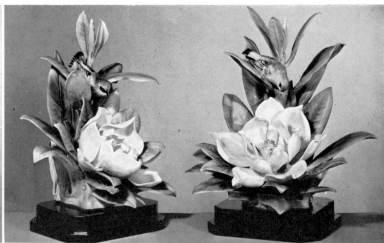

Kingfisher and Autumn Beech.
Height 12 in.
New York $750 (£371) 28.I.67.

A Pair of Magnolia Warblers in Magnolia Grandiflora.
Heights 13½ in. and 14½ in.
New York $4,750 (£1,696) 28.I.67.

pattern of European porcelain design. Her work was entirely based on the pursuit of natural representation, and in doing so she greatly extended the limits of her medium. She was a true artist, using birds and flowers to express her own simple vision of life and of nature.

Her interest extended to the delicately modelled flowers which form part of each model, and in one or two instances flowers form the principal subject, notably the Crabapple sprays and Butterfly of 1940, and the Mexican Feijoa and Ladybirds of 1950.

The American birds have been issued in limited editions which range from twenty-two in the case of the Quail to five hundred for one or two of the more popular models, and this has its effect on prices realised in the sale-room today. Some of the American series are still in production, to be bought through normal channels, but when each edition is completed the moulds are destroyed.

# Clocks and Watches

It is well known that devout horologists are a cut above ordinary mankind. People—mere people—ask of a clock that it should tell the time. Horologists demand nothing quite so simple. Their talk is of verge escapements, of fusee drums, of striking train mechanisms and other mysteries, of the fascinating story of time measurement throughout the ages, of man's slow, painful approach to split second accuracy and of the ingenious minds which have gradually achieved it. In this achievement English clockmakers have played an honourable part, and it so happens that during this season Sotheby's have had through their hands, apart from dozens of good clocks from both sides of the channel, one each from the workshops of the three men who are generally considered to be the greatest of their generation. The first was a demure little bracket clock by Edward East, the best known of English clock and watchmakers of the mid-17th century, who lived till 1693, after having been Master of the Clockmakers Company as far back as 1645. The movement is contained in a tall ebonised and veneered ebony case with a panelled pediment cresting, the frieze with a gilt-metal swag of fruit. It is thought to be one of the earliest pendulum bracket clocks by an Englishman in existence, probably made before 1670, and was sold for £2,600. The second was an ebony-cased repeating timepiece by Thomas Tompion, un-numbered and therefore probably to be dated about 1680, for Tompion began numbering his clocks between 1680 and 1685. It has the rare feature of a *silver* chapter ring, with the hour and five-minute numerals and half-hour markers seen in relief against a sanded ground, and made the highest price yet recorded for a bracket timepiece—£7,000. The third was also a horological rarity—a small bracket clock by George Graham, Tompion's assistant, nephew by marriage and successor after his master's death in 1713 until his own in 1751—both were buried in Westminster Abbey. The clock is numbered 272 which confirms that it was made in Tompion's shop perhaps about 1700, but is signed by Graham. It may therefore have been made by Graham for his own use or for a special order or (as it is signed Graham and not George Graham) that it was the first clock Graham made with his own hands. It attracted a great deal of attention and was sold for £8,500 which is also a record price for a clock by Graham. Among clocks by less famous makers, that same morning, a dignified long case by Finney of Liverpool provided a mild surprise by selling for £1,900. A sale at the end of May included numerous early table clocks; a particularly fine example was a French circular table clock which could be dated to before the introduction of the Gregorian calendar in 1582 which made £2,100, and a quarter striking astrological standing clock £3,400, while a gilt metal celestial globe supported by a figure of Atlas went up to £2,900. There were some notable watches, one of them at Parke-Bernet—an engraved ormolu carriage watch, reign of Louis XIV which made 5,000 dollars, and at Sotheby's two 18th-century gold and enamel watches with matching chatelaines—£960 and £950.

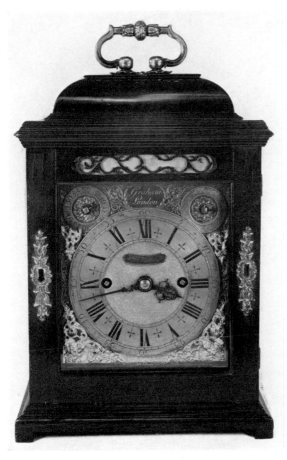

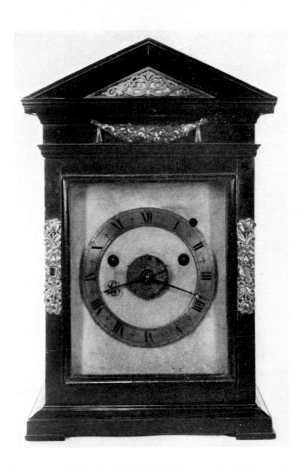

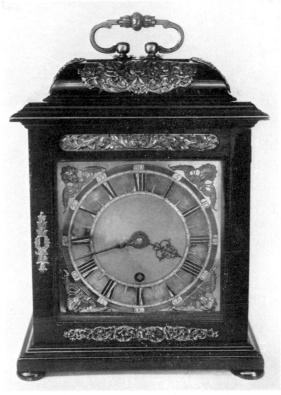

*Above left*

GEORGE GRAHAM. A Small Bracket Clock
in a veneered Ebony Case, No. 272,
the 4¾-inch dial signed *Graham, London*.
Height 10¼ in. Made in Thomas Tompion's
workshop *circa* 1700.
London £8,500 ($23,800) 2.XII.66.
From the collections of John Henry
Montgomery Bell and Leycester Anderson,
Esq. The highest price paid for any clock
by Graham.

*Above right*

An Architectural-cased Alarm Bracket
Clock, by Edward East, signed, *circa* 1670.
Height 1 ft 7 in.
London £2,600 ($7,280) 26.V.67.
From the collection of Miss C. B. Dyneley.

*Right*

THOMAS TOMPION. An Ebony-cased
Repeating Bracket Timepiece, *circa* 1680.
Height 12½ in.
London £7,000 ($19,600) 7.VII.67.

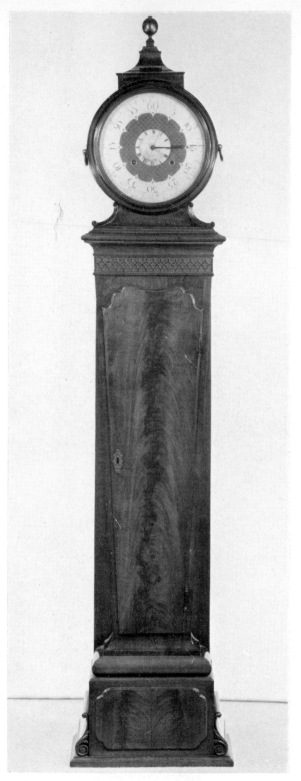

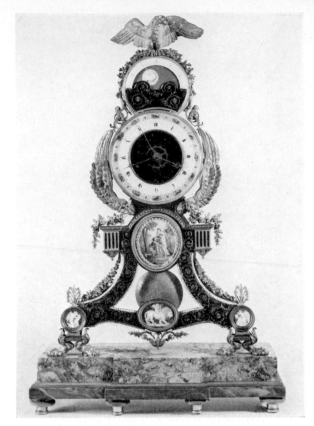

A Louis XVI Enamel and Ormolu Mantel
Clock, signed Coteau Ft. Height 1 ft 7½ in.
London £1,200 ($3,360) 18.V.67.
From the collection of the late Madame
Alexandrine de Rothschild.

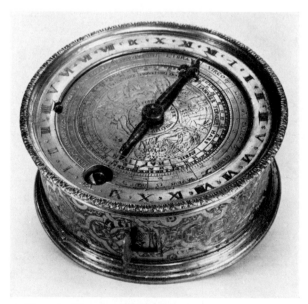

A French Circular Table Clock, diameter 5¾ in.
London £2,100 ($5,880) 22.V.67.
From the collection of P. van Alfen of Holland.

Finney of Liverpool. A Mahogany
Long-case Year Regulator, height 6 ft 8 in.
London £1,900 ($5,320) 2.XII.66.
Baillie records five members of the Finney
family in Liverpool, the earliest being
Joseph who worked between 1734 and 1761
and the last clockmaker, another Joseph,
worked between 1770 and 1796. William
and Richard Finney worked in the 1820's
but are recorded only as watchmakers.

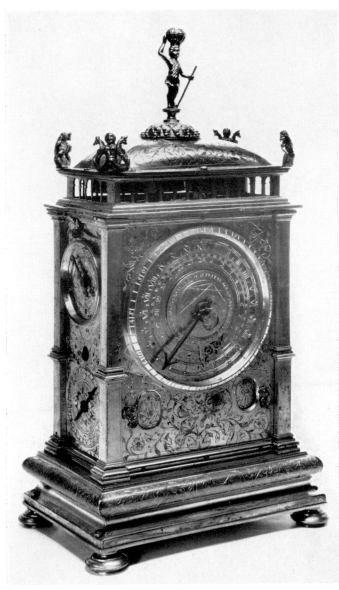

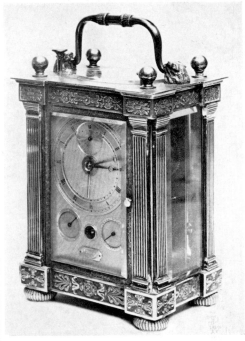

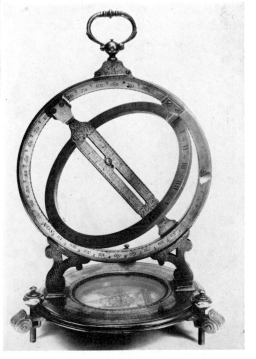

*Above*

A Quarter-striking Astrological Standing
Table Clock.
London £3,400 ($9,520) 22.V.67.
From the collection of P. van Alfen of Holland.

*Above right*

A Breguet Travelling Clock.
A Silver-cased Eight-day Travelling Clock
by L. Breguet and fils. Sold to Prince Serge
Galitzin in 1826 for 3,600 francs. (Reference
No. 3358.) Height 5 in.
London £5,000 ($14,000) 31.X.66.

An 18th-century Standing Universal Ring Dial
by Thomas Heath. Height 16½ in.
London £950 ($2,390) 10.VII.67.

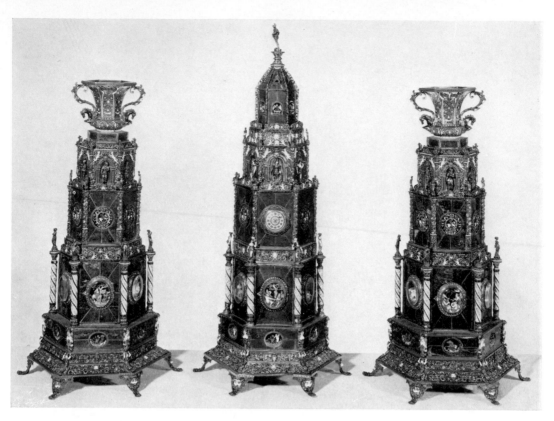

A Viennese Enamel and Lapis Lazuli Clock Garniture, Heights 27½ in. and 22½ in.
New York $7,500 (£2,679) 7–8.X.66.

A Louis XIV Engraved and Ajouré
Bronze Doré Striking Carriage Watch,
Pierry Norry, Gisors, dated 1645.
Diameter 4⅞ in.
New York $5,000 (£1,785) 9.XII.66.
From the collection of the late
Helen M. de Kay.

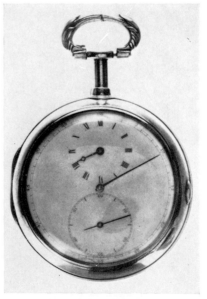

A lever Watch in silver consular case,
signed Rich. Pendleton, London, no. 175,
hallmarked 1797.
London £1,300 ($3,640) 13.III.67.
From the collection of A. J. Hubbard, Esq.

# Japanese Works of Art

The study of Japanese Netsuke received a tremendous fillip when the late Frederick Meinertzhagen's book, *The Art of the Netsuke Carver*, at last made its appearance. A collection formed by Mr M. T. Hindson which was largely built up, at least in its early stages, with Meinertzhagen's help, has now begun to make its appearance at Sotheby's. Part one was dispersed in June when one hundred and seventy-seven netsuke were sold for £16,475, and the remainder of the collection is to be divided into several equally promising sales. As befits a collection long recognised as the most representative of its kind, the catalogue for this section was designed in an unusual manner, with photographs accompanying the descriptions; the complete set will provide a valuable and scholarly view of the whole subject. The collection consists of examples, in varied materials, of signed works by carvers of all the known schools. The layman is liable to be confused if he attempts to travel too fast and too far in the literature of the subject and the first of the Hindson catalogues preserves a praiseworthy balance between over-simplification and the often esoteric language of the specialist. To appreciate these minutely carved little toggles as they deserve, one would, no doubt, need to be thoroughly well versed in Japanese folklore, a lifetime occupation in itself; otherwise ghosts, demons and goblins convey no message to the western mind. But there is one special category in which netsuke carvers excel and which presents no difficulty to the layman and that is the very varied representation of animal types. One of the best, or at any rate one of the most endearing—in the Hindson collection was an ivory model of a puppy crouching over a sandal and biting the attached rope, carved by Kwaigyokusai. This made £380 and was followed by a horse, a rare example of work by the artist Muneharu, a remarkable piece of observation in miniature, the animal reclining and turning its head back to nibble at its flank, this model made as much as £500. A rat by Okatori, scratching its cheek with a hind paw, its tail held by the forepaws, was sold for £200, a boxwood elephant with its attendant, by Miwa, for the same sum and a seated monkey in narwhal wearing a coat engraved with flowers and holding a peach by Shuraku for £210.

Another specialised Japanese collection from which we are to see other specimens in the not too distant future is that belonging to Mr Clement Milward, well known for many years as a prominent member of the Japan Society Art Circle and particularly as a collector of swords and sword fittings. Part one of his collection was sold in June for £7,689. Here one is faced by even greater difficulties—a formidable mystique, secrecy on the part of generations of sword-smiths as to the methods they used to produce their incomparable blades and a multiplicity of decoration for sword furniture. A Katana, that is the fighting sword which was carried thrust through the girdle, cutting edge upwards, made £280, and a finely mounted Aikuchi, a dagger without a guard, dated A.D. 1509, £200. A no less beautifully mounted Tonat, a dagger with a guard, dated 1413, went for £250. A fine gold and silver Kozuka, a small knife, made £230; the highest auction price previously recorded being £105.

The main reason for this high price was the presence of the signature of the important 16th-century artist Somin I. Another Kozuka in polished and patinated brass with the goddess Kwannon in gold and silver by Natsuo went for £140.

From the enormous amount of interest that has arisen from these two sales, we can anticipate a widening interest in the fascinating field of Japanese Art which still provides much scope for exploration and study.

An Ivory Netsuke of a Dog licking its left hind paw, ivory, 18th century, signed Masanao.
London £300 ($840)

An Ivory Netsuke of a Horse, signed Muneharu.
London £500 ($1,400)

A Wood Netsuke of two hares, signed Ikkwan.
London £360 ($1,008)

An Ivory Netsuke of a Puppy and Sandal, signed Kwaigyokusai.
London £380 ($1,064)

A lacquered wood and fish-skin Netsuke representing a Flat-fish, early 19th century.
London £180 ($504)

All from the M. T. Hindson collection of Netsuke sold at Sotheby's on the 26th June 1967 for a total of £16,455 ($46,074).

A Wood and Ivory Group of Two Doves and Two Fledglings in a Nest, signed
Kofu. London £300 ($840) 27.VII.67.
From the collection of the late D. B. Levinson.

An Ivory Netsuke of an Ama
or Fisher-girl, 18th century.
London £220 ($616) 26.VI.67.
From the collection of
M. T. Hindson.

A Four-case Inro with Toba on the Mule
in lacquer and inlay. Signed, Koma Kwansai.
London £315 ($882) 29–30.XI.66.
Previously sold at Sotheby's in April 1965
for £260 ($728).

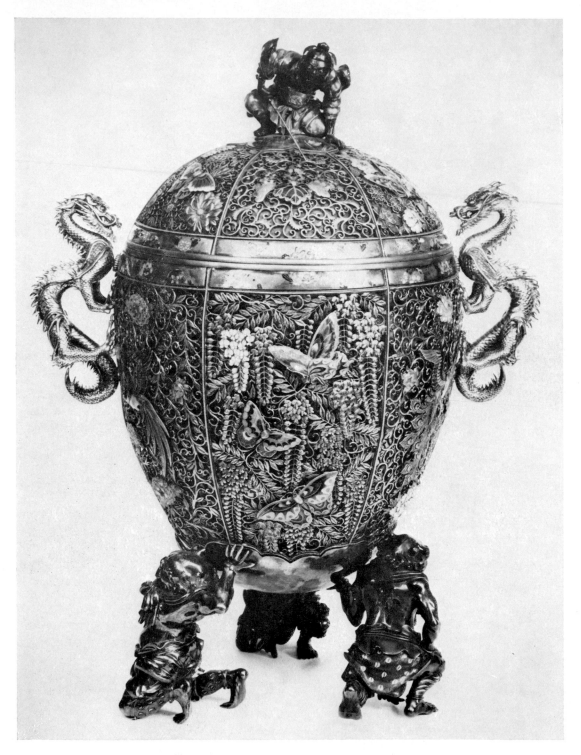

A Silver and Enamel Koro, Height 17 in.
London £700 ($1,960) 27.VII.67.

A Figure of a Girl, signed Kyotada.
Height 17 in.
London £440 ($1,232) 27.VII.67.
From the collection of the late D. B. Levinson

SCHOOL OF MORONOBU
*Figure of a Girl.*
Ink and colour on paper. 24¾ in. by 7½ in.
Unsigned. Drawn late 17th century by an
artist very close in style to Moronobu,
possibly Morofusa.
London £240 ($672) 1. XI.66.

# Acknowledgements

Messrs. Sotheby and Co. and Parke-Bernet Galleries Inc. are indebted to the following who have allowed their names to be published as the purchasers of works of art illustrated on the preceding pages.

*The figures in parentheses refer to the page numbers on which illustrations appear.*

Mrs Harry N. Abrams, New York (198 left); Acquavella Galleries, Inc., New York (116 below); Adams Gallery, The, London (175 above); Lucile and Berle Adams, Universal City, California (198 right); Thos. Agnew & Sons, Ltd, London (11, 111 above, 114, 154 above, 164 above, 167 above, 171 below, 330 above (portrait)); A La Vieille Russie, New York (217, 345 below); Mr and Mrs J. W. Alsdorf, Winnetka (336 below); Albert Amor Ltd, London (384 above); The Antique Company of New York Inc., incorporating The Antique Porcelain Co., New York and London (216, 268 above, 270, 274 left, 275, 276 left, 277, 279, 283, 289, 330 below, 338 above right, 344 below, 384 below left and right, 385, 389); The Arcade Gallery, Ltd, London (204); Asprey & Co. Ltd, London (294 right);

H. Baer, London (19, 219 below, 223 right, 224 below, 224 above); Balogh's Inc., Florida (316); Banque de Paris et des Pays-Bas, Anvers (32 below); Mr. Frederick W. Beinecke, New York (83); Mr and Mrs Charles B. Benenson, New York (99); Mr B. E. Bensinger, Chicago (80, 61); Bentley and Co., London (320 above); Pierre Berès, Paris (354, 357 above left, 356 above left); Berkeley Galleries Ltd, London (188 above); Mark Bernstein, London (130); Mr and Mrs Max Berry, Washington, D.C. (81 below); Herbert N. Bier, Esq., London (405 above left, 405 below left); F. E. Bivens, Jr., Los Angeles (402); N. Bloom and Son Ltd, London (295 left); Bluett and Sons, London (251 below, 252 above, 254 above, 255 above); Bodley Gallery, David Mann (65); Mrs L. Bomberg, London (175 below); Mr Gerald Bregman, New York (338 below right); Martin Breslauer, Esq., London (351); Aubrey Brocklehurst, London, for the Globus Collection (419 below); Brod Gallery, London (21 left); W. G. T. Burne (Antique Glass) Ltd (376 above left);

Dr H. Cahn, Munzen und Medaillen, A. G., Basel (185 above left); Cambridge University Library (369 above right); Camerer Cuss and Co., London (305 below left); B. G. Cantor, Beverly Hills, California (177 above); C. Caplan, Esq., Derbyshire (173 below); Carmel, Iris (96); Carnegie Bookshop, New York (370 below left); Frank Caro, New York (262 left); Daan Cevat, London (33, 34 below); Arthur Churchill (Glass) Ltd, London (376 above, 376 below right); Ciancimino, London (227 below); Sibyl Colefax and John Fowler, London (158, 159, 335 above); Dr Jerome S. Coles, New York (74); Philip Colleck of London Ltd, New York (335 below); P. & D. Colnaghi and Co. Ltd, London (34 above, 110, 119, 122, 147 above, 168 below, 170 above, 407 above right); M. Comer of London Inc., New York (328 below); Contemporary Art Establishment (73, 127 above right, 133); Craddock and Barnard, London (140 above, 141 above); Milo Cripps, Esq., London (187 above right); Mrs Florence Crossman, New York (334 above left); Mr Nathan Cummings, Chicago (90);

P. Dale Ltd, London (403 below); George Daniels, London (421 above right); W. Dawson, Pall Mall, London (361 below right); Peter Decker (370 above left); De Golyer Foundation, Dallas (372 above); Peter Deitsch Gallery, New York (127 below left, 136 left); Mr Richard Dentch (395 below first from left); Lucien Delplace & Fils, Brussels (289 centre); Simone de Monbrison, Paris (196 below); Richard Dennis, London (231 below left); J. & S. S. DeYoung, Inc., Boston (308 centre right, 309 top left, 313 below); Dr A. C. R. Dreesmann, Amsterdam (319 above); Mr M. F. Drinkhouse, New York (79); Arnold M. Duits, Esq., London (39); Philip C. Duschnes (370 above right);

Arthur A. Eisenberg, New York (137 right); Reed Erickson, Barton Rouge, La (84 below); Mrs Jack Erlanger, New York (323 above; Eskenazi (427 left);

Faerber and Maison Ltd, London (144–145); Richard Feigen Gallery, Inc., New York and Chicago (72); Mrs Walter Feilchenfeldt, Zürich (118); The Fine Art Society Ltd, London (150, 155 below); Fisher Gallery Ltd, London (376 above right); John F. Fleming, New York (364 below left, 373); Frost & Reed Ltd, London (161 above);

F. Gonzalez de la Fuente, Mexico (71 above, 84 above); F. and L. Gallop, London (305 below right, 305 above centre); Galerie Beyeler, Basle (51, 62); Galerie Osten-Kaschey, Ltd, New York (422 below left); Galerie Veranneman, Brussels (424 below); Garrard and Co. Ltd, London (310 right (rivière)); Paul Getty, Esq. (13, 324 above); Mrs Charles Gilman, New York (347); Ginsburg & Levy Inc., New York (395 below third from left); Mrs Helen Glatz, London (258 below); Mr Jean Goldwurm, New York (98 right); Miss Elinor Gordon, Villanova, Pa (327 below, 392, 401 above); James Graham and Sons, New York (97); Grover Antiques, Inc., Ohio (213 extreme left); Dr Peter Guggenheim, New York (421 above left);

Otto Haas, London (425 below left); The Hallsborough Gallery, London (26, 35 above); W. F. Hammond, Esq. Lymington, Hants. (361 below left); Harlem Book Company, Inc., New York, for Mr and Mrs Robert A. Feldman (137 left); The Hon. Mrs Vere Harmsworth, London (157); Lathrop C. Harper, Inc., New York (365 above right); R. L. Harrington Ltd, London (331 above); Hartman Trading Corporation, New York (266, 320 centre right); Joseph A. Heckel, New York (139 above); G. Heilbrun, Paris (357 below); Murry S. Herman, New York (315 centre right); K. J. Hewett, London (185 below left, 192 above, 187 below, 185 below right); Mr Joseph Hirschhorn, New York (88 below, 174 below); House of El Dieff, Inc., New York (368 above right, 369 below left); How of Edinburgh, for the National Museum of Wales (297 centre); Cyril Humphris Ltd, London (223 below); Hunt Foods and Industries Museum of Art (48);

C. Jacklin, Esq., Loughton, Essex (227 above); Ella Jaffe, New York (309 centre right); Geoffrey P. Jenkinson, Ohio (403 centre); Charles Jerdein, Esq. (229 above left); John Jesse, London (229 below left); Mr Jonathan Joseph, Boston (211);

Henri A. Kamer, New York (188 below, 189 left and right, 194 below left, below right and above right, 199 left); F. and R. Karger, London (314 centre left); Simon Kaye Ltd, London (303 below); Mr C. O. v. Kienbusch, New York (404 left); Sol Kittay, New Jersey (345 above, 338 above left); J. J. Klejman, New York (193 right, 196 above, 199 centre, 221); M. Knoedler & Co. Inc., New York (98 left) representing the John Marin Estate; H. P. Kraus, Inc., New York (107, 350); Kraushaar Galleries, New York (95 above); S. Kriger, Inc., Washington (261 above);

Felix Landau Gallery, Los Angeles (104); A. Laube, Zürich (106); D. S. Lavender (Antiques), London (319 below); L. P. Lee, Esq., London (395 above right); Ronald A. Lee, London (218 above, 225 above, 329, 419 above right); Leggatt Brothers, London (22 below, 23 below, 29, 153 right, 165 above); Gerald W. Leigh, London (176 left); Levinson's Inc., Chicago (309 below left, 308 above centre, 312); R. M. Light & Co. Inc., Boston (128, 125 right, 146, 138, 120 and 121); Mrs Joseph S. Lindemann, New York (85 below); Mr Charles Linn, and Mr. Michael Linn, New York (163 below); Lock Galleries, New York (16 right); Dr II. Lockett (405 right); Louis Loeb, Paris (369 above left); The London Hilton Art Galleries Ltd (127 above left, 132); Richard P. Lovell, Esq. (225 below); F. Lugt (Foundation Custodia), Paris (116 above);

Dr John J. McDonough, Ohio (94); Maggs Bros. Ltd, London (360 below right, 360 above left, 364 above left, 365 below, 369 below right); Mrs A. M. Malvin, New York (341 below); D. M. & P. Manheim (Proprietor: Peter Manheim) London (388 above left and right); N. Manoukian, Paris (231 above); Marlborough Fine Art Ltd, London (18, 20, 47, 55, 59, 64, 179 below, 181 below); E. A. Martin, Esq., London (186 below); Mr and Mrs Leonard Marx, Scarsdale, New York (326 below); The Metropolitan Museum of Art, New York (404 right); Sydney L. Moss Ltd, London (256 below, 257 above centre, 265, 424 above left, 424 above right);

Mr and Mrs John Nagel, New York (320 below); Mrs Lillian Nassau, New York (210 right); National Jewelers, Inc., New York (315 above left); W. Keith Neal, Warminster, Wilts. (403 centre); Mr and Mrs Arnold Neustadter, New York (181 above); Irving Nelkin & Company, New York (315 above right); David B. Newbon, London (388 below right); Kenneth M. Newman, The Old Print Shop, New York (139 below); Conrad Nicholls, Esq., Berkhamsted, Herts. (293 below right); Gerson Nordlinger, Jr., Washington, D.C. (170 below);

James Oakes, London (419 above left); O'Hana Gallery, London (125 left); George Ortiz Collection (187 above left); Mr S. Ovsievsky, London for the Baron Thyssen Collection, Lugano (14, 300, 321 above left);

J. B. Panchaud, Morges, Switzerland (172, 174 above); Frank Partridge, London (155 above, 205, 206, 297 candelabra, 299 right, 301, 302 below, 328 above left, 334 below, 340 below); S. J. Phillips, Ltd, London (289 above, 293 below left, 294 left, 303 above, 311 right); Phillips and Page Ltd, London (23 above); Howard Phillips, London (375 below, 377 above right); Pickering and Chatto, London (365 above left); E. Pinkus Antiques, Inc., New York (286 bird-form jugs); David W. Posnett (32 above); Dr Henry F. Pulitzer, London (222 above);

Bernard Quaritch, Ltd (355, 356 below left, 359, 364 above right);

R. Rabbani, London (360 below left); Charles Ratton, Paris (186 above); Brian Reade, Esq., London (169); Museum of Art, Rhode Island School of Design, Providence (92); Roland, Browse & Delbanco, London (171 above); Mr and Mrs Milton F. Rosenthal, New York (193 left and centre); Bertram

Rota Limited, London (403 above); Rutland Gallery, London (173 above); C. Ruxton-Love, New York, (336 above);

Israel Sack, Inc., New York (325); Ferdinando Salamon, Turin (141 below); Sanders of Oxford (409 below); Chas. J. Sawyer, London (367 below); William V. Schmidt, Co. Inc., New York (308 above left); Robert Schoelkopf Gallery, New York (192 below, 194 above left); Seiferheld and Company, New York (112); The Earl of Shaftesbury, (226 below); Mr Norton Simon (49); Merton Simpson, New York (191 above left and below); Hans Schneider, Munich (368 above left); Charles Sessler Inc., Philadelphia (372 below); Charles E. Slatkin Inc., New York (111 below, 108 right); Mrs Sylvia Sosnow (315 below left); Ira Spanierman, New York (156 below); John Sparks Ltd, London (251 above left, 253, 255 below, 264 above); Edward Speelman Ltd, London (27); Spink and Son Ltd, London (154 below, 161 below, 203, 251 right, 252 right, 254 below, 256 above left, 260 below, 262 right, 285 above, 377 below left, 401 bottom, 427 right); C. Marshall Spink, Esq., London (160 above and below); Robert Strauss, Esq. (202 above left);

J. T. Tai & Co., Inc., New York (263 all three, 264 below); The Tate Gallery, London (67); The Temple Gallery, London (41, 42, 43 above); H. Terry-Engell Gallery, London (31, 36 above); Alan G. Thomas (356 below right); Alan Tillman, London (377 above left and bottom right); Paul Tishman, New York (100 below); Arthur Tooth and Sons Ltd, London (178); V. Topper, Esq. Ontario (425 below right); Dr Torré Antiquities, Zürich (285 below right); Charles W. Traylen, Esq., Guildford, Surrey (352 below right, 363 below, 370 below right); Mr Herbert Trigger, New York (261 below);

Joseph & Earle D. Vandekar, London (258 above); Vartanian and Sons, Inc., New York (309 top left, and top right); R. G. Vater, Frankfurt (280 candlesticks); Vigo Art Galleries, London (323 below); J. and F. Van Brink, New York (422 above); René von Schleinitz, Milwaukee (168 above);

John Walter, Esq., Gloucester, on behalf of the Osborne Collection, Toronto (366 below right); Wartski, London (318 centre and below, 319 below, 320 centre left); Wasserman, Mr Otto, New York (395 below (second and fourth from left)); Julius Weitzner, London (15, 12 right, 28, 12 left, 149); Williams and Son, London (162); Winifred Williams, Eastbourne (278, 280 dish, sucrier and milk jug, 285 left); Walter H. Willson Ltd, London (299 left); Charles Woollett & Son, London (388 below left, 407 above left, 409 above left); E. E. Wrangham, Esq., Northumberland (424 centre right);

Zeitlin and Ver Brugge (362 above left).

# General Index
*see also page 432 for Books, Manuscripts and Miniatures*

# Index of Books, Manuscripts and Miniatures